Bags

a selection from
The Museum of Bags and Purses, Amsterdam

Tassen · Bolsos · Sacs

The Pepin Press
Amsterdam & Singapore

Colophon

ISBN 978 90 5496 143 7

Text by Sigrid Ivo
Photography by Leo Potma in co-operation with
Tassenmuseum Hendrikje

Tassenmuseum Hendrikje
The Museum of Bags and Purses
Herengracht 573
1017 CD Amsterdam
The Netherlands
www.tassenmuseum.nl
www.museumofbagsandpurses.com

This book is produced and published by:
The Pepin Press B.V.
P.O. Box 10349
1001 EH Amsterdam
The Netherlands
www.pepinpress.com

Printed in Singapore

Sigrid Ivo

Sigrid Ivo [1961] is the director of the Museum of Bags and Purses, the biggest bag museum in the world. The museum's origins lie in the private collection of her mother, Hendrikje Ivo, who compiled a collection of bags over a period of 35 years. As an art historian, Ivo specialised in the history of the bag and publishes articles on this subject.

Sigrid Ivo [1961] is directeur van Tassenmuseum Hendrikje, het grootste tassenmuseum ter wereld. Het museum is ontstaan uit de privé collectie van haar moeder, Hendrikje Ivo die gedurende 35 jaar tassen verzamelde. Als kunsthistorica specialiseerde Ivo zich in de geschiedenis van de tas. Zij publiceert regelmatig over dit onderwerp.

Sigrid Ivo [1961] es la directora del Museo de Bolsos Hendrikje, el más grande en su género. El museo fue creado a partir de la colección privada de su madre, Hendrikje Ivo, que durante 35 años coleccionó bolsos. Como historiadora de arte, Ivo se ha especializado en la historia del bolso y publica con regularidad artículos sobre el tema.

Sigrid Ivo [1961] est la directrice du Musée des Sacs Hendrikje, qui abrite la plus grande collection de sacs à main au monde. Le musée a été créé à partir de la collection personnelle de sa mère, Hendrikje Ivo, qui a collectionné des sacs en tous genres pendant 35 ans. En tant qu'historienne de l'art, Sigrid Ivo s'est spécialisée dans l'histoire du sac. Elle publie régulièrement des ouvrages sur le sujet.

Contents

Inhoud

Contenido

Sommaire

Introduction

Anyone who thinks that an everyday object like a bag is not worthy of interest had better think again. Few people realise that the bag has an unusually rich history and has been through a remarkable development over the centuries. First of all, there is the history of the uses of the bag – from functional object to style icon and essential fashion accessory. The bag's history can also tell us about significant developments that have taken place in society over the centuries. As such, it has been influenced by trends in art, design and fashion, as well as by socio-cultural developments and women's emancipation.

This book contains an overview of the history of the bag from the late Middle Ages up to the present day, with all the featured bags originating from the collection of the Hendrikje Museum of Bags and Purses – the biggest bag museum in the world. Its collection of more than 4,000 bags, pouches, cases, purses and accessories, reveals the diversity of the bag in terms of its use, form, adornment and material.

Like so many museums, the museum is a result of one individual's passion for collecting a specific item. The collection was built up by my parents, collectors Heinz and Hendrikje Ivo, over a period of 35 years, and falls under the authority of the Hendrikje Museum of Bags and Purses Foundation. What started out as a personal fascination has grown to become an extensive collection, and is now a remarkable, truly unique museum. The Hendrikje Museum of Bags and Purses, which was located in Amstelveen for the first 10 years, can now be found in a superb 17th century canal house in Amsterdam.

As director of the museum, I feel honoured to be able to work with such an extraordinary collection and at such a striking location. I hope this book inspires you in the same way and that it will arouse your curiosity to visit our museum.

Sigrid Ivo
Director

Introductie

Wie denkt dat een alledaags voorwerp als de tas geen interessant object is, heeft het mis. Weinig mensen realiseren zich dat de tas een buitengewoon rijke geschiedenis heeft en door de eeuwen heen een opmerkelijke ontwikkeling heeft doorgemaakt. In de eerste plaats is er natuurlijk de gebruiksgeschiedenis van tas – van functioneel voorwerp tot stijlicoon en belangrijk modeaccessoire. Maar de geschiedenis van de tas toont ook belangrijke sociaal-culturele ontwikkelingen door de eeuwen heen. De tas is beïnvloed door trends in de kunst, design en de mode alsook door sociaal-culturele ontwikkelingen en de emancipatie van de vrouw.

In dit boek geef ik u een overzicht van de geschiedenis van tas vanaf de late Middeleeuwen tot nu. Alle tassen komen uit de collectie van Tassenmuseum Hendrikje. Het museum is het grootste tassenmuseum ter wereld en bezit meer dan 4.000 tassen, buidels, koffers, beurzen en accessoires. In haar collectie laat het museum zien hoe groot de verscheidenheid is van de tas in gebruik, vorm, decoratie en materiaal.

Zoals vele musea is ook dit Tassenmuseum ontstaan uit een verzamelwoede. De collectie is in 35 jaar bijeengebracht door mijn ouders, collectioneurs Heinz en Hendrikje Ivo en is ondergebracht in de Stichting Tassenmuseum Hendrikje. Wat ooit begon als een persoonlijke fascinatie is uitgegroeid tot een uitgebreide collectie en uiteindelijk tot een prachtig uniek museum. Tassenmuseum Hendrikje, dat 10 jaar lang gevestigd was in Amstelveen, is nu gevestigd in een schitterend 17de eeuws grachtenpand in Amsterdam.

Als directeur geniet ik elke dag van het voorrecht met zo'n bijzondere collectie en op zo'n mooie locatie te werken. Ik hoop dat dit boek u op dezelfde wijze inspireert en u uitnodigt ons museum te bezoeken.

Sigrid Ivo
Directeur

Prólogo

Quién piense que un objeto cotidiano como el bolso no es un objeto interesante, se equivoca. Poca gente sabe que el bolso tiene una riquísima y singular historia y que a lo largo de los siglos ha experimentado un desarrollo notable. En primer lugar, se encuentra, por supuesto, el uso histórico: desde objeto funcional hasta icono de estilo e importante accesorio de moda. Pero la historia del bolso también refleja el importante desarrollo socio-cultural a través de los siglos. Las tendencias en el arte, el diseño y la moda han influido en el aspecto del bolso. Así también lo han hecho la evolución socio-cultural y la emancipación de la mujer.

En este libro le presento una visión general de la historia del bolso desde finales de la Edad Media hasta el presente. Todos los bolsos pertenecen a la colección del Museo de Bolsos Hendrikje. El museo es el más grande del mundo en su género, y cuenta con más de 4.000 bolsos, bolsitas, maletas, carteras y accesorios. En la colección del museo se aprecia la gran diversidad de bolsos en cuanto a uso, forma, decoración y materiales.

Al igual que muchos otros museos, también el Museo de Bolsos Hendrikje fue creado a partir de una pasión de coleccionista. La colección se formó a lo largo de 35 años por mis padres, los coleccionistas Heinz y Hendrikje Ivo, y pertenece a la Asociación Museo de Bolsos Hendrikje. Lo que comenzó como una fascinación personal se ha convertido en una extensa colección y, finalmente, en un magnífico museo. El Museo de Bolsos Hendrikje, que durante 10 años tenía sus instalaciones en Amstelveen, ahora está ubicado en un espléndido edificio del siglo XVII junto a un canal en Amsterdam.

Como directora, disfruto todos los días del privilegio de contar con una colección tan especial y de trabajar en un lugar tan maravilloso. Espero que este libro le inspire de la misma manera y le invite a visitar nuestro museo.

Sigrid Ivo
Directora

Introduction

Celui ou celle qui pense qu'un objet du quotidien comme le sac ne présente aucun intérêt commet une grave erreur. Peu de gens réalisent que le sac peut se targuer d'une histoire d'une richesse exceptionnelle et qu'il a connu une évolution remarquable au fil des siècles. Pensons en premier lieu à l'histoire de l'utilisation du sac, passé d'objet fonctionnel à une icône de style et un accessoire de mode indispensable. Mais l'histoire du sac retrace également les développements socioculturels importants qui ont eu lieu à travers les siècles. Le sac est influencé par les tendances dans les domaines de l'art, du design et de la mode, ainsi que par les évolutions socioculturelles et l'émancipation de la femme.

Dans ce livre, je vous présente un aperçu de l'histoire du sac depuis la fin du Moyen Âge jusqu'à nos jours. Tous les sacs sont issus de la collection du Musée des sacs Hendrikje, le plus grand musée consacré aux sacs du monde, et riche de plus de 4 000 sacs, sacoches, valises, porte-monnaie et accessoires. Dans sa collection, le musée permet de constater la grande diversité du sac, tant au niveau de sa forme, de sa fonction, des matières que des décorations utilisées.

Comme de nombreux musées, le Musée des sacs Hendrikje est né de la passion de collectionneurs. La collection a été constituée en 35 ans par mes parents Heinz et Hendrikje Ivo et est exposée dans la Fondation Musée des sacs Hendrikje. Ce qui a débuté comme une fascination personnelle s'est développé en collection pour devenir finalement un splendide musée, unique en son genre. Le Musée des sacs Hendrikje, installé pendant 10 ans à Amstelveen, est aujourd'hui situé dans un splendide immeuble en bord de canal à Amsterdam.

En tant que directrice, j'ai l'immense privilège de travailler tous les jours avec une collection aussi exceptionnelle et dans un lieu aussi magnifique. J'espère que ce livre vous inspirera et vous incitera à découvrir notre musée.

Sigrid Ivo
Directrice

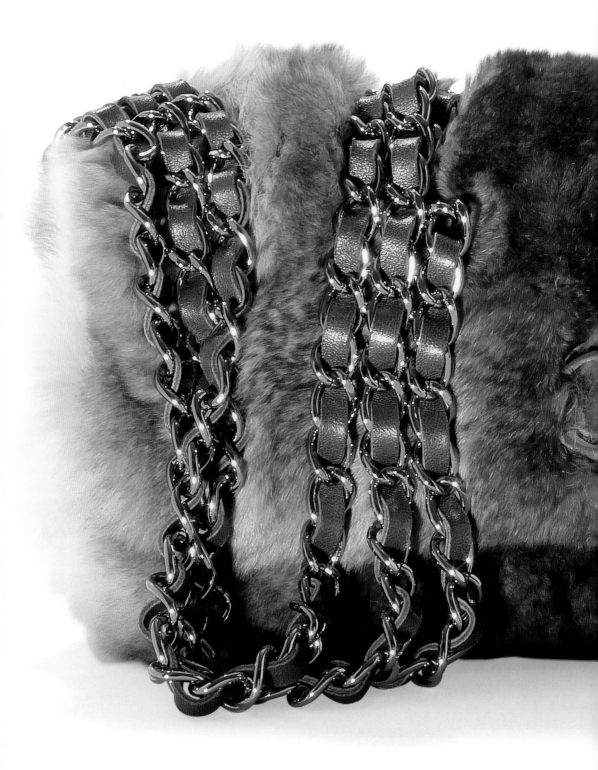

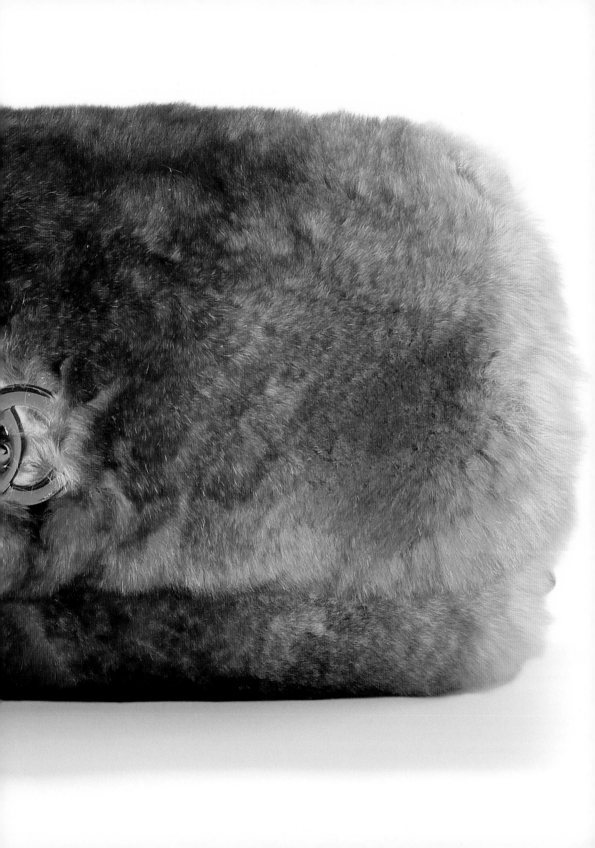

500 years of bags

1500 - 1800, hanging bags and purses

Since earliest times, bags have been useful implements for both women and men. Because clothing as yet had no inside pockets, bags and purses were used to carry money and other personal items. We can see how bags looked in past epochs from bags in museums and illustrations in paintings and prints and on carpets.

Depending on their function, there were many different kinds of bags and purses: bags with frames, leather purses and pouch-like purses with long drawstrings. Apart from a few exceptions that hung from the shoulder, bags were carried on the belt or waistband. For men, the bag gradually fell into disuse with the arrival of inside pockets in men's clothing at the end of the sixteenth century and in the seventeenth century. With the exception of game bags and briefcases, bags became the exclusive domain of women in succeeding centuries.

From the sixteenth century on, women carried their purses also on a chatelaine, a hook with chains on which accessories could be hung, such as keys, a knife sheath and sewing kit. Because of the costly materials used, the chatelaine was a status-defining ornament as well as a practical accessory. In the course of the centuries, the shape of chatelaines and the accessories that hung from them were constantly changing, but only at the beginning of the twentieth century was the chatelaine finally replaced by the handbag.

During the seventeenth, eighteenth and a large part of the nineteenth century, women's clothing was so voluminous that one or two loose pockets could be carried invisibly concealed under the skirt with no difficulty. Mostly these pockets were carried as a pair, one dangling from each hip. These tie pockets also remained popular until well into the nineteenth century.

1800 - 1900, new times, new bags

In the course of the 18th century, partly because of the discovery of Pompeii, everything related to the ancient Greeks and Romans had become popular. Under their influence, the nature of fashion changed at the end of the century. Dresses became plain and the waist was raised. There was no longer space for pockets under this flimsy apparel, and their contents were moved to the reticule. The novelty was that the reticule was carried in the hand on a cord or chain; for the first few decades of the nineteenth century, it remained

fashionable to carry bags in the hand. Reticules were made from all kinds of textiles, often by the women themselves.

Upon the arrival of new production methods with the advent of the Industrial Revolution, new materials such as papier-mâché, iron and cut steel were used to manufacture bags. The combination of these materials along with new technologies led to new kinds of bags.

With the increase in travel came new bags for the modern traveller. Hand luggage for trains became the precursor of the handbag, which was not just taken on journeys but also used for making social calls and shopping.

1900 - today, the handbag

In the twentieth century, the bag changed further under the influence of a rapid succession of art trends and materials, but the emancipation of women was quite possibly an even greater influence. Because of women's increasing participation in the working world and, partly as a result, their growing mobility, the number of practical demands on the bag grew. Leather briefcases appeared for work, handy strolling and visiting bags in leather or plastic for daytime, elegantly shimmering evening bags and minaudières for evenings, and opera bags for the theatre.

Brand names began to play a major role in the twentieth century. Brands that have become world famous for their exclusive handbags and leather goods include Hermès, Louis Vuitton, Gucci and Prada. But the handbag is also now an important fashion accessory for designers and houses such as Chanel, Dior, Yves Saint Laurent, Versace, Donna Karan and Dolce & Gabbana. In contrast to previous centuries, in which models could remain the same for decades, the bag has now become a fad that changes every season.

500 jaar tassen

1500 - 1800, hangende tassen en beurzen

Vanaf de vroegste tijden waren tassen nuttige gebruiksvoorwerpen, zowel voor vrouwen als voor mannen. Omdat kleding nog geen binnenzakken kende, gebruikte men tassen en beurzen voor het meedragen van geld en andere persoonlijke benodigdheden. Hoe tassen er in afgelopen eeuwen uitgezien hebben, is af te leiden van tassen in musea en van afbeeldingen op schilderijen, prenten en tapijten.

Afhankelijk van hun functie waren tassen en beurzen er in allerlei uitvoeringen: beugeltassen, leren beurzen en buidelvormige beurzen aan lange trekkoorden. Behalve enkele uitzonderingen die om de schouder werden gehangen, werden tassen aan de riem of gordel gedragen. De tas raakte bij de man langzaam in onbruik met de komst van binnenzakken in mannenkleding aan het einde van de zestiende eeuw en in de zeventiende eeuw. Met uitzondering van de jacht- en documententas werd de tas in volgende eeuwen het exclusieve domein van de vrouw.

Vanaf de zestiende eeuw droegen vrouwen hun beurzen ook aan een chatelaine: een haak met kettingen waaraan accessoires gehangen konden worden, zoals sleutels, een messenkoker en naaigerei. Door de kostbare materialen was de chatelaine behalve een praktische toevoeging ook een statusgevend sieraad. In de loop van de eeuwen veranderden de vorm van de chatelaines en de accessoires die eraan werden gehangen, maar pas aan het begin van de twintigste eeuw werd de chatelaine definitief door de handtas verdrongen.

Gedurende de zeventiende, achttiende en een groot deel van de negentiende eeuw was de dameskleding zo wijd, dat men zonder bezwaar onder de rok onzichtbaar verborgen een of twee losse zakken kon dragen. Meestal werden deze zakken gedragen als paar: één op elke heup hangend. Vandaar dat ze dijzakken werden genoemd. Ook de dijzak bleef tot ver in de negentiende eeuw populair.

1800 - 1900, nieuwe tijden, nieuwe tassen

In de loop van de achttiende eeuw werd mede door de ontdekking van Pompeii alles wat met de Griekse en Romeinse Oudheid te maken had populair. Onder invloed daarvan veranderde aan het eind van de eeuw het modebeeld. Japonnen werden sluik en de taille ging omhoog. Voor de dijzak was onder deze fijne kleding geen plaats meer, en de inhoud ervan verhuisde naar de reticule. Nieuw was dat de reticule aan een koord of ketting in de hand gedragen werd; de eerste decennia van de negentiende eeuw bleef het modieus om tassen in de hand te dragen. Reticules werden uit allerlei soorten textiel veelal door vrouwen zelf gemaakt.

Met de komst van nieuwe productiemethoden ten tijde van de Industriële Revolutie werden nieuwe materialen als papier-maché, ijzer en geslepen staal toegepast voor de productie van tassen. De combinatie hiervan met nieuwe technieken leverde nieuwe tasvormen op.

Met de toename van het reizen kwamen er nieuwe tassen voor de moderne reiziger. De handbagage uit de trein werd de voorloper van de handtas die men niet alleen op reis meenam, maar ook gebruikte bij het afleggen van visites en bij het winkelen.

1900 - heden, de handtas

In de twintigste eeuw veranderde de tas verder onder invloed van elkaar snel opvolgende kunststromingen en materialen, maar van zo mogelijk nog grotere invloed was de emancipatie van de vrouw. Door haar toenemende deelname aan het arbeidsproces en de mede daardoor groeiende mobiliteit groeide het aantal praktische eisen aan de tas. Er kwamen leren documententassen voor naar het werk, handzame wandel- en visitetassen van leer of kunststof voor overdag, elegante glinsterende avondtassen en minaudières voor 's avonds, en operatasjes voor in het theater.

Merknamen zijn in de twintigste eeuw een grote rol gaan spelen. Merken die wereldberoemd zijn geworden vanwege hun exclusieve handtassen en lederwaren zijn Hermès, Louis Vuitton, Gucci en Prada. Maar ook voor modeontwerpers en modehuizen als Chanel, Dior, Yves Saint Laurent, Versace, Donna Karan en Dolce & Gabbana is de tas tegenwoordig een belangrijk modeaccessoire. In tegenstelling tot vorige eeuwen, waarin sommige tasmodellen decennialang hetzelfde bleven, is de tas nu geworden tot een modeverschijnsel dat elk seizoen verandert.

500 años de bolsos

1500–1800: monederos y bolsos colgantes

Desde sus inicios, el bolso ha resultado un complemento útil tanto para mujeres como para hombres. Puesto que las prendas de vestir no disponían de bolsillos interiores como ocurre hoy en día, para transportar dinero y otros enseres personales se empleaban bolsos y monederos. El aspecto que tenían los bolsos en épocas anteriores se aprecia en los ejemplares conservados en museos, además de en las ilustraciones de cuadros, grabados y en alfombras.

Según su función, encontramos diversos tipos de bolsos y monederos: bolsos de boquilla, monederos de piel y monederos tipo morral, que pendían de largos cordones. A excepción de algunos casos que colgaban del hombro, los bolsos se llevaban en el cinturón o en la pretina. Para el hombre, el bolso cayó paulatinamente en desuso con la aparición de bolsillos en la vestimenta masculina a finales del siglo XVI y durante el siglo XVII. Exceptuando las bolsas de caza y los portafolios, en los siglos posteriores el bolso se convirtió en dominio exclusivo de la mujer.

A partir del siglo XVI, las mujeres llevaban el monedero colgado de una chatelaine, un gancho con cadenas del cual podían colgarse objetos tales como las llaves, una funda de navaja y el material de costura. Dado que se realizaban con materiales costosos, además de resultar un accesorio práctico, la chatelaine era un ornamento que definía la condición social de su propietaria. En el transcurso de los siglos, la forma de las chatelaines y los accesorios que pendían de ellas cambiaban constantemente y no fueron sustituidos definitivamente por el bolso de mano hasta principios del siglo XX.

Durante los siglos XVII y XVIII, y gran parte del XIX, la indumentaria femenina era tan voluminosa que bajo la falda podía llevarse fácilmente uno o dos bolsillos de material no rígido sin que se vieran. Generalmente se empleaban dos bolsillos, uno sobre cada cadera. Estos bolsillos exteriores siguieron siendo muy populares hasta bien entrado el siglo XIX.

1800–1900: nuevos tiempos, nuevos bolsos

En el transcurso del siglo XVIII, en parte debido al descubrimiento de las ruinas de Pompeya, todo lo relacionado con la antigua Grecia y la antigua Roma se puso de moda. Este hecho hizo cambiar la naturaleza de la moda a finales de siglo. Los vestidos se volvieron lisos y se elevó la cintura. Estas prendas tan finas no dejaban espacio para los bolsillos exteriores, cuyo contenido pasó a transportarse en retículas. La novedad residía en que la retícula se llevaba en la mano o colgada de una cuerda o cadena. Durante las primeras décadas del siglo XIX, llevar los bolsos en la mano estaba de moda. Las retículas se elaboraban con los más diversos materiales y, a menudo, las confeccionaban las mismas mujeres.

Con la aparición de los nuevos medios de producción que trajo consigo la Revolución Industrial, en la producción de bolsos comenzaron a emplearse materiales no utilizados nunca hasta entonces tales como el cartón piedra, el hierro y el acero cortado. De la combinación de estos materiales con las nuevas tecnologías surgieron tipos de bolsos novedosos.

Viajar se convirtió en una actividad frecuente y fue preciso diseñar nuevos tipos de bolsas para el viajero moderno. El equipaje de mano para los viajes en ferrocarril fue el precursor del bolso de mano, que no sólo se utilizaba en los trayectos largos, sino también cuando se iba de visita o se salía de compras.

1900: hoy, el bolso de mano

Si bien en el siglo XX el bolso siguió su evolución influido por la rápida sucesión de corrientes artísticas y por los nuevos materiales, hubo un factor posiblemente más decisivo: la emancipación de la mujer. Puesto que cada vez participaba de forma más activa en el mundo laboral y, en parte como resultado de ello, cada vez tenía más movilidad, aumentaron las exigencias prácticas de los bolsos. Así, aparecieron maletas de cuero para el trabajo; los bolsos de paseo y de visita elaborados en cuero o material sintético se llevaban durante el día, por la noche se lucían bolsos de elegantes brillos y minaudières y, para asistir al teatro, se utilizaban las bolsas para la ópera.

Fue en el siglo XX cuando los nombres de marca comenzaron a desempeñar un papel destacado. Hermès, Louis Vuitton, Gucci y Prada son ejemplos de marcas que han adquirido fama mundial por sus exclusivos bolsos y otros artículos de cuero. Pero actualmente el bolso de mano también es un accesorio de moda importante para empresas y diseñadores como Chanel, Dior, Yves Saint-Laurent, Versace, Donna Karan y Dolce & Gabbana. A diferencia de lo que ocurría en siglos anteriores, en los que un mismo modelo se mantenía inalterado durante décadas, hoy en día el bolso es un capricho que cambia cada temporada.

5 siècles de sacs

1500 - 1800, sacs et bourses suspendus

Depuis les temps les plus anciens, les sacs sont un accessoire des plus utiles pour les femmes autant que les hommes. Comme les vêtements n'étaient alors pas encore dotés de poches intérieures, les sacs et les bourses servaient à transporter son argent et tout autre objet personnel. On peut voir l'apparence qu'avaient ces sacs autrefois dans les musées et les illustrations des peintures, gravures ou tapisseries.

Selon leurs fonctions, il existait de multiples sortes de sacs et de bourses : sacs à fermoirs, bourses en cuir ou en forme de bourse suspendue à de longs cordons. Sauf rares exceptions de modèles à l'épaule, les sacs se portaient à la ceinture. Pour les hommes, le sac est peu à peu tombé en désuétude avec l'introduction de poches dans les habits à la fin du seizième siècle et au dix-septième siècle. À l'exception des gibecières et des porte-documents, les sacs sont devenus l'apanage exclusif des femmes au cours des siècles suivants.

À partir du seizième siècle, les femmes portent leur bourse attachée à une châtelaine aussi, une agrafe dotée de chaînes auxquelles divers accessoires peuvent être accrochés, tels que des clés, un couteau dans sa gaine ou des ustensiles de couture. Réalisée dans des métaux précieux, la châtelaine est alors autant un bijou et un signe extérieur de richesse qu'un accessoire pratique. Si la forme des châtelaines et les objets qui y pendent n'ont cessé de changer au cours des siècles, ce n'est qu'au début du vingtième siècle que le sac a main s'impose définitivement.

Au dix-septième, dix-huitième et pendant une grande partie du dix-neuvième siècle, les vêtements féminins sont si volumineux qu'une ou deux poches peuvent aisément pendre, dissimulées sous les jupes. Ces poches vont en général par paires, une sur chaque hanche, et sont restées populaires jusque tard au dix-neuvième siècle.

1800 - 1900, à temps nouveaux, sacs nouveaux

Au dix-huitième siècle, notamment depuis la découverte de Pompéi, tout ce qui rappelle les anciens Grecs et Romains est apprécié. Sous cette influence, la nature de la mode change à la fin du siècle. Les robes se simplifient et leur taille monte pour en faire des vêtements légers, ne laissant plus d'espace aux poches nouées en dessous dont le contenu est transféré aux réticules. Toute la nouveauté tient alors à la manière de porter ce dernier, à savoir à la main au bout d'un cordon ou d'une chaîne. Cette mode qui va durer toutes les premières décennies du dix-neuvième siècle. Les réticules sont coupés dans toutes sortes de tissus, souvent par les femmes elles-mêmes.

Avec l'introduction de nouvelles méthodes de production et l'avènement de la Révolution industrielle, de nouveaux matériaux comme le papier mâché, le fer et le fil d'acier coupé sont employés pour la fabrication des sacs. L'association de ces matières aux nouvelles technologies permet la création de sacs d'un genre nouveau.

Avec la multiplication des voyages, voient le jour de nouveaux sacs pour les voyageurs modernes. Les bagages à main pour le train sont les précurseurs du sac à main et servent en dehors des voyages pour les visites en société et le lèche-vitrines.

1900 - aujourd'hui, le sac à main

Au vingtième siècle, le sac poursuit sa transformation sous l'influence d'une succession rapide de tendances artistiques et de matériaux, mais aussi celle, sans doute encore plus importante, de l'émancipation féminine. Avec la présence accrue des femmes dans le monde du travail et la mobilité qui en découle, les exigences pratiques envers le sac se multiplient. C'est ainsi qu'apparaissent les porte-documents en cuir pour le travail, les sacs en cuir ou en plastique de promenade ou de visite pour la journée, les sacs du soir et minaudières scintillants et élégants pour les soirées et les sacs d'opéra pour le théâtre.

Les marques commencent à jouer un rôle majeur au vingtième siècle. Certaines sont devenues célèbres dans le monde entier pour leurs sacs à main et leurs articles de maroquinerie exclusifs comme Hermès, Louis Vuitton, Gucci et Prada. Mais le sac à main est désormais aussi un accessoire de mode important pour des créateurs et des maisons comme Chanel, Dior, Yves Saint Laurent, Versace, Donna Karan et Dolce & Gabbana. Contrairement aux siècles précédents où un modèle pouvait rester inchangé pendant des dizaines d'années, le sac est aujourd'hui éphémère et change à chaque saison.

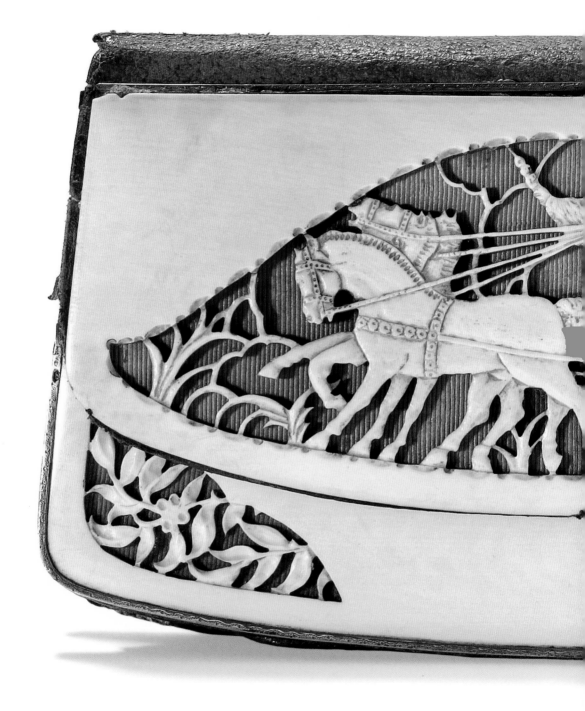

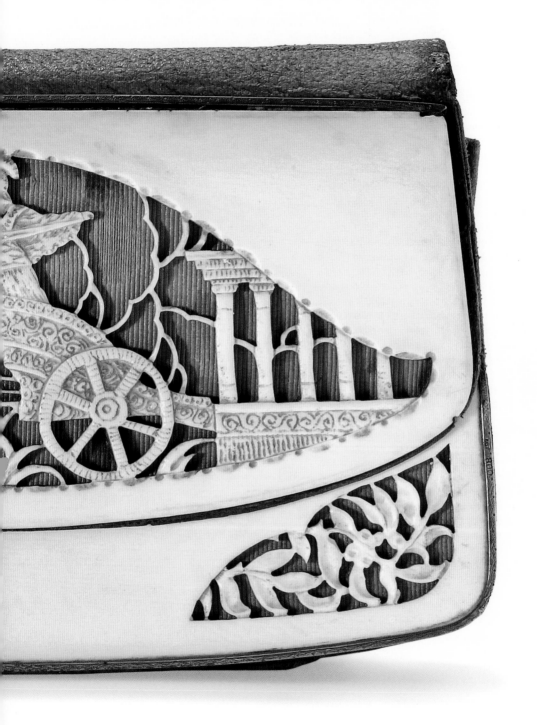

Early bags and purses

From the late Middle Ages until the seventeenth century, men and women used bags and purses to store and carry around their coins, papers, letters, alms, bibles and holy relics. These bags and purses were worn on a strap or belt and were often made from unadorned leather or cloth. But there were also more luxurious models made from costly materials with beautiful embroidery in silk, gold and silver thread. The oldest bag in the Bag Museum is a sixteenth-century goat leather man's pouch with decorative buttons and a metal frame. Eighteen pockets are concealed behind the mostly secret clasps. In addition to wearing them on their belts, women wore their bags and purses on chatelaines.

Small pouches and bags could serve as luxury packaging for money or fragrant flower petals. In England and France, purses containing money were given to the King at the New Year. Purses containing flower petals or perfumed powder were laid or hung as sweet bags between clothing. It was also the tradition in various European countries to give a purse containing money as a wedding present. In the French city of Limoges, special bridal bags were produced between 1690 and 1760: little flat oval purses made of silk with enamel depictions of the bride and groom, or sometimes of saints, on both sides. Other wedding purses were made from minuscule glass beads (sablé beads), tiny beads as small as grains of sand strung on a silk thread. A horse's hair was used as a needle for this, because the beads were so small that no normal needle could go through them. Purses with other uses include gaming purses and alms purses. Card players kept their coins or gambling chips in these gaming purses, which had a stiff round bottom so that they could stand upright on the table. Sometimes the bottom was decorated with a family crest so that there could be no doubt as to the owner. A beaded purse with the inscription 'Remember the Pore 1630' hints at alms purses, or aumônières, which were used from the thirteenth to the fifteenth century.

Vroege tassen en beurzen

Vanaf de late middeleeuwen tot in de zeventiende eeuw hebben mannen en vrouwen tassen en beurzen gebruikt voor het bewaren en meenemen van muntgeld, documenten, brieven, aalmoezen, bijbels en relikwieën. Deze tassen en beurzen werden gedragen aan een riem of gordel en waren veelal gemaakt van onversierd leer of textiel. Er waren echter ook luxere uitvoeringen van kostbare stoffen met fraai borduurwerk in zijde-, goud- en zilverdraad. De oudste tas uit het Tassenmuseum is een zestiende-eeuwse geitenleren mannentas met sierlijke knopen en een metalen beugel. Achter de veelal geheime sluitingen gaan achttien vakken schuil. Vrouwen droegen hun tassen en beurzen behalve aan de riem ook aan de chatelaine.

Kleine beursjes en tasjes konden dienen als luxe verpakking voor geld of lekker ruikende bloemblaadjes. In Engeland en Frankrijk werden met nieuwjaar beurzen met geld aan de koning geschonken. De beurzen met bloemblaadjes of geparfumeerd poeder werden als reuktasjes tussen kleding gelegd of gehangen. Ook was het in diverse Europese landen traditie om bij een huwelijk een beurs met geld cadeau te geven. In de Franse stad Limoges werden tussen 1690 en 1760 speciale bruidsbeurzen gemaakt: kleine platte ovale beurzen van zijde, met aan weerszijden emaillen afbeeldingen van bruid en bruidegom, of soms van heiligen. Andere huwelijksbeurzen werden gemaakt van zeer fijne glaskralen (sablékralen): kraaltjes zo klein als zandkorrels die aan een zijdedraad werden geregen. Een paardenhaar werd daarbij als naald gebruikt, omdat de kralen zo klein waren dat er geen gewone naald doorheen kon. Beurzen met weer andere toepassingen zijn speelbeurzen en aalmoezenbeurzen. Kaartspelers bewaarden hun geld of fiches in deze speelbeurzen die een stijve ronde bodem hadden, waardoor ze op tafel konden blijven staan. Soms was die bodem voorzien van een familiewapen, zodat er geen twijfel kon ontstaan over de eigenaar. Een kralenbeurs met het opschrift 'Remember the Pore 1630' doet denken aan aalmoezenbeurzen, aumônières, uit de dertiende tot en met vijftiende eeuw.

Los primeros bolsos y monederos

Desde finales de la Edad Media hasta el siglo XVII, hombres y mujeres se servían de bolsas y monederos para almacenar y transportar monedas, documentos, cartas, limosnas, Biblias y reliquias religiosas. Estos recipientes pendían de una correa o cinturón y a menudo estaban elaborados con cuero o tela no decorados. Existían, asimismo, modelos más lujosos confeccionados con materiales más costosos y decorados con hermosos bordados realizados con hilos de seda, oro y plata. El exponente más antiguo con que cuenta el museo es un morral masculino elaborado en cuero de cabra que data del siglo XVI y que presenta botones decorativos y una boquilla metálica. Tras unos cierres, en su mayoría secretos, se esconden dieciocho bolsillos. Además de en el cinturón, las mujeres también llevaban las bolsas y los monederos colgados de chatelaines.

Los morrales y bolsos de menor tamaño resultaban un envoltorio de lujo para el dinero o los pétalos de flores perfumados. En Inglaterra y en Francia, los portamonedas se regalaban con la llegada de un nuevo año. Los que contenían pétalos de flores o polvos perfumados se disponían o colgaban como bolsas perfumadas entre las prendas de ropa. En diversos países europeos también era tradición ofrecer un monedero lleno de dinero como regalo de bodas. En la ciudad francesa de Limoges, entre los años 1690 y 1760 se produjeron bolsos especiales para las bodas. Se trataba de pequeños monederos planos y ovalados confeccionados en seda con una representación de los novios en esmalte a cada lado, o a veces de santos. También se realizaban monederos nupciales con delicadísimos abalorios de cristal (sablé), diminutas cuentas del tamaño de un grano de arena ensartadas en un hilo de seda. Para ello se empleaba una cerda de caballo a modo de aguja, ya que las cuentas eran tan pequeñas que una aguja normal no podía atravesarlas. Había monederos con otros usos, como los monederos de juego y las limosneras. Los jugadores de cartas guardaban el dinero o las fichas para las apuestas en estos monederos de juego, cuyo fondo era redondo y rígido para que pudieran sostenerse de pie sobre la mesa. Algunas veces el fondo se decoraba con el escudo familiar para que no hubiera dudas sobre la identidad de su propietario. Un monedero de abalorios con la inscripción 'Remember the Pore 1630' (no se olviden de los pobres) hace recordar las limosneras o aumônières, del siglo XIII al siglo XV.

Premiers sacs et bourses

De la fin du Moyen Âge au dix-septième siècle, hommes et femmes ont utilisé des sacs et des bourses pour ranger et transporter leurs pièces, papiers, aumônes, bibles et reliques saintes. Ces accessoires se portaient à une courroie ou ceinture et étaient souvent en simple cuir ou toile. Cependant, il existait aussi des modèles plus sophistiqués en tissus précieux et richement brodés de soie ou de filaments d'or et d'argent. Le sac le plus ancien du Musée des sacs est une bourse d'homme du seizième siècle en chevreau ornée de boutons décoratifs et dotée d'un fermoir métallique : dix-huit poches sont dissimulées par les différentes boucles, la plupart secrètes. Les femmes portaient quant à elles les sacs et porte-monnaie à la ceinture, mais aussi accrochés à des châtelaines.

Les bourses et sacs de petit format pouvaient aussi servir de récipients de luxe pour de l'argent ou des pétales de fleurs. En Angleterre et en France, ils sont offerts au Nouvel an, alors que des sacs remplis de pétales de fleurs ou de poudres parfumées sont posés ou suspendus entre les vêtements. Dans plusieurs pays européens, la tradition était d'offrir une bourse d'argent en cadeau de mariage, des bourses de mariage ayant été fabriquées à cet effet dans la ville de Limoges entre 1690 et 1760 : de petites bourses plates et ovales en soie portant des deux côtés la représentation émaillée des époux ou parfois de saints. D'autres sont faits de minuscules perles de verre, aussi petites que des grains de sable, enfilées sur un fil de soie (pour cela on utilisait un crin de cheval, aucune aiguille ne pouvant passer à travers ces toutes petites perles). Parmi d'autres usages connus, on trouve les bourses de jeu et les bourses à aumônes. Les joueurs de cartes conservaient leurs pièces ou jetons dans les premières, qui avaient un fond rond et dur afin de tenir debout sur la table. Le fond était parfois orné des armoiries familiales pour écarter tout doute quant au propriétaire. Un sac en perles portant l'inscription « Remember the Pore » (N'oubliez pas les pauvres) de 1630, quant à lui, rappelle les bourses à aumônes, ou aumônières, utilisées du treizième au quinzième siècle.

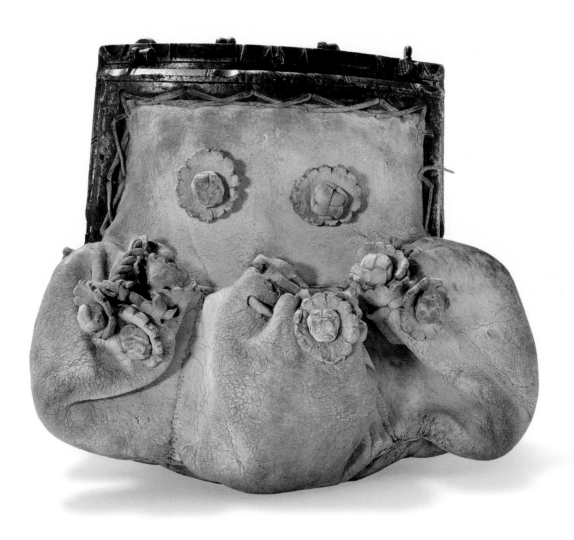

Goat leather belt pouch with iron frame and with 18 pockets, some behind secret closures, France, 16th c.

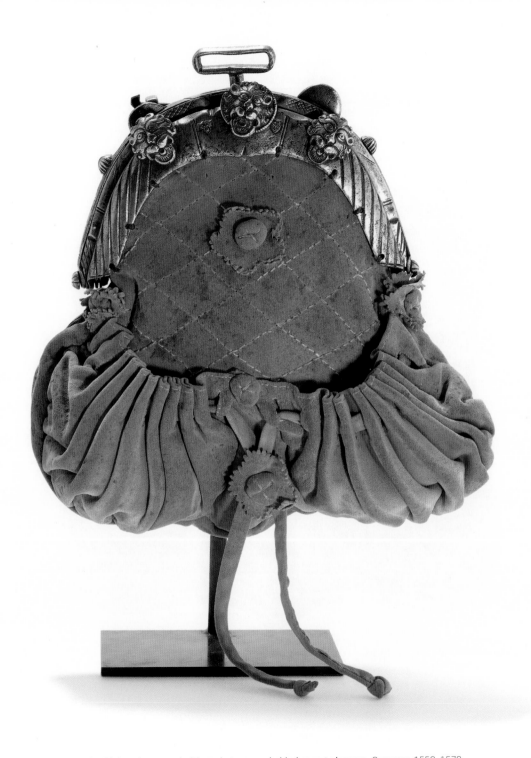

Velvet belt pouch with iron frame and with pockets, some behind secret closures, Germany, 1550-1570.

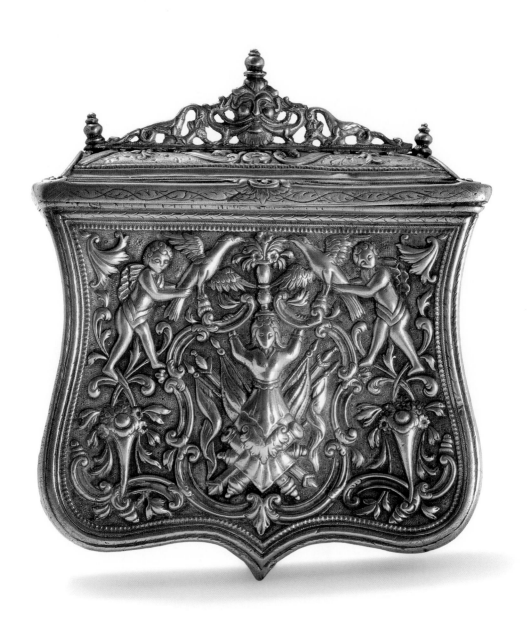

Silver and parcel-gilt belt pouch with picture of goddess Victoria, Europe, early 17th c.

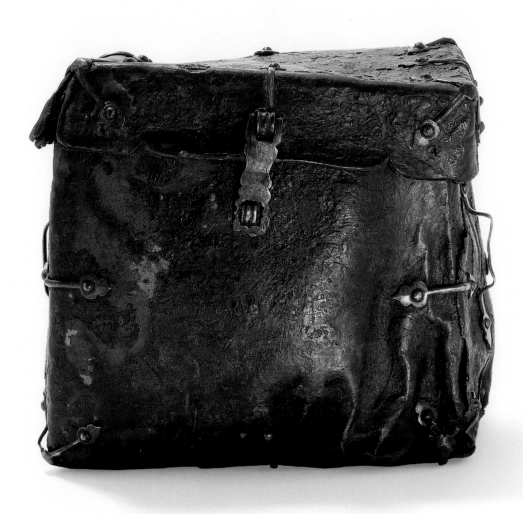

Leather belt bag, Flanders, 16th c.

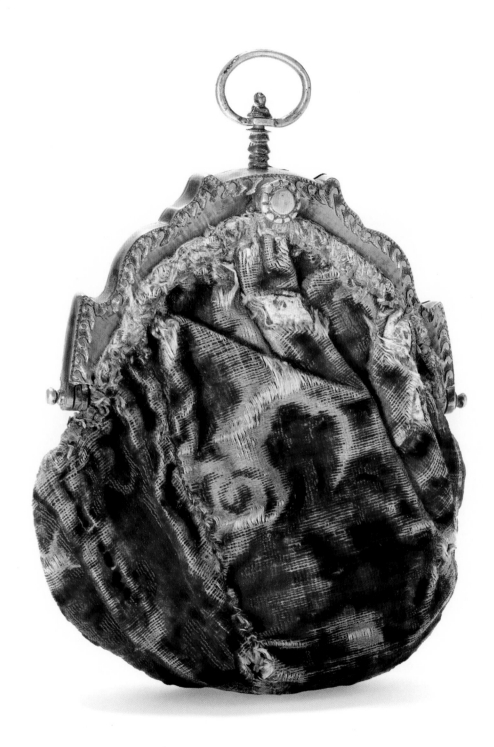

Velvet bag with chamois lining and brass frame, The Netherlands, late 17th c.

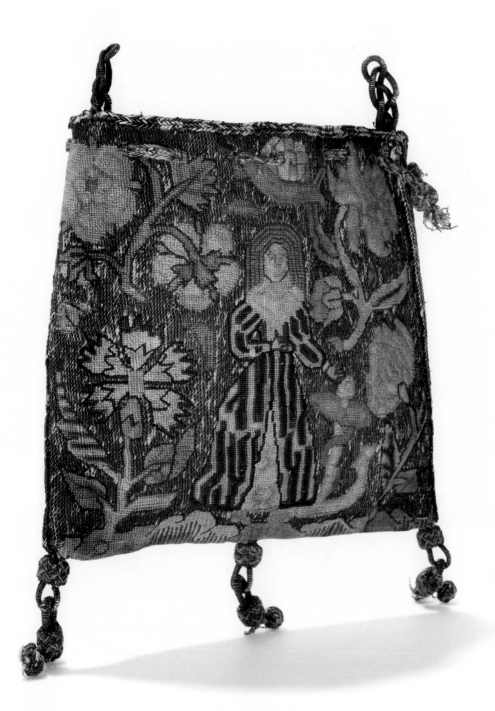

Sweetbag embroidered with silk on a ground of silver thread, lady amidst flowers and insects, England, 1630-1640.

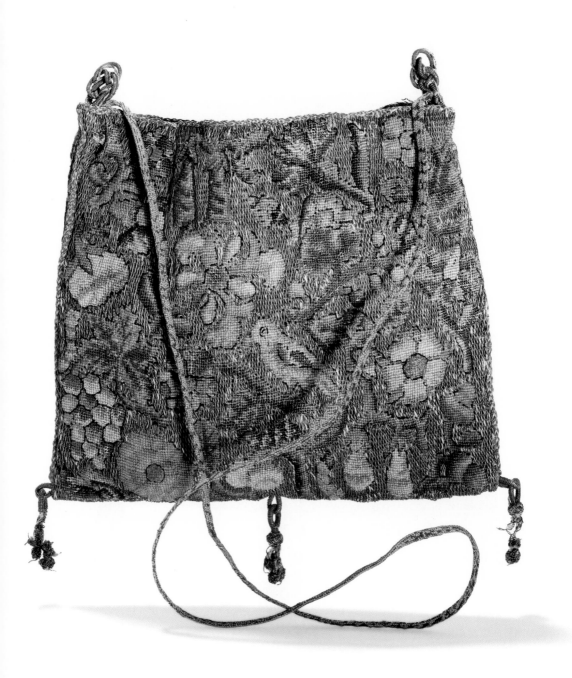

Sweetbag worked in silks on a ground of silver thread with text woven in drawstring, England, 1620-1630.

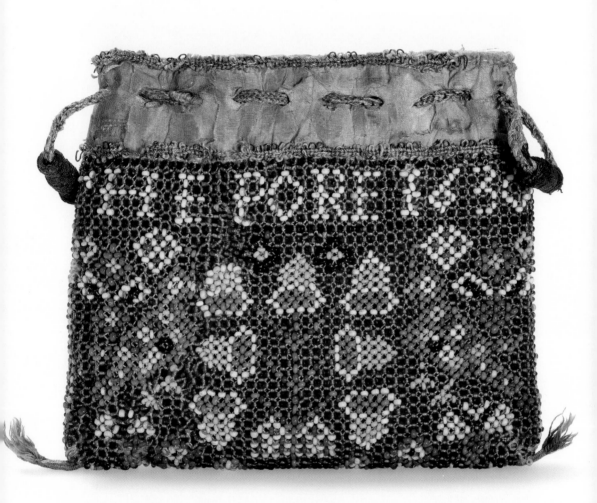

A beadwork purse with inscription 'Remember the pore 1630', England, 1630.

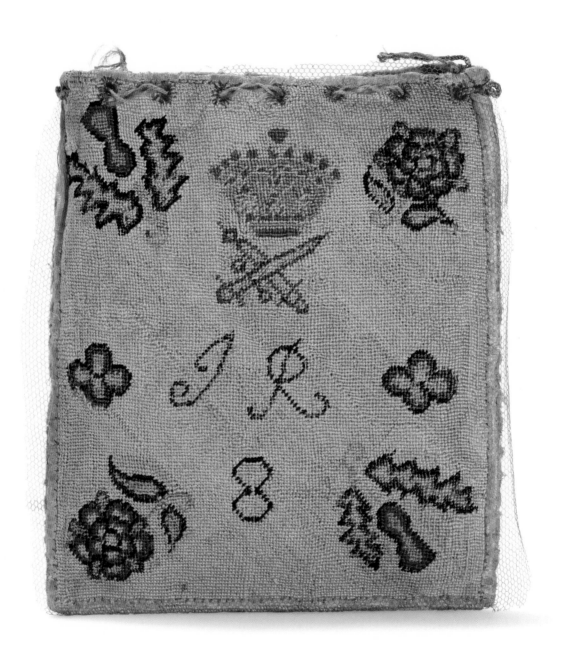

Bag embroidered with thistles and initials: J.R. 8 for James VIII, The Old Pretender, Scotland, early 18th c.

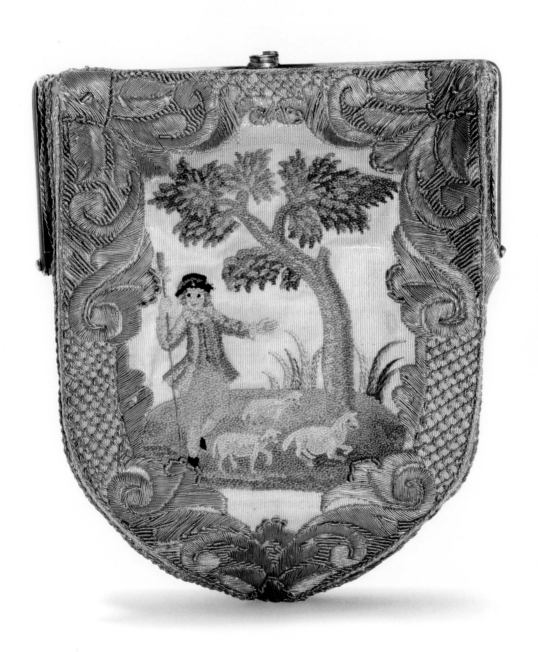

Shield shaped purse with silk and gilt thread embroidery, France, 1700-1730.

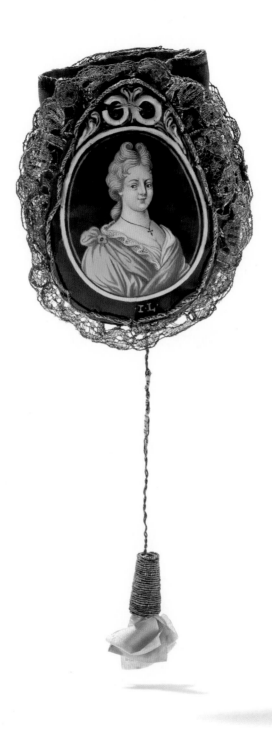

Silk bridal bag with bride and groom in enamel on copper and gold lace trim, Limoges, France, 1690-1715.

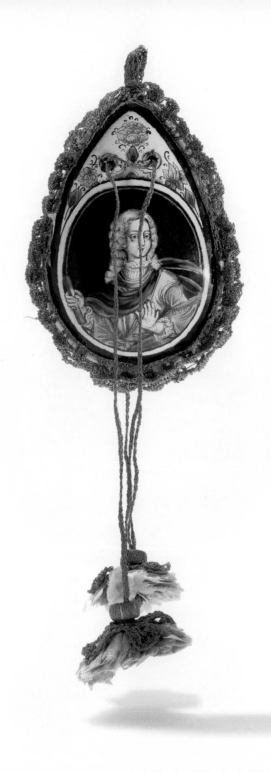

Silk bridal bag with bride (Princess Maria Lesczynska) and groom (the French king Louis XV) in enamel on copper, Limoges, France, 1725.

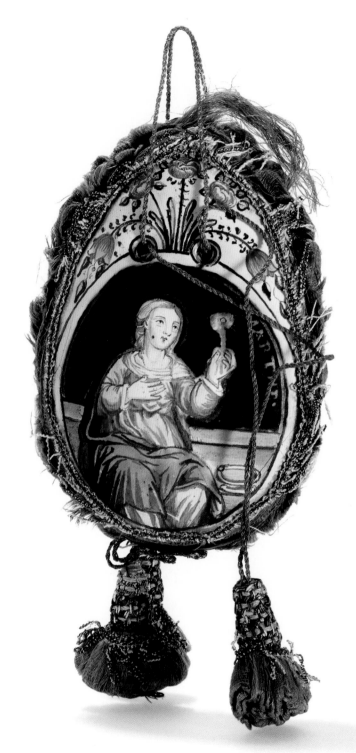

Silk bridal bag with Martha and Maria Magdalene in enamel on copper, Limoges, France, 1690-1730.

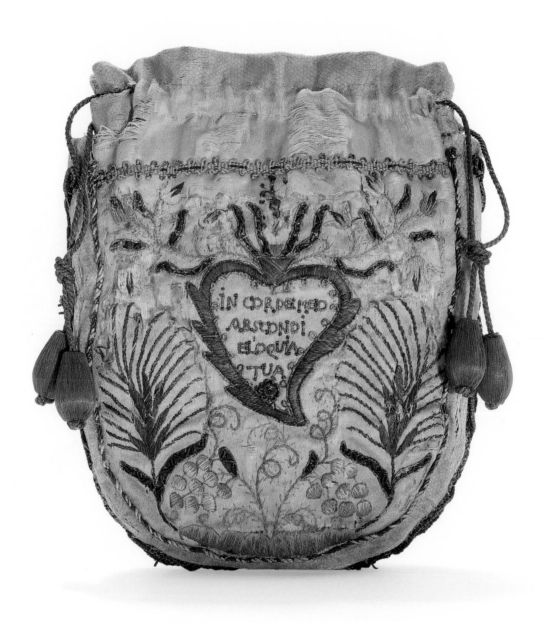

Silk bridal bag with decoration in silver and gold thread, Italy, ca. 1700.

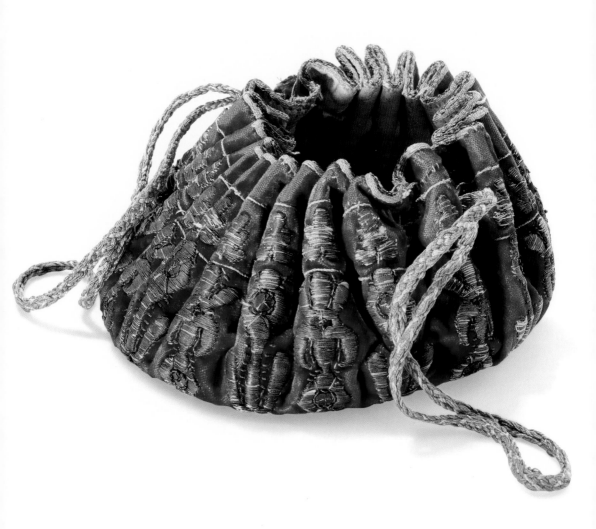

Velvet gaming purse embroidered with silver thread, France, 18th c.

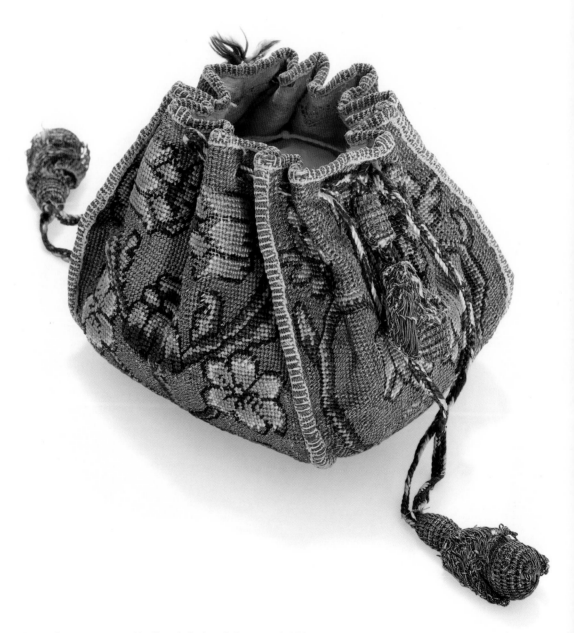

Drawstring purse woven with silk and gilt thread, France, early 18th c.

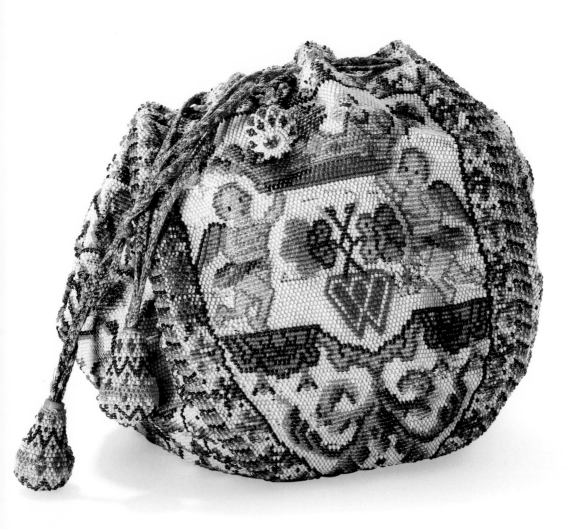

Drawstring bridal purse made of 'Sable' glass beads, France, 18th c.

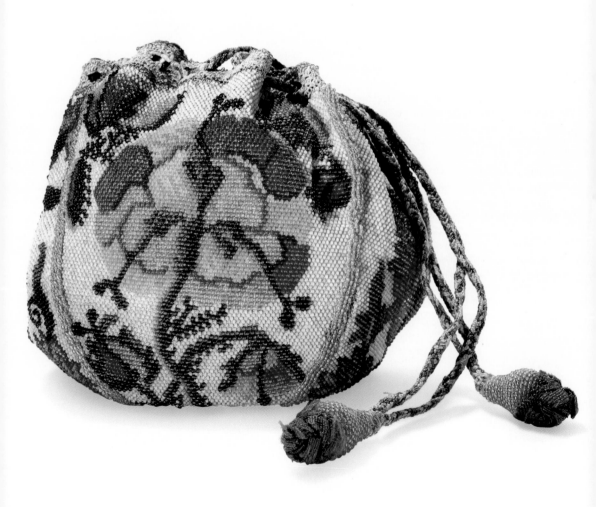

Drawstring purse made of 'Sable' glass beads, France, 18th c.

Letter cases and wallets

From the seventeenth century on, both men and women kept their letters and valuable papers in letter cases or wallets. They kept their coins in purses. There were many different varieties of letter cases, and materials such as leather, silk, glass beads and straw were popular.

Many letter cases were made from coloured leather, with one or more compartments which were sometimes lined with marbled paper. Letter cases could serve as a gift or souvenir. An example is the brown leather letter case with the embroidered inscription 'Constantinopoli 1732' on the obverse side and the name of the owner under the flap. Letter cases like these were often made in Constantinople in the late seventeenth and in the eighteenth century. It is clear that this city had long specialised in the production of this kind of leather letter case, which were embroidered with name and date on request.

Silk letter cases were embroidered with silk or metal thread, sequins and/or foil. They were also embroidered or pasted with straw and hair or painted with Indian ink. The eighteenth-century letter cases with sablé beads are highly unique.

Many of the illustrations and motifs on letter cases were related to love and loyalty: cupids, hearts with and without flames, the love god Venus, two dogs (a symbol of faithfulness), two birds (betrothal) and an anchor (hope). Letter cases with such motifs were very probably given at engagements and weddings. A rare example is a letter case in green leather embroidered with silver gilt thread and set off with a gilt border, with a minute painted portrait of a young woman and an embroidered love poem for her beau inside.

Portefeuilles

Zowel mannen als vrouwen bewaarden vanaf de zeventiende eeuw hun brieven en waardepapieren in portefeuilles. Hun muntgeld stopten ze in beurzen. De portefeuilles laten een gevarieerd beeld zien: materialen als leer, zijde, glaskralen en stro waren populair.

Veel portefeuilles werden vervaardigd van gekleurd leer, voorzien van een of meerdere vakken die soms met gemarmerd papier beplakt werden. Portefeuilles konden dienen als geschenk of souvenir. Een voorbeeld hiervan is de bruine leren portefeuille met het geborduurde opschrift 'Constantinopoli 1732' op de achterzijde en de naam van de eigenaar onder de flap. Portefeuilles als deze werden aan het eind van de zeventiende en in de achttiende eeuw veelal gemaakt in Constantinopel. Deze stad was kennelijk langere tijd gespecialiseerd in de vervaardiging van dit soort leren portefeuilles, die in opdracht van naam en datum werden voorzien.

Zijden portefeuilles werden geborduurd met zijde- of metaaldraad, met pailletten en/of folie. Ook werden ze geborduurd of beplakt met stro en haar, of beschilderd met Oost-Indische inkt. Bijzonder zijn de achttiende-eeuwse portefeuilles met sablékralen.

Veel van de afbeeldingen en motieven op portefeuilles hadden betrekking op liefde en trouw: cupido's, harten met en zonder vlammen, de liefdesgodin Venus, twee honden (symbool voor trouw), twee vogels (trouwbelofte) en een anker (hoop). Portefeuilles met dergelijke motieven waren hoogstwaarschijnlijk geschenken bij verlovingen en huwelijken. Een zeldzaam exemplaar is een portefeuille van groen leer, geborduurd met verguld zilverdraad en afgezet met een verguld montuur, met aan de binnenzijde een minutieus geschilderd portret van een jonge vrouw en een geborduurd liefdesgedicht voor haar man.

Portafolios y carteras

A partir del siglo XVII, tanto los hombres como las mujeres empleaban portafolios para conservar cartas y documentos de valor. Las monedas se guardaban en monederos. Estos estuches forman un conjunto variopinto: entre los materiales más utilizados figuran el cuero, la seda, los abalorios de cristal y la paja.

Muchos de estos portafolios se confeccionaban con cuero teñido y disponían de uno o más compartimentos, que a veces se forraban con papel jaspeado. Los portafolios podían servir de regalo o de recuerdo de viaje. Como ejemplo de ello encontramos uno de cuero marrón que lleva bordada la inscripción 'Constantinopoli 1732' en la parte exterior y el nombre del propietario bajo la solapa. Este tipo de estuches se confeccionaban en Constantinopla a finales del siglo XVII y durante el siglo XVIII. Queda patente que durante mucho tiempo la ciudad estuvo especializada en la producción de este tipo de carteras de piel, en las que se bordaba el nombre y la fecha a petición del comprador.

Los portafolios de seda se bordaban con hilo de seda o de metal, con lentejuelas y/o láminas metálicas. También se bordaban o se les pegaba paja y pelo, o se pintaban con tinta china. Son exponentes únicos los que datan del siglo XVIII y presentan cuentas sablé.

Muchas de las ilustraciones y motivos representados en ellos se inspiran en el amor y la lealtad: cupidos, corazones con y sin llamas, Venus (diosa del amor), dos perros (símbolo de la fidelidad), dos pájaros (desposorios) y un ancla (esperanza). Es muy probable que los portafolios decorados con estos motivos se regalaran en ceremonias de pedida de mano y en bodas. Constituye un raro ejemplo un portafolio elaborado en cuero verde, bordado con hilo de plata dorada y resaltado con un reborde dorado, que en el interior presenta el minucioso retrato de una joven y un poema de amor bordado para su pretendiente.

Pochettes et portefeuilles

À partir du dix-septième siècle, hommes et femmes conservent leurs lettres et papiers importants dans des portefeuilles et transportent leurs pièces de monnaie dans des bourses. Il existe de multiples variétés de portefeuilles et divers matériaux comme le cuir, la soie, les perles de verre et la paille sont extrêmement populaires.

Beaucoup de portefeuilles sont en cuir teint avec un ou plusieurs compartiments parfois doublés de papier marbré. Ils servent également de présent ou de souvenir, comme par exemple la pochette de cuir brun portant l'inscription brodée « Constantinopoli 1732 » au recto et le nom de son propriétaire sous le rabat. À la fin du dix-septième et au dix-huitième siècle, ces pochettes venaient souvent de Constantinople, qui s'était spécialisée dans leur production en cuir brodé sur demande du nom et de la date.

Les portefeuilles en soie sont brodés de fils de soie ou métalliques, de sequins et/ou de feuille métallique. Ils sont parfois aussi brodés ou collés de paille et de cheveux, ou encore peints à l'encre de Chine. Les portefeuilles sablés en perles du dix-huitième siècle sont des pièces absolument uniques.

Probablement offerts lors de fiançailles ou de mariages, les portefeuilles sont souvent ornés d'illustrations et de motifs ayant trait à l'amour et à la fidélité : amours, cœurs avec et sans flammes, Vénus déesse de l'amour, deux chiens (symbole de loyauté), deux oiseaux (fiançailles) ou une ancre (espérance). Parmi les exemplaires rares, un portefeuille de cuir vert brodé de fils d'argent et rehaussé d'une bordure dorée, renfermant le portrait miniature d'une jeune femme et un poème d'amour brodé pour son galant.

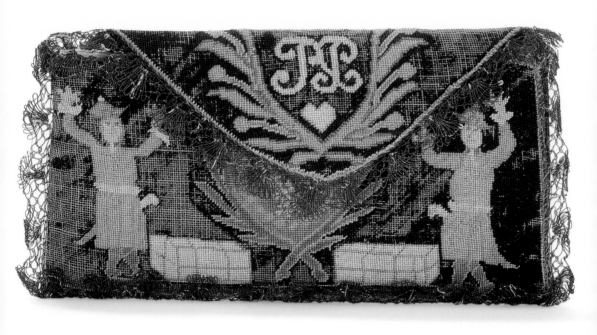

Linen letter case embroidered with silk and trimmed with silver lace, France, 17th c.

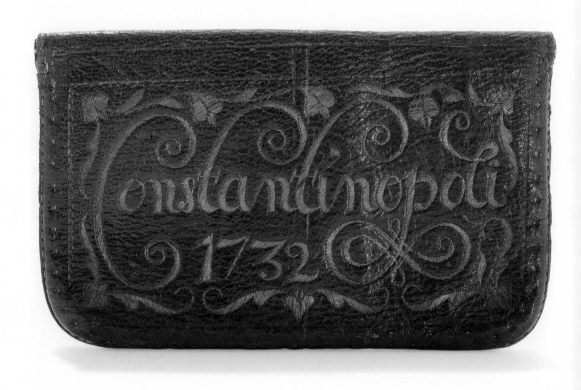

Leather letter case embroidered with gold thread and text 'Constantinopoli 1732', Turkey, 1732.

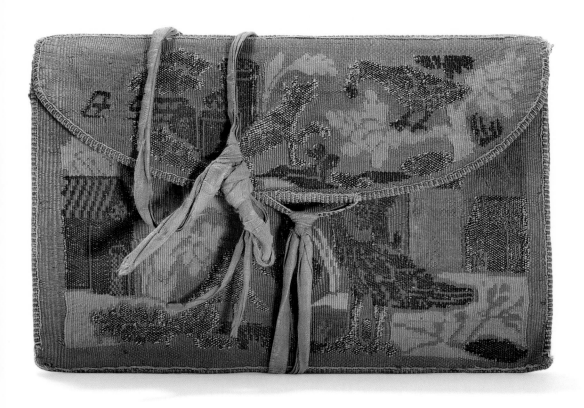

Letter case woven and embroidered with silk, gold and silver thread and two fables from Jean La Fontaine (1621-1695), France, late 17th c.

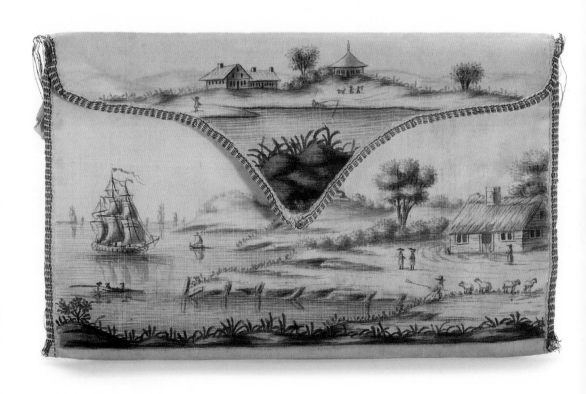

Envelope style letter case with ink paintings, England, late 18th c.

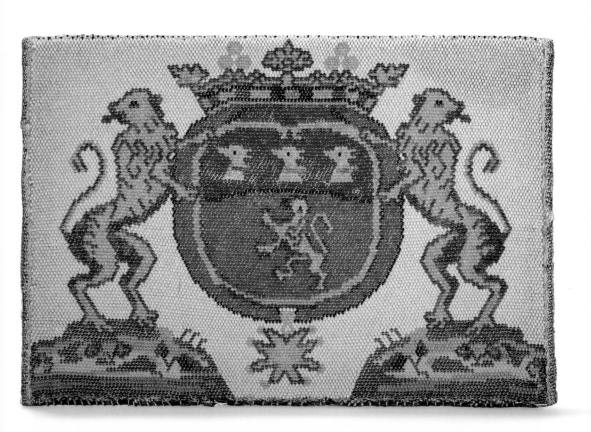

Letter case made of sablé beads i.e. so small as grains of sand, France, 18th c.

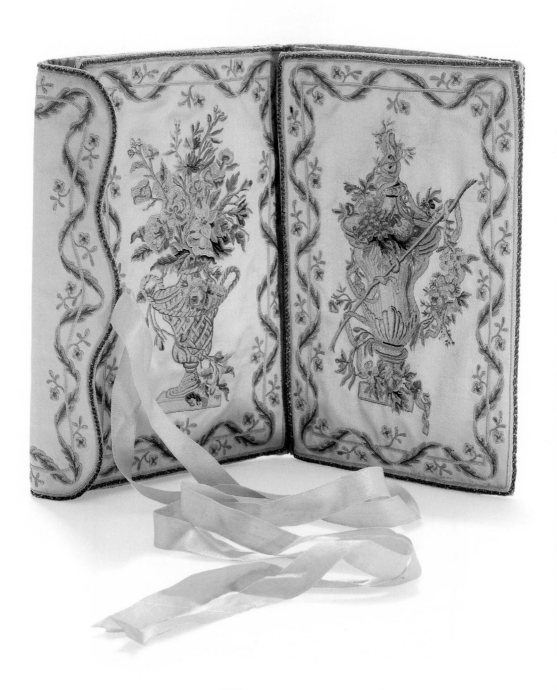

Finely embroidered silk letter case, France, ca. 1800.

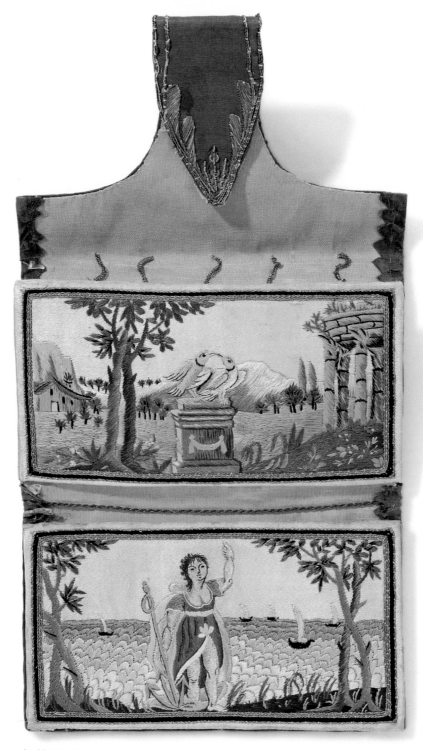

Silk letter case embroidered with silk, silver thread and sequins, France, late 18th c.

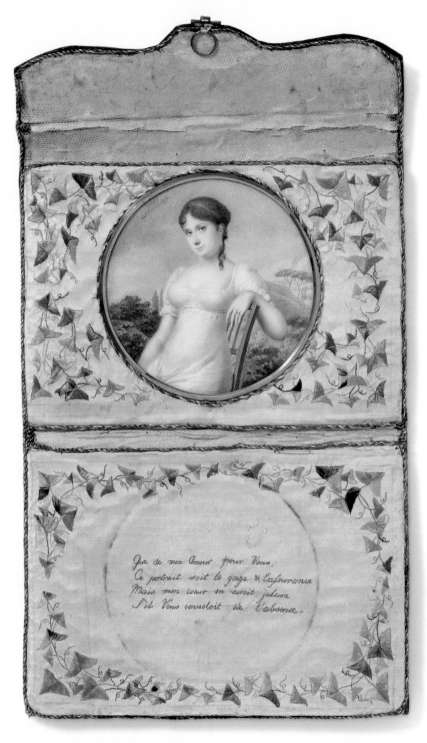

Leather and silk letter case with embroidery, love poem and miniature painted by Favorin Lerebours, France, 1806.

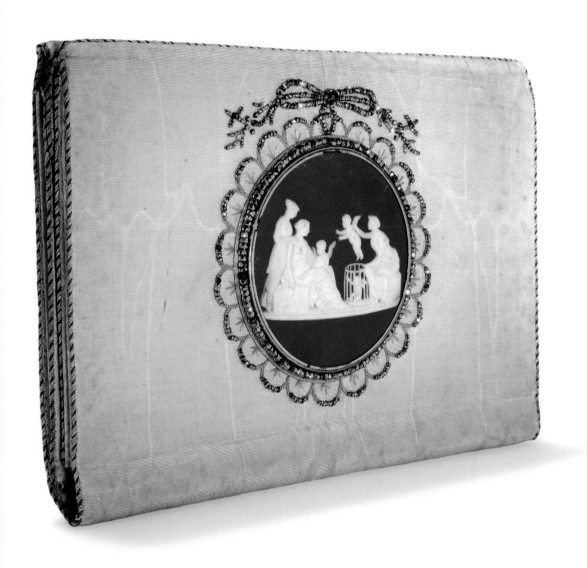

Silk letter case with Wedgwood medaillon, England, early 19th c.

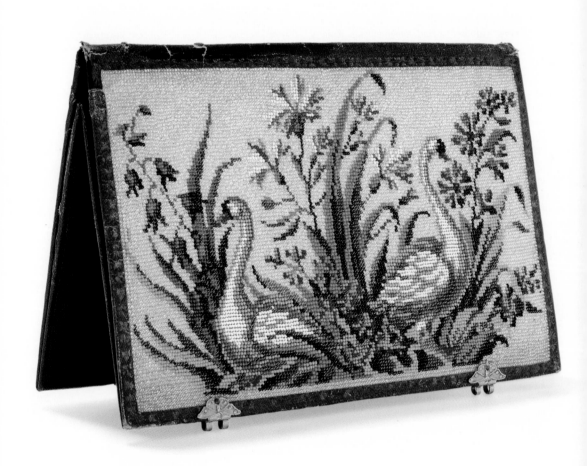

Leather letter case with fine beaded pictures, Russia, 1st half 19th c.

Chatelaines

The symbol of power for the medieval lady of the manor was the keys she wore on chains on her waistband or belt. These long chains, which hung together on a hook from the belt or skirt waistband, were also called chatelaines (after the French châtelaine, lady of the manor, or château), a term that incidentally only came into use in 1828. Before that time they were called equipages. Chatelaines were worn for centuries, although their form and use were always changing.

In the sixteenth and seventeenth centuries, women hung their purse, bible, keys, fan, pomander and knife sheath on ankle-length chains. In the eighteenth century, the chains became shorter and more sewing equipment was hung on them, as were a smelling box, seals for documents and a watch. In the meantime, the chatelaine had become common among greater strata of the population. In addition to versions in silver and gold, they were now also available in pinchbeck, enamel, mother of pearl and cut steel.

The chatelaine underwent a revival in the nineteenth century. All kinds of new types of chatelaines appeared with spectacle holders, devices for holding up the skirt, key holders, umbrellas and notebooks. There also appeared chatelaines for the evening with a dance card, mirror, perfume bottle and fan holder, and chatelaines with a little bag, called chatelaine bags. The chatelaines were constructed from gold, gold or silver plated metal, silver and cut steel and were often decorated with carnelian, porcelain and enamel. Cheaper chatelaines were available in leather, and instructions for making cloth chatelaines were published in needlework magazines. The chatelaine went out of fashion in the first decade of the twentieth century due to the arrival of the handbag.

Chatelaines

Het symbool van de macht van de middeleeuwse kasteel-vrouwe waren de sleutels die zij aan kettingen aan haar riem of gordel droeg. Deze lange kettingen die samen aan een haak aan de gordel of rokband hingen, worden dan ook chatelaines (naar het Franse châteleine, kasteelvrouwe) genoemd, een naam die overigens pas in 1828 in gebruik is gekomen. Voor die tijd werden ze tuigjes genoemd. Chatelaines zijn eeuwen-lang gedragen, hoewel vorm en gebruik steeds veranderden.

In de zestiende en zeventiende eeuw hingen vrouwen hun beurs, bijbel, sleutels, waaier, reukbal en messenkoker aan enkellange kettingen. In de achttiende eeuw werden de ket-tingen korter en werd er meer naaigerei aan gehangen, maar ook lodereindoosjes, signetten en een horloge. De chatelaine was inmiddels in grotere lagen van de bevolking gemeen-goed geworden. Naast uitvoeringen in zilver en goud waren ze nu ook in pinchbeck, email, parelmoer en geslepen staal verkrijgbaar.

In de negentiende eeuw werd de chatelaine opnieuw popu-lair. Er ontstonden allerlei nieuwe soorten: chatelaines met brillenhouders, rokophouders, sleutelhouders, paraplu's en notitieboekjes; chatelaines voor de avond met balboekje, spiegel, parfumflesje en waaierhouder, en chatelaines met een tasje, die chatelainetassen werden genoemd. De cha-telaines werden in goud, verguld of verzilverd metaal, zil-ver en geslepen staal uitgevoerd en vaak gedecoreerd met kornalijn, porselein en email. Goedkopere chatelaines waren verkrijgbaar in leer, en in handwerkbladen stonden aanwij-zingen voor het maken van stoffen chatelaines. In het eerste decennium van de twintigste eeuw raakte de chatelaine uit de mode door de opkomst van de handtas.

Chatelaines

El símbolo de poder de las damas medievales de las casas feudales eran las llaves que llevaba colgadas con cadenas de la pretina o cinturón. Estas largas cadenas, que pendían juntas del gancho del cinturón o de la pretina de la falda, también se denominaban chatelaines (palabra procedente del francés châtelaine, dama del castillo o château), un término que comenzó a emplearse de manera accidental a partir de 1828. Antes de ese tiempo se les denominaban equipajes. Si bien las chatelaines se utilizaron durante varios siglos, su forma y uso cambiaban constantemente.

En los siglos XVI y XVII, la mujer colgaba el monedero, la Biblia, las llaves, el abanico, un recipiente de porcelana con hierbas perfumadas y la funda para la navaja en cadenas largas hasta el tobillo. En el siglo XVIII las cadenas se acortaron y de ellas pendía más material de costura, así como una cajita aromática, sellos para documentos y un reloj. En esta época, la chatelaine ya era un elemento habitual para amplios sectores de la población. Además de las versiones confeccionadas en oro y plata, entonces también se creaban modelos en similor, esmalte, madreperla y acero cortado.

La chatelaine volvió a cobrar popularidad en el siglo XIX. Surgió entonces todo un abanico de chatelaines con soportes para lentes, aparatos para sostener la falda, llaveros, sombrillas y blocs de notas. Aparecieron también chatelaines para la noche con un soporte para la tarjeta de baile, el espejo, el frasco de perfume y el abanico, además de chatelaines con una pequeña bolsa denominada escarcela. Las chatelaines se elaboraban con oro, metal plateado o dorado, plata y acero cortado, y a menudo se decoraban con cornalina, porcelana y esmalte. Las versiones más económicas se realizaban en cuero y las revistas especializadas en costura explicaban cómo confeccionar chatelaines de tela. En la primera década del siglo XX, la chatelaine pasó de moda debido a la llegada del bolso de mano.

Châtelaines

Le symbole du pouvoir pour les châtelaines dans leurs manoirs est la série de clés qu'elles portaient à des chaînes pendant à leur ceinture. Ces longues chaînes, fixées à la ceinture par une agrafe, étaient appelées châtelaines, du nom de leurs principales utilisatrices, même si ce terme n'est vraiment utilisé que depuis 1828. Avant cette date, on parlait simplement d'équipages. Les châtelaines ont été portées pendant des siècles mais leur forme et leurs usages n'ont cessé de changer.

Aux seizième et dix-septième siècles, les femmes suspendent bourse, bible, clés, éventail, parfum et couteau dans sa gaine à des chaînes qui leur pendent jusqu'aux chevilles. Au dix-huitième siècle, les chaînes raccourcissent et retiennent surtout des ustensiles de couture, ainsi que des sels, des sceaux à cacheter et une montre. À cette époque, la châtelaine a gagné les autres couches de la société et, outre les versions en or et argent, il s'en fabrique en chrysocale, en émail, en nacre et en acier.

La châtelaine connaîtra un renouveau au dix-neuvième siècle, avec porte-lunettes, dispositifs pour relever les jupes, porte-clés, ombrelles et bloc-notes. Sans compter les châtelaines du soir, avec carnet de bal, miroir, flacon de parfum et porte éventail, ou les châtelaines assorties d'un petit sac, appelées sacs-châtelaines. Elles sont en or, métal doré ou argenté, argent ou acier coupé, et sont souvent ornées de cornaline, porcelaine ou émail. Les moins chères sont en cuir et les magazines de couture expliquent comment en fabriquer en toile. La châtelaine passera de mode dans la première décennie du vingtième siècle avec l'arrivée du sac à main.

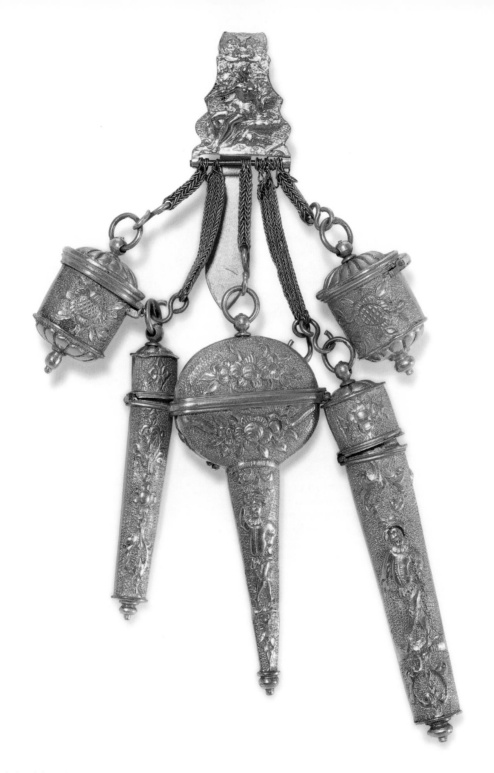

Gilded chatelaine with Diana on hook, England, ca. 1740.

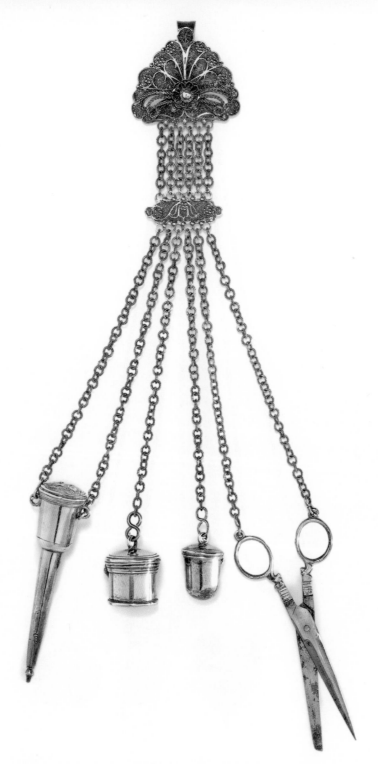

Silver chatelaine with needle case, scissors, vinaigrette and thimble box, maker: Willem Rosier, Amsterdam,
The Netherlands, ca. 1740.

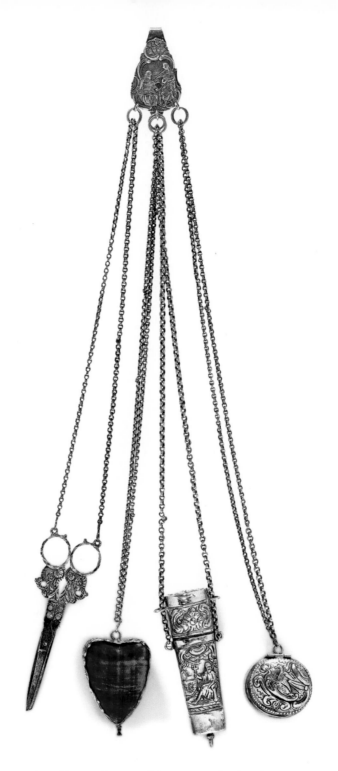

Silver chatelaine with scissors, pin cushion, needle case and vinaigrette, maker: Roelof Snoek, Leeuwarden, The Netherlands, 1775-1800.

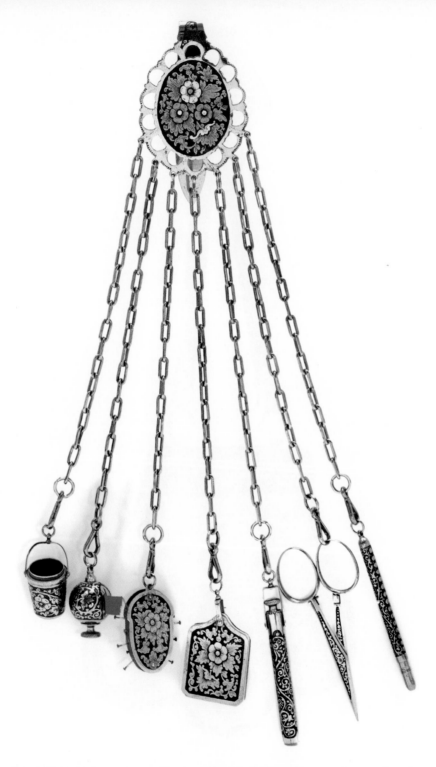

Cut steel chatelaine with thimble box, tape measure, pin cushion, notebook, needle case, scissors and pencil, England, 19th c.

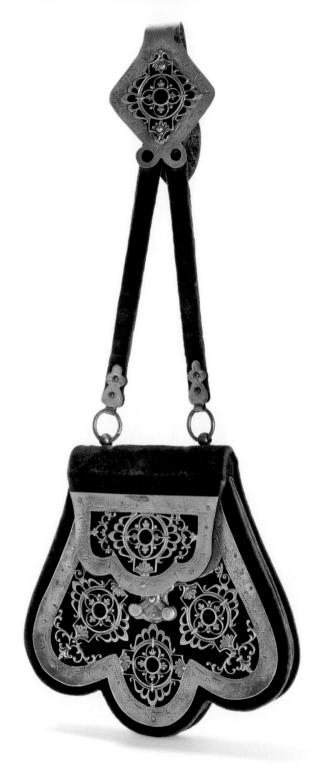

Velvet chatelaine bag with brass decoration and hook, France, 1874.

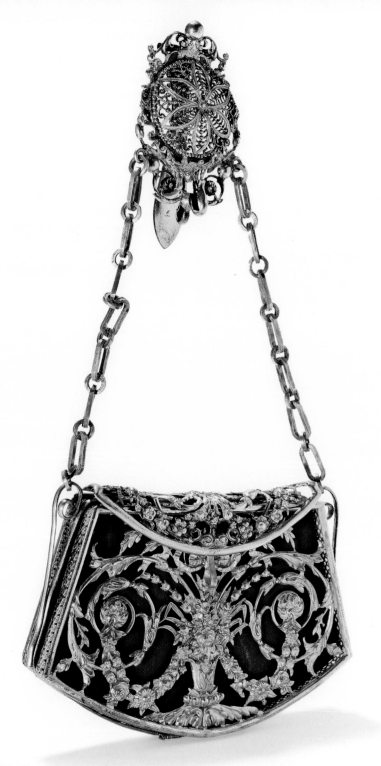

Silver plated chatelaine bag, Austria, late 19th c.

Framed bags

Bags with silver frames came into fashion among Dutch women starting in the last quarter of the seventeenth century. Bags with frames were traditionally worn under the apron with a hook on the belt or skirt waistband. The bags usually had a silver frame but could also be made from other metals. Because silver was costly, the frame was often handed down from mother to daughter. There is a wide variety in the form and decoration of bags with frames. In line with the prevailing fashion, a new bag made of velvet, damask, silk or leather could be attached to the silver frame. The silver frame with a knitted beaded bag, still seen quite frequently today, is a version that first appeared shortly after 1800.

When the handbag finally became an indispensable part of the wardrobe at the beginning of the twentieth century, many old bags with frames were altered, with the hook disappearing and the bag being supplied with a little chain as a handle. At that time, bags with frames were so sought after that the old silver frames were imitated and then furnished with a chain and modern snap fastening. In addition to bag frames, from the eighteenth century onward there were also smaller frames for money purses.

Beugeltassen

Tassen met zilveren beugels raakten bij Nederlandse vrouwen in de mode vanaf het laatste kwart van de zeventiende eeuw. De beugeltas werd op traditionele wijze met een haak aan gordel of rokband onder het schort gedragen. De tassen hadden meestal een zilveren beugel, maar werden ook van andere metalen gemaakt. Omdat zilver kostbaar was, werd de beugel vaak van moeder op dochter doorgegeven. De beugeltassen laten een grote verscheidenheid aan vorm en versiering zien. In stijl met de heersende mode werd aan de zilveren beugel een nieuwe tas van fluweel, damast, zijde of leer gezet. De zilveren beugel met gebreide kralentas, zoals die nu nog veel voorkomt, is een uitvoering die pas kort na 1800 ontstond.

Toen in het begin van de twintigste eeuw de handtas definitief een onmisbaar onderdeel van de garderobe was geworden, werden veel oude beugeltassen vermaakt, waarbij de haak verdween en de tas voorzien werd van een kettinkje als handvat. De beugeltassen waren toen zo gewild, dat de oude zilveren beugels werden nagemaakt, maar dan wel voorzien van een ketting en moderne knipsluiting. Naast de tasbeugels kende men vanaf de achttiende eeuw ook kleinere beugels voor geldbeurzen.

Bolsos de boquilla

Los bolsos con boquilla de plata se pusieron de moda entre las mujeres holandesas a partir del último cuarto del siglo XVII. Tradicionalmente, el bolso de boquilla se llevaba bajo el delantal, con un gancho que colgaba del cinturón o de la pretina de la falda. Por regla general la boquilla era de plata, pero también podía ser de otro metal. La plata era un metal caro, por lo que la boquilla solía pasar de madres a hijas. Los bolsos de boquilla presentan una amplia variedad de formas y de motivos decorativos. Según la moda imperante, a la boquilla de plata podía unirse una bolsa de terciopelo, damasco, seda o cuero. El bolso de boquilla de plata tejido con abalorios, aún en uso hoy en día, es una versión que apareció poco después del año 1800.

Cuando el bolso de mano se convirtió definitivamente en parte indispensable de la indumentaria a comienzos del siglo XX, muchos bolsos de boquilla se modificaron: el gancho desapareció y a la bolsa se le añadió una pequeña cadena a modo de asa. Los bolsos de boquilla eran tan buscados que se imitaba la antigua boquilla de plata pero se les dotaba de una cadena y un broche a presión moderno. Además de los bolsos de boquilla, a partir del siglo XVIII aparecieron boquillas de menor tamaño para los monederos.

Sacs à fermoir

Chez les Néerlandaises, la mode du sac à fermoir en argent commence dès le dernier quart du dix-septième siècle. Il est alors traditionnellement porté sous le tablier, fixé par un crochet à la ceinture de la robe. Les fermoirs étaient généralement en argent mais pouvaient aussi être faits d'un autre métal ; en raison du coût de l'argent, le fermoir se transmettait de mère à fille. Les formes et ornements des sacs à fermoir sont extrêmement variés. Selon la mode du moment, un nouveau sac de velours, soie damassée, soie ou cuir se fixait au fermoir d'argent. La version avec sac de perles tricoté, encore d'actualité, est apparue pour la première fois peu après 1800.

Au début du vingtième siècle, lorsque le sac à main devient définitivement un accessoire indispensable de la garde-robe, de nombreux sacs à fermoir anciens sont adaptés en éliminant le crochet et en le remplaçant par une petite chaîne tenant lieu de poignée. Les anciens sacs à fermoir d'argent sont alors si recherchés que des imitations sont faites avec une chaîne et un fermoir moderne. Outre les fermoirs pour sacs, il existe depuis le dix-huitième siècle des fermoirs plus petits pour bourses.

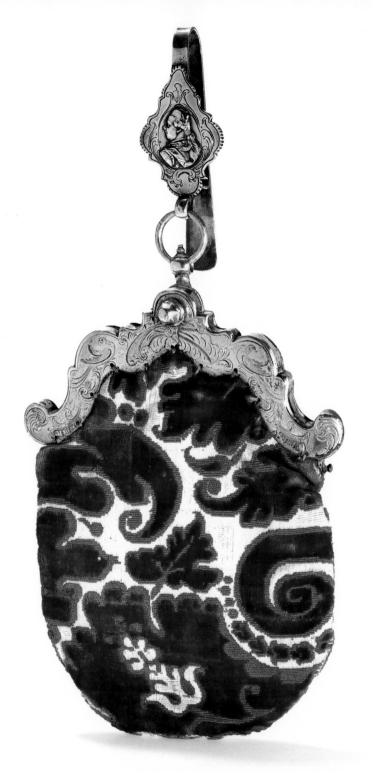

Velvet bag with silver frame and hook. On hook a picture of stadholder Willem V, maker: Van Gelderen, Schoonhoven, The Netherlands, 1773.

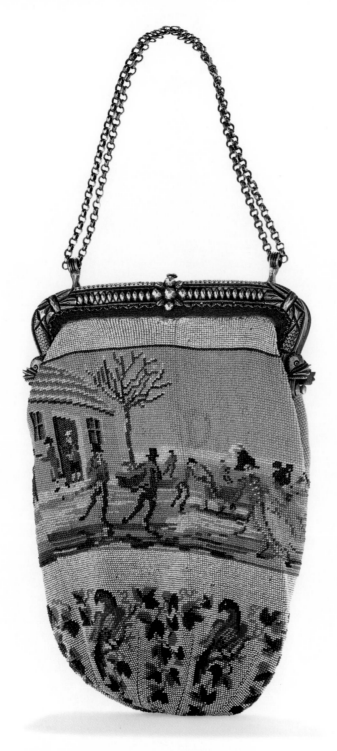

Beaded handbag with silver frame and chain, The Netherlands, 1830s.

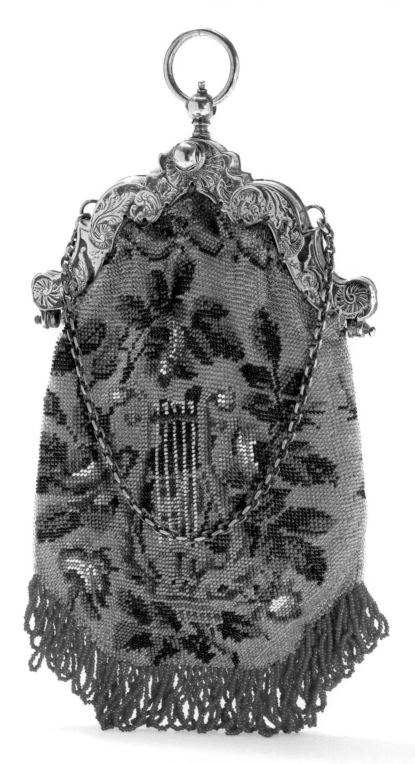

Beaded bag with silver frame, hook and chain, maker: Van Wijk, Amsterdam (bag and chain 19th c), The Netherlands, 1771.

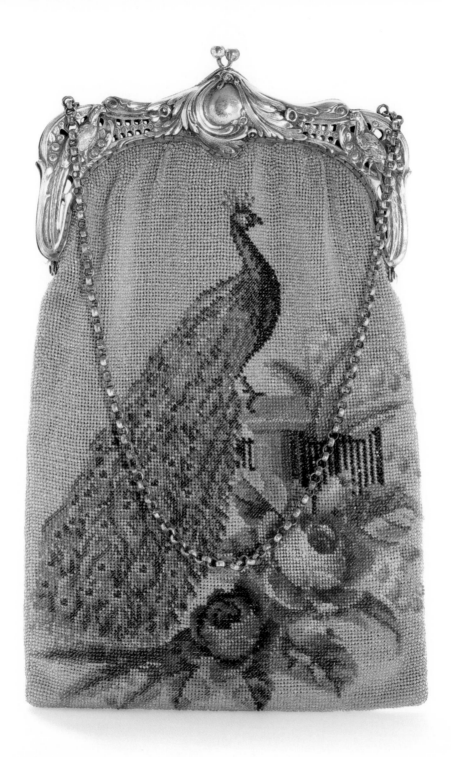

Beaded bag with silver plated frame, Germany, 1918.

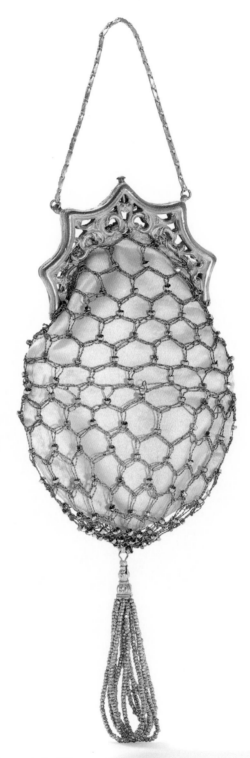

Silk bag with gilded frame and fringe, net of gold thread and Fer de Berlin beads, France, 19th c.

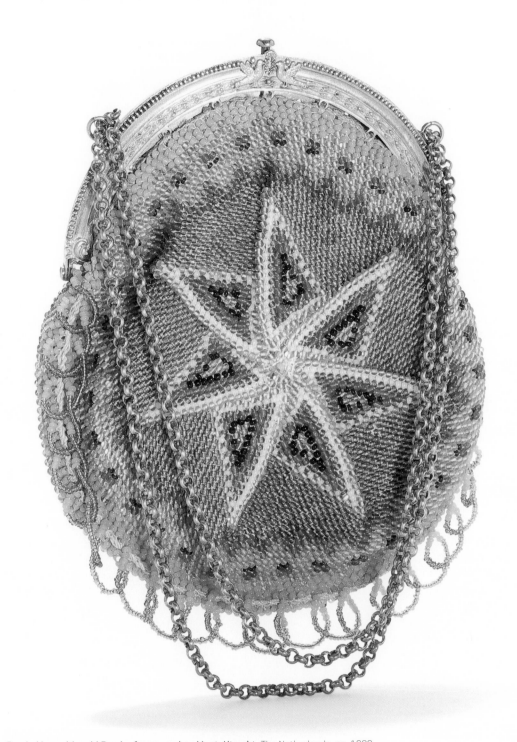

Beaded bag with gold Empire frame, maker: Moot, Utrecht, The Netherlands, ca. 1820.

Pockets

As skirts became more capacious in the seventeenth and eighteenth centuries, loose pockets became popular. Women used them to carry their personal belongings, such as their money purse, letter case, sewing kit, snuffbox, perfume bottle, handkerchief and keys.

The pocket is a long rectangular or pear-shaped bag that is tied round the middle with a ribbon. Most were made from sturdy linen or cotton, and they were often decorated with embroidery. In the front centre there was a vertical opening. The pocket was worn (often two at a time) over the upper petticoat and was reached through a slit in the side of the dress or skirt. Thus, because pockets were hidden from view, illustrations of them are rare in paintings and prints.

Although during the nineteenth century women's clothing gradually came to have more inside pockets, loose pockets remained in use until the twentieth century. In women's magazines they were recommended as travel purses. The same magazines published patterns for making them at home, but shops also carried tie pockets made of cloth or leather.

Dijzakken

Met het wijder worden van de rokken werden in de loop van de zeventiende en in de achttiende eeuw dijzakken populair. Vrouwen bewaarden daarin hun persoonlijke bezittingen, zoals hun beurs, portefeuille, naaigerei, snuifdoos, parfumfles, zakdoek en sleutels.

De dijzak is een lange rechthoekige of peervormige zak, die met een lint om het middel werd gebonden. De meeste werden gemaakt van stevig linnen of katoen, en vaak werden ze versierd met borduurwerk. Middenvoor zat een verticale opening. De dijzak werd (vaak als paar) op de bovenste onderrok gedragen en was bereikbaar door een split in de zijkant van de japon of rok. Doordat dijzakken dus aan het oog onttrokken waren, zijn afbeeldingen ervan op schilderijen en prenten zeldzaam.

Hoewel vrouwenkleding in de loop van de negentiende eeuw steeds meer van binnenzakken werd voorzien, bleven dijzakken tot in de twintigste eeuw in gebruik. In damesbladen werden ze aangeraden als reisbeurs. Diezelfde bladen publiceerden daarvoor zelfmaakpatronen, maar ook winkels boden dijzakken te koop aan, uitgevoerd in stof of leer.

Los bolsillos exteriors

En el transcurso de los siglos XVII y XVIII, a medida que la falda se hacía más ampulosa se fueron popularizando los bolsillos exteriores. Las mujeres los utilizaban para transportar pertenencias tales como el monedero, el portadocumentos, el material de costura, la tabaquera, el frasco de perfume, el pañuelo y las llaves.

El bolsillo exterior es una bolsa en forma de pera o de rectángulo alargado, que se ata por la cintura con un lazo. La mayoría estaban realizados en algodón o lino resistente y a menudo se decoraban con bordados. La parte delantera presentaba una abertura vertical en el centro. Estos bolsillos (generalmente eran dos) se llevaban sobre la parte superior de las enaguas y se accedía a ellos a través de un orificio practicado en el lateral del vestido o la falda. Puesto que los bolsillos exteriores se ocultaban a la vista, raramente pueden apreciarse en cuadros y grabados.

A pesar de que a lo largo del siglo XIX las prendas femeninas cada vez se proveían de más bolsillos interiores, los bolsillos exteriores siguieron utilizándose hasta el siglo XX. Las revistas femeninas recomendaban su uso como monederos de viaje. Estas mismas revistas publicaban patrones para poder confeccionarlos, aunque en las tiendas también podían adquirirse modelos realizados en tela o cuero.

Poches

Aux dix-septième et dix-huitième siècles, les jupes se faisant de plus en plus volumineuses, les poches deviennent très populaires. Les femmes y mettent leurs objets personnels – porte-monnaie, pochette, ustensiles de couture, tabatière, flacon de parfum, mouchoir et clés.

La poche à nouer est un long sac rectangulaire ou en forme de poire noué autour de la taille par un ruban. Le plus souvent en lin ou coton résistant, elles sont souvent ornées de broderies. Elles portent sur l'avant une ouverture verticale au centre, se portent (souvent par paire) sur le jupon du dessus et sont accessibles par une fente pratiquée sur le côté de la robe ou de la jupe. Cachées des regards, les représentations de ces poches sont rares dans les peintures et les gravures.

Au dix-neuvième siècle, les poches intérieures gagnent de plus en plus les vêtements féminins, mais les poches à nouer demeurent jusqu'au vingtième siècle. Les magazines féminins conseillaient leur usage comme porte-monnaie de voyage et proposaient des patrons pour les réaliser soi-même, tandis que les boutiques en proposaient en toile ou en cuir.

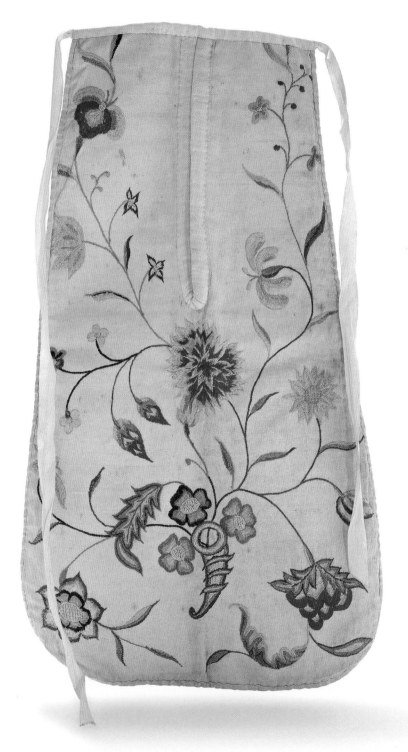

Linen pocket embroidered in coloured silks, England, 1725-1750.

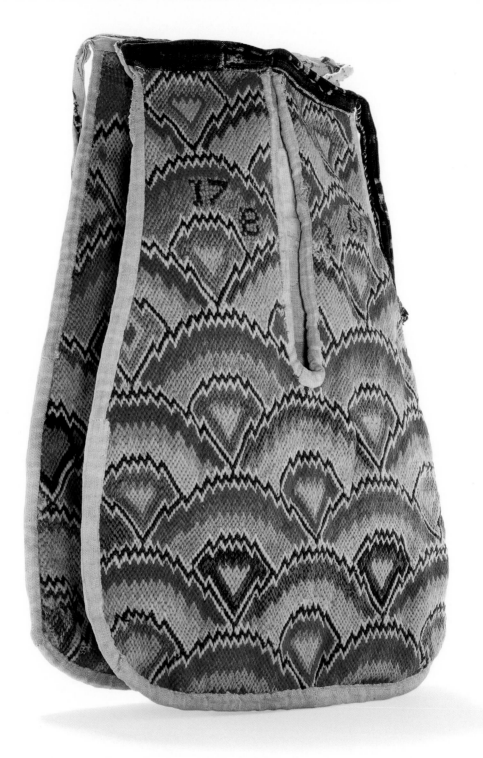

Pair of linen pockets embroidered in flame-stitch with date and initials, England,1766.

Reticules and needlework bags

Partly influenced by the discovery of Pompeii and the revived interest in the Greek temples, in the course of the eighteenth century everything related to classical antiquity became popular. For fashion, this meant that at the end of the century monumental, capacious dresses gave way to simply-cut dresses made of thin fabrics with a higher waist. There was no longer space for heavy tie pockets under these gossamer-thin garments, and a new place had to be found for their contents. They moved to the already-existing workbag and to the fashionable new reticule, the first real forerunner of the handbag.

The reticule, made of cloth or other materials, always had a cord or chain with which the bag could be drawn shut and carried. The French term réticule probably comes from the Latin reticulum, which refers to the small ladies' net bags from Roman times. Despite the return of ample skirts after 1825, the reticule remained in use until the early decades of the twentieth century.

At a time when every well-bred woman was expected to spend her leisure time on fine needlework, the workbag was an indispensable accessory. Both needlework and sewing materials were stowed away in it. The workbag was often taken on visits. From the 1770s on, the most popular work-bag was a flat rectangular bag that was closed at the top with a drawstring. These workbags were mostly made of white satin and were embroidered and decorated with ribbons, foil and sequins. In many cases, women most likely made their reticules and workbags themselves.

Reticules en handwerktassen

Mede onder invloed van de ontdekking van Pompeii en de herwaardering voor de Griekse tempels werd in de loop van de achttiende eeuw alles populair wat met de klassieke oudheid te maken had. Voor de mode betekende dit dat monumentale, wijde japonnen aan het eind van die eeuw plaatsmaakten voor sluike japonnen van dunne stof met een verhoogde taillenaad. Voor zware dijzakken was onder deze ragfijne kleding geen plaats meer en voor de inhoud ervan moest een nieuwe plek worden gevonden. Die verhuisde naar de al bestaande handwerktas en naar de modieuze nieuwe reticule, de eerste echte voorloper van de handtas.

De reticule van textiel of ander materiaal had altijd een koord of ketting waarmee de tas dichtgetrokken en gedragen kon worden. De Franse term réticule komt waarschijnlijk van het Latijnse reticulum, dat verwijst naar de kleine damestassen van netwerk uit de Romeinse tijd. Ondanks de terugkeer van de wijde japonnen na 1825 bleef de reticule tot in de eerste decennia van de twintigste eeuw in gebruik.

In een tijdperk waarin van iedere beschaafde vrouw werd verwacht dat ze haar vrije uren doorbracht met fijn handwerk, was de handwerktas een onmisbaar attribuut. Zowel het handwerk als het naaigerei werd erin opgeborgen. Niet zelden werd de handwerktas meegenomen bij het afleggen van visites. Vanaf de jaren zeventig van de achttiende eeuw was de populairste handwerktas een rechthoekige platte tas die bovenaan met een draagkoord werd gesloten. Deze handwerktassen waren veelal van wit satijn, geborduurd en versierd met lint, folie en lovertjes. In veel gevallen zullen vrouwen zelf hun reticules en handwerktassen hebben gemaakt.

Retículas y bolsas de labores

En parte influidos por el descubrimiento de Pompeya y el revivido interés por los templos griegos, durante el siglo XVIII se popularizó todo lo relacionado con la Antigüedad clásica. En la esfera de la moda esto significó que, a finales de siglo, los vestidos monumentales y ampulosos dieron paso a vestidos de corte sencillo, confeccionados con telas ligeras y con una cintura más alta. Bajo estas finísimas prendas ya no quedaba espacio para los pesados bolsillos exteriores, por lo que era preciso encontrar un nuevo recipiente donde guardar su contenido. Éste se trasladó a la bolsa de labores, ya existente, y a la moderna retícula, el primer precedente real del bolso de mano.

La retícula, confeccionada en tela u otro material, siempre estaba provista de una cuerda o cadena con la que la bolsa podía cerrarse y asirse. El término francés réticule probablemente procede del latín reticulum, que se refiere a las pequeñas bolsas de tejido similar a una red que utilizaban las mujeres de la época romana. A pesar del retorno de las faldas anchas después de 1825, la retícula siguió utilizándose hasta las primeras décadas del siglo XX.

En una época en la cual se esperaba que las mujeres de educación refinada dedicaran su tiempo libre a realizar labores, la bolsa de labores era un accesorio indispensable. En ella se guardaban tanto las labores como el material de costura. Cuando se realizaban visitas era frecuente llevar consigo la bolsa de labores. A partir de 1770, la bolsa de labores más extendida era plana y rectangular, cerrada en la parte superior con un cordón. La mayoría de estas bolsas estaban confeccionadas en satén blanco, y se bordaban y decoraban con lazos, láminas metálicas y lentejuelas. Es probable que en muchos casos fueran las propias mujeres quienes confeccionaran sus retículas y bolsas de labores.

Réticules et sacs à ouvrage

Au dix-huitième siècle, en partie sous l'influence de la découverte de Pompéi et de l'intérêt accru pour les temples grecs, tout ce qui a trait à l'antiquité classique connaît un grand succès. Dans la mode, les robes imposantes et volumineuses font place à la fin du siècle à d'autres de coupe simple en tissus fins et à la taille plus haute. Ces vêtements, souvent aussi fins que la gaze, ne laissent plus d'espace à de lourdes poches nouées par-dessous. Leur contenu doit alors être transféré ailleurs. On choisit pour cela le sac à ouvrage, qui existe déjà, et surtout le réticule, nouveau et très chic, premier véritable précurseur du sac à main.

En toile ou autre matière, le réticule était toujours muni d'une chaîne ou d'un cordon pour le fermer et le porter. Le terme vient sans doute du latin reticulum qui désignait les petits sacs en filet des dames de l'époque romaine. Il continuera d'être utilisé jusqu'aux premières décennies du vingtième siècle – malgré le retour des jupes amples après 1825.

À une époque où toute femme de bonne famille est supposée passer son temps libre à de délicats travaux d'aiguille, le sac à ouvrage est un accessoire indispensable. On y range lesdits travaux et les ustensiles de couture et on l'emmène souvent avec soi en visite. À partir des années 1770, le sac à ouvrage le plus populaire est un sac plat et rectangulaire fermé en haut par un cordon. Le plus souvent en satin blanc, il peut être brodé et décoré de rubans, feuilles métalliques et sequins. La plupart des réticules et sacs à ouvrage ont très probablement été réalisés par leurs utilisatrices.

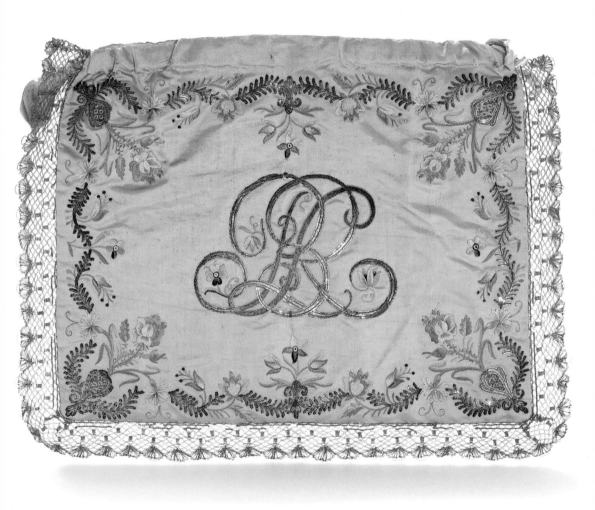

Silk work bag embroidered with silk, wire and sequins, England, late 18th c.

Linen work bag with embroidery, France, ca. 1825.

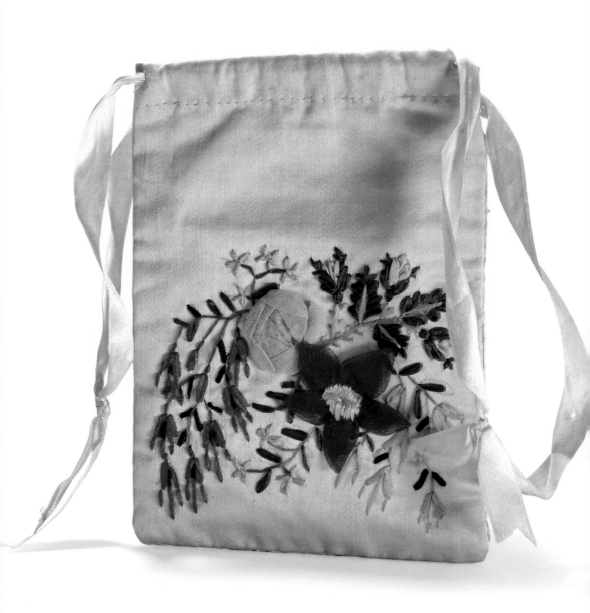

Satin reticule with ribbons and embroidery, England, ca. 1830.

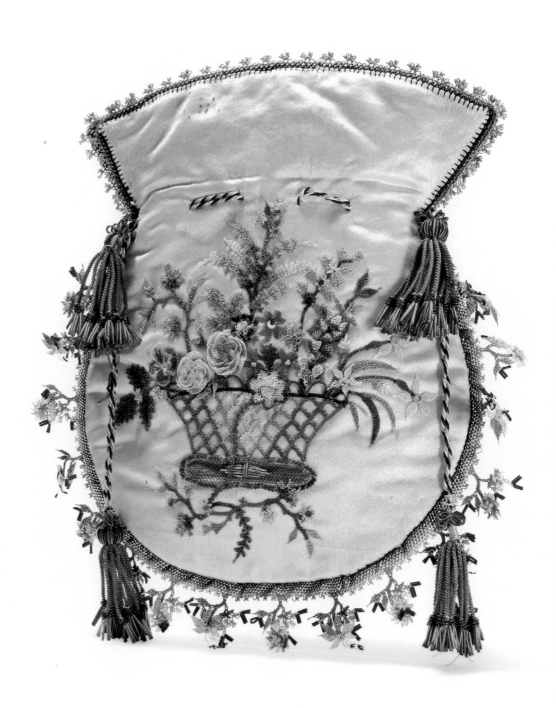

Satin reticule with embroidery and Turkish knots along border, France, early 19th c.

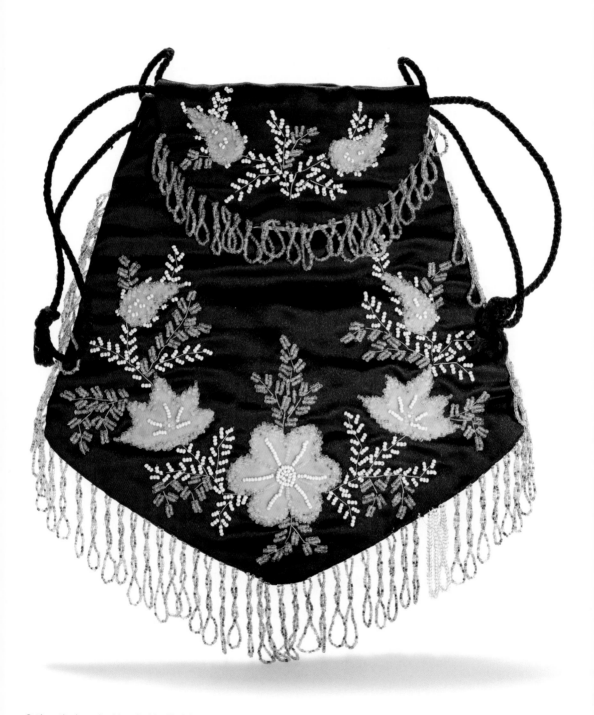

Satin reticule embroidered with silk, felt and beads, England, 1850s.

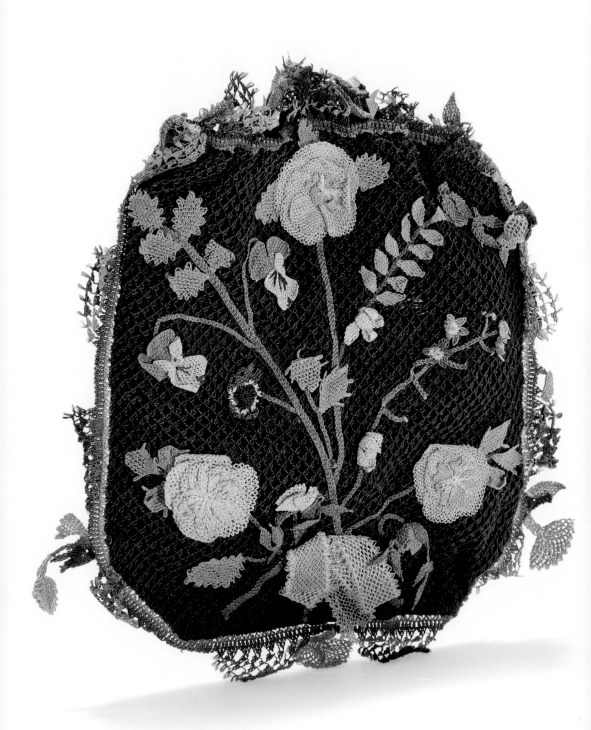

Crocheted reticule with embroidery, England, 19th c.

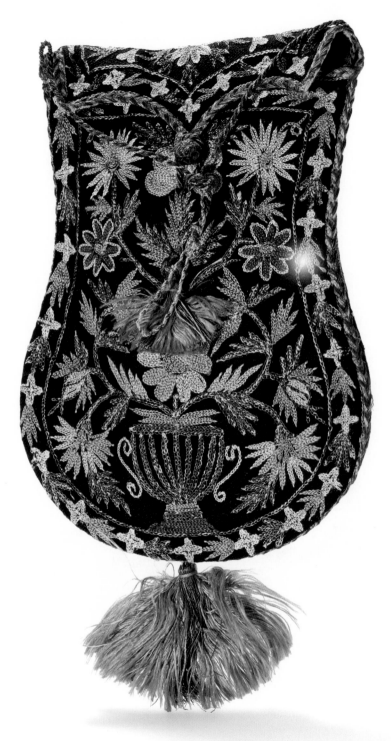

Fabric reticule with silk embroidery, France, early 19th c.

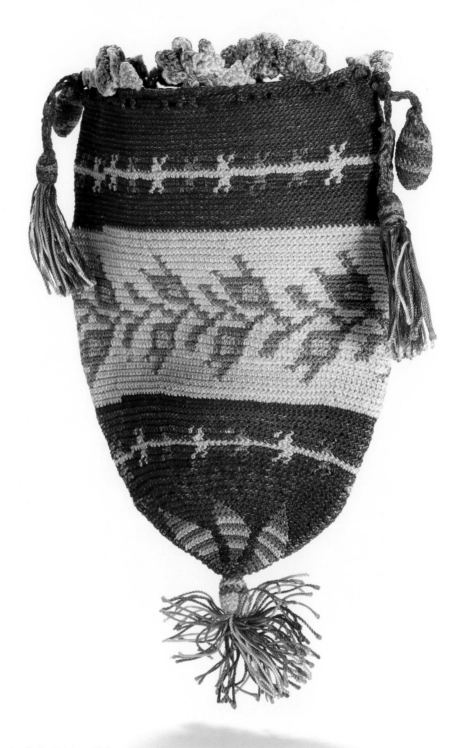

Knitted reticule, Belgium, 19th c.

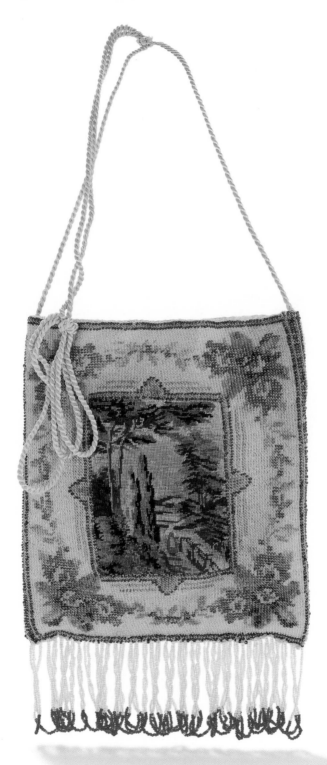

Silk reticule with beads and embroidery, Austria, 1830s-1840s.

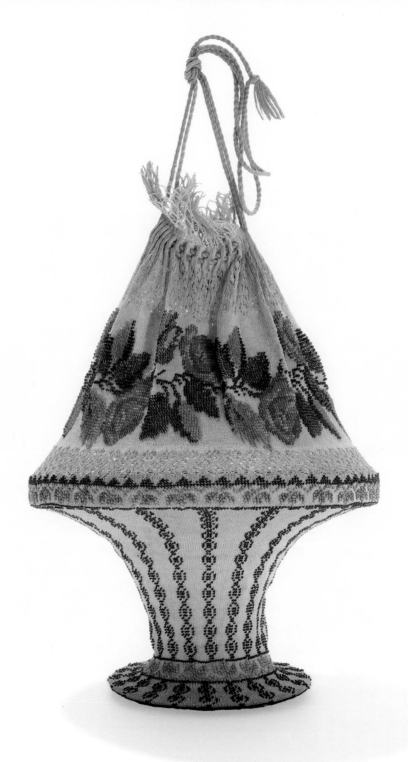

Cotton reticule with beads, Germany, ca. 1820.

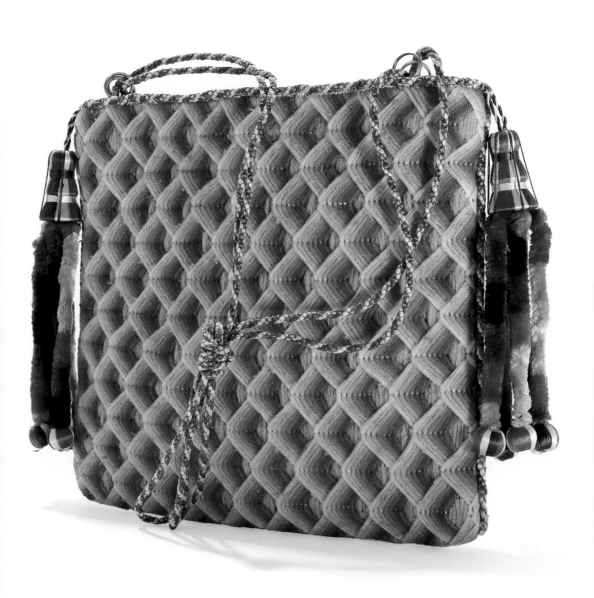

Reticule in Berlin woolwork and with chenille tassels, England, 1840-1870.

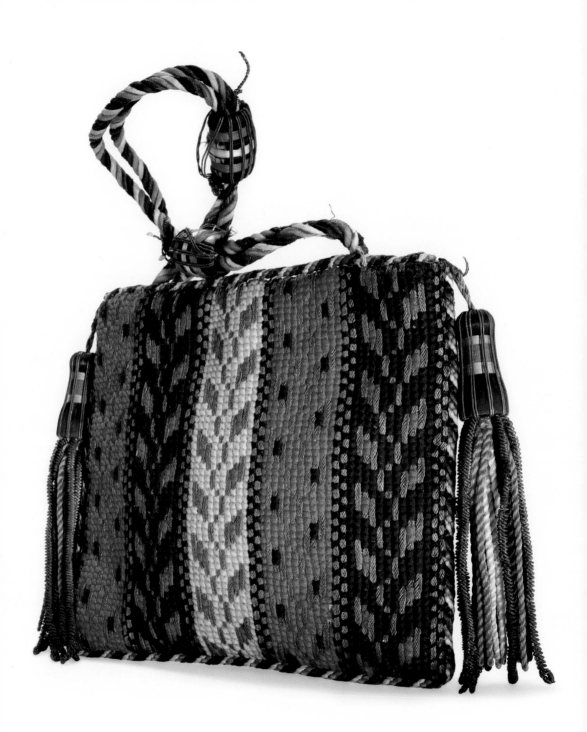

Reticule in woolwork, England, 1840-1870.

Coin purses

A strikingly long purse that became popular in the last quarter of the eighteenth century is the stocking purse (also called the long purse, ring purse or gentlemen's purse). The stocking purse is a long crocheted or knitted sheath which is closed at both ends and carried in the middle. In that same middle of the purse was the opening, through which money could be dropped toward one of the two sides. The two ends were often different, so that one could easily distinguish what was kept on which side. Two rings around the middle were moved towards the ends in order to close off the contents. The stocking purse remained in use until the 1920s, although its popularity decreased rapidly with the arrival of paper money at the beginning of the century.

Variations on the stocking purse were the 'à la reine Elisabeth' (the Queen Elizabeth) and the 'en diable' purse (the Devil's purse). The latter was so christened because it was so difficult to open and close. A typical French purse was the 'bourse à Louis', a little purse made of gilt metal or gold named after the Louis d'Or, the French gold coin.

Beurzen

Een opvallende lange beurs die in het laatste kwart van de achttiende eeuw populair werd, is de kousenbeurs (ook wel lange beurs of wel herenbeurs genoemd). De kousenbeurs is een, aan beide uiteinden gesloten, lange koker van haak- of breiwerk, die in het midden gedragen werd. In datzelfde midden van de beurs zat de opening, waardoor men het geld naar een van beide kanten kon laten vallen. Vaak waren de uiteinden verschillend van vorm, zodat makkelijk te onthouden was wat aan welke kant bewaard werd. Twee ringen om het midden werden naar de uiteinden geschoven om de inhoud af te sluiten. De kousenbeurs is tot in de jaren twintig van de twintigste eeuw in gebruik gebleven, hoewel zijn populariteit met de komst van het papiergeld in het begin van die eeuw snel afnam.

Varianten op de kousenbeurs waren de beurs 'à la reine Elisabeth' en de beurs 'en diable'. De laatste werd zo genoemd omdat het zo lastig was hem open en dicht te krijgen. Een typische Franse beurs was de 'bourse à Louis', een beursje van verguld metaal of goud, genoemd naar de Louis d'Or, de Franse gouden munt.

Portamonedas

La bolsa de media es un bolso sorprendentemente largo que se popularizó en el último cuarto del siglo XVIII. También recibe el nombre de bolsa larga, bolsa de aro o bolsa de caballero. Se trata de una funda larga de punto o ganchillo cerrada en ambos extremos, que se ase por el medio. Justo aquí es donde se hallaba la abertura a través de la cual el dinero podía meterse hacia uno u otro lado. Por lo general, cada uno de los extremos era diferente a fin de poder distinguir fácilmente qué se guardaba en cada lado. En el medio había dos aros que se desplazaban hacia los extremos para evitar que saliera el contenido. La bolsa de media siguió en uso hasta la década de 1920, si bien su popularidad disminuyó rápidamente con la llegada del papel moneda, a principios de siglo.

La bolsa de media tenía variantes como la bolsa "à la reine Elisabeth" (de la reina Isabel) y la bolsa "en diable" (del diablo). Ésta última se bautizó así porque resultaba muy complicado abrirla y cerrarla. Típicamente francesa era la "bourse à Louis", pequeña y elaborada con metal dorado u oro y que toma su nombre del Louis d'Or, la moneda de oro francesa.

Bourses

Une bourse d'une longueur étonnante a connu un grand succès dans le dernier quart du dix-huitième siècle : la bourse chaussette (également appelée longue bourse, bourse à anneau ou bourse de gentleman), un long fourreau crocheté ou tricoté fermé aux deux extrémités et porté par le milieu, où se trouve l'ouverture par laquelle l'argent pouvait être déposé d'un côté ou de l'autre. Les deux bouts étaient souvent différents pour permettre de distinguer facilement ce que chacun contenait et deux anneaux au milieu pouvaient être glissés vers les extrémités pour en enfermer le contenu. La bourse chaussette a été utilisée jusqu'aux années 1920, pour perdre ensuite rapidement sa popularité avec l'introduction du papier monnaie au début du siècle.

Parmi les variantes de bourses chaussette, on trouve les bourses « à la reine Elisabeth » et « en diable » (ainsi nommée parce qu'elle était si difficile à ouvrir et fermer). Typiquement française, la « bourse à louis » était quant à elle une petite bourse de métal doré ou d'or qui doit son nom au louis d'or.

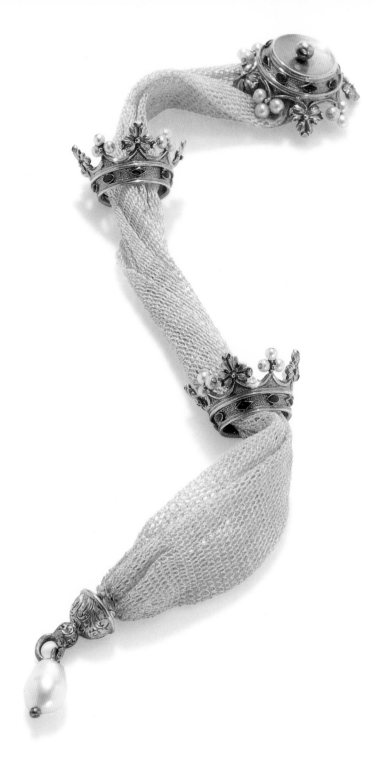

Long purse with gilt rings and decoration of stones and pearls, France, late 18th c.

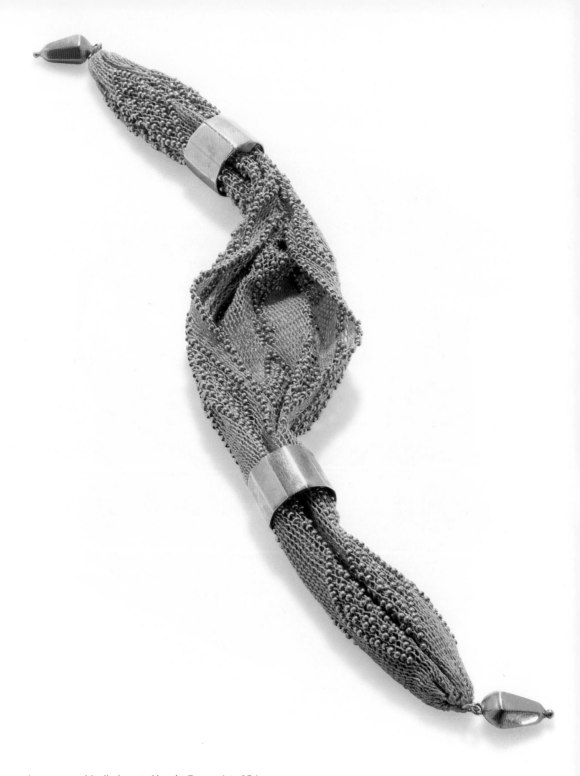

Long purse with gilt rings and beads, France, late 18th c.

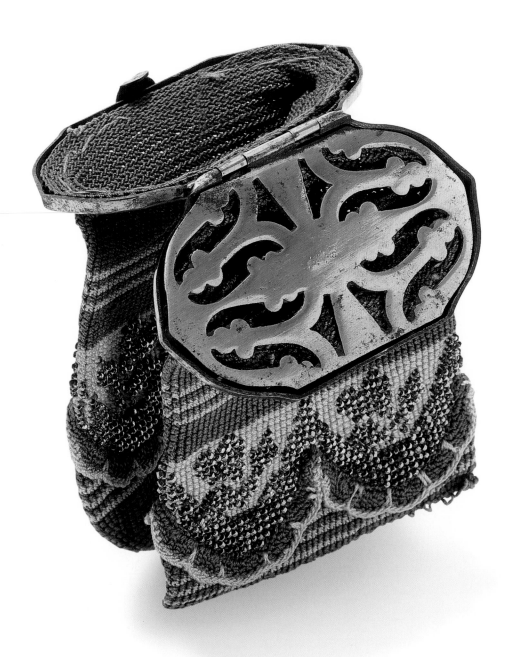

Long purse with special closure, decorated with steel beads, France, ca. 1880.

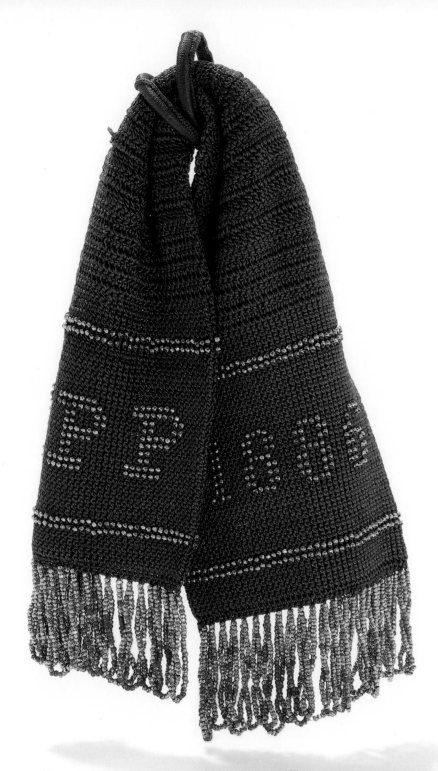

Crocheted long purse with cut steel beads and with date and initials, England, 1886.

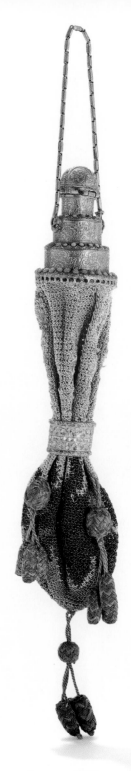

Crocheted long purse with perfume bottle on top, France, ca. 1855.

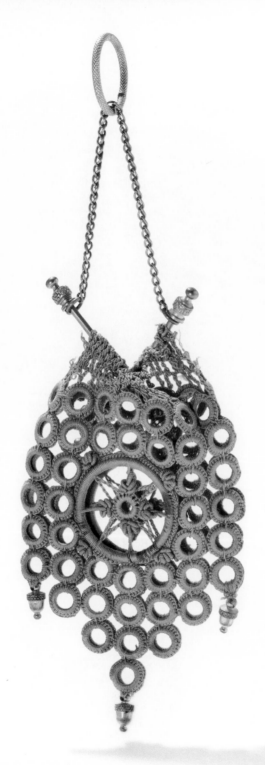

Crocheted coin purse in the so called 'en diable'-execution, France, 19th c.

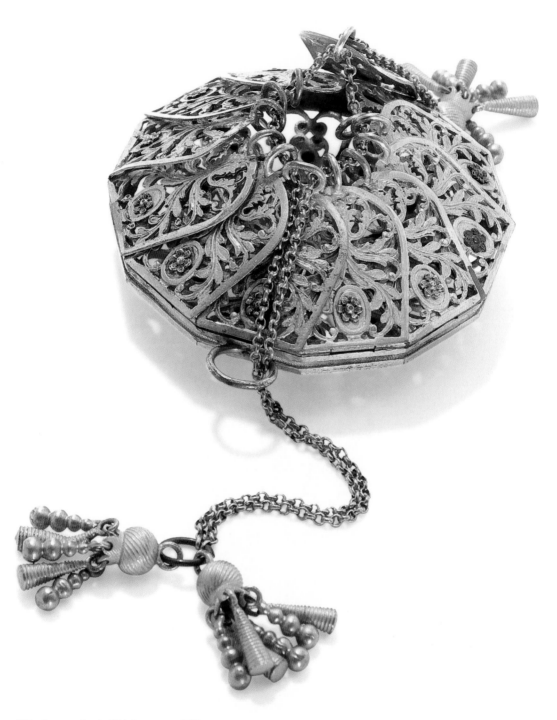

Gilt coin purse 'Louis d'Or', France, ca. 1830.

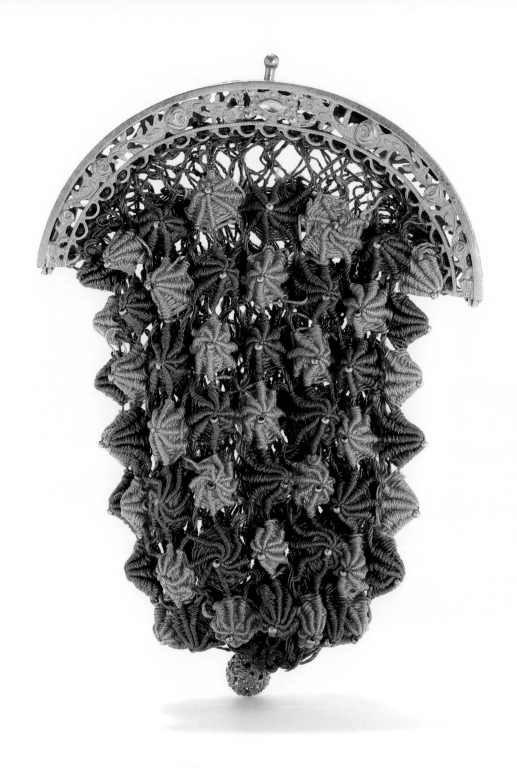

Coin purse with gilt frame, France, 1st half 19th c.

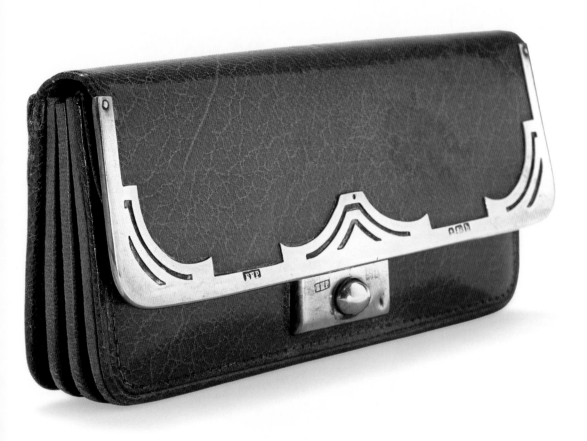

Leather wallet with compartments for coins and bank notes, England, Birmingham, 1907.

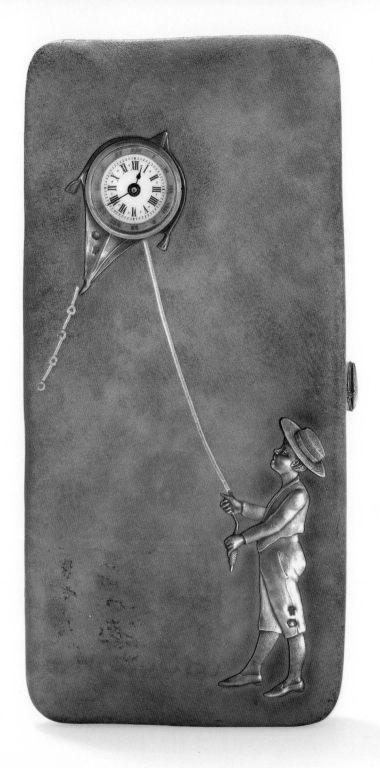

Leather wallet for bank notes with watch and silver decoration, Austria, early 20th c.

Souvenirs

With the increase in travel, the demand for souvenirs increased. In France, special little purses and bags showing pictures of Paris were sold as souvenirs. Souvenir purses in different forms made from cloth, gilt metal, silver, gold, mother of pearl, ivory, tortoiseshell or celluloid were purchased by travellers to take home as a memento of their trip. The front of many nineteenth-century souvenir purses had a picture of a church, castle or other well-known building or monument from the city visited.

A handbag with wooden cover sheets showing pictures of Fontainebleau and a little wooden money box showing the house where the Scottish poet Robbie Burns was born are typical examples of Mauchline Ware: small implements (needle cases, letter openers, little boxes, bags and purses) with pictures of tourist attractions produced in the nineteenth century in the Scottish town of Mauchline, amongst other places. The pictures were initially applied by hand, but towards the middle of the nineteenth century they were printed with the aid of transfer plates.

Some souvenirs are mementos of historical events, such as the beaded coin purse from circa 1827 showing a picture of Zarafa, the first giraffe in France, and the beaded reticule showing the Sirius, the first steamship to cross the Atlantic Ocean in 1838.

A special set of leather handbags and clutches with coloured relief decorations of Japanese and Egyptian scenes strongly hints at being souvenirs. These bags were probably made in the Far East for the European market. Comparable bags were sold in around 1930 at Liberty & Co in London under the name of Japanese leatherwork. They are evidence of Europe's interest in the Far East at that time. Simple versions in dark green or brown leather were for sale in the bazaar in Port Said in Egypt from the thirties to the early fifties.

Souvenirs

Met het toenemende reisverkeer steeg de vraag naar souvenirs. In Frankrijk werden speciale beursjes en tasjes met taferelen van Parijs als souvenir verkocht. Souvenirbeursjes in aparte vormen gemaakt van textiel, verguld metaal, zilver, goud, parelmoer, ivoor, schildpad of celluloid werden door de reiziger gekocht om mee te nemen naar huis als herinnering aan een mooie reis. Veel negentiende-eeuwse souvenirbeursjes hadden op de voorkant een afbeelding van een kerk, kasteel of een ander bekend gebouw of monument uit de bezochte stad.

Een handtas met houten dekbladen met afbeeldingen van Fontainebleau en een houten beursje met het geboortehuis van de Schotse dichter Robert Burns zijn typische voorbeelden van Mauchline Ware: kleine gebruiksvoorwerpen (naaldenkokers, briefopeners, doosjes, tassen en beursjes) met afbeeldingen van toeristische attracties, die in de negentiende eeuw onder andere werden geproduceerd in het Schotse Mauchline. De afbeeldingen werden aanvankelijk met de hand aangebracht, maar tegen het midden van de negentiende eeuw gebeurde dat met behulp van gedrukte transferplaatjes.

Sommige souvenirs herinneren aan een historische gebeurtenis, zoals de kralenbeurs van rond 1827 met een afbeelding van Zarafa, de eerste giraf in Frankrijk, en de kralenreticule met de Sirius, het eerste stoomschip dat in 1838 de Atlantische Oceaan overstak.

Een bijzondere serie leren hand- en enveloptassen met kleurige reliëfdecoraties van Japanse en Egyptische taferelen doet sterk denken aan souvenirs. Deze tassen werden waarschijnlijk in het Verre Oosten gemaakt voor de Europese markt. Vergelijkbare tassen waren rond 1930 onder de benaming Japans leerwerk te koop bij Liberty & Co in Londen. Zij tonen de belangstelling voor het Verre Oosten die er in die jaren in Europa bestond. Eenvoudige uitvoeringen in donkergroen of bruin leer werden van de jaren dertig tot begin jaren vijftig te koop aangeboden op de bazaar van de Egyptische havenstad Port Said.

Recuerdos de viajes

Con el aumento de los viajes, aumentó también la demanda de recuerdos. En Francia se confeccionaban especialmente pequeños portamonedas y bolsas que mostraban imágenes de París y que se vendían como recuerdos de viaje. El viajero se llevaba consigo bolsas de distintas formas realizadas con tela, metal dorado, plata, oro, madreperla, marfil, carey o celuloide para rememorar el viaje. En el siglo XIX, la parte delantera de muchas de estas bolsas presentaba la imagen de una iglesia, un castillo u otro edificio o monumento célebre de la ciudad visitada.

Un bolso de mano con cubiertas de madera que muestra imágenes de Fontainebleau y una cajita de madera para monedas que lleva pintada la casa donde nació el poeta escocés Robbie Burns, son ejemplos típicos de productos de la ciudad escocesa de Mauchline. En esta localidad y en algunas otras, se producían durante el siglo XIX pequeños complementos (recipientes para agujas, abrecartas, pequeñas cajas, bolsos y portamonedas) con imágenes de atracciones turísticas. En su origen, las imágenes se pintaban a mano, pero hacia mediados de siglo comenzaron a imprimirse con la ayuda de planchas.

Algunos recuerdos de viajes rememoran acontecimientos históricos como es el caso del monedero con abalorios que data de 1827 aproximadamente y que presenta una imagen de Zarafa, la primera jirafa que hubo en Francia, así como la retícula con abalorios que muestra el Sirius, el primer barco de vapor que cruzó el océano Atlántico en 1838.

Existe un conjunto especial de clutches y bolsos de mano de cuero con decoraciones de colores en relieve que muestran escenas japonesas y egipcias que hacen sospechar de que se trate de recuerdos de viaje. Es probable que estas bolsas se confeccionaran en el Lejano Oriente para el mercado europeo. Hacia 1930 en la tienda Liberty & Co de Londres se comercializaban bolsas parecidas a éstas bajo la denominación de "marroquinería japonesa", lo cual constituye una muestra del interés que Europa sentía por los países orientales en aquellos momentos. Desde los años treinta hasta principios de los años cincuenta se vendían versiones sencillas en cuero de color verde oscuro o marrón en el bazar de la ciudad portuaria egipcia de Port Said.

Souvenirs

Avec le développement des voyages, la demande de souvenirs s'accroît. En France, on vend à cet effet des petits sacs et porte-monnaie avec des images de Paris, et les voyageurs achètent des porte-monnaie souvenir de différentes formes en tissu, métal doré, argent, or, nacre, ivoire, écaille ou celluloïd en souvenir de leur voyage. Beaucoup de ces porte-monnaie souvenir du dix-neuvième siècle portent par devant l'image d'une église, d'un château ou de tout bâtiment ou monument célèbre de la ville visitée.

Un sac à main dont la feuille de couverture en bois illustre Fontainebleau et la petite tirelire en bois avec l'image de la maison où le poète écossais Robert Burns est né sont des exemplaires typiques de la production de Mauchline : petits ustensiles (porte-aiguilles, coupe-papier, petites boîtes, sacs ou porte-monnaie) ornés de représentations de lieux touristiques et fabriqués au dix-neuvième siècle dans la ville écossaise de Mauchline, entre autres. Les images étaient au départ appliquées à la main ; à partir du milieu du dix-neuvième siècle, elles commencent à être imprimées à l'aide de plaques de transfert.

Certains de ces souvenirs rappellent des événements historiques, comme la bourse en perles de 1827 environ qui montre Zarafa, la première girafe arrivée en France, ou le réticule de perles illustré du Sirius, premier paquebot à traverser l'océan Atlantique en 1838.

Une série spéciale de sacs à main et de pochettes en cuir aux décorations en relief colorées représentent des scènes japonaises et égyptiennes et sont visiblement des souvenirs : ils ont sans doute été fabriqués en Extrême-Orient pour le marché européen. Des modèles comparables étaient vendus vers 1930 chez Liberty & Co, à Londres, sous le nom de maroquinerie japonaise et témoignent de l'intérêt de l'Europe pour l'Extrême-Orient à cette époque. Des versions plus simples en cuir vert ou brun foncé ont été vendues dans le bazar de Port-Saïd, en Égypte, des années trente au début des années cinquante.

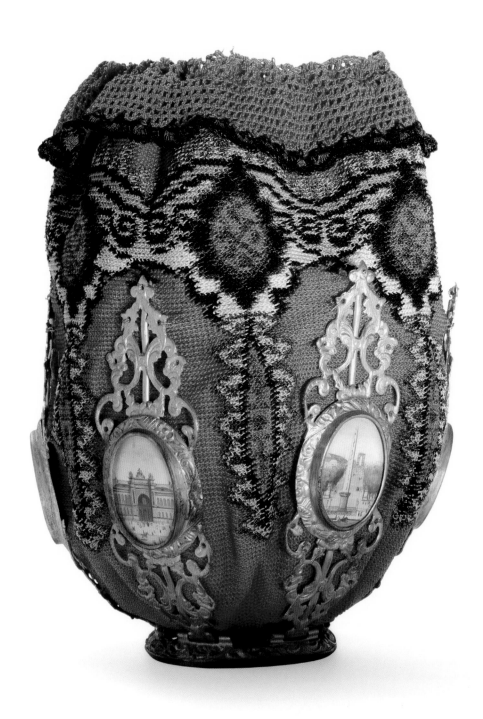

Crocheted reticule with medaillons showing Paris' buildings, France, 1855.

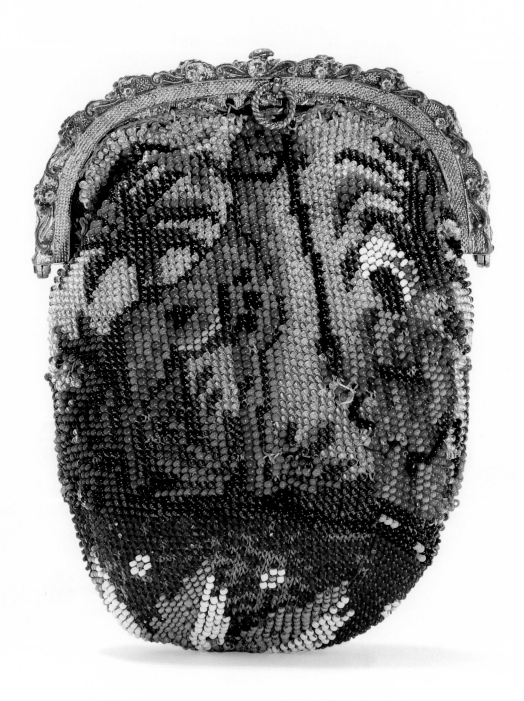

Beaded coin purse showing the arrival of the first giraffe in France, France, 1827.

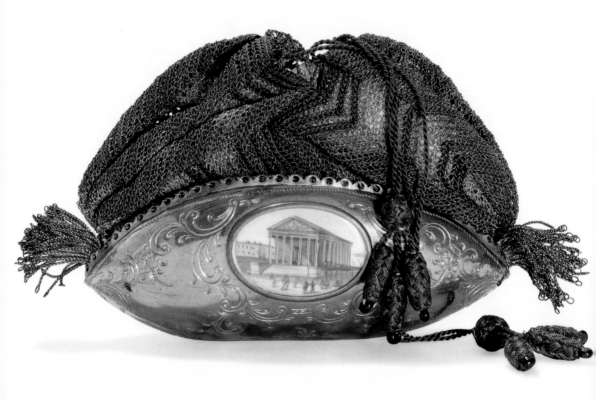

Crocheted reticule with medaillons showing Paris' buildings, France, 1855.

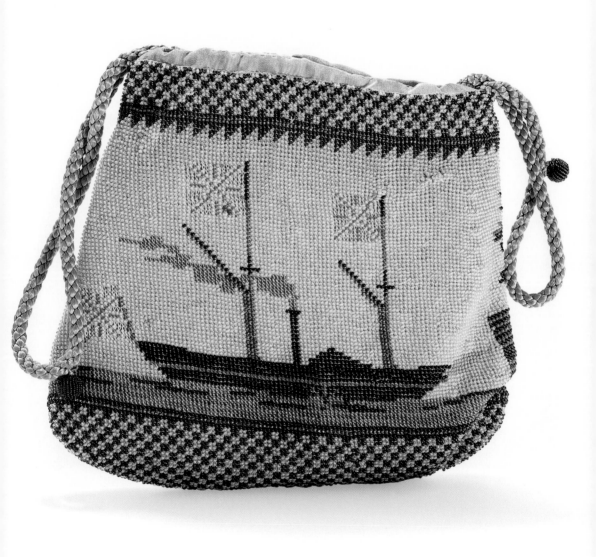

Beaded bag showing the 'Sirius', the first steamship crossing the ocean, England, 1838.

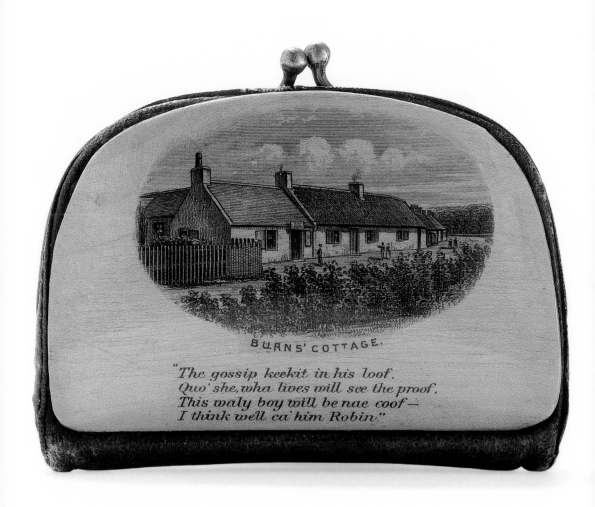

Leather coin purse with wooden cover in Mauchline ware showing 'Burns Cottage', Scotland, late 19th c.

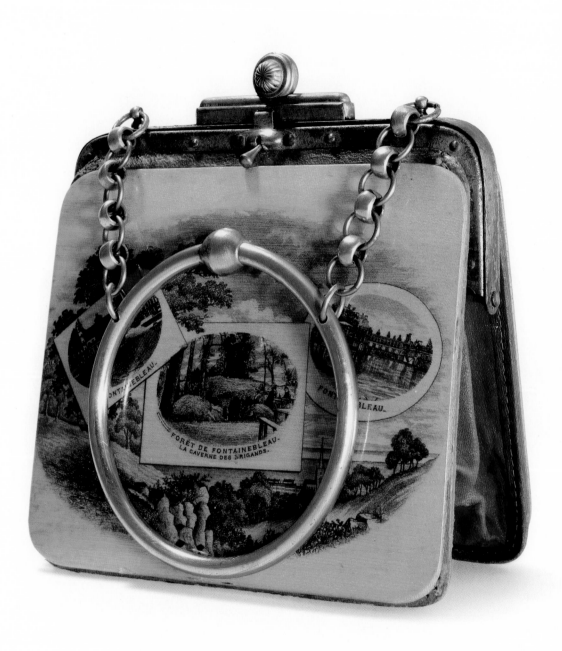

Leather handbag with wooden cover in Mauchline ware showing buildings in French city Fontainebleau, Scotland, 1880s.

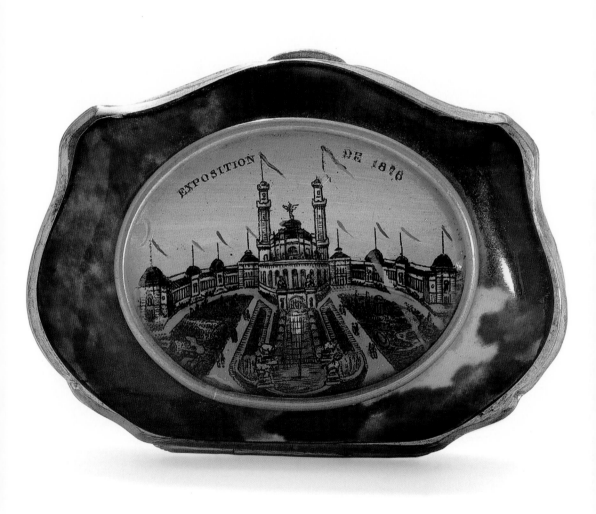

Tortoise-shell coin purse with picture of the Trocadéro, World's Fair in Paris, France, 1878.

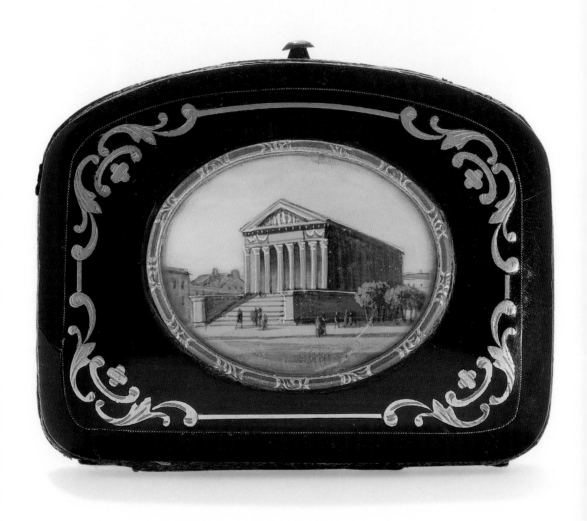

Coinpurse of tortoise-shell with painting of the 'Madeleine church' in Paris , France, mid. 19th c.

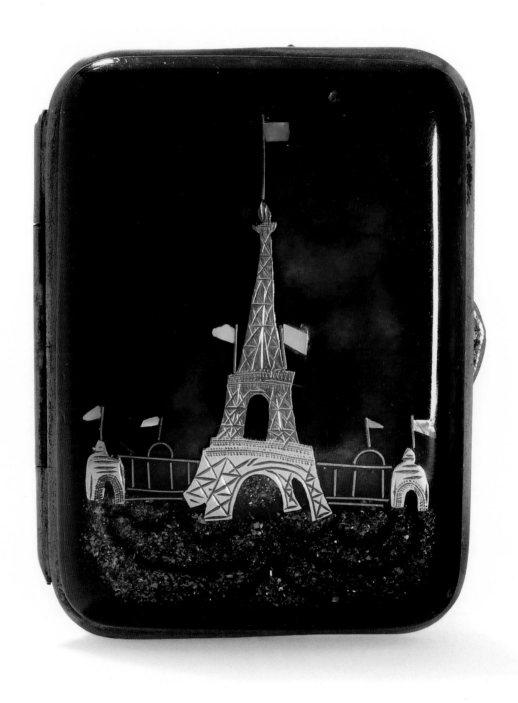

Tortoise-shell coin purse inlaid with Eiffel Tower in silver, World's Fair in Paris, France, 1889.

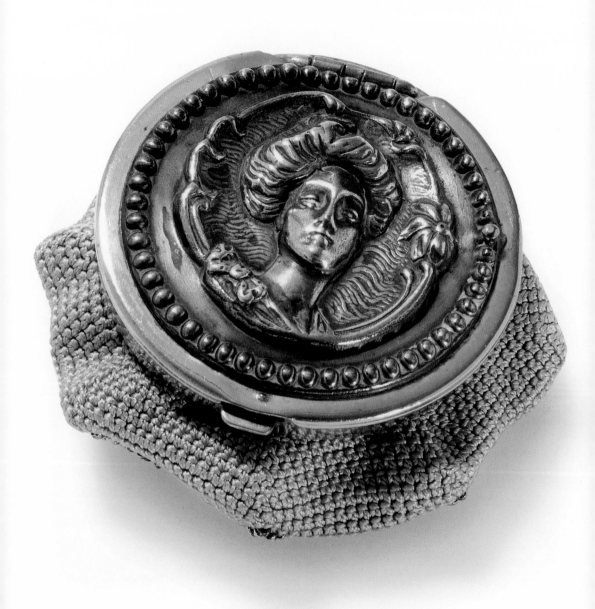

Tam O'Shanter coin purse with steel beaded crocheted bottom, England, 1903.

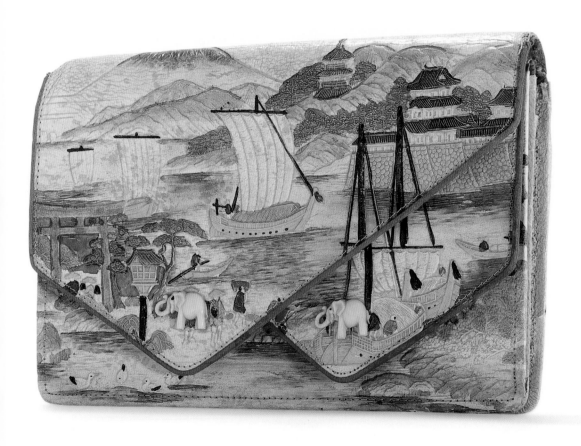

Leather clutch with embossed Japanese decoration, Japan, 1925-1935.

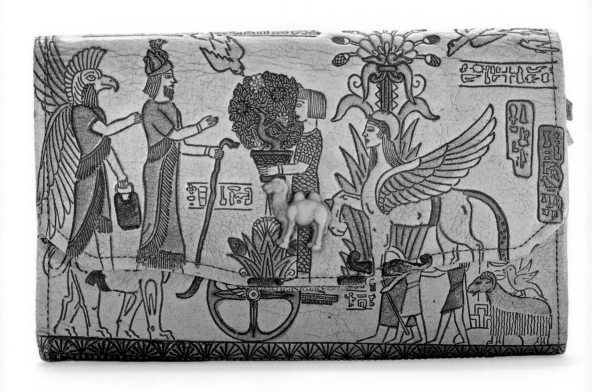

Leather clutch with embossed Egyptian decoration, Egypt, 1925-1935.

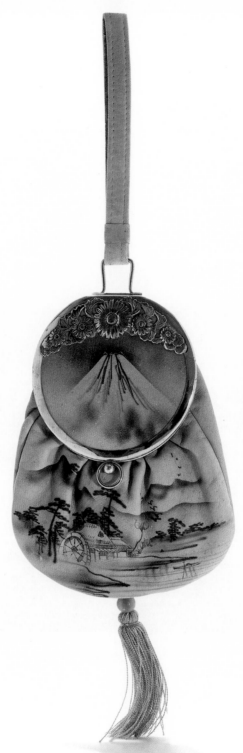

Suede cloth handbag with decoration of Mount Fuji and silver cover and matching wallet, Japan, 1920s.

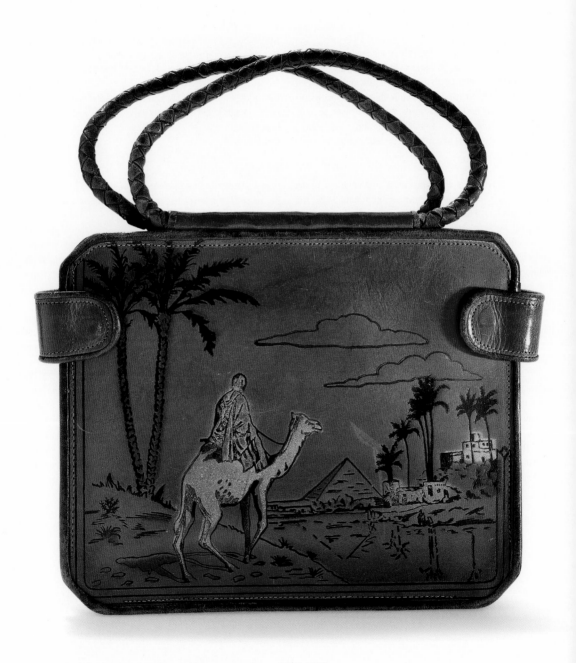

Leather clutch with embossed Egyptian decoration, Egypt, 1950-1955.

Suitcases and travel bags

In the nineteenth century, steam trains and steamships made travelling more comfortable, faster and cheaper. Because people were travelling more often and with different types of transport, the range of suitcases, shoe and hat boxes, and dressing cases changed.

Trunks with spherical lids, which could be easily transported on top of a horse-drawn carriage, were increasingly replaced by flat leather suitcases that could be stacked and easily carried by hand. Dressing cases containing brushes, manicure sets, little bottles and boxes made of silver, crystal, ivory and mother of pearl were the forerunners of today's beauty case. The travel bag was also an indispensable article for travelling.

Suitcases, travel bags, dressing cases, shoe and hat boxes were mostly made of leather; however, in around 1826, the Frenchman Pierre Godillot made a travelling bag out of canvas which became extraordinarily popular in the second half of the nineteenth century. The canvas travelling bag was also very suitable for being embroidered in Berlin wool work. Many women embroidered their bags themselves and then had the local saddler add leather corners, handles and a metal frame.

For shorter journeys, Gladstone bags, city bags and baskets were used. The oblong leather doctor's bag with a metal frame and leather handle was mostly used by men for work.

From 1870 on, a wicker basket with flaps became popular for holding shopping, lunch or needlework. Until the early decades of the twentieth century, many different versions of these little baskets could be seen. For a trip to the countryside, there was the leather picnic set or hamper, neatly filled with plates, cutlery, teacups, sugar bowl, biscuit tin, thermos flask and in some cases even a spirit burner.

Koffers en reistassen

In de negentiende eeuw maakten stoomtreinen en stoomboten het reizen comfortabeler, sneller en goedkoper. Doordat er meer en anders gereisd werd, veranderde het aanbod aan koffers, schoenen- en hoedentassen en reisnecessaires.

Reiskisten met bolvormige deksels, die eenvoudig bovenop een koets vervoerd konden worden, werden steeds meer vervangen door leren, platte stapelbare koffers, die ook makkelijk in de hand gedragen konden worden. Reisnecessaires met borstels, manicuresets, flesjes en dozen van zilver, kristal, ivoor en parelmoer waren de voorlopers van de huidige beautycase. Daarnaast werd de reistas tijdens het reizen een onmisbare attribuut.

Koffers, reistassen, reisnecessaires, schoenen- en hoedentassen waren meestal van leer. Rond 1826 had de Fransman Pierre Godillot een reistas gemaakt van canvas. Deze werd in de tweede helft van de negentiende eeuw buitengewoon populair. De reistas van canvas was bovendien heel geschikt om geborduurd te worden in Berlijnse wol. Veel vrouwen borduurden hun tassen zelf, om er daarna bij de plaatselijke zadelmaker leren hoeken, handvatten en een metalen beugel aan te laten maken.

Voor de kortere reizen werden Gladstone bags, city bags en manden gebruikt. De langwerpige leren dokterstas met metalen beugel en leren handgreep werd veelal door mannen gebruikt als werktas.

Vanaf 1870 werd het rieten spoormandje met kleppen populair voor het meenemen van boodschappen, lunch of handwerk. Tot in de eerste decennia van de twintigste eeuw zag men deze mandjes in allerlei uitvoeringen. Voor een uitje in de vrije natuur had men de picknickkoffer of -mand, op efficiënte wijze gevuld met borden, bestek, theekopjes, suikerpot, koektrommel, thermoskan en in sommige gevallen zelfs een spiritusstel.

Maletas y bolsas de viaje

En el siglo XIX, los trenes y barcos de vapor hicieron de viajar una actividad más cómoda, rápida y económica. Puesto que cada vez se viajaba con más frecuencia, la gama de maletas, cajas para zapatos, sombrereras y neceseres se fue modificando.

Los baúles de tapa esférica que se podían transportar fácilmente sobre el techo de un carruaje tirado por caballos se fueron sustituyendo paulatinamente por maletas planas de cuero que podían apilarse y transportarse a mano sin dificultad. Los antiguos neceseres, que contenían cepillos, utensilios de manicura, pequeños frascos y cajitas de plata, cristal, marfil y madreperla fueron los precursores de los neceseres actuales. La bolsa de viaje también constituía un artículo indispensable para viajar.

Las maletas, bolsas de viaje, neceseres, cajas para zapatos y sombrereras se elaboraban principalmente en cuero. Sin embargo, hacia 1826, el francés Pierre Godillot confeccionó una bolsa de viaje con lona, que tuvo una gran aceptación en la segunda mitad del siglo XIX. Esta bolsa también resultaba muy adecuada para ser bordada al estilo de Berlín. Muchas mujeres bordaban ellas mismas las bolsas y luego las llevaban al guarnicionero del barrio para que añadiera los ganchos de cuero, las asas y una boquilla de metal.

En los trayectos cortos se empleaban maletines, así como cestos y bolsas de ciudad. El maletín rectangular de médico con una boquilla metálica y un asa de cuero era utilizado principalmente por los hombres para trabajar.

A partir de 1870, se difundió el uso del cesto de mimbre con tapas para transportar la compra, la comida o las labores. Hasta las primeras décadas del siglo XX podían verse distintas versiones de estos cestos de pequeñas dimensiones. Si se hacía una excursión al campo, se utilizaba una maleta o cesta de picnic en cuero con platos, cubiertos, tazas de té, azucarera, caja de galletas, termo e, incluso, un quemador de alcohol, todo bien ordenado.

Valises et sacs de voyage

Au dix-neuvième siècle, les trains à vapeur et les paquebots rendent les voyages plus agréables, plus rapides et plus accessibles. Les gens se mettent à voyager plus souvent et le choix de valises, boîtes à chaussures, cartons à chapeaux et nécessaires de toilette évolue.

Les malles à couvercle bombé, faciles à transporter sur le toit d'une voiture à chevaux, sont peu à peu remplacées par des valises plates en cuir, empilables et faciles à porter à la main. Les nécessaires de toilette contenant des brosses, kits de manucure, flacons et boîtes en argent, cristal, ivoire et nacre, sont quant à eux les précurseurs des vanity-cases actuels.

Le sac de voyage est lui aussi indispensable : comme les valises, nécessaires de toilette, boîtes à chaussures et cartons à chapeaux, il est alors le plus souvent en cuir. Cependant, vers 1826, le Français Pierre Godillot fabrique un sac de voyage en tapisserie qui connaîtra un succès extraordinaire dans la deuxième moitié du dix-neuvième siècle. Il se prête également très bien à la broderie de laine et de nombreuses femmes broderont elles-mêmes leurs sacs avant d'y faire ajouter par leur sellier des crochets et poignées en cuir, ainsi qu'un fermoir en métal.

Pour les voyages courts, on préfère des sacs diligence, sacs de ville et paniers. La trousse de médecin oblongue en cuir avec un fermoir métallique et une poignée en cuir est principalement utilisée par les hommes pour le travail.

À partir de 1870, le panier en osier à rabats s'impose comme sac à provisions, panier-repas ou pour les travaux d'aiguilles. On en verra de multiples versions jusqu'aux premières décennies du vingtième siècle. Enfin, pour les excursions à la campagne, on remplit soigneusement un panier de pique-nique avec assiettes, couverts, tasses, sucrier, boîte à biscuits, bouteille thermos et parfois même un réchaud à gaz.

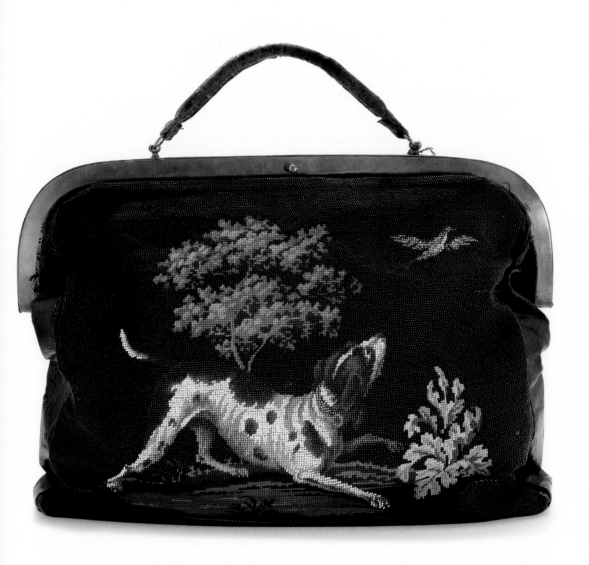

Berlin woolwork and beaded travelling bag with brass frame, Germany, mid. 19th c.

Alligator print leather brief bags, England, early 20th c.

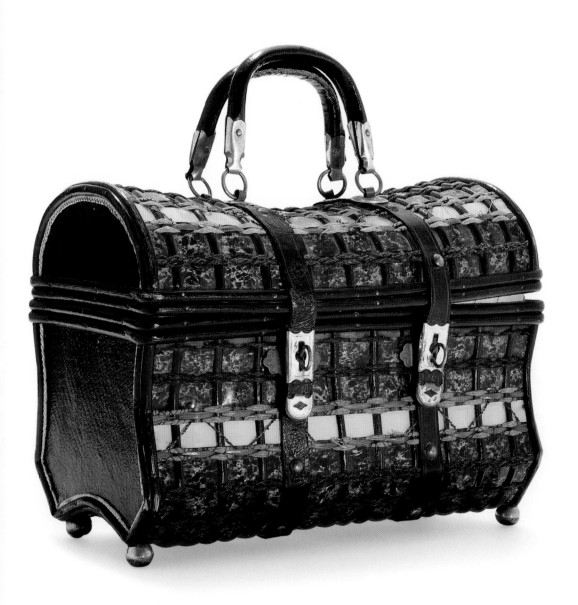

Rail-basket of straw, wood, leather and celluloid strip, Germany, late 19th c.

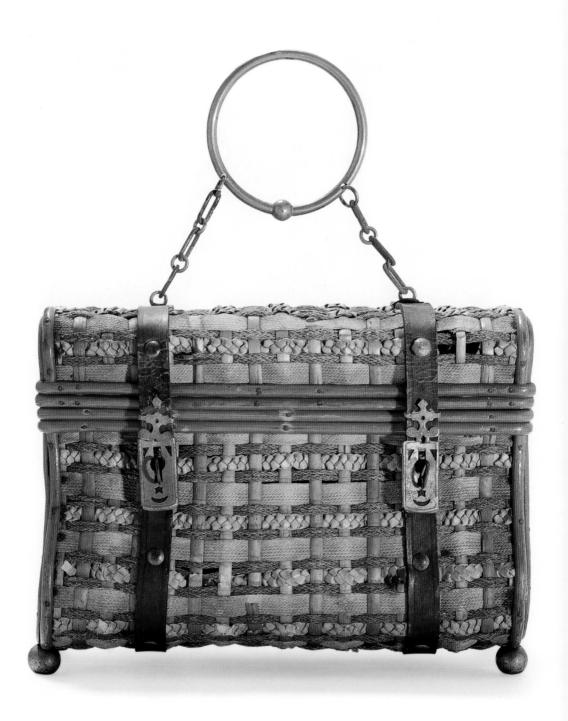

Rail-basket of straw, wood and leather, with metal handle, Germany, 1880s.

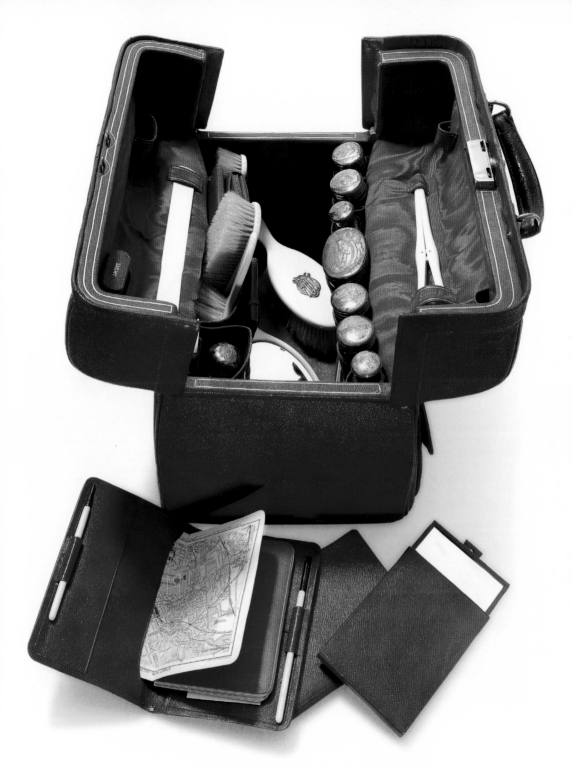

Leather ladies' dressing case with silver, ivory and cristal nécessaires England, 1896.

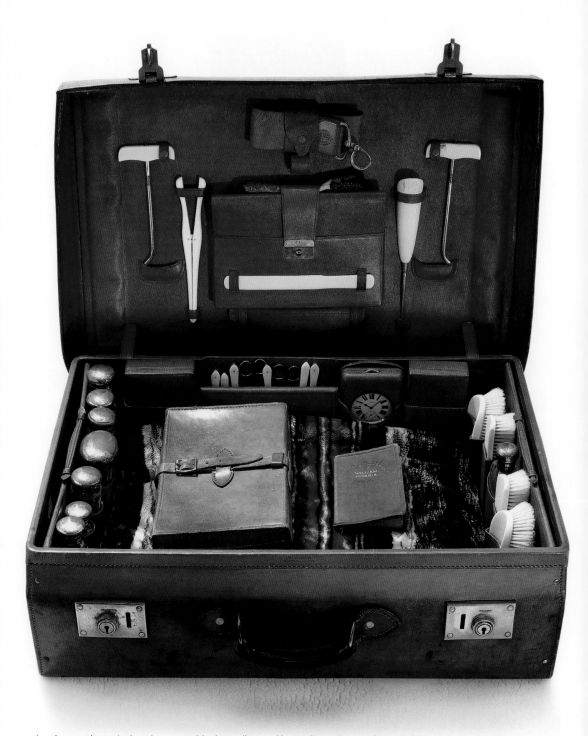

Leather gentleman's dressing case with glass, silver and ivory nécessaires, maker: J.W. Benson, England, 1910.

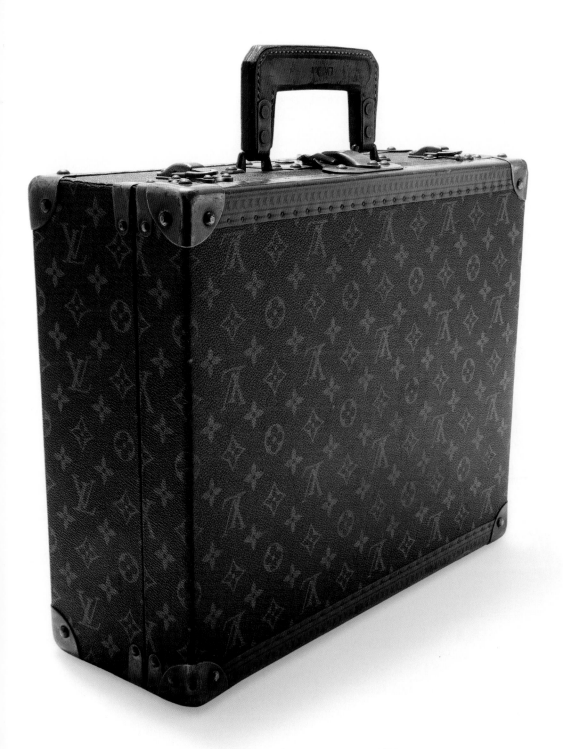

Suitcase of canvas and leather with monogram LV print, Louis Vuitton, France, ca. 1920.

Snakeskin suitcase, France, 1920s.

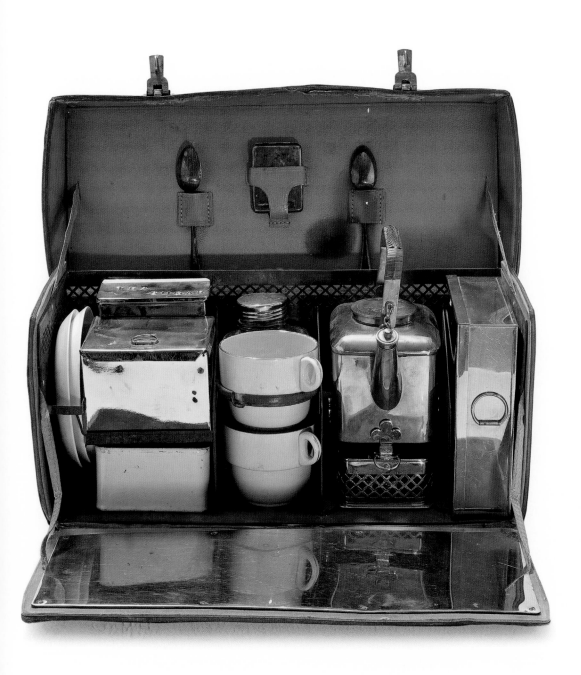

Leather picnic case for Tea for two, chromium and porselain, Asprey, England, 1920s.

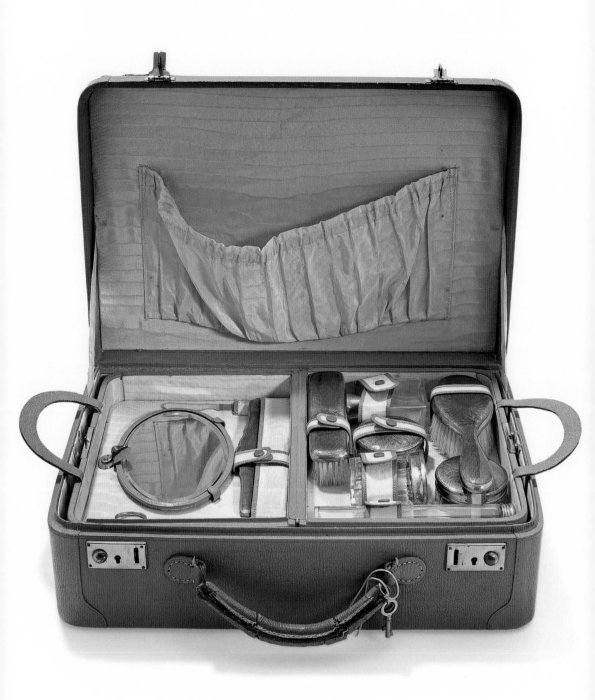

Leather ladies' dressing suitcase, Verweegen & Kok, The Netherlands, 1950s.

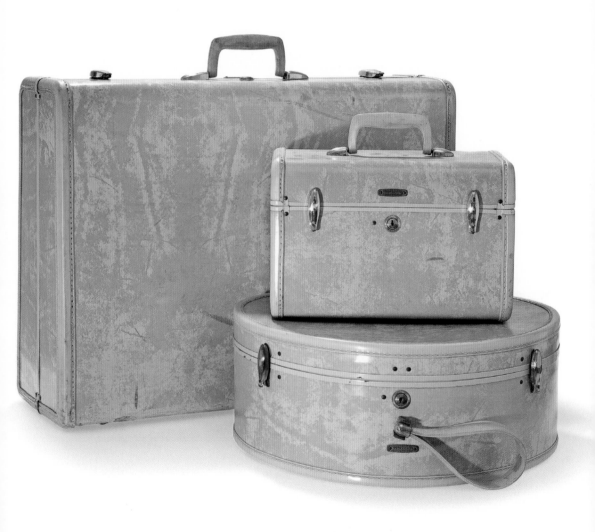

Light weighted suitcase, beauty case and hatbox, Samsonite, U.S.A., 1950s.

Patent leather handbag with metal frame, Samsonite Black Label by Viktor & Rolf, U.S.A., 2009.

Handbags

The real breakthrough for the leather handbag came during the nineteenth century with the arrival of railway travel. Rail travellers needed bags that were less delicate. Initially, small leather bags were worn as chatelaine bags on the belt or skirt waistband. In the course of the nineteenth century, it became more and more usual to carry bags in one's hands. Bags made of cloth took on yet another function: whereas leather bags served for travelling or visits, cloth bags were used indoors and with formal dress. In the first decade of the twentieth century, the handbag finally took over the function of the chatelaine and chatelaine bag.

A rich variety of handbags emerged in the twentieth century. Some were specially made as visiting bags or vanity bags with a mirror, powder puff, scent bottle and coin purse. For theatre outings, there were opera bags with compartments for opera glasses, fan, mirror, powder puff, coin purse and ticket. Even today, the handbag has a variety of forms and uses, such as the clutch, which is carried under the arm or in the hands.

Handtassen

De echte doorbraak van de leren handtas kwam in de loop van de negentiende eeuw met de opkomst van het reizen per trein. Treinreizigers hadden behoefte aan minder kwetsbare tassen. Aanvankelijk werden de kleine leren tasjes als chatelainetas aan riem of rokband gedragen. In de loop van de negentiende eeuw werd het steeds gebruikelijker om de tas in de hand te dragen. Tassen van textiel kregen een andere functie: terwijl leren tassen dienden voor op reis en op visite, waren tassen van textiel voor gebruik binnenshuis en bij de formele japon. In het eerste decennium van de twintigste eeuw nam de handtas definitief de functie van de chatelaine en chatelainetas over.

In de twintigste eeuw ontstond een rijke variatie aan handtassen. Sommige werden speciaal gemaakt als visitetasje of avondtasje met een spiegel, een poederdons, een reukflesje en een beurs. Voor theaterbezoek waren er operatasjes met vakjes voor toneelkijker, waaier, spiegel, poederdons, beurs en entreekaartje. Tot op heden kent de handtas diverse vormen en toepassingen, zoals de enveloptas, die onder de arm of in de hand wordt gedragen.

El bolso de mano

La llegada de los viajes en ferrocarril durante el siglo XIX fue el factor decisivo para que se fabricaran bolsos de mano en piel, pues los viajeros necesitaban bolsas que fueran menos delicadas. Al principio, en el cinturón o pretina de la falda se llevaban pequeñas bolsas de cuero a modo de escarcela. En el transcurso del siglo XIX, cada vez era más frecuente llevar bolsas en la mano. Bolsas confeccionadas con tela adquirieron una función distinta: mientras que las de cuero se utilizaban para los viajes o las visitas, las bolsas de tela se empleaban dentro de casa y con vestidos formales. En la primera década del siglo XX, el bolso de mano finalmente adoptó la función de la chatelaine y de la escarcela.

En el siglo XX surgió un amplio espectro de bolsos de mano. Algunos de ellos se realizaban especialmente como bolsos de visita o bolsos de noche, con un espejo, una borla de polvos, un frasco de perfume y un monedero. En las salidas al teatro se llevaban las bolsas para la ópera con compartimentos para los binóculos, el abanico, un espejo, una borla de polvos, un monedero y el billete de entrada. Incluso en la actualidad, el bolso de mano cuenta con gran variedad de formas y usos, como es el caso del clutch, que se lleva bajo el brazo o en la mano.

Sacs à main

Le sac à main en cuir doit sa percée aux voyages en chemin de fer du dix-neuvième siècle qui demandaient des sacs moins fragiles. De petits sacs en cuir seront d'abord portés en châtelaines accrochés à la ceinture avant que, au dix-neuvième siècle, la tendance soit de porter de plus en plus ses sacs à la main. Les sacs en tissu, eux aussi, changent de fonction, utilisés pour l'intérieur et les tenues de cérémonie, tandis que les sacs en cuir servent en voyage ou en visite. Enfin, dans les années 1910, le sac à main finit par remplacer la châtelaine et son sac.

Le vingtième siècle verra émerger toute une variété de sacs à main. Certains ont été spécialement conçus pour les visites ou les soirées, avec un miroir, une houppe à poudre, un flacon à parfum et un porte-monnaie ; pour les sorties au théâtre, les sacs d'opéra comptent plusieurs compartiments pour les jumelles, l'éventail, le miroir, la houppe à poudre, le porte-monnaie et l'entrée au spectacle. Aujourd'hui encore, le sac à main présente de multiples formes et usages, comme par exemple la pochette, portée sous le bras ou dans la main.

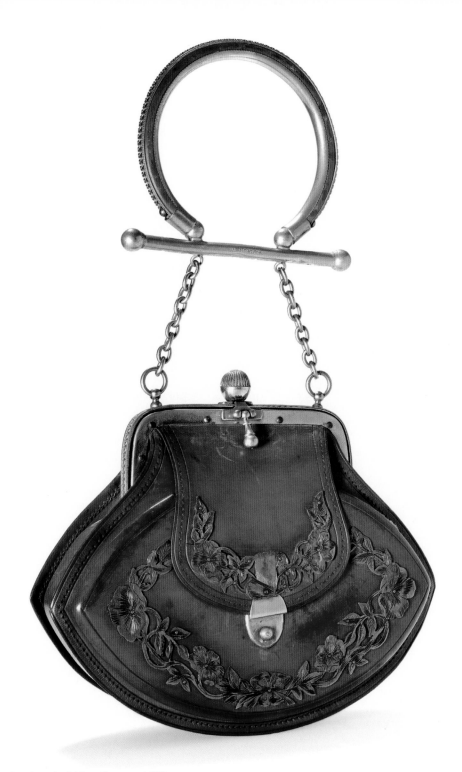

Leather hand- and wrist bag, Germany, 1880s.

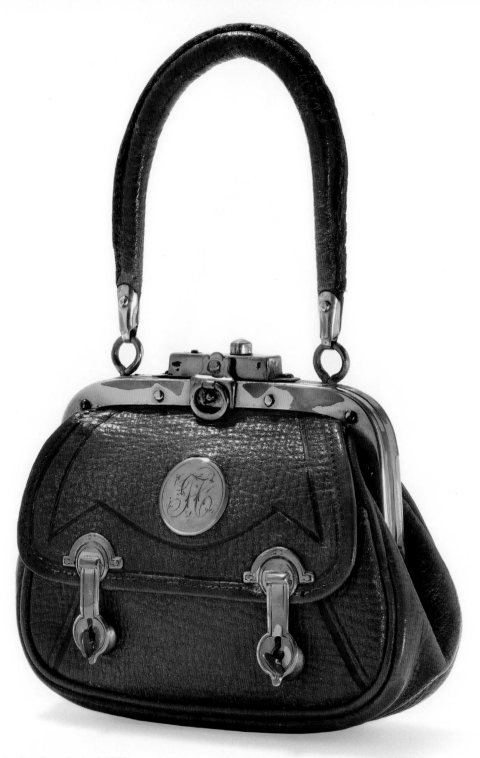

Leather handbag , England, 1870s.

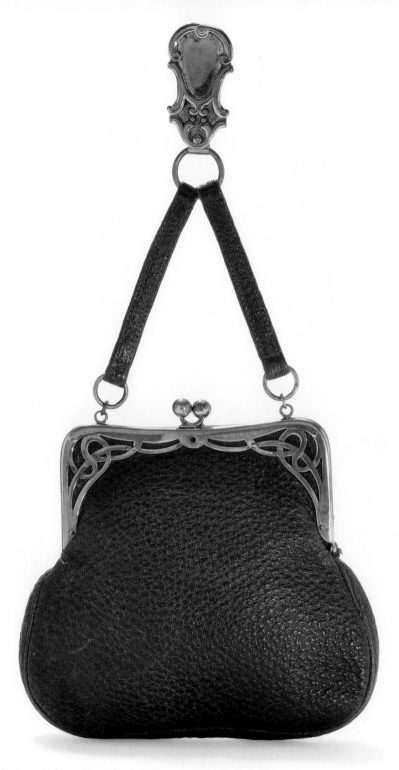

Leather chatelaine bag with brass decoration in Art Nouveau style, France, ca.1900.

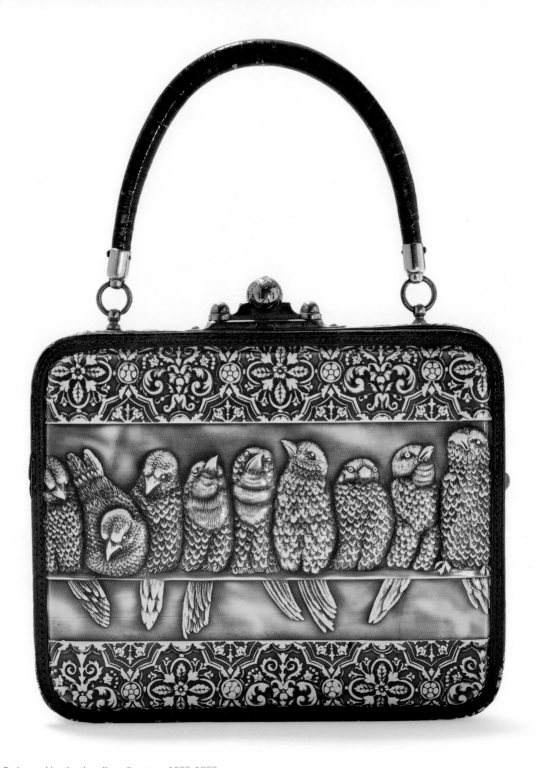

Embossed leather handbag, Germany, 1880-1900.

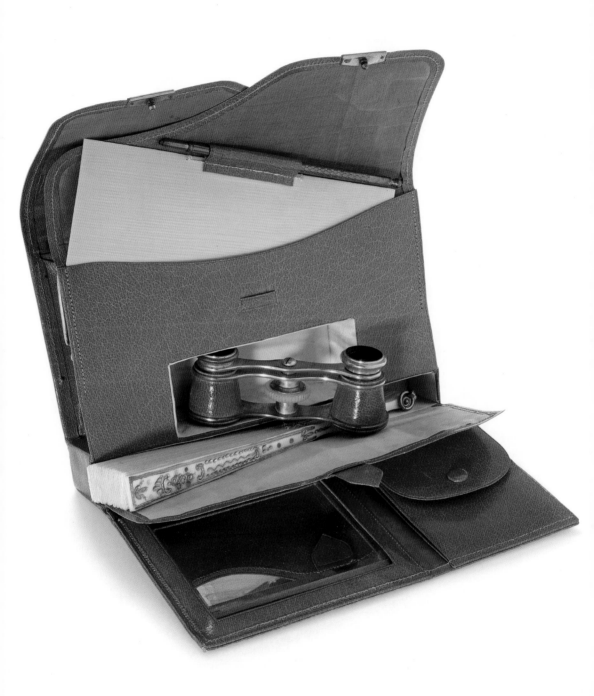

Leather opera bag fitted with opera glasses, notebook and folding fan, England, ca. 1906.

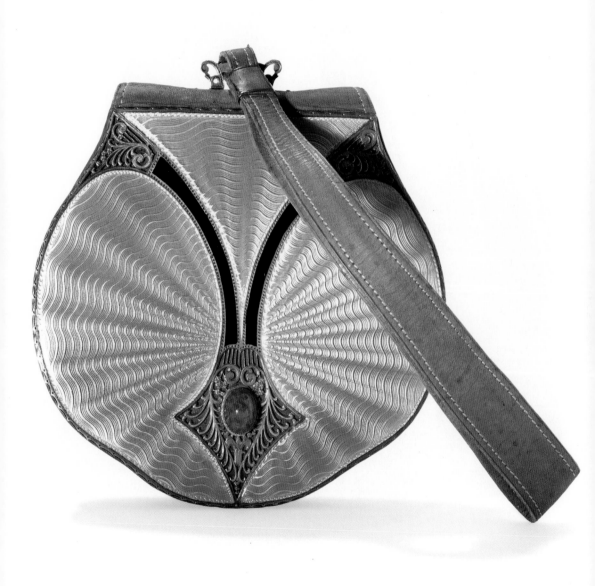

Leather handbag with enamel and silver cover, Austria, early 20th c.

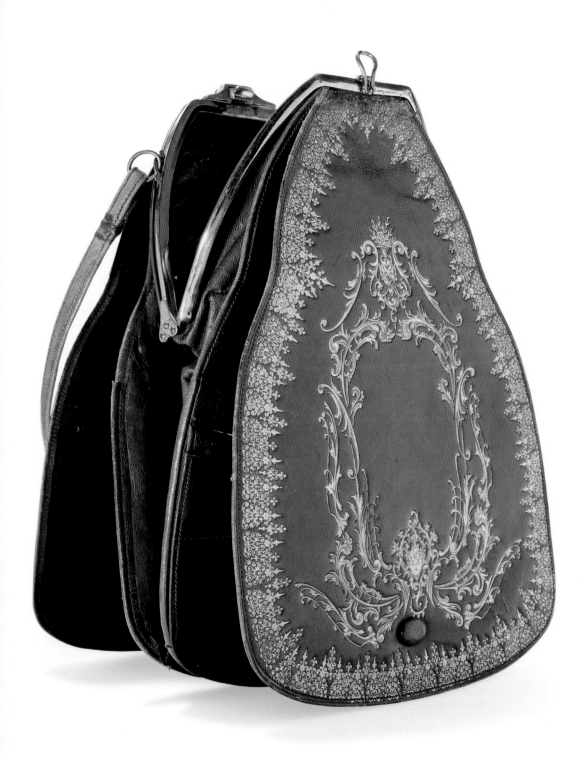

Embossed leather handbag, Europe, ca. 1910.

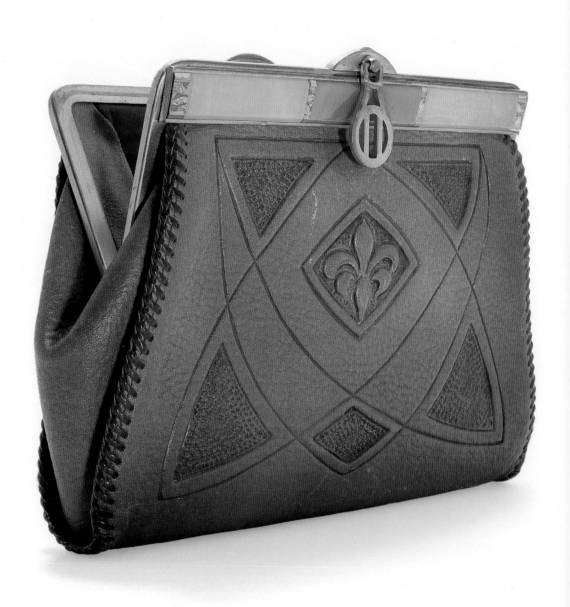

Embossed leather handbag, Reedcraft NY, U.S.A., 1915-1920.

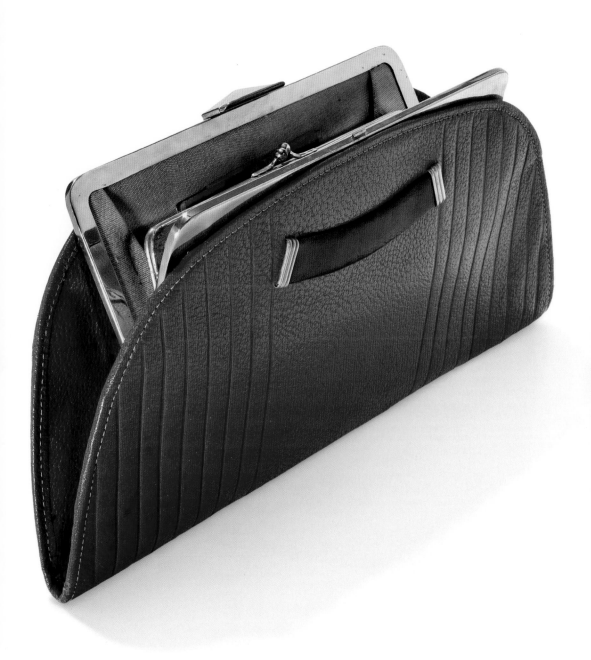

Leather clutch with chrome frame, England, 1930-1935.

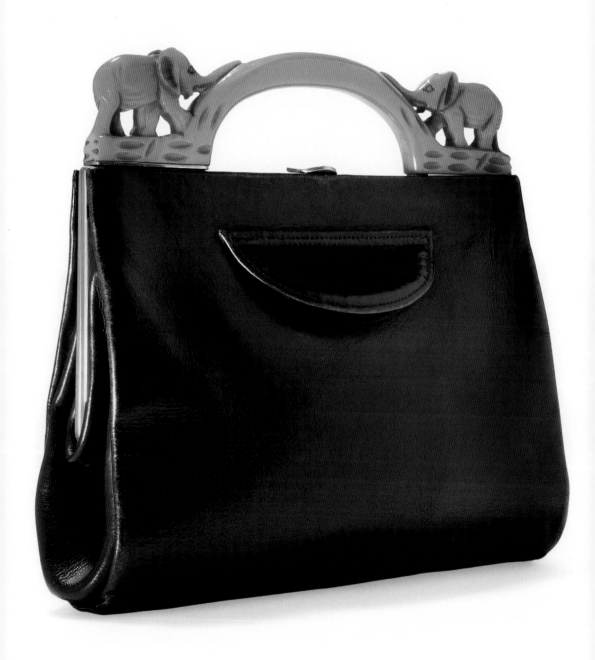

Leather handbag with plastic handle/decoration, England, 1930s.

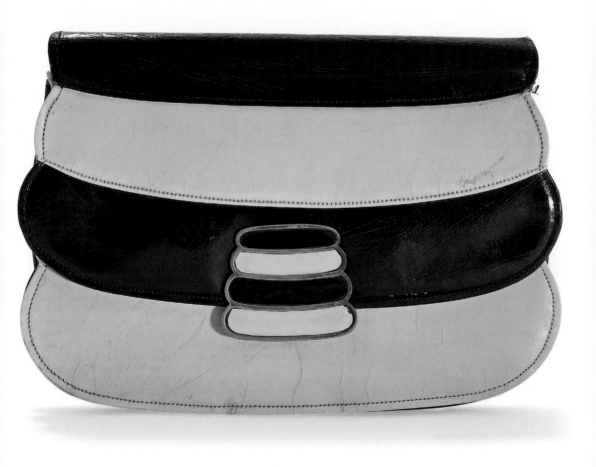

Leather clutch, France, 1930s.

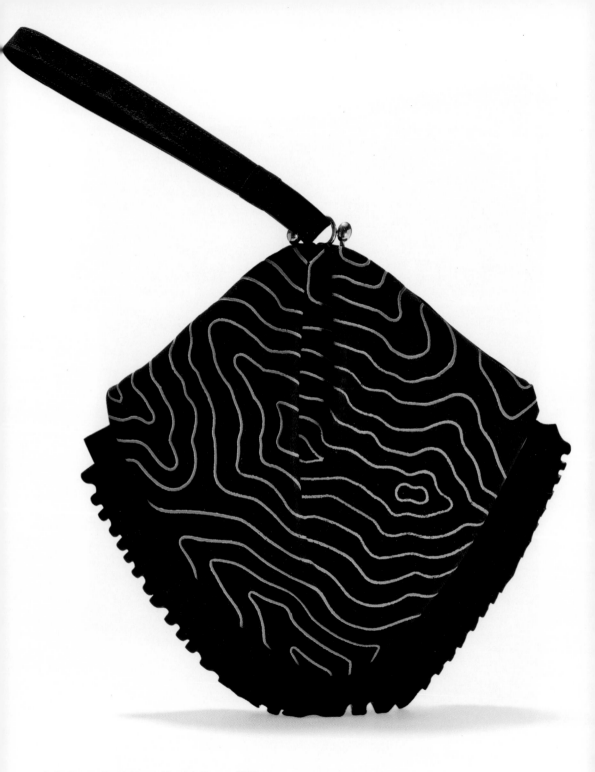

Imitation suede wrist bag with print, France, 1940s.

Suede clutch with 'Sentinel' watch', original by Rath, U.S.A., 1940s-1950s.

Synthetic leather handbag, The Netherlands, 1968.

Leather shoulder bag 'Melloni', Eveline, France, 1980s.

Silk printed handbag, Coblentz for Saks Fifth Avenue NY, U.S.A., 1960s.

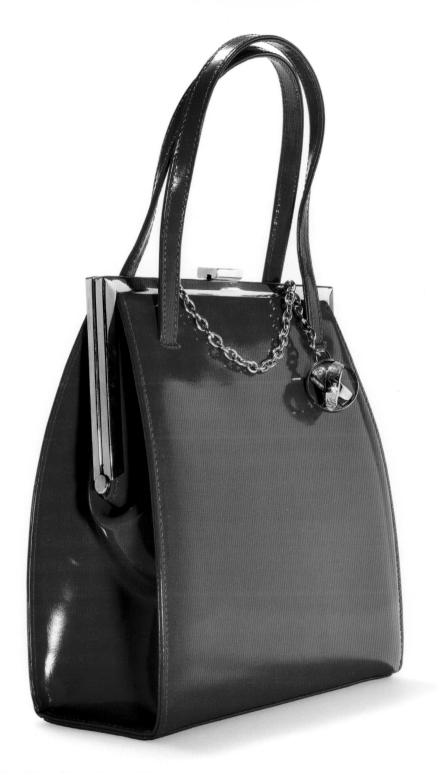

Leather handbag, Paloma Picasso, France, 1998.

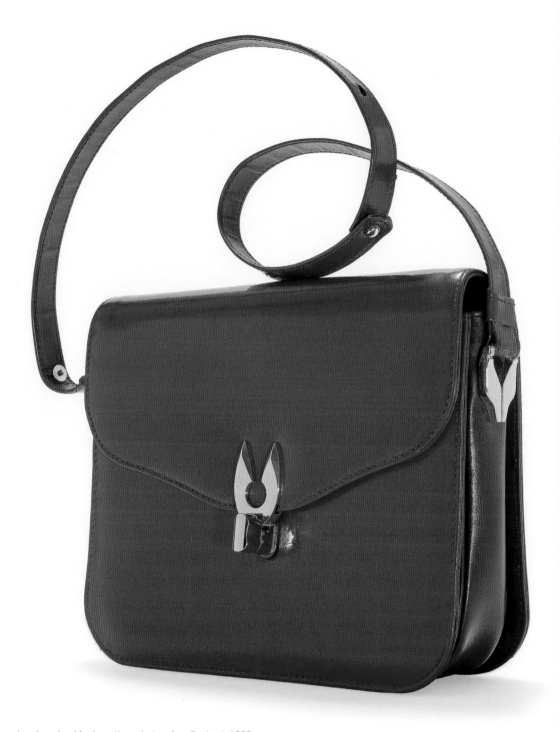

Leather shoulder bag, Harrods, London, England, 1980s.

Decoration

The applied arts were flourishing in the late nineteenth and in the beginning of the twentieth centuries. Various styles succeeded one another, and their influence on the bags from that time can be clearly seen.

Under the influence of art movements such as Arts & Crafts (1874-1910) in England, the Roycrafters (1895-1938) in the United States and the Wiener Werkstaette (1903-1932) in Austria, much attention was paid by bag makers to handcrafted leather. The leather was worked and decorated so that the beauty of the material itself was especially highlighted.

From 1906 to 1932, the Wiener Werkstaette made portfolios, wallets and bags mostly in dark leather with gold-tooled patterns. The designs often had linear motifs, but after 1915 the leatherwork had more stylised flower and plant motifs. Various kinds or colours of leather were also combined, such as in the orange leather handbag decorated with narrow coloured stripe inserts.

Art Deco, an international applied arts movement that emerged around 1910 and was popular well into the twenties and thirties, furnished Cubist and geometric forms, new materials and bright primary colours. In this period, handbags were created in chrome, aluminium and in the colours red, blue, black and silver.

In the twenties, batik on leather and cloth bags was in vogue. Examples are the velvet bag by the designer Agathe Wegerif and the leather bag by decorative artist Cris Agterberg.

Sierkunst

Eind negentiende en het begin van de twintigste eeuw kenden de toegepaste kunsten een bloeiperiode. Verschillende stijlen volgden elkaar op, en hun invloed op tassen uit die tijd is duidelijk zichtbaar.

Onder invloed van kunststromingen als de Arts & Crafts (1874-1910) in Engeland, de Roycrafters (1895-1938) in de Verenigde Staten en de Wiener Werkstätte (1903-1932) in Oostenrijk ontstond er bij tassenmakers veel aandacht voor de ambachtelijke bewerking van leer. Men bewerkte en versierde het leer zo dat de schoonheid van het materiaal zelf er extra goed in uitkwam.

De Wiener Werkstätte vervaardigde vanaf 1906 tot in 1932 mappen, portefeuilles en tassen van veelal donkerkleurig leer met in goud geperste patronen. De ontwerpen hadden vaak lijnmotieven, maar na 1915 kreeg het leerwerk ook meer gestileerde bloem- en plantenmotieven. Ook combineerde men wel verschillende leersoorten of verschillende kleuren leer, zoals bij de oranje leren handtas die versierd is met smalle ingewerkte kleurrijke banden.

Art Deco, een internationale stroming in de toegepaste kunst die al rond 1910 opkwam en populair was in de jaren twintig en dertig, zorgde voor kubistische en geometrische vormen, nieuwe materialen en heldere primaire kleuren. Tassen werden in die periode uitgevoerd in chroom, aluminium en in de kleuren rood, blauw, zwart en zilver.

In de jaren twintig was batik op tassen van leer en textiel in zwang. Voorbeelden hiervan zijn de fluwelen tas van ontwerpster Agathe Wegerif en de leren tas van sierkunstenaar Cris Agterberg.

Motivos decorativos

El florecimiento de las artes aplicadas tuvo lugar a finales del siglo XIX y en las primeras décadas del siglo XX. En las bolsas personales de aquella época se aprecian con claridad los diversos estilos que se sucedieron y su influencia.

Influidos por movimientos como el de las Arts & Crafts (1874-1910) en Inglaterra, los Roycrafters (1895-1938) en Estados Unidos y el Wiener Werkstaette (1903-1932) en Austria, los fabricantes de bolsos centraron su atención en el cuero labrado a mano. Este material se trabajaba y se decoraba para hacer destacar especialmente su belleza intrínseca.

De 1906 a 1932, el Wiener Werkstaette confeccionó por-tafolios, carteras y bolsos, casi todos en cuero oscuro con motivos estampados en oro. A menudo se realizaban moti-vos lineales, pero después de 1915 las creaciones en cuero presentaban dibujos de flores y plantas más estilizados. También se combinaban distintas clases o colores de cuero como es el caso del bolso de cuero naranja decorado con finas cintas de color.

El art déco, un movimiento internacional de artes aplicadas que surgió alrededor de 1910 y que gozó de gran populari-dad en los años veinte y treinta, empleaba formas cubistas y geométricas, materiales nuevos y colores primarios vivos. En esta época, se creaban bolsos de mano de cromo y aluminio, y en color rojo, azul, negro y plateado.

En la década de 1920, estaba de moda la técnica del batik en los bolsos de cuero y tela. Ejemplos de ello son el bolso de terciopelo de la diseñadora Agathe Wegerif y el bolso de cuero del artista decorativo Cris Agterberg.

Décoration

À la fin du dix-neuvième et au début du vingtième siècle, les arts appliqués fleurissent. Les styles variés se succèdent et leur influence sur les sacs à main de l'époque est flagrante.

Sous l'influence de mouvements comme Arts & Crafts (1874-1910) en Angleterre, les Roycrafters (1895-1938) aux États-Unis et les Wiener Werkstaette (1903-1932) en Autriche, les fabricants de sac accordent une plus grande attention au travail artisanal du cuir, qui est alors traité et décoré de manière à mettre particulièrement en valeur la beauté de la matière elle-même.

De 1906 à 1932, les Wiener Werkstaette fabriquent des por-tefeuilles et des sacs en cuir sombre aux motifs repoussés dorés. Les dessins sont d'abord principalement linéaires ; après 1915 toutefois, la maroquinerie adopte des motifs de fleurs et de plantes plus stylisés. On associe aussi différentes sortes ou couleurs de cuir, comme pour le sac à main de cuir orange décoré par insertion d'étroites rayures de couleur.

L'Art déco, mouvement artistique international né vers 1910 et qui se prolongera jusqu'à la fin des années vingt et trente, apporte des formes cubiques et géométriques, de nouvelles matières et des couleurs primaires vives. Les sacs à main créés à cette époque sont rouges, bleus, noirs et argentés en chrome ou aluminium.

Dans les années vingt, c'est la mode du batik sur les sacs en tissu ou en cuir, comme le sac en velours de la créatrice Agathe Wegerif et le sac en cuir de l'artiste décoratif Cris Agterberg.

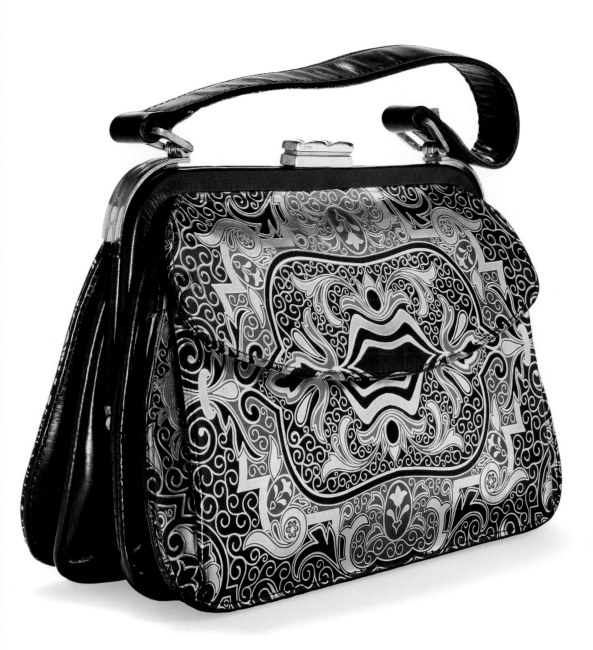

Gold tooled embossed leather handbag, Italy, 1930s.

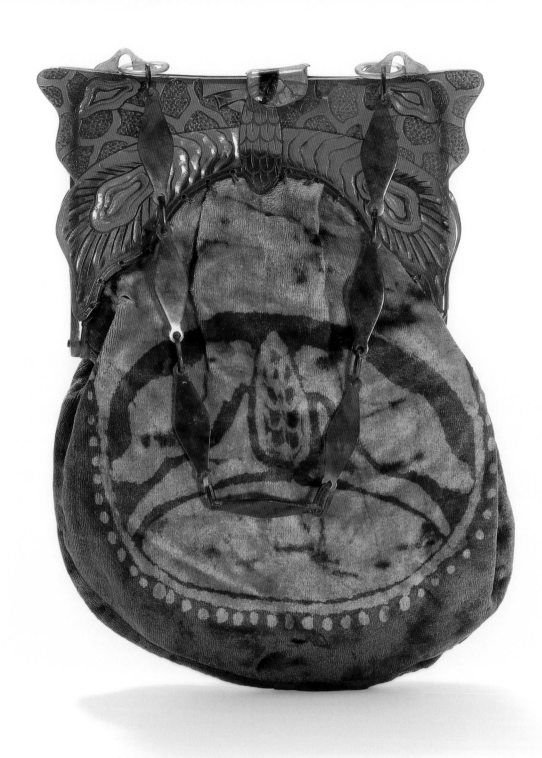

Batik velvet handbag with plastic frame and chain, Agathe Wegerif, The Netherlands, ca. 1919.

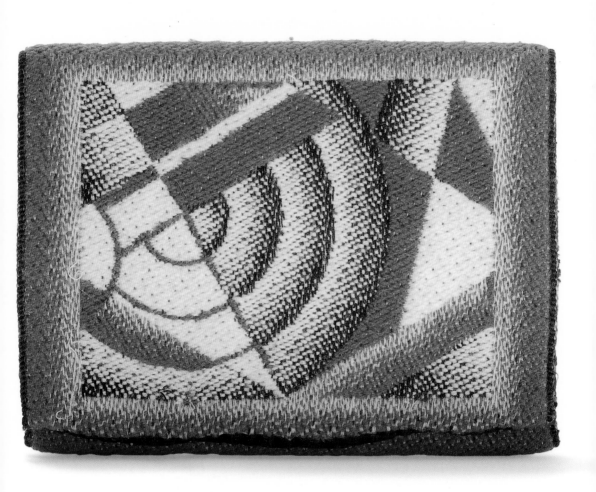

Wol woven clutch, The Netherlands, 1920s.

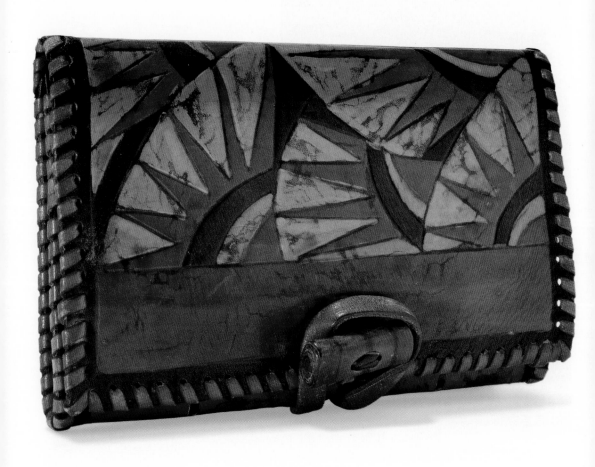

Embossed and batik leather clutch, Cris Agterberg, The Netherlands, ca. 1926.

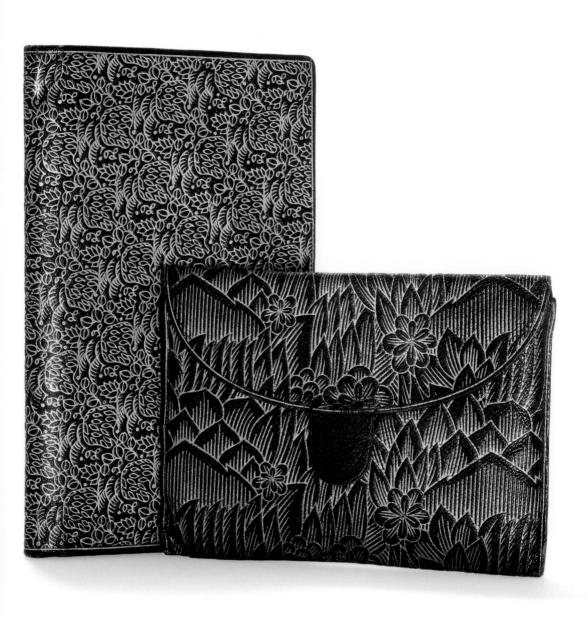

Strawberry' clutch bag (l) and leaf-patterned letter case no. 162 (r), gold tooled leather, Wiener Werkstätte, Josef Hoffmann. Designs by Dagobert Peche, Austria, 1918 and 1922.

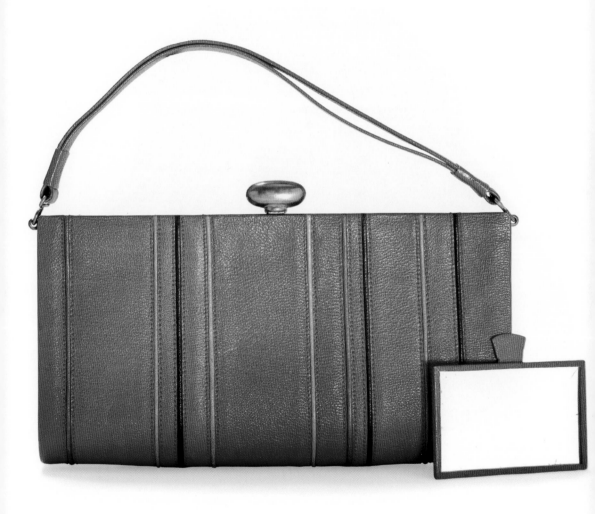

Leather handbag, Wiener Werkstätte, Maria Likarz, Austria, 1929.

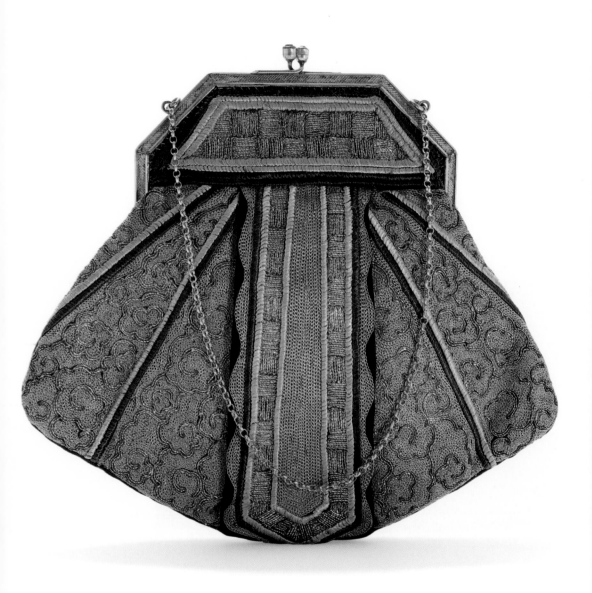

Silk embroidered handbag with brass frame, France, 1920s.

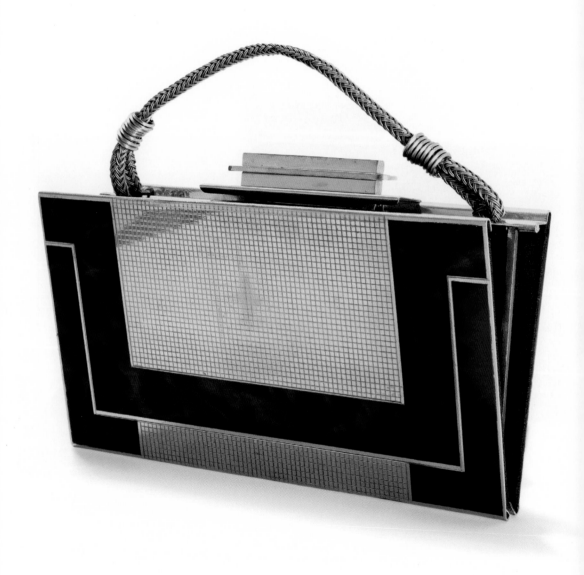

Aluminium handbag with plastic trim, France, ca. 1930.

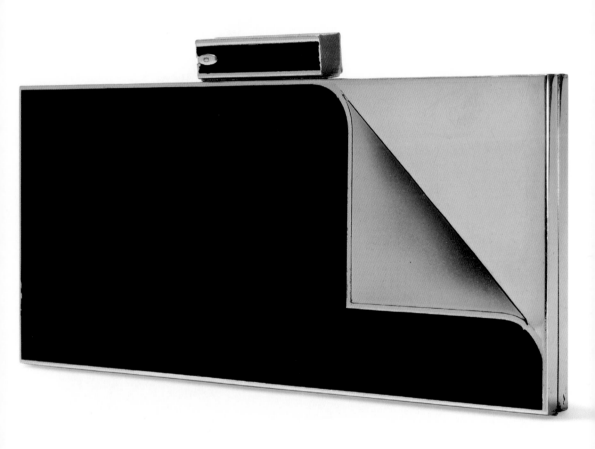

Metal enameled minaudière, France, 1930s.

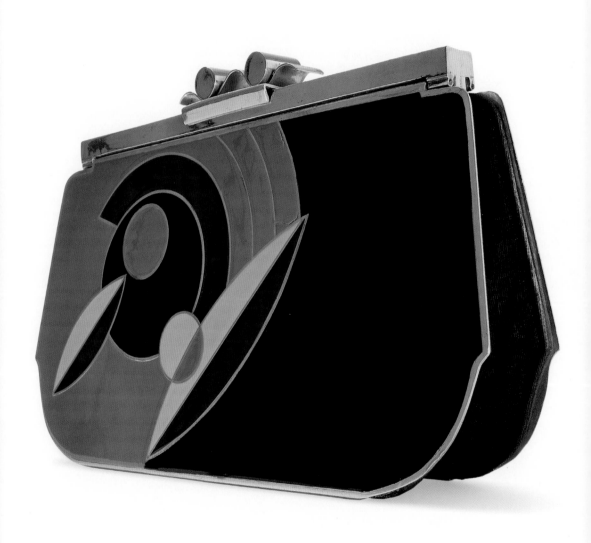

Metal clutch with enameled decoration, France, ca. 1930.

Vanity cases and minaudières

After the First World War, the use of cosmetics increased sharply under the influence of women's emancipation and the enormous popularity of film stars. Because of this, a need arose for special bags for cosmetics. In around 1905, handbags were sold with a purse, scent bottle, mirror and compartment with powder and puffs. In the twenties, the vanity case became popular: a small bag with compartments for powder, rouge, lipstick, perfume and/or cigarettes. The shape of the vanity case was attributed to the Japanese inro, a small box with compartments for medicinal herbs and perfumed water. Exclusive vanity cases were made by jewellers such as Cartier and Van Cleef & Arpels in silver or gold, enamel, mother of pearl, jade and lapis lazuli. Cheap vanity cases were made from coloured plastic decorated with glass stones. It is characteristic for the lipstick to often be hidden in the tassel.

At the beginning of the thirties, a customer of the Paris jeweller Van Cleef & Arpels used her cigarette case as a handbag. This inspired the jeweller to design the minaudière: a small, usually rectangular, metal box with compartments for powder, rouge, lipstick and cigarettes, and with a mirror, comb and/or a lighter. Minaudières were often made of silver or gold and decorated with enamel or precious stones. With this luxurious (evening) bag, Van Cleef & Arpels set a trend followed by many well-known jewellers and brands, while cosmetics companies came out with more affordable versions.

Jewellers, bag manufacturers and cosmetics companies also sold special powder boxes, lipstick holders and similar items in the most curious shapes: hidden in a bracelet, for example, or in the form of a gramophone record, telephone dial or piano.

Vanity cases en minaudières

Na de Eerste Wereldoorlog nam onder invloed van de vrouwen-emancipatie en de enorme populariteit van filmsterren het cosmeticagebruik sterk toe. Hierdoor ontstond de behoefte aan speciale tassen voor cosmetica. Rond 1905 werden al handtassen verkocht met een beurs, een reukflesje, een spiegel en een vakje met poeder en dons. In de jaren twintig werd de vanity case populair: een kleine tas met vakjes voor poeder, rouge, lippenstift, parfum en/of sigaretten. De vorm van de vanity case wordt wel toegeschreven aan de Japanse inro, een kleine tas met vakjes voor geneeskrachtige kruiden en reukwater. Exclusieve vanity cases werden door juweliers als Cartier en Van Cleef & Arpels vervaardigd in zilver of goud, email, parelmoer, jade en lapis lazuli. Goedkope vanity cases werden gemaakt van gekleurde kunststof versierd met glas-stenen. Kenmerkend is dat de lippenstift vaak in de kwast verscholen zit.

In het begin van de jaren dertig gebruikte een klant van de Parijse juwelier Van Cleef & Arpels haar sigarettendoosje als handtas. Dit inspireerde de juwelier tot het ontwerpen van de minaudière: een kleine veelal rechthoekig metalen tas met vakjes voor poeder, rouge, lipstick en sigaretten, en met een spiegel, een kam en/of een aansteker. Minaudières waren vaak van zilver of goud en versierd met email of edelste-nen. Met deze luxueuze (avond)tas zette Van Cleef & Arpels een trend die door vele bekende juweliers en merken werd gevolgd; cosmeticahuizen kwamen met goedkope versies.

Ook verkochten juweliers, tassenfabrikanten en cosmetica-huizen speciale poederdozen, lipstickhouders en dergelijke in de meest bizarre vormen: verborgen in een armband, bijvoorbeeld, of in de vorm van een grammofoonplaat, tele-foonschijf of piano.

Neceseres y minaudières

Después de la Primera Guerra Mundial, el uso de los cosméticos aumentó de forma drástica debido a la emancipación de la mujer y a la enorme popularidad que adquirieron las estrellas cinematográficas. Por ello, surgió la necesidad de disponer de bolsas especiales para los productos cosméticos. En torno a 1905, todos los bolsos que se comercializaban contaban con un monedero, un frasco de perfume, un espejo y un compartimento con polvos y una borla para aplicarlos. En los años veinte se popularizó el uso del neceser. Se trataba de una bolsa pequeña con compartimentos para los polvos, el colorete, el pintalabios y/o los cigarrillos. Su forma se inspiró en el inro japonés, una pequeña caja con compartimentos para guardar hierbas medicinales y agua perfumada. Joyeros como Cartier y Van Cleef & Arpels crearon neceseres en plata u oro, esmalte, madreperla, jade y lapislázuli. Los neceseres más económicos se realizaban con material sintético de colores y se decoraban con piedras de cristal. A menudo, el pintalabios aparece escondido en la borla.

Entrados los años treinta, una clienta del joyero parisino Van Cleef & Arpels utilizó su pitillera como bolso de mano. Esto fue motivo de inspiración para el joyero, que diseñó la minaudière, una caja metálica pequeña, de forma rectangular, con compartimentos para la polvera, el colorete, el pintalabios y los cigarrillos, así como un espejo, un peine y/o un mechero. A menudo, las minaudières se realizaban en plata u oro y se decoraban con esmaltes o piedras preciosas. Con este lujoso bolso (de noche), Van Cleef & Arpels fijó una tendencia que siguieron numerosos joyeros y marcas de renombre, mientras que las empresas de cosmética ofrecían versiones algo más asequibles.

Los joyeros, los fabricantes de bolsos y las empresas de cosmética también vendían polveras especiales, fundas para pintalabios y otros artículos similares de las más variadas formas: escondidos en un brazalete, por ejemplo, o en forma de disco de gramófono, de disco telefónico o de piano.

Vanity-cases et minaudières

Après la Première Guerre mondiale, l'usage des cosmétiques se généralise avec l'émancipation féminine et l'immense popularité des stars de cinéma. Un besoin naît alors de sacs spécialement conçus pour contenir des cosmétiques. Vers 1905, tous les sacs à main sont vendus avec un porte-monnaie, un flacon à parfum, un miroir et un compartiment pour la poudre et sa houppe. Dans les années vingt, c'est le vanity-case qui s'impose, un petit sac avec différents compartiments pour la poudre, le rouge à joues, le rouge à lèvres, le parfum et/ou les cigarettes. Il doit sa forme à l'inro japonais, une petite boîte comportant divers compartiments pour les herbes médicinales et eaux parfumées. Des vanity-cases très chics sont proposés par des bijoutières comme Cartier ou Van Cleef & Arpels, en argent, or, émail, nacre, jade et lapis-lazuli. Les moins chers sont en plastique coloré et décoré de cailloux de verre imitant des pierres précieuses. Tous ont pour caractéristique commune de souvent dissimuler le rouge à lèvres dans le gland.

Au début des années trente, le bijoutier parisien Van Cleef & Arpels constate que l'une de ses clientes utilise son étui à cigarettes comme un sac à main et s'en inspire pour créer la minaudière, une petite boîte métallique généralement rectangulaire, avec plusieurs compartiments pour la poudre, le rouge à joues, le rouge à lèvres et les cigarettes, et fournie avec un miroir, un peigne et/ou un briquet. Les minaudières étaient souvent en or ou argent décorées d'émaux ou de pierres précieuses. Avec ce sac de luxe (du soir), Van Cleef & Arpels lance une mode qui sera suivie par de nombreux bijoutiers et marques célèbres, sans compter les fabricants de cosmétiques qui en sortiront des versions plus abordables.

Bijoutiers, fabricants de sacs et de cosmétiques vendent alors aussi des boîtes spéciales pour la poudre, des étuis à rouge à lèvres et d'autres articles de ce type dans les formes les plus étranges : cachés dans un bracelet, ou en forme de disque pour gramophone, de cadran de téléphone ou de piano.

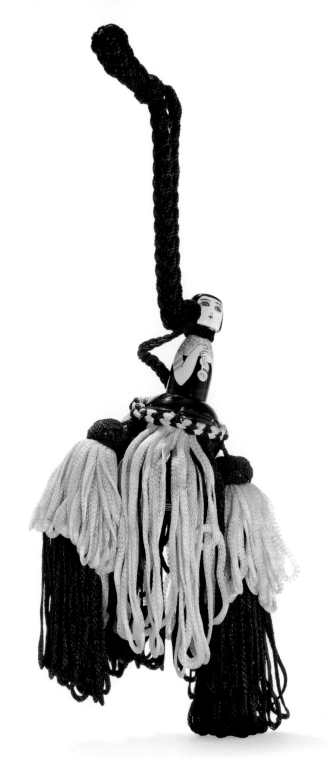

Plastic vanity case in shape of a woman, France, 1920s.

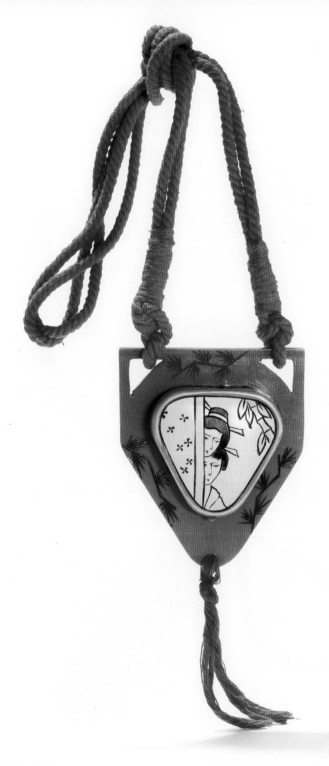

Plastic vanity case, France, 1920s.

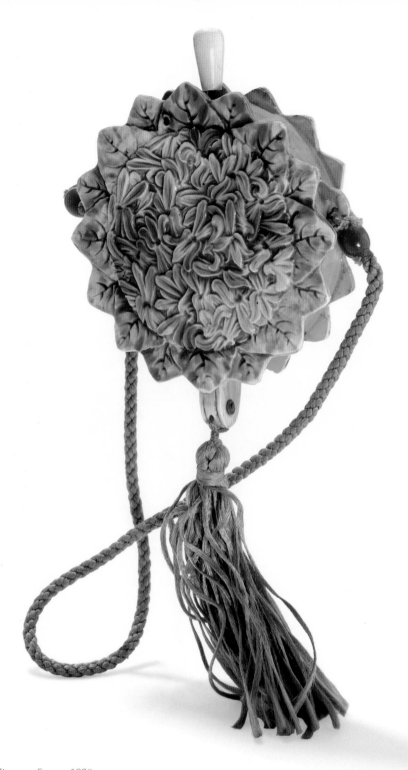

Plastic vanity case, France, 1924.

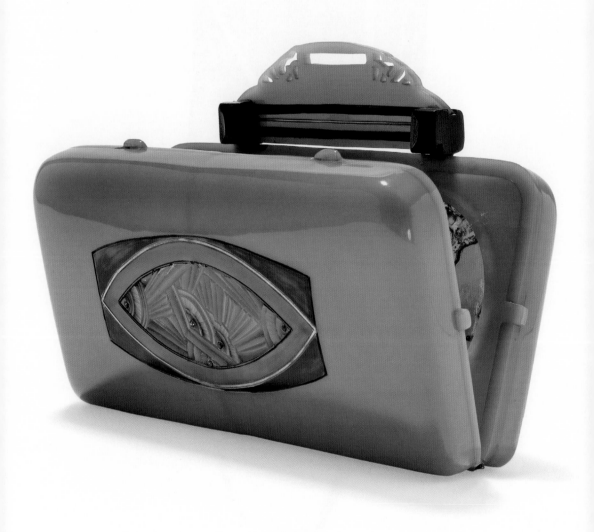

Plastic vanity bag, France, 1920s.

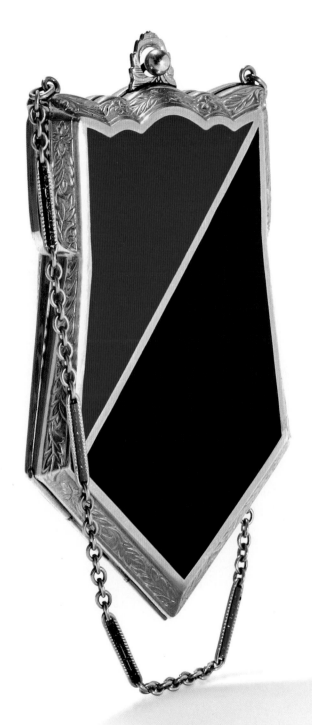

Silver vanity case with enamel, England, ca. 1930.

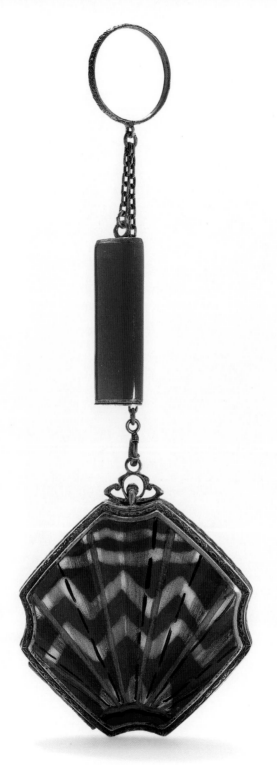

Silver vanity case with enamel, La Mode, U.S.A., 1920s.

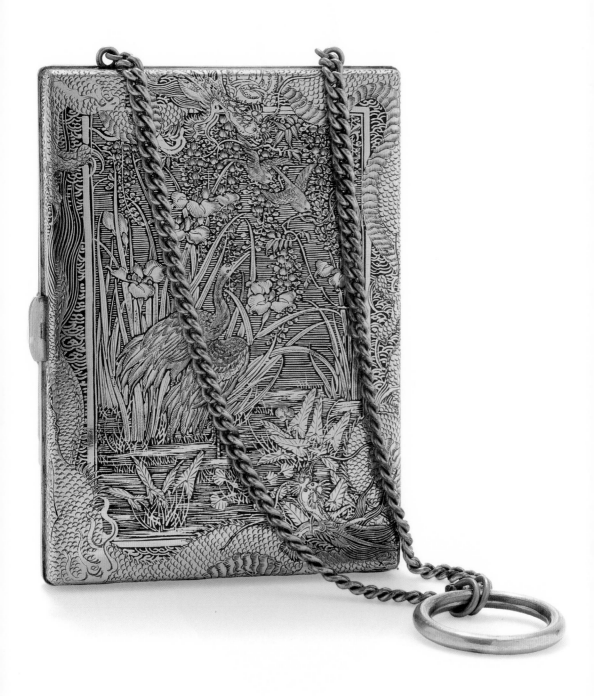

Metal vanity case with engraved portrayal of crane, France, 1920s.

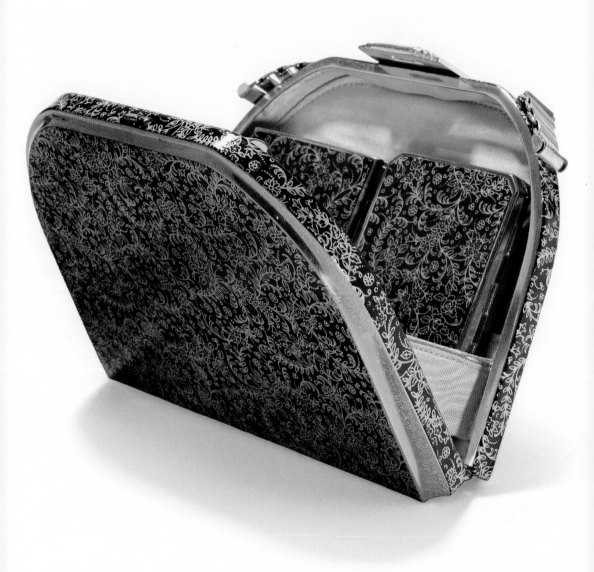

Vanity bag with gilt filigree design printed on enamel background, Stratton, U.S.A., 1950s.

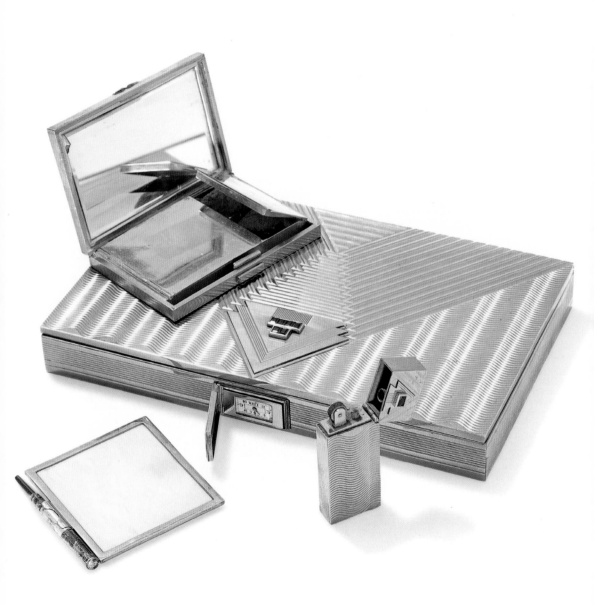

Minaudière inlaid with gold and sapphires, watch in lock, Lacloche Frères, Paris, France, 1930s.

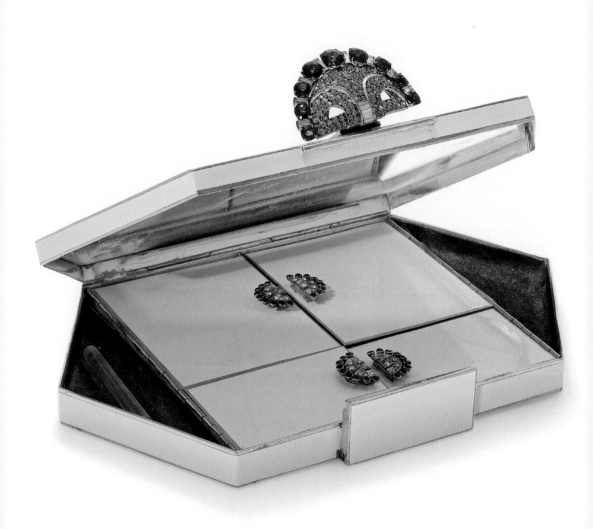

Enamelled minaudière with jewelled clasp which can also be used as brooch, Asprey, London, England, 1939.

Evening bags

At the start of the twentieth century, women had bags for all occasions: a city or visiting bag for the daytime, and an opera bag or evening bag for the evening. Bags that were used during the daytime were often made of leather, whereas evening bags were generally made from materials like shimmering silk and brocade, strikingly adorned with embroidery, beads, sequins or colourful, shiny stones.

Real diamonds are not often seen on bags, so the evening bags of famous jewellers' brands such as Cartier and Van Cleef & Arpels are exceptions. To give evening bags that extra sparkle, fake diamonds made of glass – like strass for example – were generally used. Strass gets its name from G.F. Strass, a jeweller from Strasbourg, who invented the fake diamond around 1730. Strass became popular in the 1920s and '30s, influenced by costume jewellery made by fashion designer Coco Chanel. As well as being incorporated into jewellery and bags, strass was also found in hats, hatpins, shoes and visiting card holders, with coloured strass being used to imitate precious stones for jewellery and bag frames.

Marcasite (a generally used – but incorrect – name for the mineral pyrite) was also often used to imitate diamonds on jewellery and bag frames, and was enormously popular as an adornment on the frames and clasps of black suede or silk evening bags. It used to be cut and set just like a real diamond.

Beads were also used to decorate evening bags. Mayer, the Parisian company, incorporated sablé beads on its evening bags, which were then exported all over the world. In the course of the 20th century, countries such as Belgium and India started playing a bigger role in the manufacture of evening bags that incorporated embroidery and beads. Today, designers such as Judith Leiber are renowned for their dazzling evening bags.

Avondtassen

In het begin van de twintigste eeuw hadden vrouwen voor elke gelegenheid een tas: voor 's middags een stads- of visitetas en voor 's avonds een opera- of avondtasje. Tassen voor overdag waren vaak van leer, maar voor avondtassen gebruikte men materialen als glanzende zijde en brokaat, opvallend versierd met borduursels, kralen, lovertjes of kleurrijke, flonkerende stenen.

Echte diamanten ziet men minder vaak op tassen, hoewel de avondtassen van beroemde juweliersmerken als Cartier, Van Cleef & Arpels en dergelijke hierop een uitzondering vormen. Om avondtassen te laten glinsteren werden meestal namaakdiamanten van glas gebruikt, zoals strass. Strass is vernoemd naar de Straatsburgse juwelier G.F. Strass, die de namaakdiamant rond 1730 uitvond. In de jaren twintig en dertig van de twintigste eeuw werd strass populair, mede door de bijoux van modeontwerper Coco Chanel. Behalve op sieraden en tassen werd strass ook op hoeden, hoedenspelden, schoenen en visitekaarthouders verwerkt. Gekleurd strass werd ter imitatie van edelstenen voor sieraden en tasbeugels gebruikt.

Ook markasiet (een algemeen gebruikte, maar onjuiste benaming voor het mineraal pyriet) werd veel toegepast ter imitatie van diamanten op sieraden en tasbeugels. Het was uitermate populair als decoratie op beugels en sluitingen van avondtassen van zwarte suède of zijde. Het werd net als diamant geslepen en in setting gezet.

Ook werden kralen gebruikt om avondtassen te versieren. De Parijse firma Mayer verwerkte sablékralen op zijn avondtassen, die hij over de hele wereld exporteerde. In de loop van de twintigste eeuw zijn landen als België en India een grote rol gaan spelen bij de vervaardiging van avondtassen met borduursels en kralen. Tegenwoordig zijn ontwerpers als Judith Leiber bekend om hun schitterende avondtassen.

Bolsos de noche

A comienzos del siglo XX, las mujeres usaban un bolso para cada ocasión: por las tardes, un bolso para la ciudad o un bolso de visita, y por las noches, uno para la ópera o para salir por la noche. Los bolsos para el día eran generalmente de cuero, pero para los de noche, se utilizaban materiales como la seda brillante y el brocato, decorados llamativamente con bordados, cuentas, lentejuelas o piedras brillantes de colores.

Los diamantes auténticos se ven con menos frecuencia en los bolsos, aunque los de noche de marcas de joyerías famosas, como Cartier, Van Cleef & Arpels y semejantes, constituyen la excepción que confirma la regla. Para hacer brillar a estos bolsos de noche, generalmente se utilizaban diamantes de imitación de vidrio, como el strass. El strass recibe su nombre por el joyero de Estrasburgo, G.F. Strass, que alrededor de 1730 inventó el diamante de imitación. En los años veinte y treinta del siglo XX se popularizó el strass, debido en parte a la bisutería de la diseñadora Coco Chanel. Además de ser utilizado en joyería y en bolsos, el strass también se incluía en sombreros, broches de sombreros, zapatos y cajitas para tarjetas de presentación. En joyería y en soportes de bolsos se utilizaba strass de colores imitando piedras preciosas.

También la marcasita (un nombre de uso común, pero incorrecto, para la pirita) se ha utilizado a menudo como imitación de diamantes en joyería y en las boquillas de bolsos. Fue extremadamente popular en la decoración de boquillas y cierres de bolsos de noche, de gamuza o seda negra. Al igual que el diamante, se tallaba y se incrustaba.

También se utilizaban cuentas para decorar bolsos de noche. La firma parisina Mayer incluía cuentas sablé en sus bolsos de noche, que exportaba a todo el mundo. Durante el siglo XX, países como Bélgica y la India jugaron un papel importante en la fabricación de bolsos de noche con bordados y abalorios. Hoy en día, diseñadores como Judith Leiber son conocidos por sus deslumbrantes bolsos de noche.

Sacs du soir

Au début du vingtième siècle, les femmes disposaient d'un sac à main pour chaque occasion : un sac de ville ou de jour pour l'après-midi et un petit sac opéra ou une pochette de soirée pour le soir. Alors que les sacs de jour étaient souvent en cuir, les sacs de soirée étaient confectionnés à partir de matériaux tels que la soie et le brocart, et magnifiquement décorés de broderies, de perles, de paillettes ou de pierres colorées et scintillantes.

De vrais diamants ornent moins fréquemment les sacs, exception faite des pochettes de soirée créées par de prestigieux joailliers, parmi lesquels Cartier, Van Cleef & Arpels et d'autres. Pour apporter une touche scintillante aux sacs de soirée, on utilisait généralement des imitations de diamant fabriquées à partir de verre, la plus populaire étant le strass tirant son nom du joaillier strasbourgeois G.F. Strass qui a inventé ce faux diamant vers 1730. La popularité du strass a atteint son paroxysme dans les années 1920 à 1930, grâce aux bijoux de la grande couturière Coco Chanel. Outre les bijoux et les sacs, le strass ornait également chapeaux, épingles à chapeau, chaussures et porte-cartes de visite. Le strass coloré, imitant les pierres précieuses, était utilisé pour les bijoux et les fermoirs de sac.

Par ailleurs, on recourait à grande échelle à la marcassite (un terme largement utilisé, à tort, pour désigner la pyrite) pour imiter les diamants sur les bijoux et les fermoirs de sac. Elle était très en vogue en tant qu'élément décoratif sur les fermoirs et les fermetures des sacs de soirée confectionnés en soie ou suède noir. Elle était taillée et sertie comme le diamant.

Les perles servaient également à orner les sacs de soirée. La maison parisienne Mayer décorait ses sacs de soirée avec des perles sablées qu'elle exportait dans le monde entier. Au cours du vingtième siècle, des pays comme la Belgique et l'Inde ont joué un rôle de premier plan dans la confection de sacs de soirée agrémentés de broderies et de perles. De nos jours, des créateurs, tels que Judith Leiber, sont réputés pour leurs somptueux sacs de soirée.

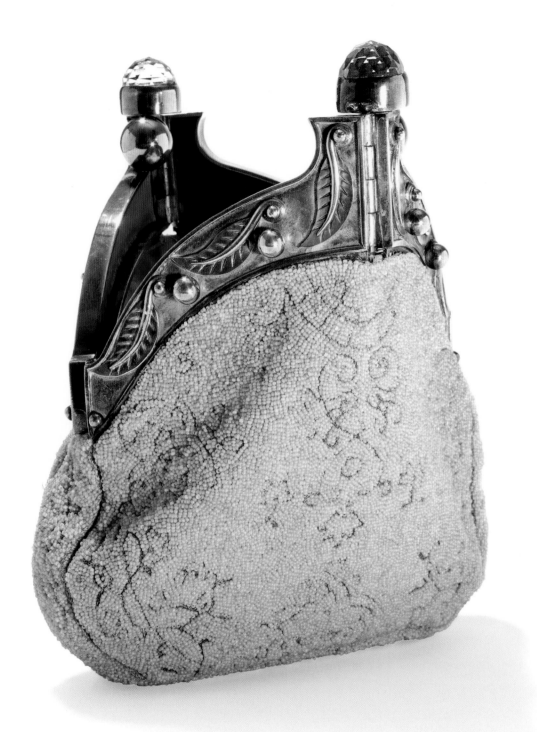

Evening clutch embroidered with sablé beads, silver frame, Mayer, France, ca. 1928.

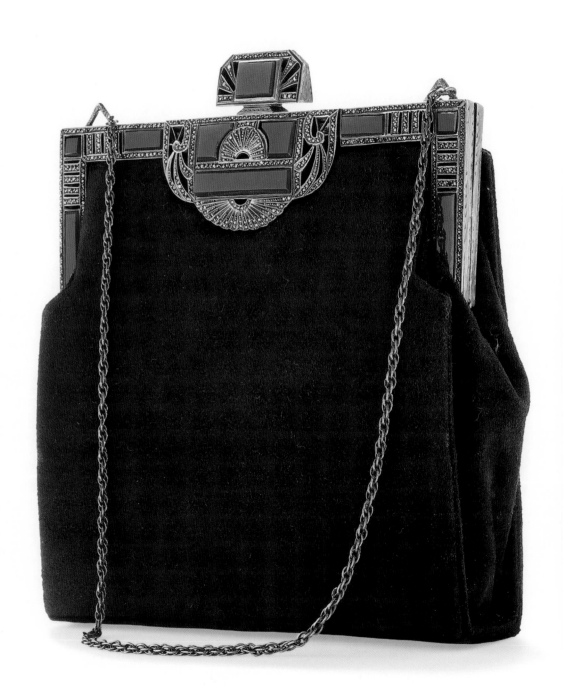

Suede evening bag, silver frame with marcasite and carnelian, Germany, 1929.

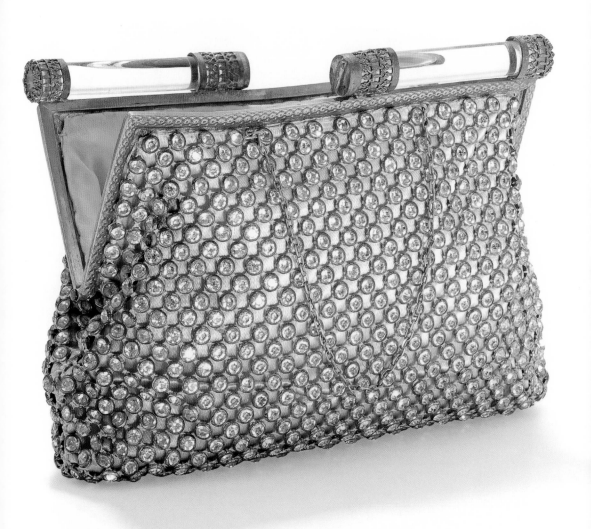

Silk evening bag with strass decoration and perspex frame, Maison de Bonneterie, The Netherlands, 1930s.

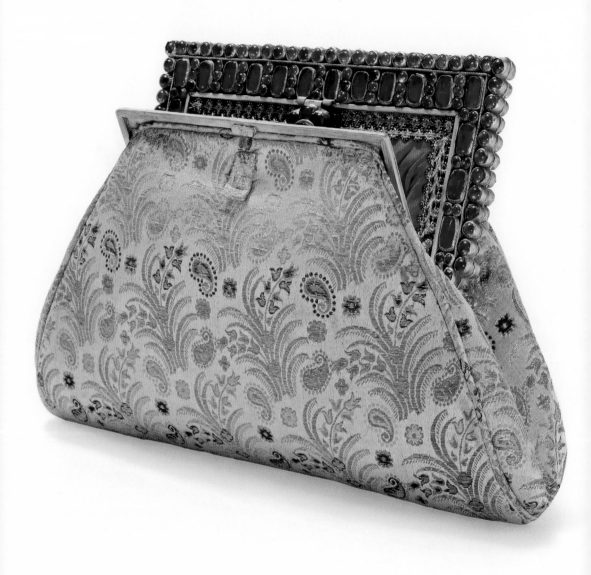

Brocade evening clutch and brass frame encrusted with glass stones, France, 1930s.

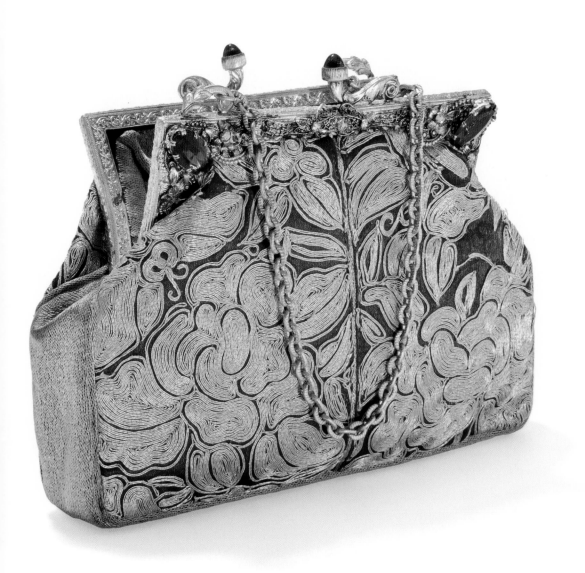

Silk evening bag embroidered with gold thread and brass frame encrusted with glass stones, France, early 1930s.

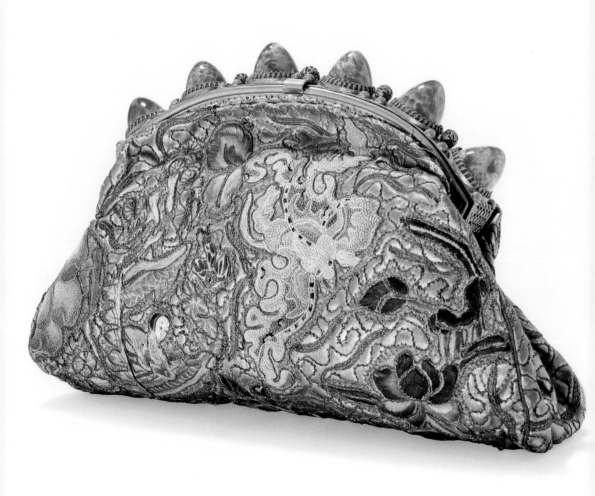

Gold leather evening bag embroidered with silk and frame encrusted with stones, France, 1920s.

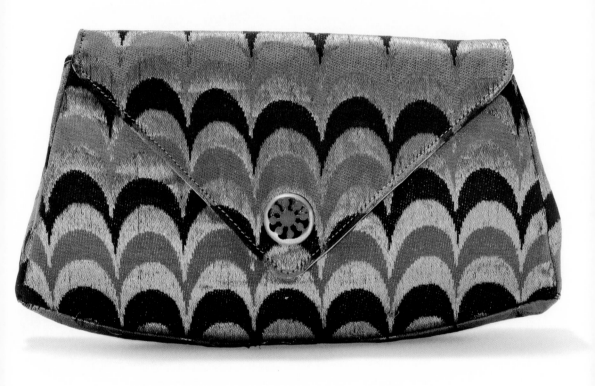

Brocade evening clutch, Mayer, France, 1925.

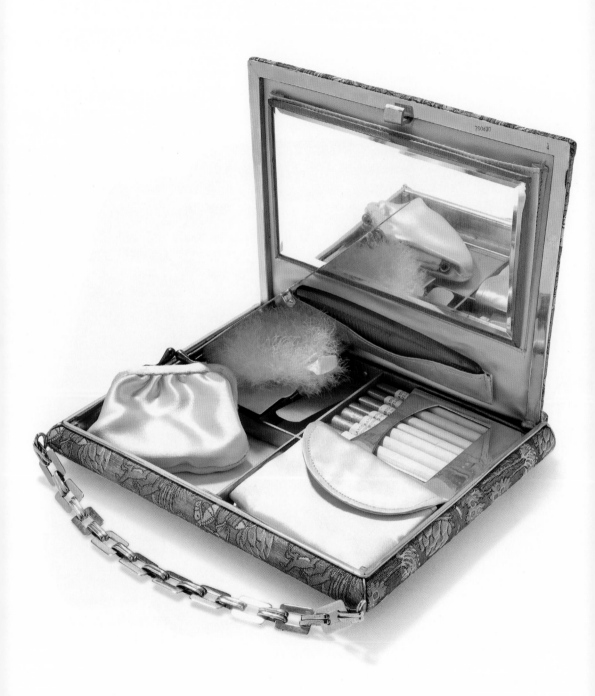

Brocade evening bag with coinpurse, lipstickholder, comb, sigaretholder, Belgium, 1950s

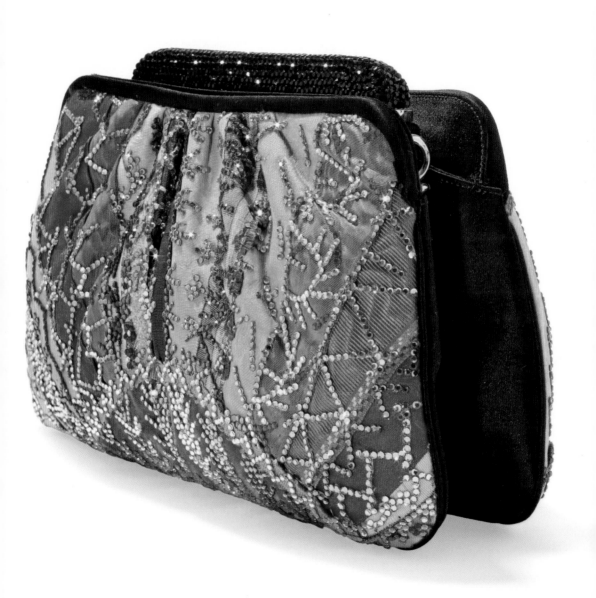

Quilt clutch embroidered with rhinestones, Judith Leiber, U.S.A., 1994.

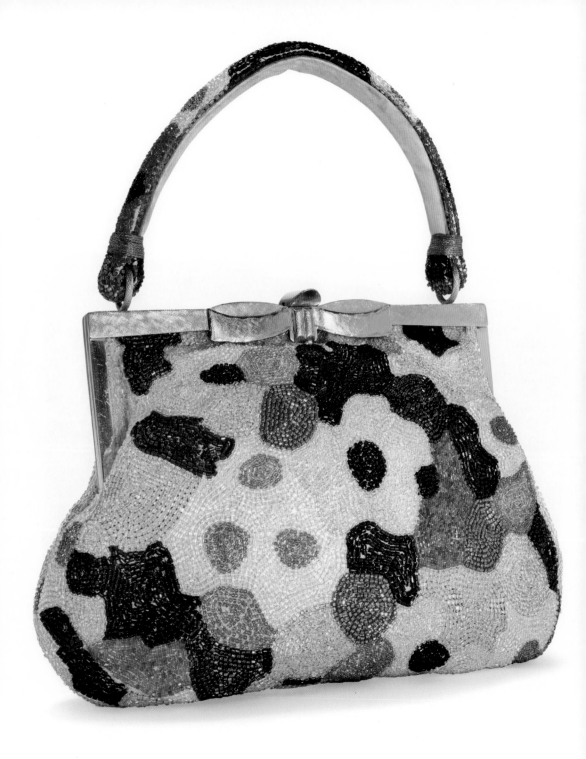

Beaded handbag with gold-coloured frame and beaded handle, Belgium, 1950s.

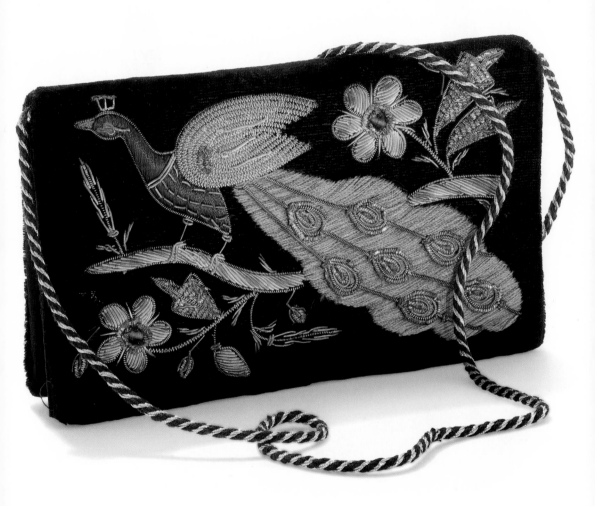

Velvet evening bag with embroidery of silk, gold and silver thread, India, 1970s.

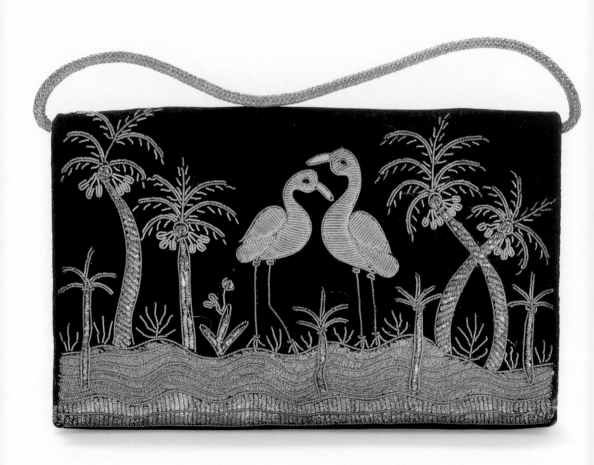

Velvet evening bag with embroidery of silk, gold and silver thread, India, 1970s.

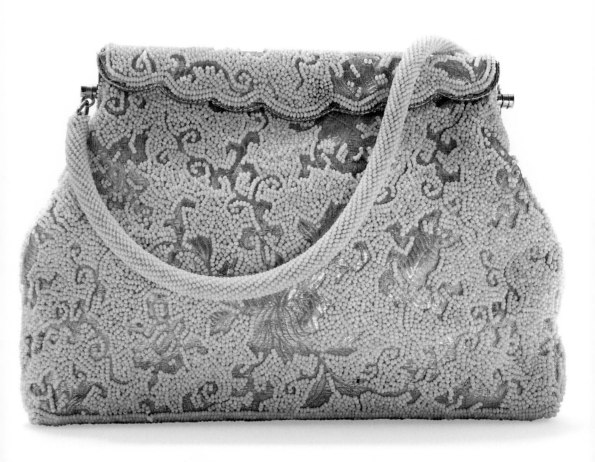

Beaded evening bag with gold embroidery, Belgium, 1950s.

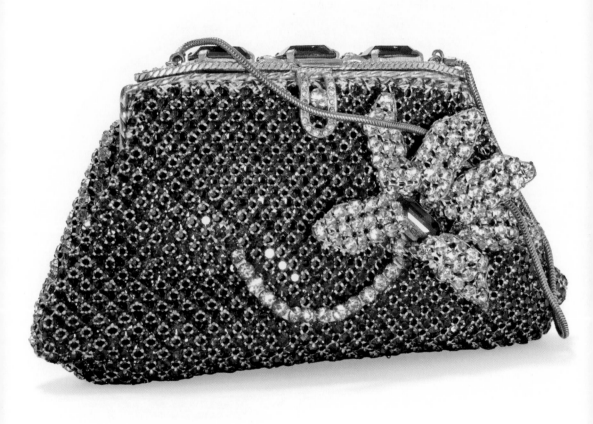

Evening bag extensively encrusted with coloured strass, Cameleon, The Netherlands, 1950s.

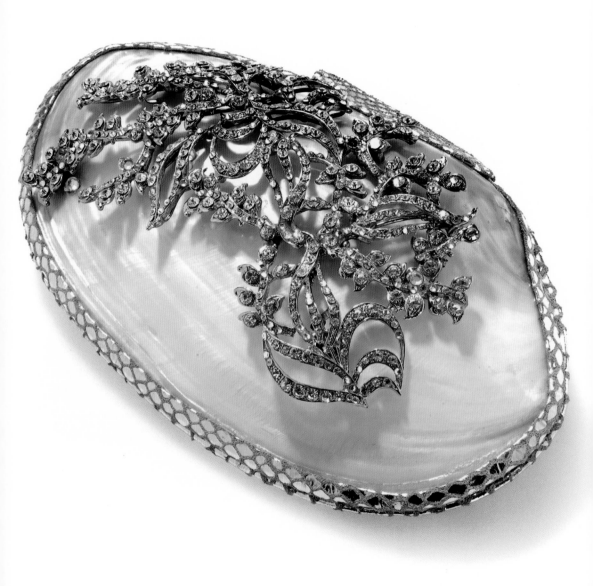

Evening bag 'Nymph' made of a pacific shell trimmed with leather and decorated with rhinestones, Cora Jacobs, Philippines, 2009.

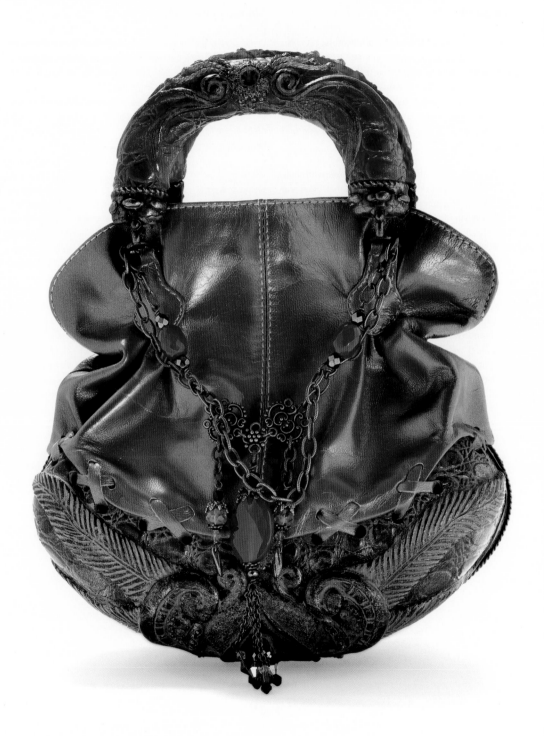

Evening bag made of leather and resin, Maya, U.S.A., ca. 2005.

New materials

In the first thirty years of the nineteenth century, reticules and bags were made in different forms and from different materials than before. Due to the new technologies brought about by the Industrial Revolution (which begun in around 1760 in England), materials and products could be produced much better and faster. A good example is the papier-mâché bag in the shape of a vase, with a cut steel frame and decorations.

Papier-mâché is finely powdered paper that, mixed with chalk or clay, is pressed into all kinds of shapes and then dried and varnished. Papier-mâché techniques originated in Asia and arrived in Europe in the seventeenth century via France. Not until the Industrial Revolution was papier-mâché used on a large scale: snuffboxes, trays, pen and ink sets, candlesticks, card tables, chairs and bags were made in great numbers.

Steel had already been known in Europe since the Middle Ages, but due to improvements in the production process, cut steel became popular in the nineteenth century. It was used for jewellery, decorative combs, buckles, buttons, chatelaines and watch chains. Bags were decorated with sequins, foliage, beads, frames and clasps made of cut steel. On bags made of dark velvet or leather, cut steel was a good imitation of diamonds.

Another trend between 1813 and 1850 was the use of fine filigree ironwork, the so-called fer de Berlin (or Berlin iron), for bags and jewellery. Because of their matte black lustre, these jewellery pieces were also sought after as mourning jewellery.

Nieuwe materialen

In de eerste dertig jaar van de negentiende eeuw werden reticules en tassen gemaakt in andere vormen en uit andere materialen dan voorheen. Door de nieuwe technieken van de Industriële Revolutie (die rond 1760 in Engeland begint) konden materialen en producten veel beter en sneller geproduceerd worden. Een goed voorbeeld hiervan is de papier-mâché-tas in de vorm van een vaas met een beugel en decoraties van geslepen staal.

Papier-mâché is fijngestampt papier dat, vermengd met krijt of klei, in allerlei vormen geperst en vervolgens gedroogd en gevernist wordt. De papier-mâché-techniek is oorspronkelijk afkomstig uit Azië en kwam in de zeventiende eeuw via Frankrijk naar Europa. Pas tijdens Industriële Revolutie werd papier-mâché op grote schaal toegepast: snuifdozen, presenteerbladen, inktstellen, kandelaars, speeltafels, stoelen en tassen werden toen in grote oplagen vervaardigd.

Staal kende men in Europa al sinds de Middeleeuwen, maar door verbeteringen in het productieproces werd geslepen staal in de negentiende eeuw populair. Het werd gebruikt voor sieraden, sierkammen, gespen, knopen, chatelaines en horlogekettingen. Tassen werden versierd met pailletten, lovertjes, kralen, beugels en sluitingen van geslepen staal. Op tassen van donker fluweel of leer was het een goede imitatie van diamanten.

Een ander modesnufje tussen 1813 en 1850 was het gebruik van fijn filigraanijzerwerk: het zogenaamde fer de Berlin (ijzer uit Berlijn) voor tassen en sieraden. Deze sieraden waren vanwege hun zwarte doffe uitstraling ook geliefd als rouwsieraden.

Nuevos materiales

En las tres primeras décadas del siglo XIX, las retículas y los bolsos se realizaban con formas y materiales diferentes a los empleados hasta entonces. Gracias a las nuevas tecnologías que trajo consigo la revolución industrial (que tiene sus orígenes en Inglaterra alrededor de 1760), podían producirse materiales y productos de mejor calidad y con más rapidez. Un buen ejemplo de ello es el bolso de cartón piedra en forma de jarrón, con una boquilla y elementos decorativos de acero cortado.

El cartón piedra es un papel finamente espolvoreado que, si se mezcla con yeso o arcilla, puede modelarse en múltiples formas y, posteriormente, secarse y barnizarse. Las técnicas para trabajarlo tienen sus orígenes en Asia y entraron en Europa en el siglo XVII a través de Francia. Nunca antes de la revolución industrial se había utilizado el cartón piedra a tan gran escala. Con él se produjeron grandes cantidades de tabaqueras, bandejas, conjuntos de pluma y tinta, candelabros, mesas de juego, sillas y bolsos.

El acero ya se conocía en Europa desde la Edad Media, pero como resultado de las mejoras en el proceso de producción, el acero cortado adquirió popularidad en el siglo XIX. Se utilizaba en joyas, peines decorativos, hebillas, botones, chatelaines y cadenas de reloj. Los bolsos se decoraban con lentejuelas, láminas metálicas, cuentas, boquillas y broches realizados con acero cortado. En los bolsos que se realizaban en cuero o terciopelo oscuro, el acero resultaba una acertada imitación de los diamantes.

Otra tendencia entre los años 1813 y 1850 fue el uso de filigranas de hierro, el denominado fer de Berlin (hierro de Berlín), en los bolsos y joyas. Debido al lustre de color negro mate que les caracterizaba, estas joyas también eran codiciados ornamentos de luto.

Nouvelles matières

Au cours des trente premières années du dix-neuvième siècle, les réticules et les sacs adoptent des formes et des matières différentes de celles utilisées auparavant. Avec les nouvelles technologies introduites par la Révolution industrielle (qui débute en Angleterre aux alentours de 1760), la fabrication de matières et de produits gagne en qualité et en rapidité. Le sac de papier mâché en forme de vase, avec un fermoir et des décorations en fil d'acier coupé, en est un parfait exemple.

Le papier mâché est du papier finement réduit en poudre et mélangé à de la craie ou de l'argile, puis moulé en formes diverses, séché et verni. Cette technique est née en Asie et arrivée en Europe au dix-septième siècle par la France. Il faudra cependant attendre la Révolution industrielle pour voir son usage se généraliser à grande échelle et assister à la production en grandes quantités de tabatières, plateaux, encriers et porte-plumes, bougeoirs, tables de jeu, chaises et sacs.

L'acier était connu en Europe depuis le Moyen Âge, mais les progrès des processus de production le rendront populaire au dix-neuvième siècle. Il sert alors à divers bijoux, peignes d'ornement, boucles, boutons, châtelaines et chaînes de montre. Les sacs sont ornés de sequins, feuillage, perles, fermoirs et boucles en acier coupé, une bonne imitation des diamants pour les sacs en velours ou cuir sombre.

Parmi les autres tendances entre 1813 et 1850 s'inscrit l'utilisation de ferronnerie filigrane, dite fer de Berlin, pour les sacs et bijoux. Du fait de leur éclat noir mat, ces bijoux étaient aussi recherchés pour les ornements de deuil.

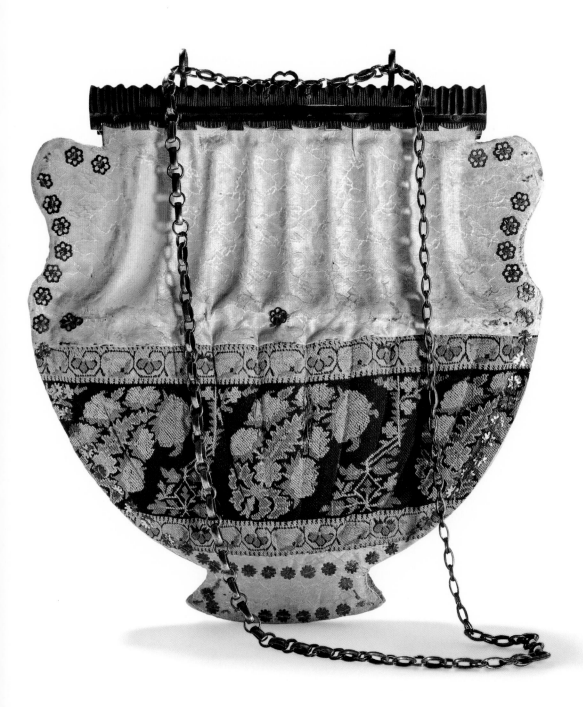

Papier-mâché handbag covered with silk and cut steel sequins, with cut steel frame, France, 1820s.

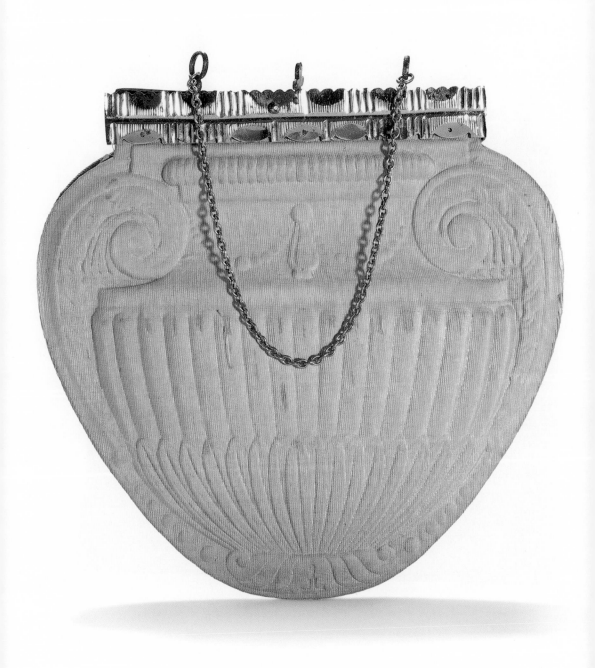

Papier-mâché handbag with cut steel frame, France, 1820s.

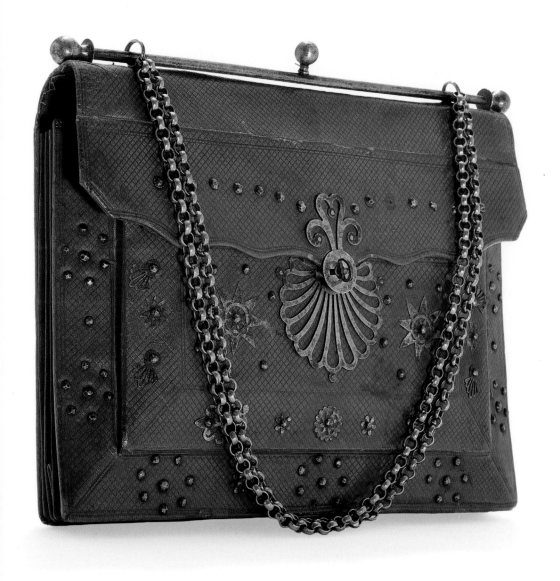

Leather handbag with cut steel frame and decoration, France, ca. 1830.

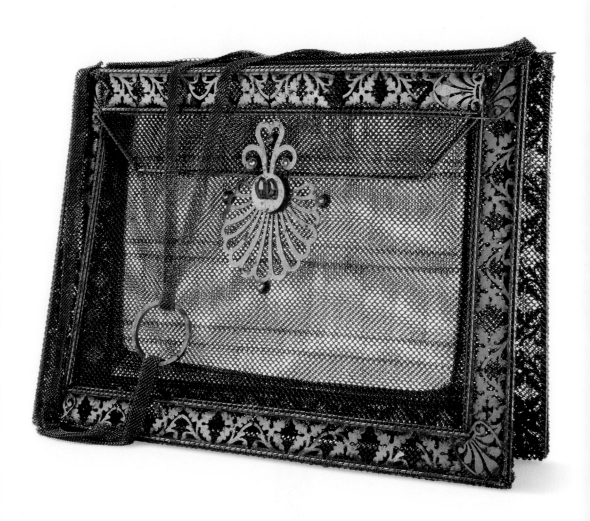

Fer de Berlin handbag with decoration and lock of cut steel, Germany, ca. 1820.

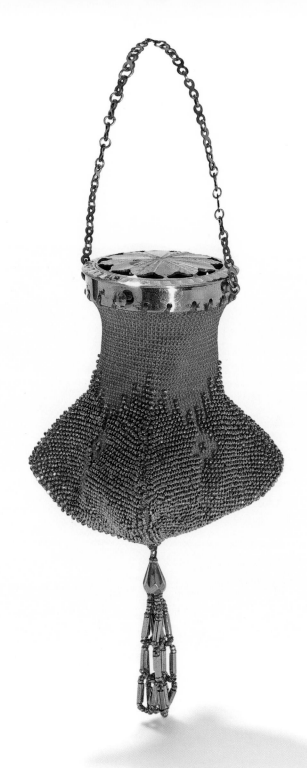

Crocheted coin purse decorated with cut steel beads and with cut steel lid, France, 19th c.

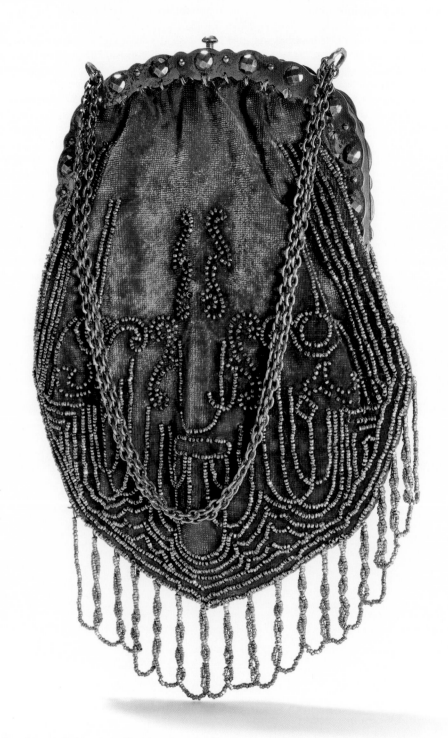

Velvet handbag decorated with cut steel beads and cut steel frame, France, 1910s.

Tortoiseshell, ivory and imitations

From the nineteenth century on, tortoiseshell was used to decorate and make fashion accessories such as bags, combs, spectacle cases, etuis and coin purses. It was difficult to work with, so objects made of tortoiseshell were truly luxury articles. What is more, tortoiseshell accessories were often also inlaid with gold, silver or mother of pearl. To imitate tortoiseshell, horn was used.

Ivory was also used in the nineteenth and the first quarter of the twentieth century for bags and purses. Detailed images were often carved from ivory, which showed up well against the bag's dark leather background. A special set of leather bags from the Museum of Bags and Purses collection has cover sheets of carved ivory with a silver border. The best example is without a doubt a snakeskin bag with an ivory detail of Eve plucking an apple in paradise.

As a substitute for ivory buttons and needlework accessories in the nineteenth century, the much cheaper vegetable ivory was used, made from ivory nuts from the ivory palm.

After the arrival of the first plastics, such as celluloid (1868), casein (1897) and cellulose acetate (1926), tortoiseshell and ivory were often imitated. For bags in the twenties, this specifically meant semicircular frames that were flat in structure or decorated to excess with historical, romantic, oriental and Egyptian motifs. In the thirties, handbags and clutches appeared made completely from plastic. The plastics were no longer used as a cheap imitation but because of their modern smooth structure.

Schildpad, ivoor en imitaties

Vanaf de negentiende eeuw werd schildpad gebruikt voor het versieren of maken van modeaccessoires als tassen, haarkammen, brillenkokers, etuis en beursjes. De verwerking ervan was duur, waardoor voorwerpen met schildpad tot de echte luxeartikelen behoorden. Bovendien werden accessoires van schildpad vaak ook nog ingelegd met goud, zilver of parelmoer. Ter imitatie van schildpad werd hoorn gebruikt.

Ook ivoor werd in de negentiende eeuw en het eerste kwart van de twintigste eeuw gebruikt voor tassen en beursjes. Vaak werden in het ivoor gedetailleerde voorstellingen gesneden, die goed uitkwamen tegen de donkere achtergrond van het leer van de tas.
Een bijzondere serie leren tassen uit de collectie van het Tassenmuseum is voorzien van dekplaten van bewerkt ivoor, afgewerkt met een zilveren rand. Het mooiste exemplaar is zonder twijfel een slangenleren tas met daarop in ivoor een afbeelding van Eva die een appel plukt in het paradijs.

Als substituut voor ivoren knopen en handwerkaccessoires gebruikte men in de negentiende eeuw wel het veel goedkopere ivoriet, gemaakt van de kiem van de ivoorpalm.

Na de komst van de eerste kunststoffen, zoals celluloid (1868), caseïne (1897) en celluloseacetaat (1926), werden schildpad en ivoor vaak nagebootst. Bij tassen in de jaren twintig ging het vooral om halfronde beugels, die vlak van structuur waren of overdadig versierd werden met historische, romantische, oosterse en Egyptische motieven. In de jaren dertig verschenen handtassen en onderarmtassen die helemaal van kunststof waren gemaakt. De kunststoffen werden niet meer gebruikt als goedkope imitatie, maar vanwege hun moderne, strakke structuur.

Carey, marfil e imitaciones

A partir del siglo XIX, el carey se utilizó para decorar o elaborar accesorios de moda tales como bolsos, peines, fundas de binóculos, estuches y portamonedas. Resultaba un material difícil de trabajar, por lo que los objetos realizados con carey eran verdaderos artículos de lujo. Y, más aún, en los accesorios de este tipo a menudo se realizaban incrustaciones de oro, plata o madreperla. Para imitar el carey se utilizaba el cuerno.

También se empleó el marfil en el siglo XIX y el primer cuarto del siglo XX en la confección de bolsos y monederos. Este material solía utilizarse para labrar imágenes detalladas, que resaltaban bien con el fondo de cuero oscuro del bolso. Hay un conjunto especial de bolsos de cuero procedente de la colección del Museo de Bolsos que presenta cubiertas de marfil tallado que se hacen resaltar con un borde de plata. El mejor ejemplo sin ninguna duda es un bolso de piel de serpiente con la imagen de Eva cogiendo una manzana en el Paraíso.

Como sustituto de los accesorios tallados a mano y los botones de marfil, en el siglo XIX también se empleaba el marfil vegetal, que resultaba mucho más económico y se obtenía de las semillas de la tagua.

Con la aparición de los primeros materiales sintéticos, como el celuloide (1868), la caseína (1897) y el acetato de celulosa (1926), el carey y el marfil fueron objeto de numerosas imitaciones. En la década de 1920, esto se traducía en bolsos de boquillas semicirculares con una estructura plana o decorados en exceso con motivos históricos, románticos, orientales y egipcios. Los clutches y los bolsos de mano que aparecieron en la década siguiente estaban elaborados íntegramente en material sintético. Este material ya no se utilizaba tanto como imitación barata sino por su moderna estructura rígida.

Écaille, ivoire et imitations

Depuis le dix-neuvième siècle, l'écaille de tortue est utilisée pour la décoration ou la fabrication d'accessoires de mode tels que sacs, peignes, étuis à lunettes, étuis et petits porte-monnaie. Du fait de la difficulté à la travailler, les objets en écaille étaient des articles de grand luxe, d'autant qu'ils étaient souvent incrustés d'or, d'argent ou de nacre. L'imitation de l'écaille se faisait avec de la corne.

L'ivoire aussi a été utilisé au dix-neuvième siècle et pendant le premier quart du vingtième pour des sacs et porte-monnaie. Des représentations très détaillées étaient souvent sculptées en ivoire, qui tranchait sur le fond de cuir sombre du sac. Le Musée des sacs possède dans sa collection une série spéciale de sacs en cuir avec des feuilles de couverture en ivoire sculpté et garnies d'une bordure en argent. Le meilleur exemple est sans aucun doute le sac en peau de serpent représentant Ève au Paradis en train de cueillir une pomme.

Au dix-neuvième siècle, on utilisait, en guise de substitut pour les boutons et accessoires artisanaux en ivoire, l'ivoire végétal tiré des noix du palmier à ivoire et nettement moins cher.

Avec l'arrivée des premiers plastiques comme le celluloïd (1868), la caséine (1897) et l'acétate de cellulose (1926), les imitations d'écaille et d'ivoire se multiplient. On les retrouve en particulier, pour les sacs des années vingt, dans les fermoirs semi-circulaires de structure plate ou décorée à l'excès de motifs historiques, romantiques, orientaux et égyptiens. Dans les années trente, des sacs à main et pochettes entièrement en plastique apparaissent : les plastiques ne sont plus désormais utilisés comme une imitation moins onéreuse mais pour leur texture rigide moderne.

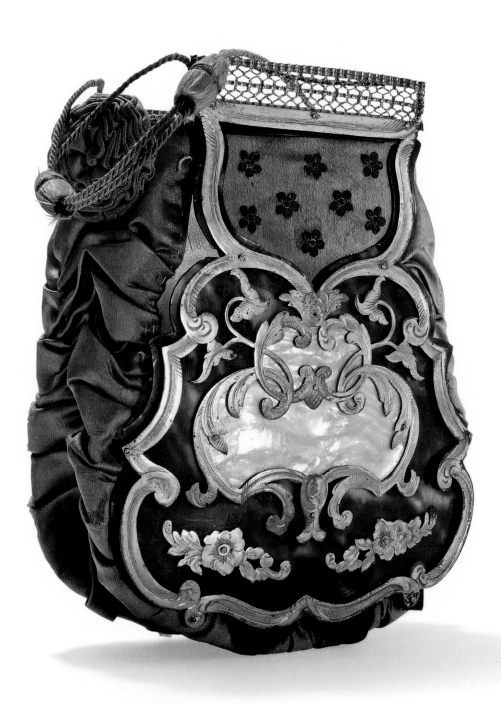

Silk reticule decorated with tortoise-shell, mother-of-pearl and gilt leaves, Germany, 1840s.

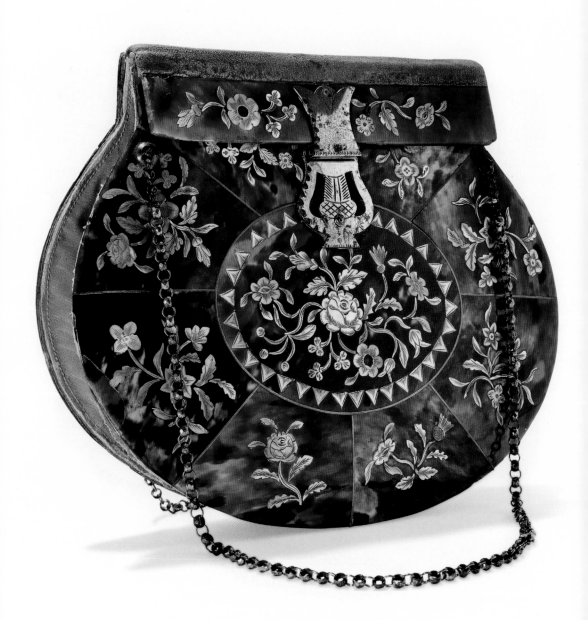

Leather handbag with cover-sheet of tortoise-shell inlaid with mother-of-pearl, Germany, 1810-1820.

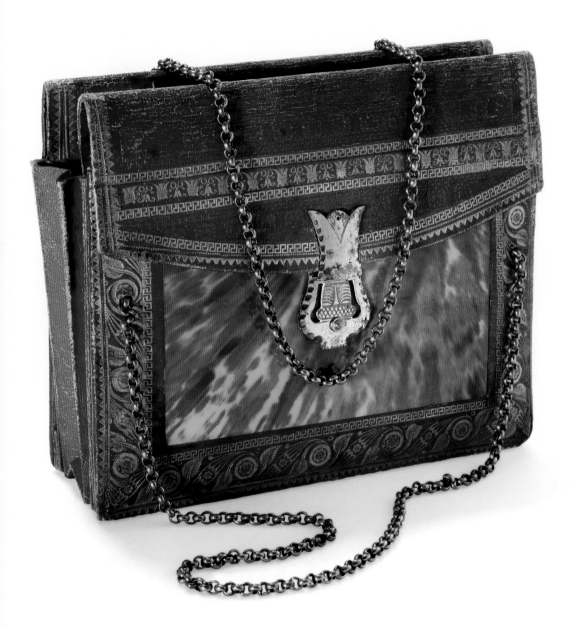

Leather handbag with cover-sheet of tortoise-shell, Germany, 1810-1820.

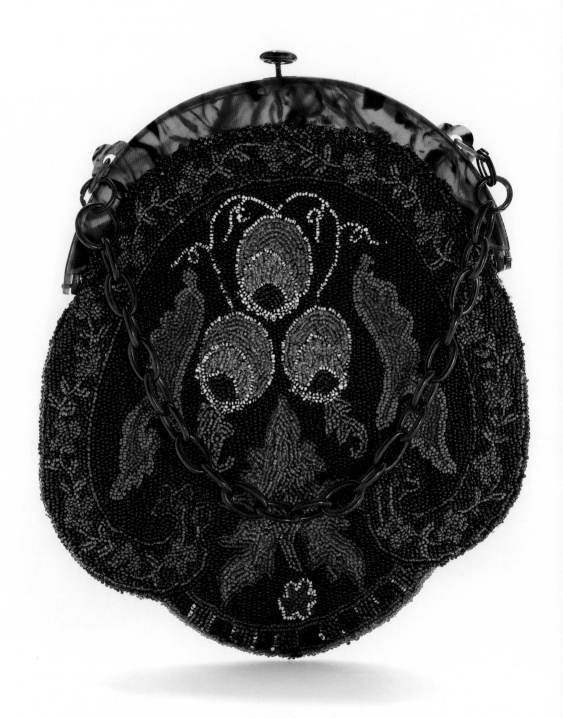

Beaded handbag with plastic (imitation tortoise-shell) frame, Czechoslovakia, 1920s.

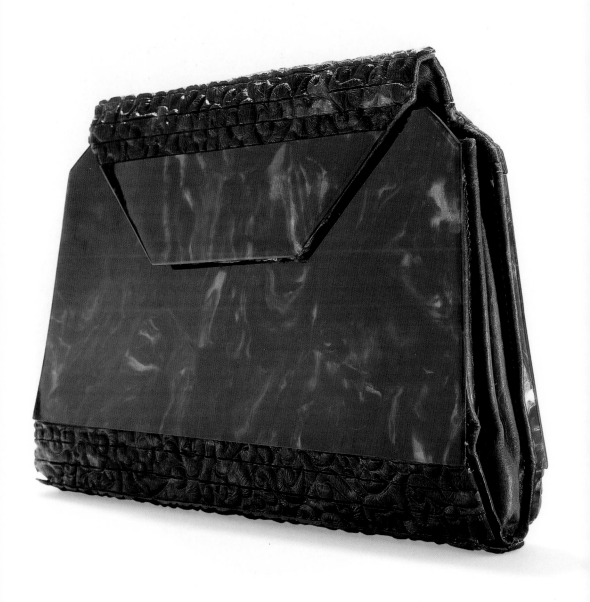

Plastic (imitation tortoise-shell) clutch, France, 1930s.

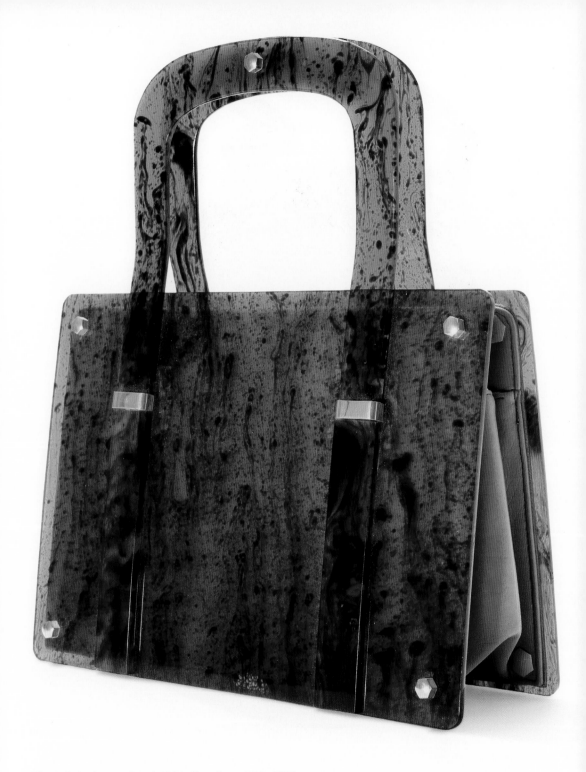

Plastic (imitation tortoise-shell) handbag, Koret, U.S.A., 1950s.

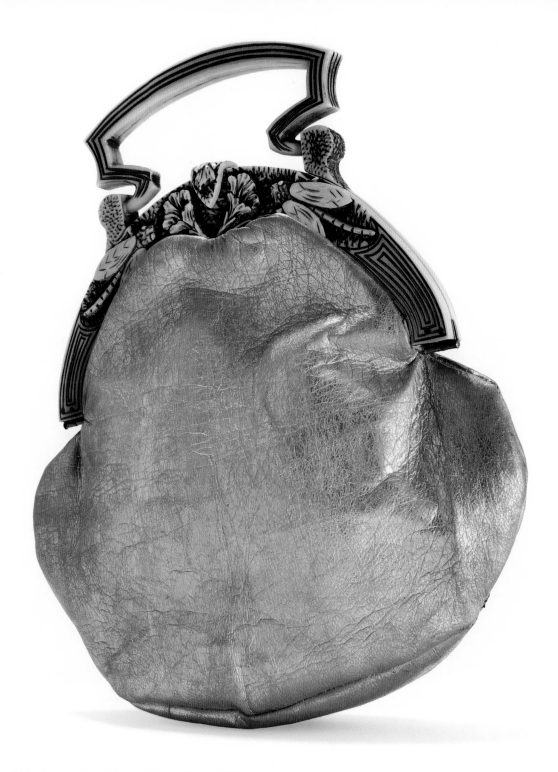

Gold leather handbag with plastic frame, France, 1920s.

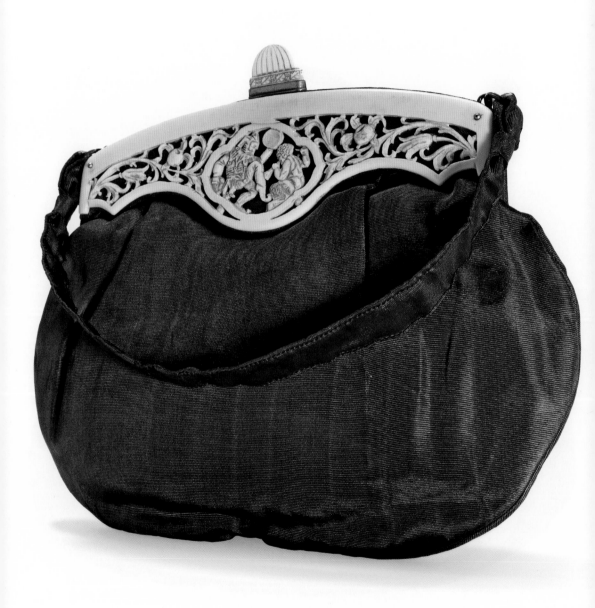

Fabric handbag with ivory decoration of Greek god Pan, France, 1920-1925.

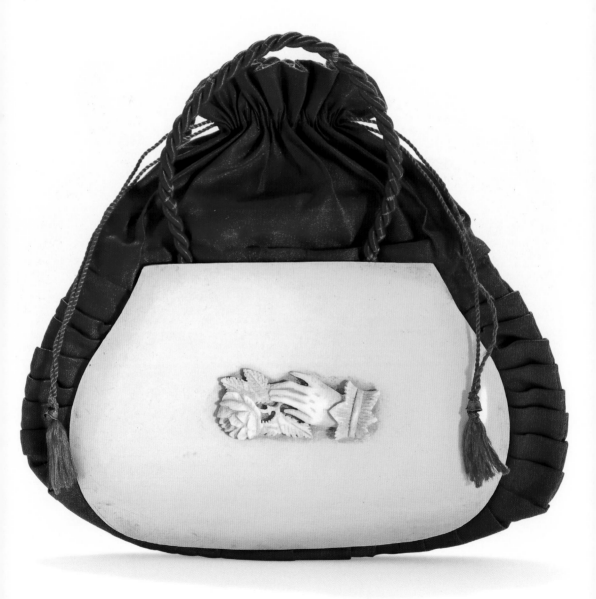

Silk reticule with cover of celluloid, Germany, early 20th c.

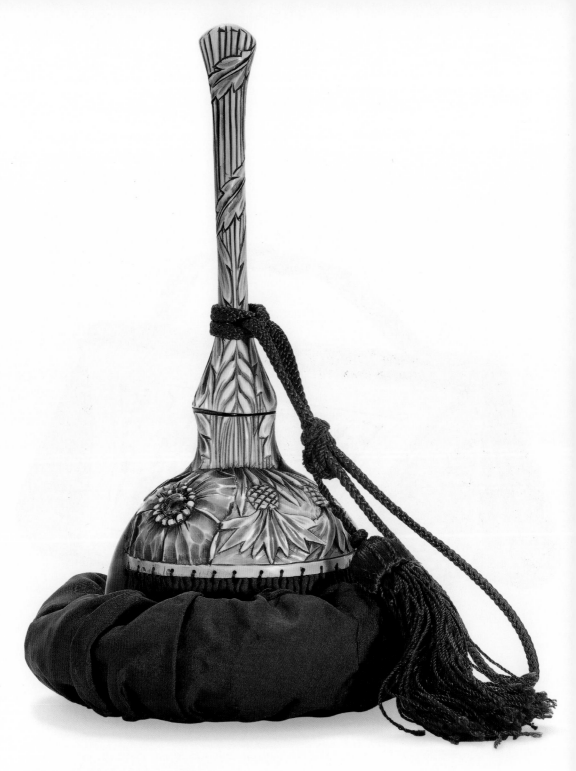

Fabric handbag with plastic frame and handle, France, 1920s.

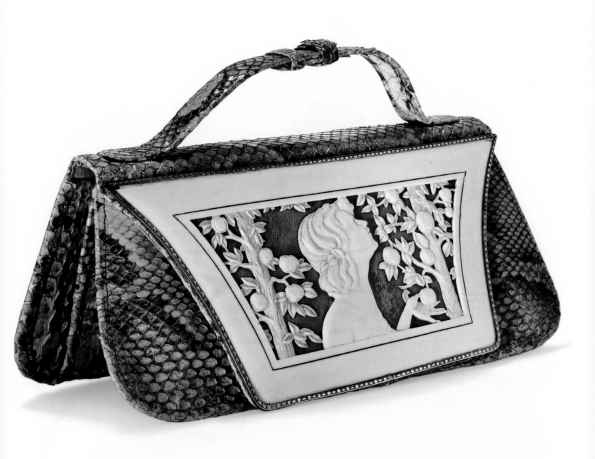

Snakeskin handbag with ivory cover-sheet, Eve and the apple, and with silver border, Germany, 1920s.

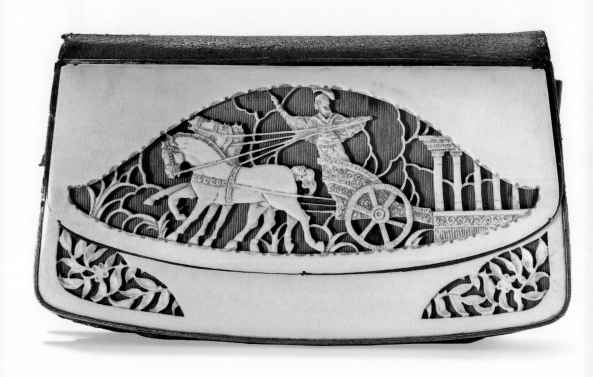

Leather clutch with ivory cover-sheet and with silver border, Germany, 1920s.

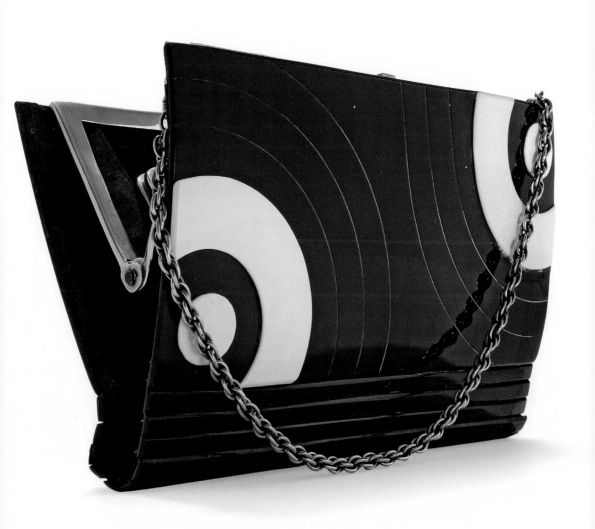

Plastic clutch, France, 1930s.

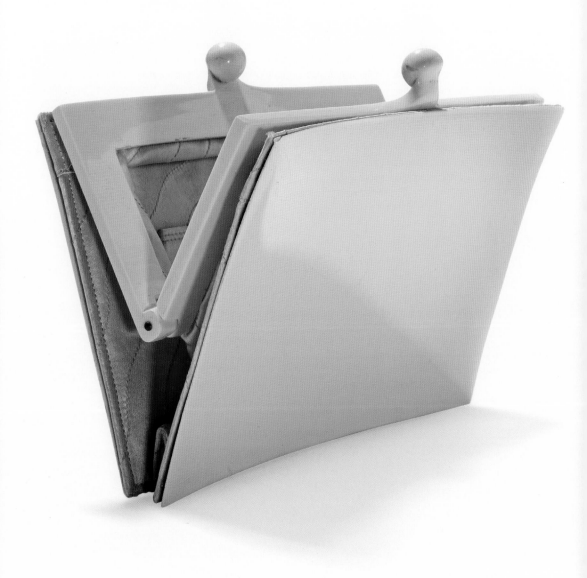

Plastic clutch to imitate ivory, Chanel, France, 1930s.

Special kinds of leather

Leather is one of the oldest materials used by human beings. After plastic, in the twentieth century leather was still the most frequently used material for handbags. It was valued not just for its durability but also because of its sleek or sometimes striking texture.

In theory, all skins can be converted into leather, but mainly those from cattle, goats, donkeys, sheep and pigs are used. The leather from exotic animals such as snakes, crocodiles, ostriches, lizards and armadillos are valued for their unique textures. Fish leather has also been used for bags; for example, skate and shark leather have been used in the past, and currently Nile perch are also made into leather.

In accordance with the prevailing fashion, leather handbags are furnished with decorations, clasps and frames, from silver fittings to clasps and decorations in chrome and plastic.

Bijzondere leersoorten

Leer is een van de oudste door de mens gebruikte materialen. Naast kunststof was leer in de twintigste eeuw nog altijd het meest toegepaste materiaal voor de vervaardiging van tassen. Het werd niet alleen gewaardeerd om zijn duurzaamheid, maar ook om zijn gladde of soms juist opvallende structuur.

In principe kunnen alle huiden tot leer worden verwerkt, maar vooral die van runderen, geiten, ezels, schapen en varkens worden veel gebruikt. Het leer van exotische dieren als slangen, krokodillen, struisvogels, hagedissen en gordeldieren werd gewaardeerd om hun bijzondere structuur. Ook vissenleer werd wel gebruikt voor tassen. Dat gebeurde bijvoorbeeld met roggen- en haaienleer; tegenwoordig wordt ook de nijlbaars tot leer verwerkt.

Overeenkomstig de heersende mode werden leren tassen van decoraties, sluitingen en beugels voorzien, uiteenlopend van zilverbeslag tot sluitingen en decoraties van chroom en kunststof.

Tipos de cuero especiales

El cuero es uno de los materiales más antiguos utilizados por el ser humano. Tras el material sintético, en el siglo XX el cuero seguía siendo el material más utilizado en la producción de bolsos. Su valor reside no sólo en su durabilidad sino también por su textura lisa o a veces consistente.

En teoría pueden usarse todo tipo de pieles, pero las más utilizadas son las de bovinos, cabras, equinos, ovinos y cerdos. El cuero de animales exóticos como serpientes, cocodrilos, avestruces, lagartos y armadillos se aprecia por su textura única. En la elaboración de bolsos también se ha empleado la piel de peces. Así, en otros tiempos se utilizó el cuero de raya y de tiburón, y en la actualidad también se usa la piel de las percas del Nilo.

Según la moda del momento, los bolsos de cuero se ornamentan con motivos decorativos, cierres y boquillas, desde accesorios de plata hasta hebillas y ornamentos de cromo y material sintético.

Cuirs spéciaux

Le cuir est l'un des matériaux travaillés depuis le plus longtemps par l'homme. Après le plastique, il reste le plus utilisé pour les sacs à main au vingtième siècle et est apprécié pour sa longévité et sa texture lisse parfois superbe.

En théorie, toutes les peaux peuvent être transformées en cuir, mais on utilise essentiellement celles de bovins, chèvres, ânes, moutons et porcs, ou d'animaux exotiques comme les serpents, crocodiles, autruches, lézards et tatous, appréciées pour leurs textures uniques. On trouve également dans le passé des sacs en cuir de poisson, notamment de raie ou de requin ; aujourd'hui, les perches du Nil sont transformées en cuir.

La mode actuelle équipe les sacs à main en cuir de décorations, boucles et fermoirs de divers matériaux, de l'argent au chrome ou au plastique.

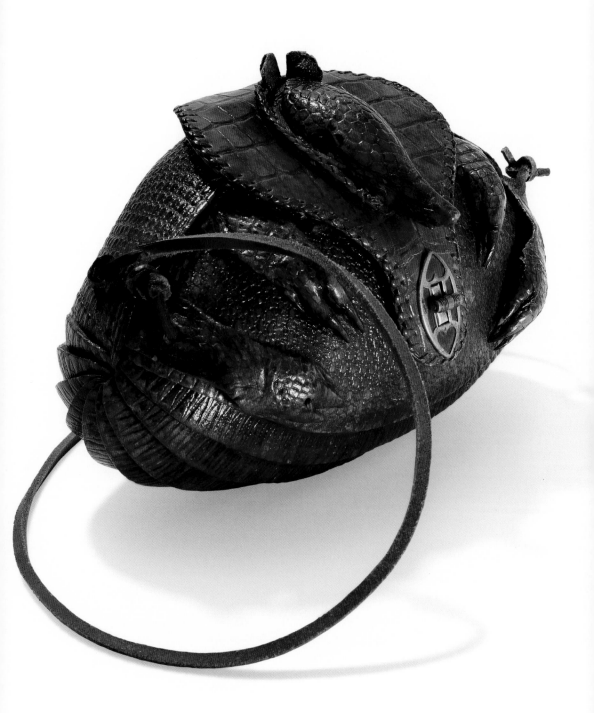

Armadillo shoulder bag, Argentina, 2nd quarter 20th c.

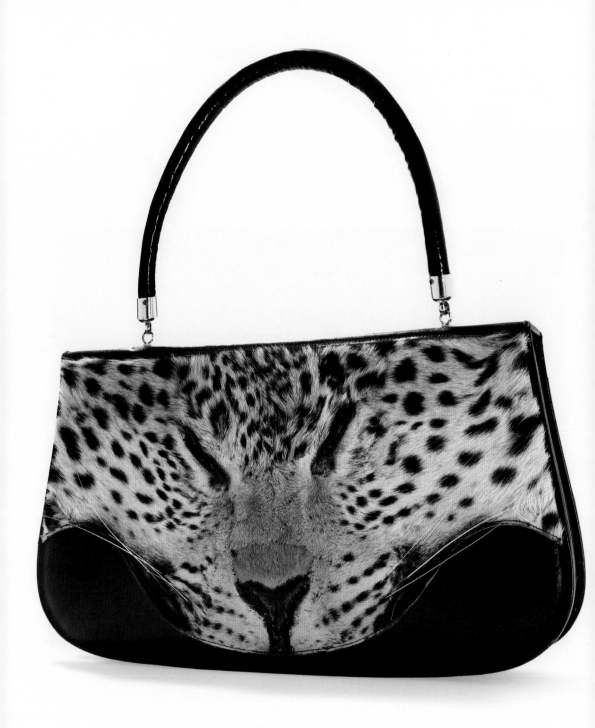

Leather handbag with leopard skin, Botswana, 1962.

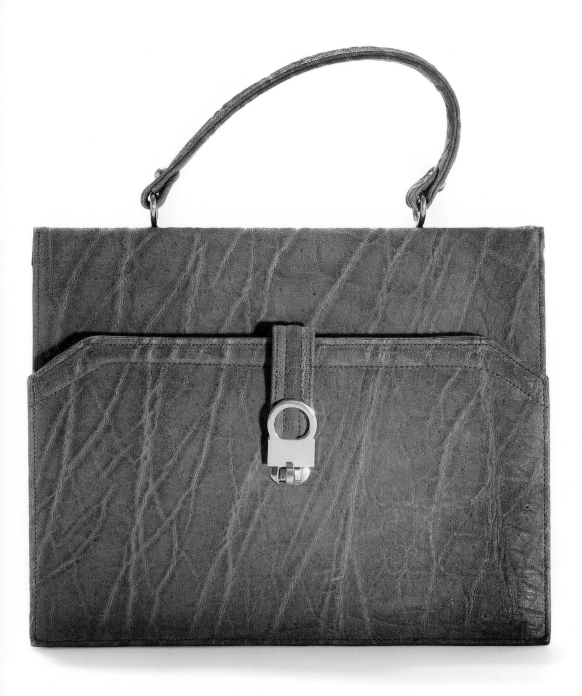

Handbag in elephant leather, Italy, ca. 1965.

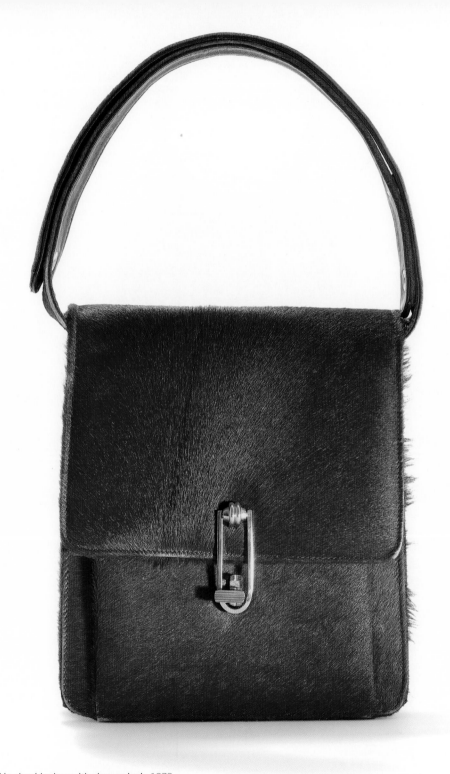

Foalskin shoulder bag with chrome lock, 1970s.

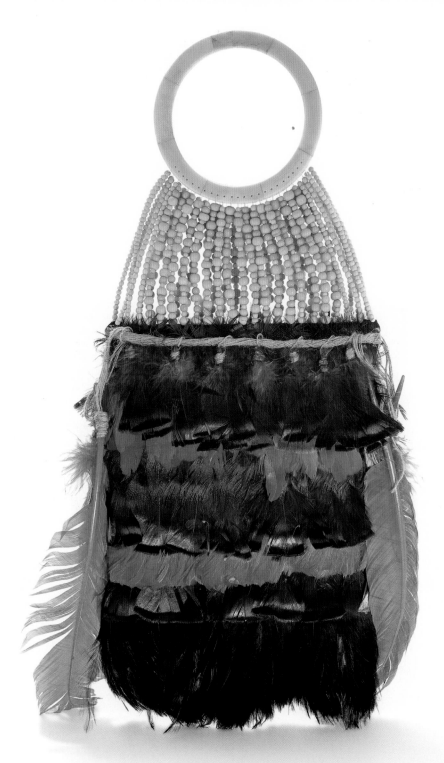

Handbag decorated with feathers and plastic beads, Alexander McQueen, England, 2003.

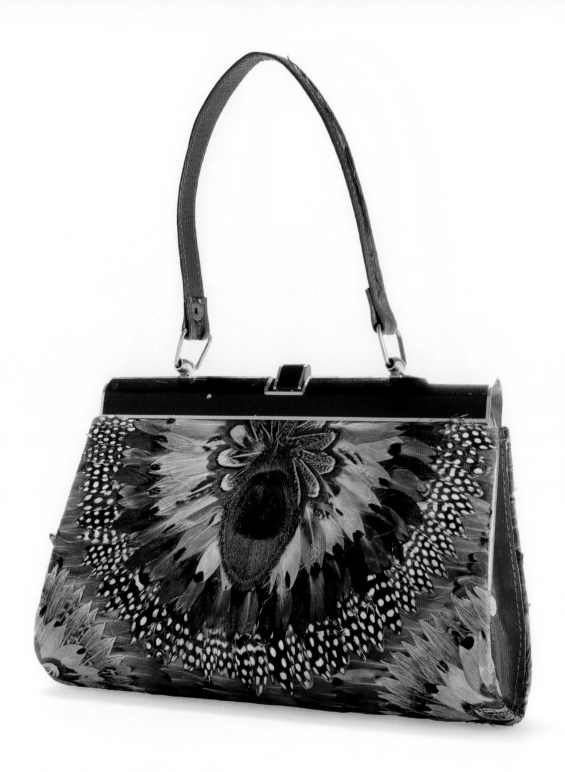

Leather handbag covered with peacock feathers, Europe, 1970s.

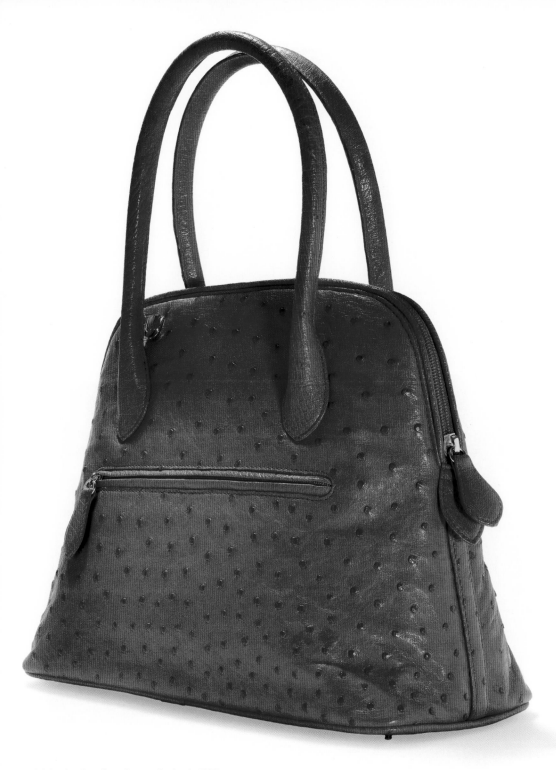

Ostrich leather handbag, Asprey, England, 1990s.

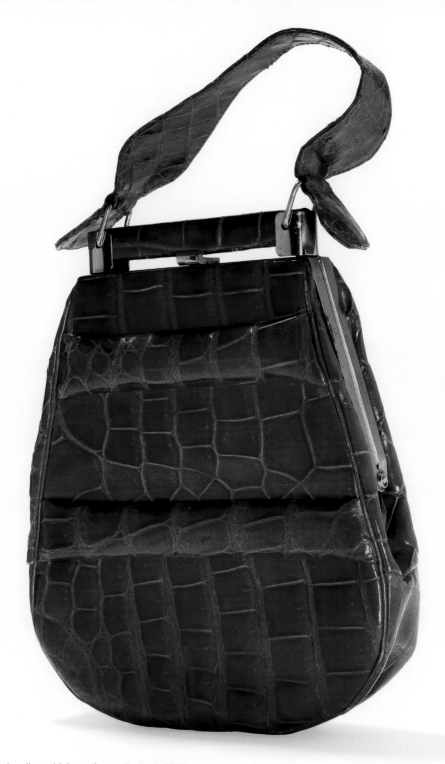

Alligator handbag with brass frame, England, 1940s.

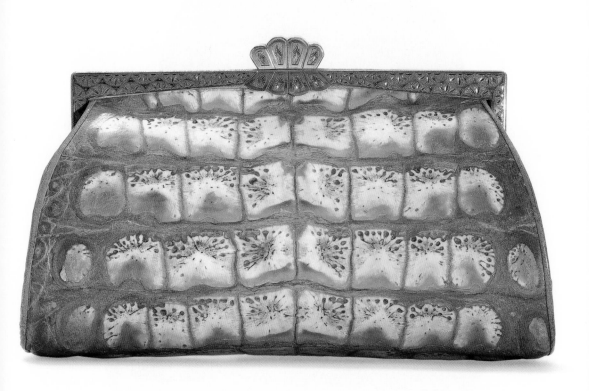

Alligator clutch with silver frame and lock, Austria, 1920s.

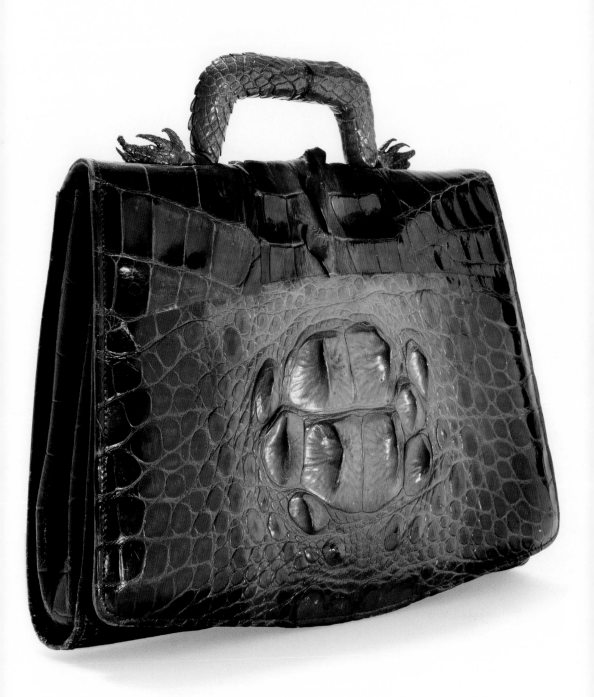

Alligator handbag, Indonesia, 1930s.

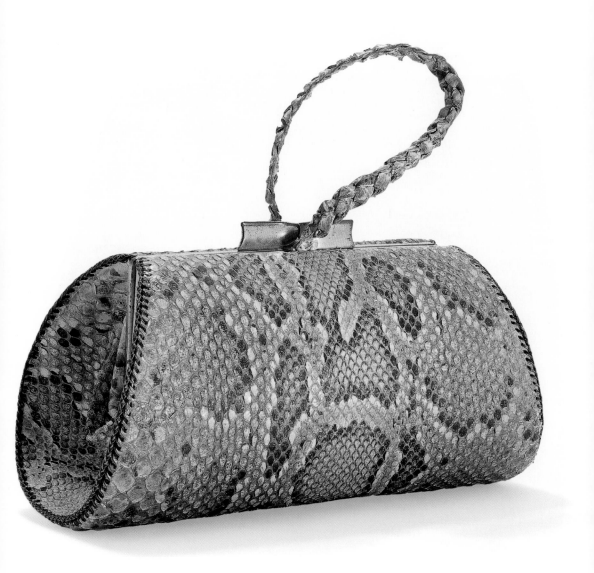

Snakeskin handbag, Indonesia, 1930s-1940s.

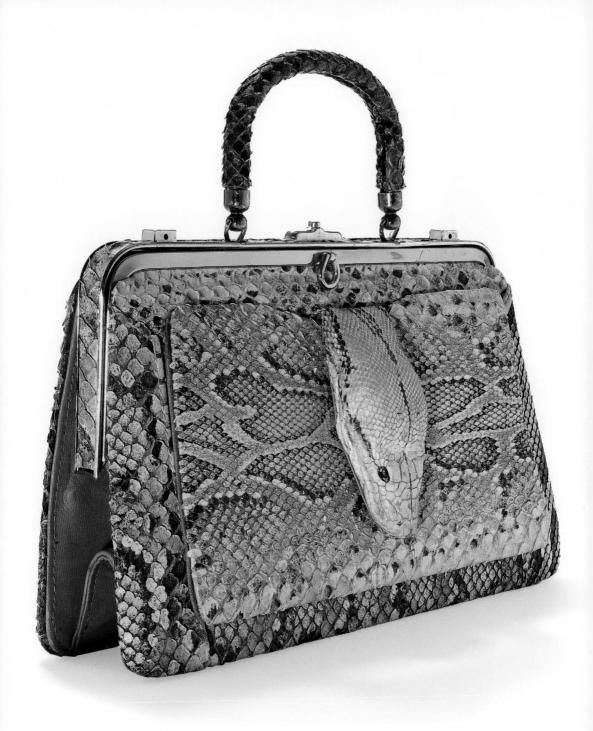

Snakeskin handbag, Indonesia, 1950s.

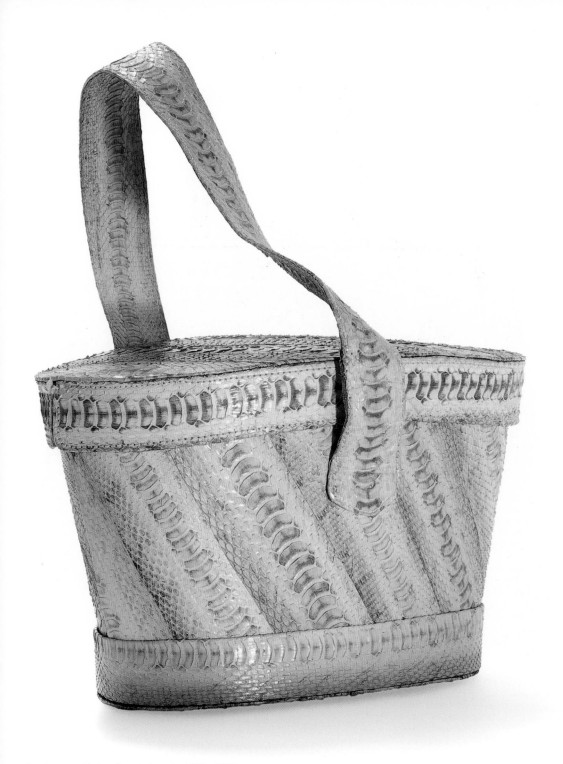

Rattlesnakeskin handbag, Indonesia, 1950s-1960s.

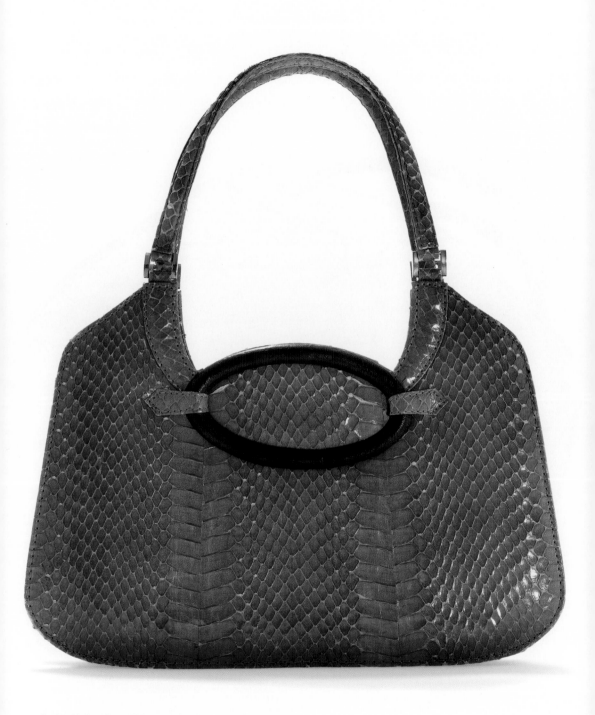

Snakeskin handbag, Blok van Heijst, The Netherlands, 1970.

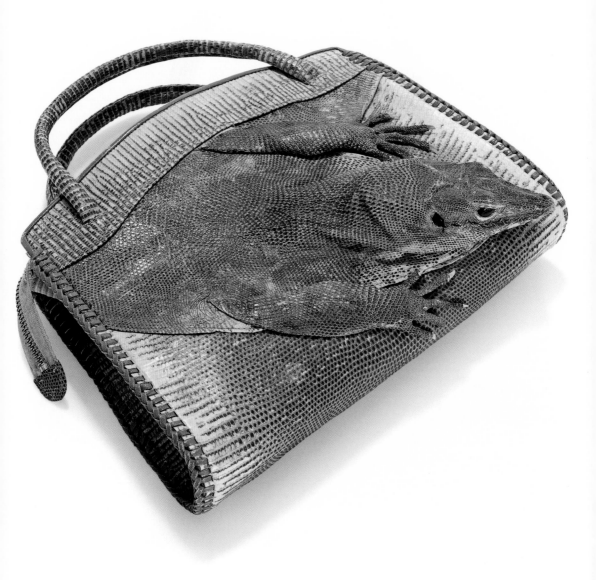

Lizard handbag, Indonesia, 1930s-1940s.

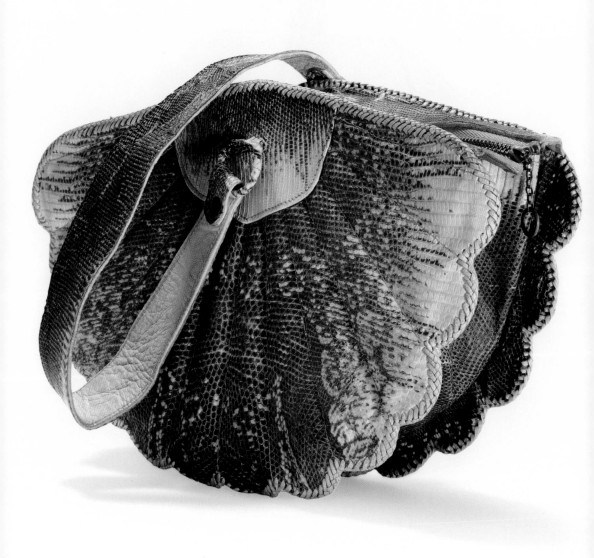

Lizard handbag, Indonesia, 1930s.

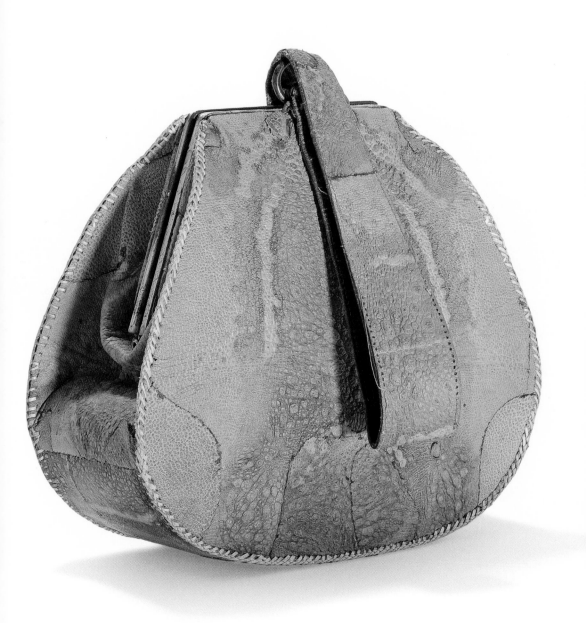

Toad leather handbag, Europe, 1930s.

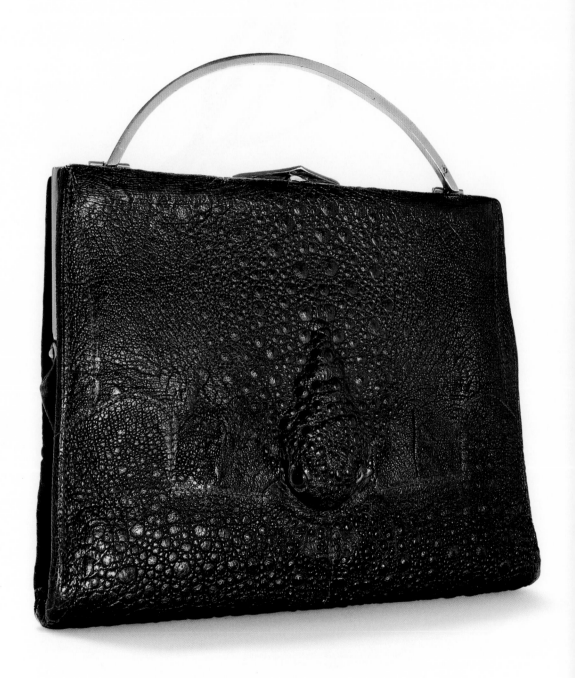

Toad leather handbag with chrome frame, England, 1930s.

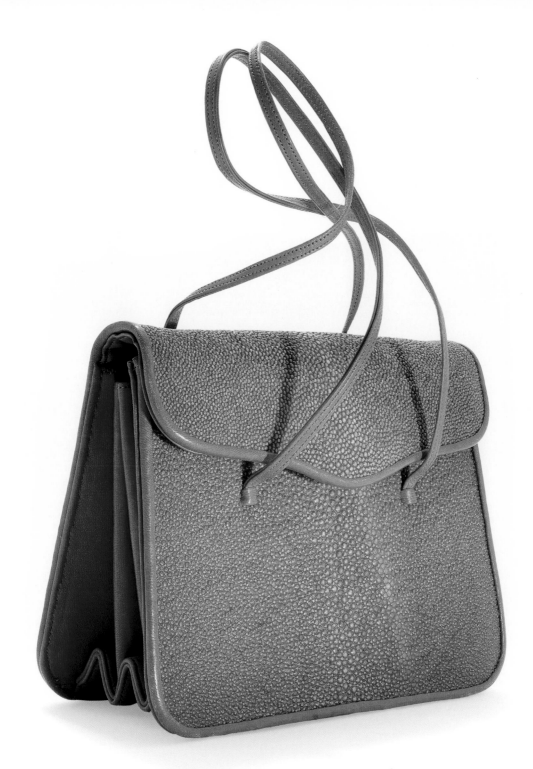

Stingray handbag, 'Jackie O', Judith Leiber (designed in 1963), U.S.A., 1995.

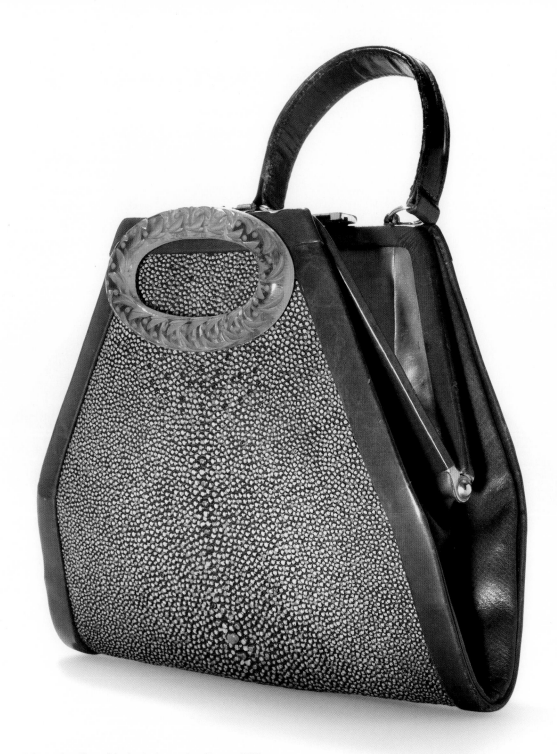

Stingray handbag with plastic decoration, France, 1930s.

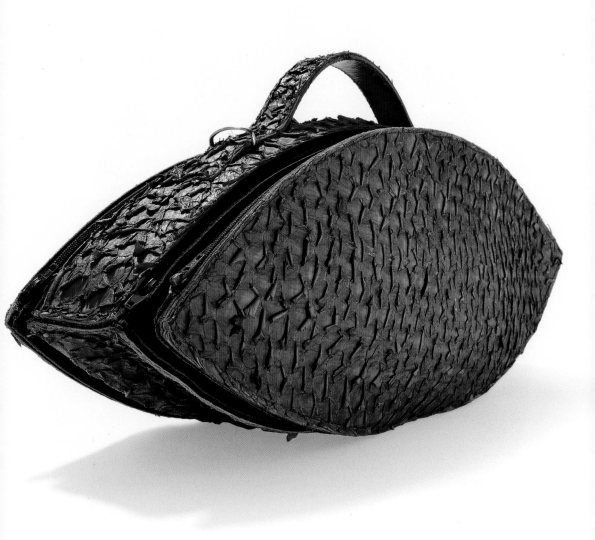

Nile perch handbag, Maria Hees, The Netherlands, 1993.

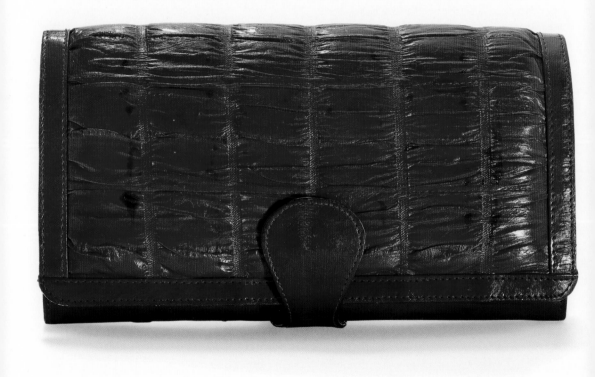

Eel skin clutch, 4th quarter 20th c.

Plant-derived materials

Plant-derived products such as straw, wicker, raffia and wood have been used throughout the ages to make or decorate implements. In the eighteenth and nineteenth centuries, many bags and letter cases or wallets were decorated with straw. Wicker, aloe and cactus fibres, wood and nuts have, apart from straw, also been used. The straw was first split and pressed flat and then applied to the wood, leather, cardboard or cloth background that was to be decorated. When used to decorate wallets or letter cases and bags, straw was, depending on the background, embroidered or pasted on. As is well-known, straw is naturally golden in colour; various colour nuances were obtained by heating the straw with a flatiron. The result could be further embellished by sprinkling and pasting on granules of gold or other metals, or by staining it in various colours.

In the twentieth century, plant-derived materials such as straw, raffia, wicker, wood and bamboo were mainly used to make woven bags and baskets. Although they are associated with being simple shopping bags, these baskets and bags were certainly prime fashion accessories in the spring and summer. In the fifties, bags made of imitation bamboo and straw were popular.

Plantaardige materialen

Plantaardige producten als stro, riet, raffia en hout zijn door de eeuwen heen gebruikt om gebruiksvoorwerpen te maken of te decoreren. In de achttiende en negentiende eeuw werden veel tassen en portefeuilles met stro gedecoreerd. Behalve stro werden ook riet, aloë- en cactusvezels, hout en noten gebruikt. Het stro werd eerst gesplitst en platgeperst en daarna aangebracht op de te decoreren ondergrond van hout, leer, karton of textiel. Stro ter decoratie van portefeuilles en tassen werd afhankelijk van de ondergrond geborduurd of geplakt. Van nature is stro, zoals men weet, goudkleurig; verschillende kleurnuances verkreeg men door het stro met de strijkbout te verhitten. Het resultaat kon nog verder verfraaid worden door het te bestrooien en te beplakken met korreltjes goud of ander metaal, of door het in verschillende kleuren te beitsen.

In de twintigste eeuw werden van plantaardige materialen als stro, raffia, riet, hout en bamboe voornamelijk gevlochten tassen en manden gemaakt. Hoewel ze met eenvoudige boodschappentassen geassocieerd worden, waren deze manden en tassen wel degelijk modieuze accessoires van het voorjaars- en zomerseizoen. In de jaren vijftig waren tassen van imitatiebamboe en –stro gewild.

Materiales de origen vegetal

Los productos derivados de plantas como la paja, el mimbre, la rafia y la madera se han utilizado en todas las épocas para elaborar o decorar utensilios. En los siglos XVIII y XIX, muchos bolsos y portafolios o carteras se decoraban con paja. Además de la paja, el mimbre y las fibras de áloe y cactos, también se han empleado madera y cáscaras de frutos secos. En primer lugar, la paja se separaba y se prensaba, y posteriormente se aplicaba al fondo de madera, cuero, cartón o tela que debía decorarse. En su uso como decoración de carteras o portafolios y bolsos, los adornos se bordaban o se pegaban sobre la paja, siempre dependiendo de las características del fondo. Como es sabido, el color natural de la paja es dorado, pero podían obtenerse variados matices cromáticos calentando la paja con la ayuda de una plancha. A su vez, el resultado podía embellecerse esparciendo por encima y pegando gránulos de oro u otros materiales o tiñéndola de varios colores.

En el siglo XX, los materiales de origen vegetal como la paja, la rafia, el mimbre, la madera y el bambú se empleaban sobre todo para realizar cestos y bolsas trenzados. A pesar de que generalmente se consideran simples recipientes para transportar la compra, estos cestos y bolsas eran accesorios de moda de primera línea en primavera y en verano. En la década de 1950 se popularizaron los bolsos confeccionados en paja y bambú de imitación.

Matières végétales

Les produits d'origine végétale comme la paille, l'osier, le raphia et le bois ont toujours été utilisés pour fabriquer ou décorer de petits ustensiles. Aux dix-huitième et dix-neuvième siècles, nombre de sacs et de portefeuilles étaient ornés de paille, sans compter les fibres d'osier, d'aloès et de cactus, ainsi que le bois et les noix. La paille était d'abord fendue, puis pressée à plat et appliquée sur une base de bois, de cuir, de carton ou de tissu à décorer. Pour les portefeuilles et sacs, la paille était brodée ou collée selon le fond. Outre sa couleur naturelle dorée, on obtenait différentes nuances colorées en la chauffant au fer à repasser ; le résultat pouvait être amélioré en appliquant dessus des granules d'or ou d'autres métaux ou par teinture.

Au vingtième siècle, les matériaux d'origine végétale comme la paille, le raphia, l'osier, le bois et le bambou ont surtout été utilisés pour des sacs et paniers tressés. Bien qu'assimilés à de simples paniers à provisions, ils constituent aussi des accessoires de mode essentiels au printemps et en été. Les sacs en imitation de bambou et paille ont connu un grand succès dans les années cinquante.

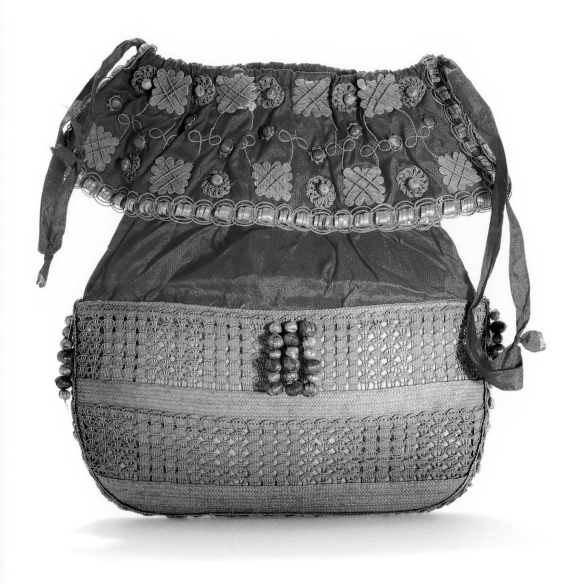

Reticule of silk and straw, 19th c.

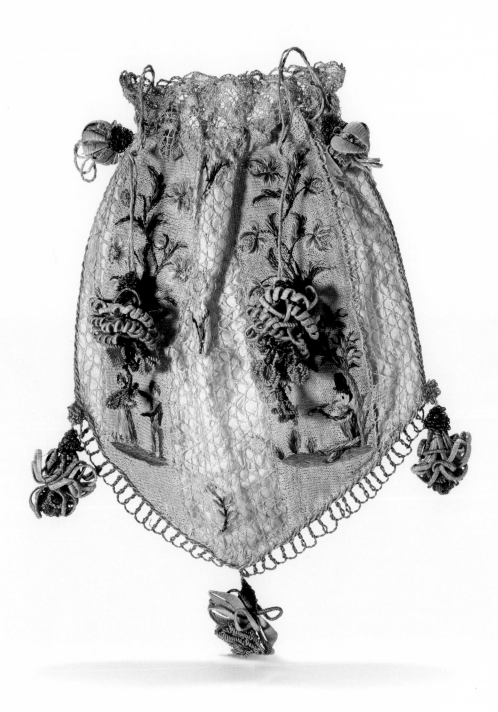

Reticule of aloe fibre and lace, France, late 18th c.

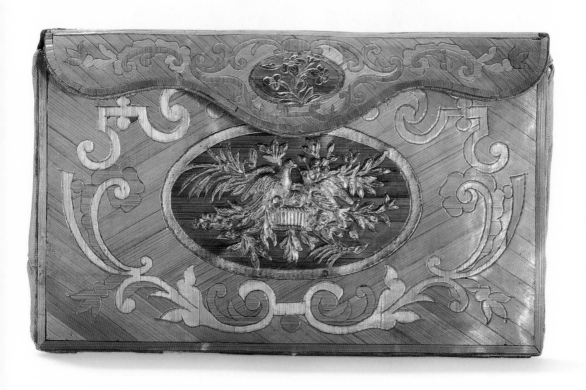

Letter case covered with coloured straw and with gilt decorations, France, late 18th c.

Wooden schoolbag with handpainted image, The Netherlands, 19th c.

Straw bag, Germany, early 20th c.

Straw handbag, Indonesia, 3nd quarter 20th c.

Rattan basket with appliqué decoration and fabric lining, Annie Laurie Originals, U.S.A.,1950s.

Straw handbag with embroidery, Princess Charming by Altas/Hollywood Fla., Hong Kong, 1950s.

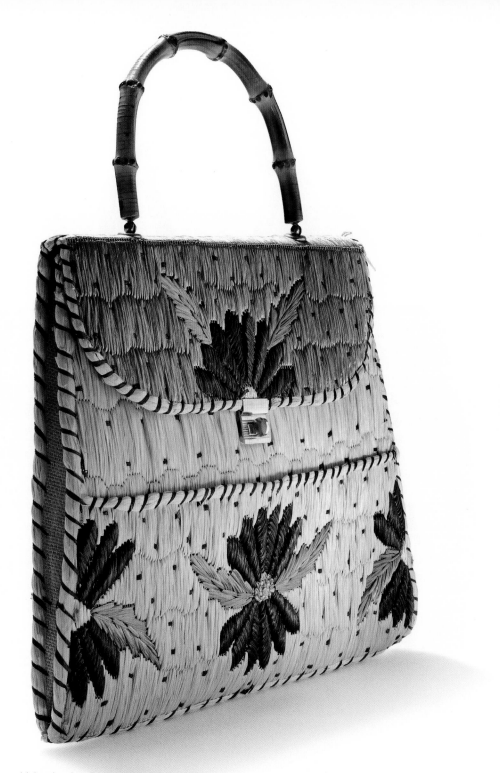

Raffia handbag with bamboo handle, The Netherlands, 1970s.

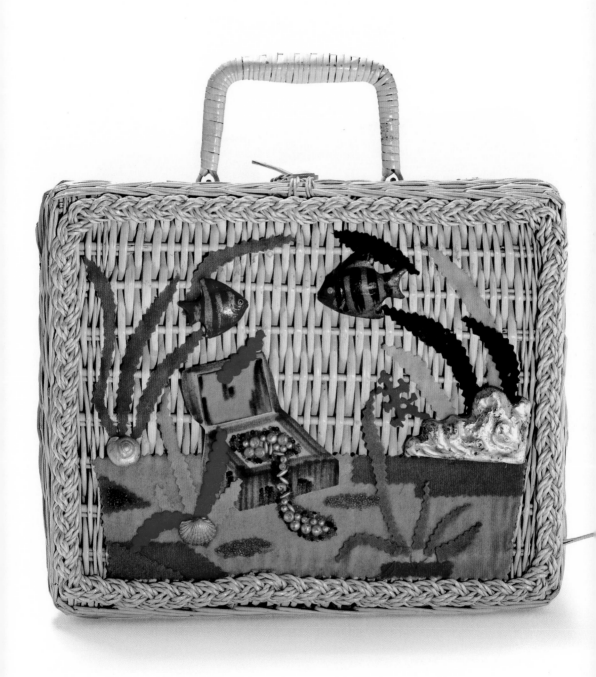

Straw basket with emboidery, U.S.A.,1960s.

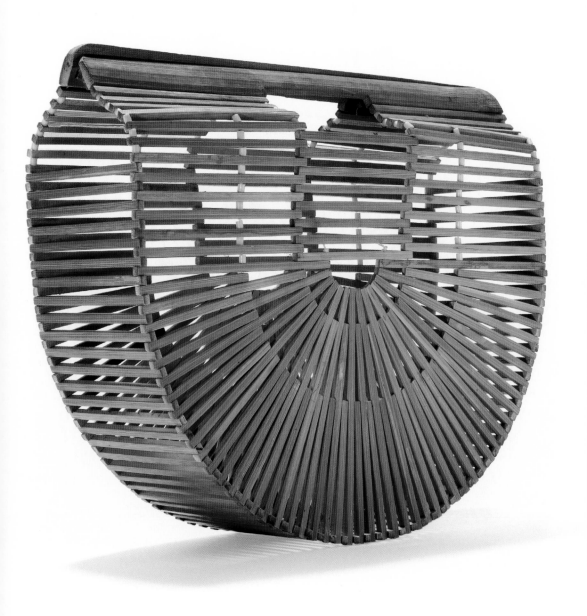

Bamboo basket bag, Italy, 1974.

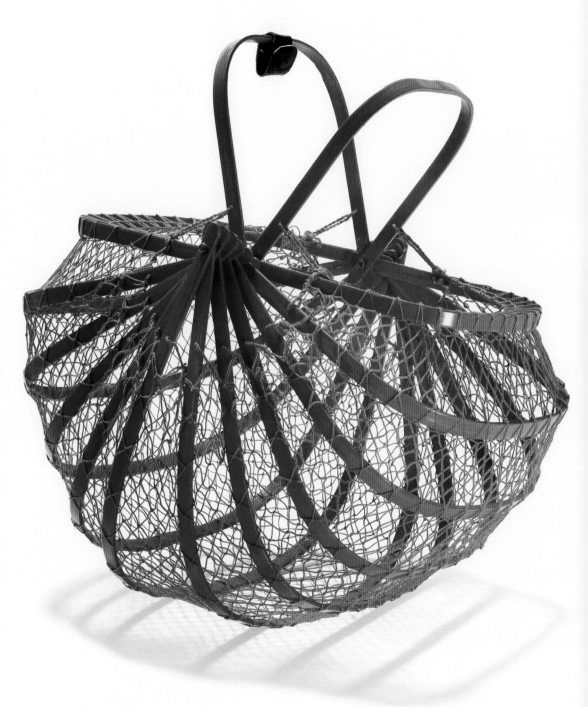

Folding bamboo handbag, Japan, 1970s.

Beadwork

In the past two hundred years, beaded bags and pouches have been very popular in certain periods. Although it was certainly not easy, knitting with beads became popular at the beginning of the nineteenth century. An experienced knitter needed two full working weeks to complete a beaded bag: more than 50,000 beads had to be strung in the right order according to the pattern - without making a mistake - before the bag could be knitted. Patterns were sold in many versions or could be obtained from almanacs and women's magazines. Flowers, temples, gravestones, weeping willows, harps, hunting scenes and smoking Chinese people frequently adorned nineteenth century beaded bags and pouches. Because of the arduous and time-consuming technique, owning one of these beaded bags was considered a true luxury.

In the early decades of the twentieth century, beaded bags were fitted with drawstrings as handles or finished off with decorative frames made of metal, tortoiseshell or plastic. Popular motifs included flowers, picturesque landscapes with traditional houses, castles and ruins, children, historical tableaux and oriental carpets. Other bags had Cubist or Art Deco motifs.

In the twenties, handbags were also made from cut steel or aluminium beads. The cut steel beads were at first only available in gold, silver and bronze colours, but later in France they were also made in other colours.

After 1930, beaded bags lost some of their prominence. But a particular type of beaded bag was still fashionable for some time: the envelope style. Large, heavy, box-shaped bags in gleaming bronze, black, blue and white beads were all the rage in the United States in the forties.

Kralen

De afgelopen tweehonderd jaar waren kralentassen en -buidels in bepaalde periodes zeer gewild. Hoewel het bepaald niet gemakkelijk was, werd begin negentiende eeuw het breien met kralen populair. Een geoefend breister had twee volledige werkweken nodig om een kralentas te maken: meer dan 50.000 kralen moesten volgens patroon in de juiste volgorde geregen worden – zonder fouten te maken –, voordat de tas gebreid kon worden. Patronen waren in vele uitvoeringen te koop of over te nemen uit almanakken en tijdschriften. Bloemen, tempels, grafzerken, treurwilgen, harpen, jachttaferelen en rokende Chinezen sierden de negentiende-eeuwse kralentassen en -buidels. Door de bewerkelijke en tijdrovende techniek behoorden deze kralentassen tot de luxueuze producten.

In de eerste decennia van de twintigste eeuw werden kralentassen uitgevoerd met trekkoorden als hengsel of afgewerkt met decoratieve beugels van metaal, schildpad of kunststof. Populaire motieven waren bloemen, pittoreske landschappen met traditionele huizen, kastelen en ruïnes, kinderen, historische taferelen en oosterse tapijten. Andere tassen hadden kubistische of Art Deco-motieven.

In de jaren twintig werden tassen ook van geslepen stalen kralen of van aluminiumkralen gemaakt. De kralen van geslepen staal waren in eerste instantie alleen in goud-, zilver- en bronskleur te krijgen, maar werden later in Frankrijk ook in andere kleuren gemaakt.

Na 1930 speelde de kralentas een bescheidener rol. Wel was een bijzonder type kralentas nog enige tijd in de mode: de envelopstijl. Grote, zware doosvormige tassen in glinsterende bronzen, zwarte, blauwe en witte kralen waren in de jaren veertig een rage in de Verenigde Staten.

Cuentas y abalorios

En los últimos doscientos años, los bolsos y morrales con abalorios han gozado de gran aceptación en determinados momentos. A pesar de que resultaba realmente complicado, tejer con abalorios cobró gran popularidad a principios del siglo XIX. Una persona especializada precisaba de dos semanas enteras de trabajo para terminar un bolso de este tipo, pues tenía que colocar más de 50.000 cuentas o abalorios en el orden correcto –sin cometer un solo error– según dictara el patrón, antes de poder tejer el bolso. Había patrones de todo tipo a la venta y también podían extraerse de almanaques y revistas femeninas. Los motivos más frecuentes en la ornamentación de bolsos con cuentas o morrales del siglo XIX eran: flores, templos, lápidas, sauces llorones, arpas, escenas de caza e imágenes de personas de origen chino fumando. Puesto que era una técnica ardua y laboriosa, poseer uno de estos bolsos se consideraba un verdadero lujo.

En las primeras décadas del siglo XX, los bolsos con abalorios se proveían de cordones a modo de asas o se remataban con boquillas decorativas realizadas en metal, carey o material sintético. Entre los motivos más populares encontramos flores, paisajes pintorescos con casas tradicionales, castillos y ruinas, niños, tableros históricos y alfombras orientales. Otros bolsos presentan motivos cubistas o art déco.

En la década de 1920, los bolsos de mano también se realizaban con cuentas de acero cortado o de aluminio. Al principio, las cuentas de acero cortado sólo se comercializaban en los colores oro, plata o bronce pero, posteriormente, en Francia también se encontraban en otros colores.

Si bien después de 1930, los bolsos con cuentas o abalorios perdieron parte de su importancia, hubo un tipo muy especial de bolso que siguió en boga: el bolso de estilo sobre. Estos bolsos largos, pesados y en forma de caja con relucientes cuentas de color bronce, negro, azul y blanco fueron el último grito en Estados Unidos durante los años cuarenta.

Perles

Depuis deux cent ans, les sacs et bourses perlés ont connu plusieurs périodes de grand succès. Malgré la difficulté que la technique représente, le tricotage de perles était très populaire au début du dix-neuvième siècle. Un tricoteur expérimenté mettait alors deux bonnes semaines pour un sac perlé : plus de 50 000 perles devaient être enfilées dans le bon ordre selon le motif voulu (sans droit à l'erreur) avant de pouvoir tricoter le sac. Des motifs de toutes sortes étaient vendus ou offerts dans les almanachs et journaux : fleurs, temples, tombes, saules pleureurs, harpes, scènes de chasse et des Chinois en train de fumer étaient les plus fréquents. En raison de la complexité et de la longueur de la tâche, posséder un sac perlé était alors considéré comme un véritable luxe.

Dans les premières décennies du vingtième siècle, les sacs perlés étaient dotés de cordons en guise de poignées ou fermés par des fermoirs décoratifs en métal, écaille ou plastique. Les motifs les plus en vogue comprenaient les fleurs, les paysages pittoresques aux maisons traditionnelles, les châteaux et les ruines, les enfants, les tableaux historiques et les tapis d'Orient. Certains sacs affichent aussi des motifs cubistes ou art déco.

Dans les années vingt sont apparus des sacs à main en perles d'acier coupé ou d'aluminium. Le premier type n'a d'abord été disponible que dans les teintes doré, argenté et bronze, puis d'autres couleurs sont venues s'y ajouter en France.

Après 1930, les sacs perlés ont perdu leur place de choix, à l'exception d'un style particulier resté en vogue quelque temps : l'enveloppe. Ces grands sacs lourds en forme de boîte et ornés de perles bronze, noires, bleues et blanches brillantes ont fait fureur aux États-Unis dans les années quarante.

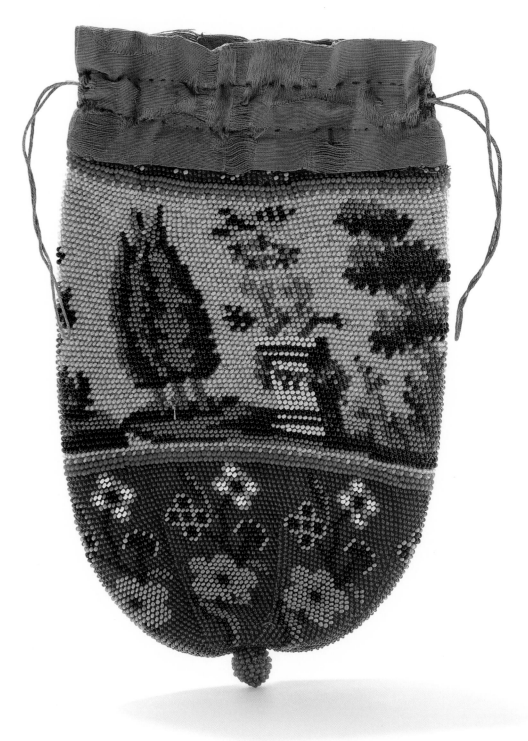

Beaded reticule, France, 1820-1850.

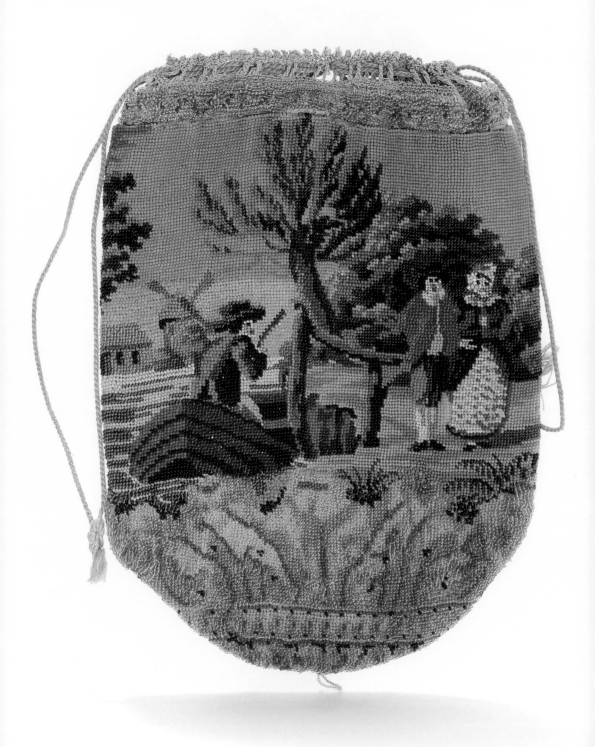

Glass beaded reticule, The Netherlands, 1820-1830.

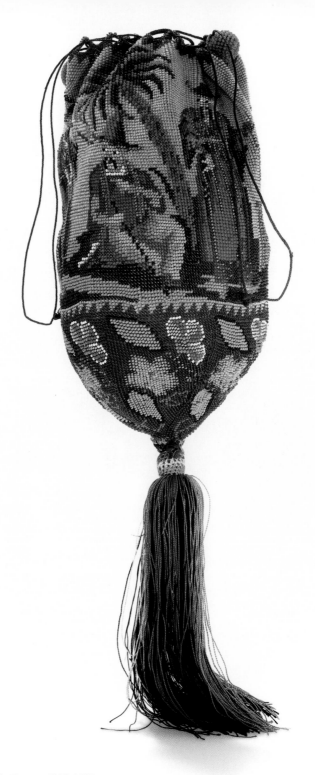

Glass beaded reticule, Europe, 1820-1850.

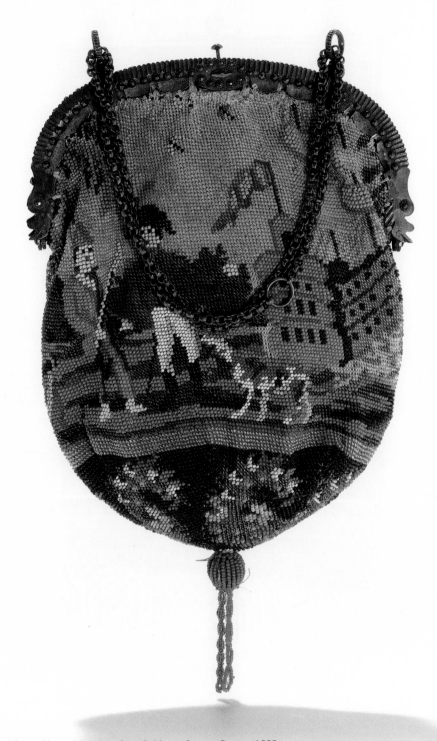

Glas beaded framed bag with scenes from Robinson Crusoe, Europe, 1820.

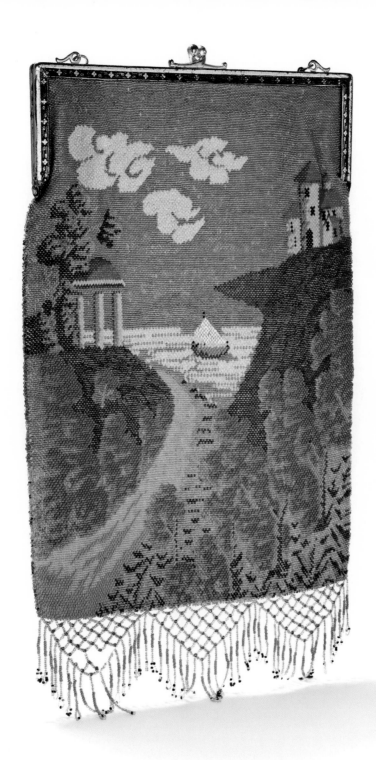

Beaded handbag with silver frame and chain, Germany, 1920s.

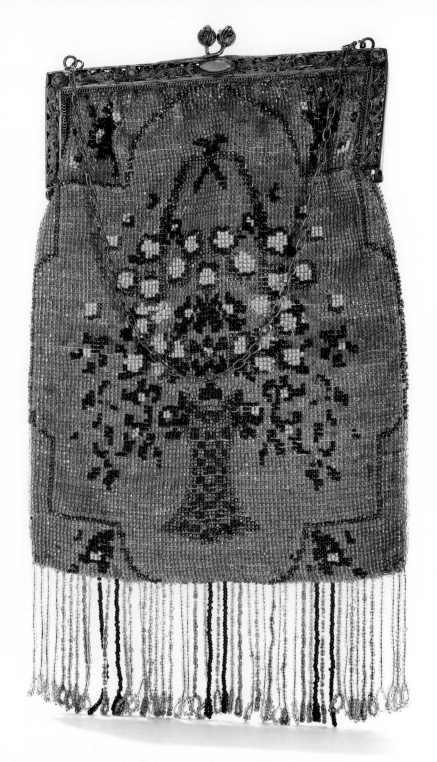

Beaded handbag with frame encrusted with glass stones, Germany, 1920s.

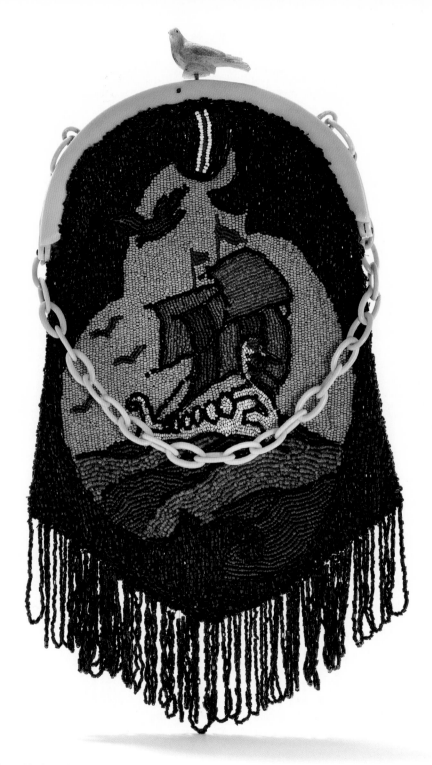

Beaded handbag with plastic frame to imitate ivory, Germany, 1920s.

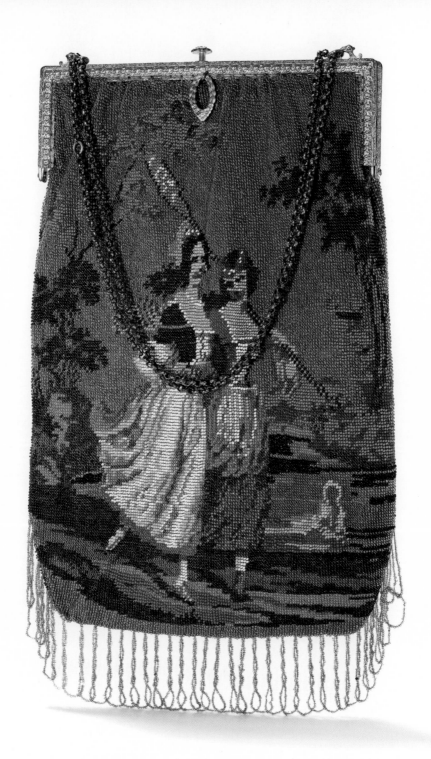

Beaded handbag with scene 'the Butterfly Hunters', Germany, 1920s.

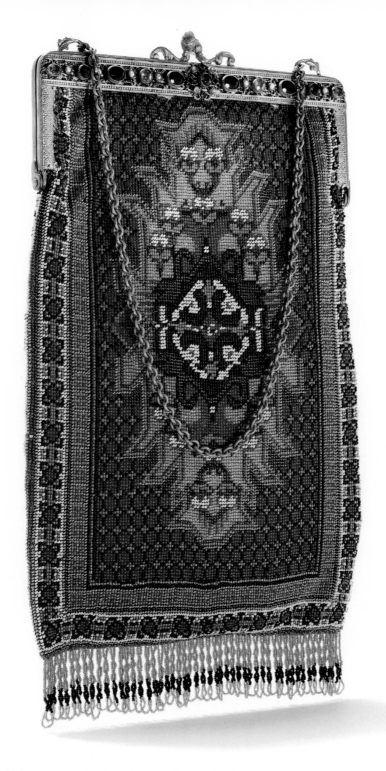

Beaded handbag with frame encrusted with glass stones, Germany, 1920s.

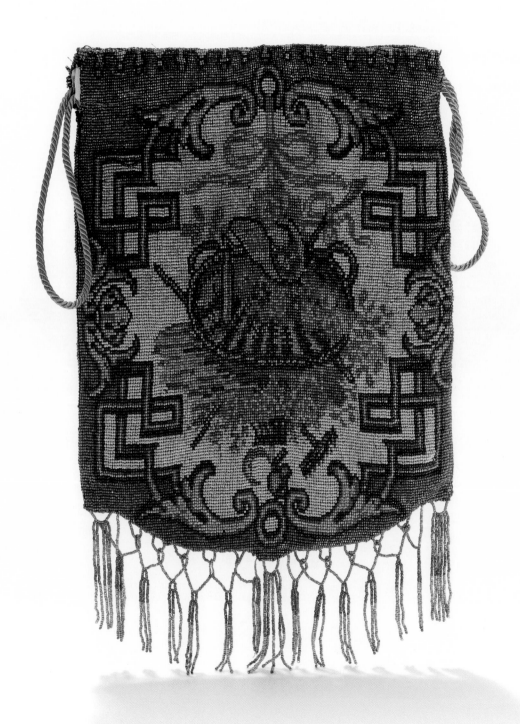

Steel beaded reticule, France, 1920s.

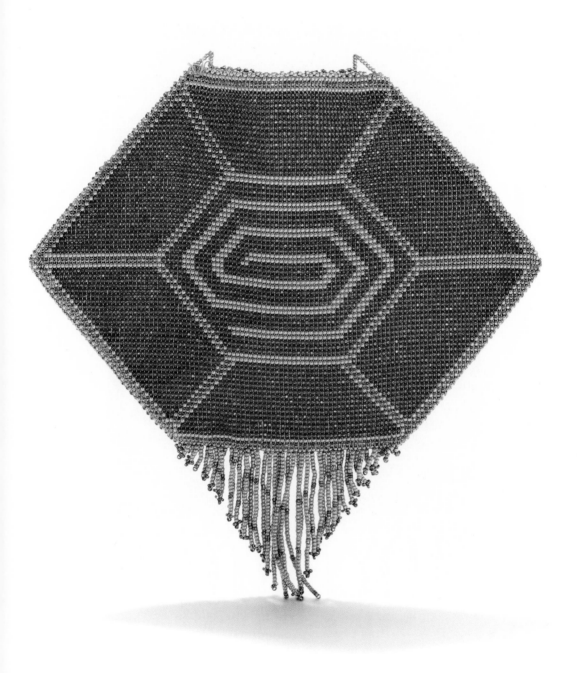

Aluminium beaded handbag, France, ca. 1927.

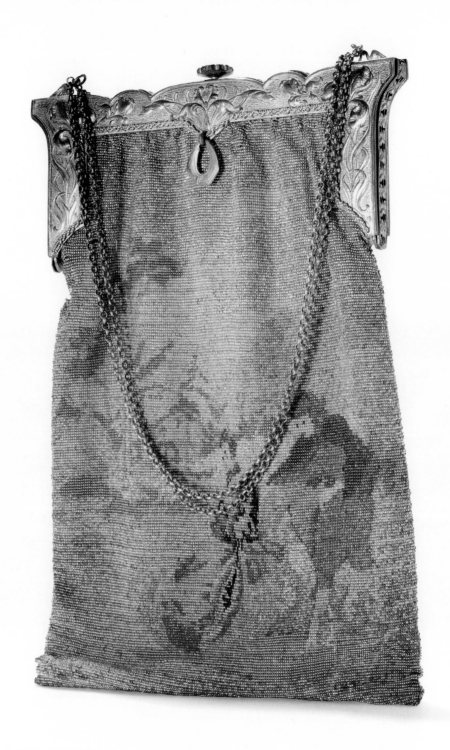

Steel beaded handbag with steel frame, France, 1920s.

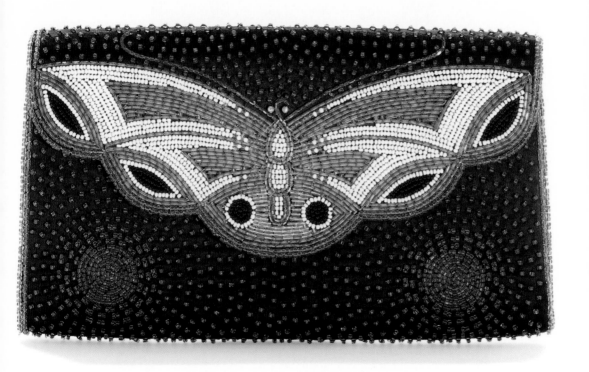

Silk clutch with beaded embroidery, France, 1930s.

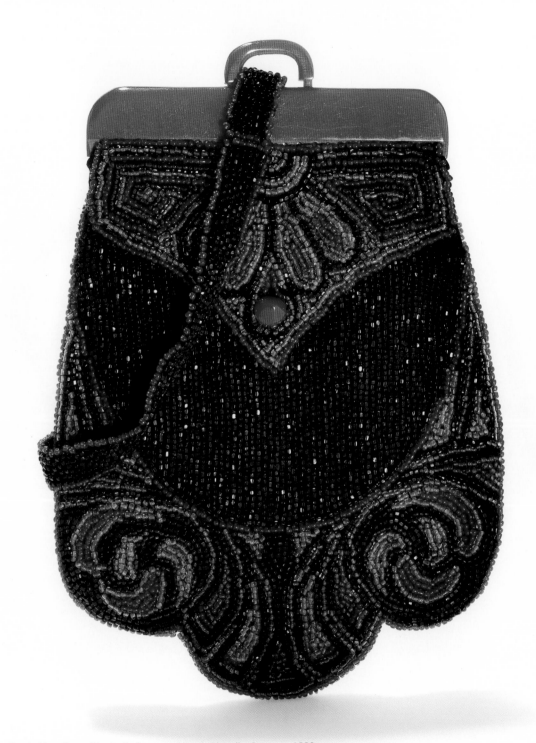

Beaded handbag with plastic frame and beaded handle, Germany, 1920s.

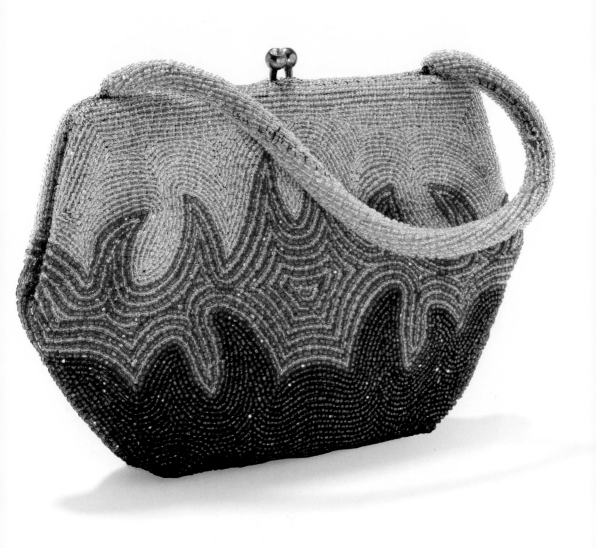

Beaded handbag, Belgium, 1930s.

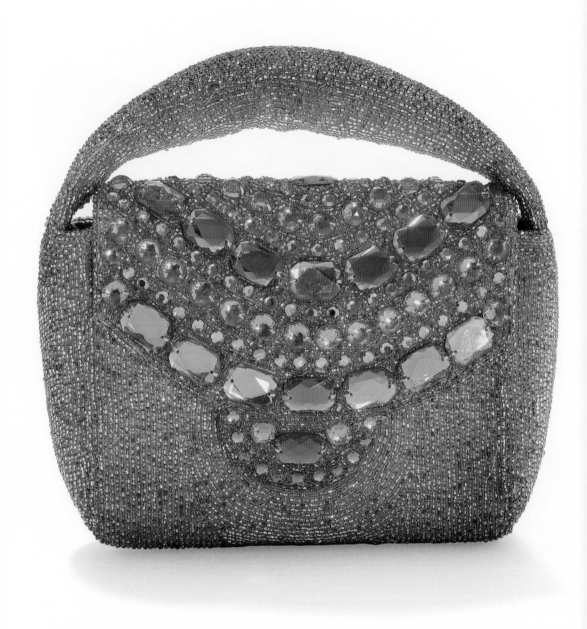

Beaded evening bag embroidered with beads and glass stones, Belgium, 1950s-1960s.

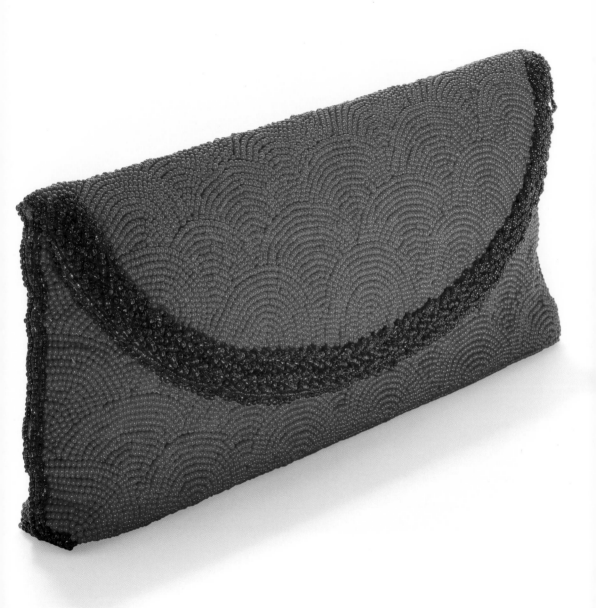

Beaded evening clutch, Belgium, 1950s-1960s.

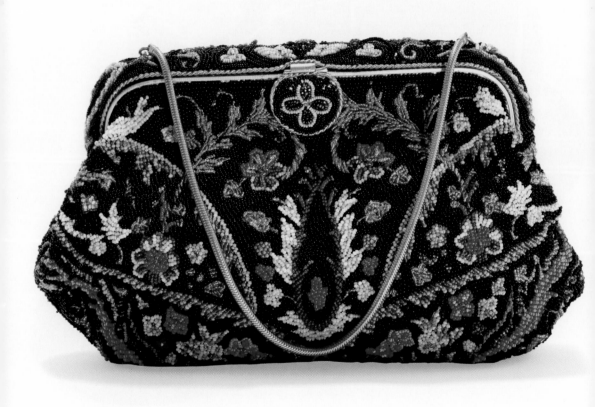

Beaded evening bag with bead-covered frame, France, 1950s-1960s.

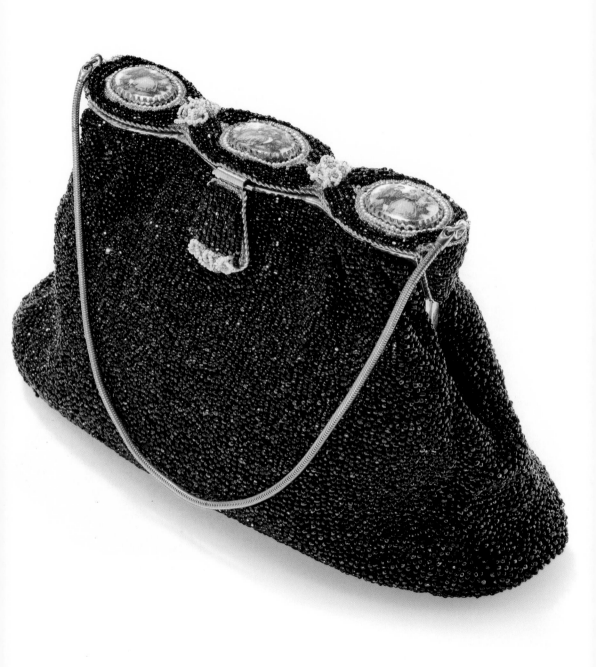

Beaded evening bag with enamel images on frame, U.S.A., 1940s.

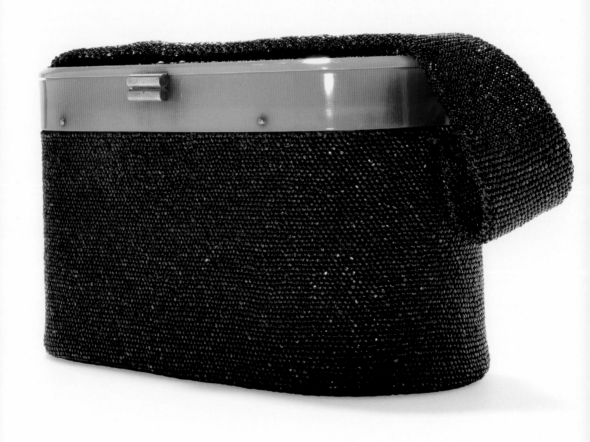

Beaded box-shaped handbag with plastic lid, U.S.A., 1940s.

Petit-point, lace and cloth

Until the nineteenth century, fine needlework was performed not only by women as a home industry, but also by professional embroiderers. Partly due to technological developments, the variety of needlework techniques increased sharply. Although less very fine needlework was done at that time, there were many techniques for making reticules, such as Berlin wool work, black work, lace, weaving, embroidery, crocheting and knitting.

One of the techniques still used today in the manufacture of handbags is petit point: embroidery in half cross-stitch on canvas. Petit point became popular in the nineteenth century due to the use of coloured grid patterns, in which each grid cell stood for a stitch. These patterns were also used for other needlework techniques. The technique was so simple that both professional embroiderers and women at home used them. Paris and Vienna were the most important centres for professional petit-point bags. Depictions of animals, flowers and people are often seen on petit-point bags.

Another needlework technique that has been around for a long time is lace making. Little bridal bags or communion bags were often made of white lace. Irish needlework technique is also used for this kind of bag. There are also white lace bags that have most likely been used as evening bags. Due to the delicate nature of the material, lace bags are not often found.

Printing on cloth is a technique that was employed quite frequently in the twentieth century, also in the production of bags.

Petit-point, kant en textiel

Het fijne handwerk werd tot in de negentiende eeuw door vrouwen met huisvlijt uitgevoerd, maar ook door professionele borduurders. Mede door technologische ontwikkelingen nam de variatie in handwerktechnieken snel toe. Hoewel het zeer fijne handwerk in die tijd steeds minder gedaan werd, waren er vele technieken voor het maken van reticules, zoals Berlijns wolwerk, blackwork, kant, weven, borduren, haken en breien.

Een van de technieken die tegenwoordig bij de fabricage van tassen nog steeds wordt gebruikt, is petit-point: met halve kruissteken op stramien borduren. Petit-point werd in de negentiende eeuw populair door het gebruik van gekleurde ruitjespatronen, waarbij ieder ruitje stond voor een steek. Deze patronen werden ook voor andere handwerktechnieken benut. De techniek was zo eenvoudig, dat zowel professionele borduurders als vrouwen thuis er gebruik van maakten. Parijs en Wenen waren de belangrijkste centra voor professionele petit-point-tassen. Men ziet op petit-point-tassen vaak voorstellingen van dieren, bloemen en mensen.

Een andere handwerktechniek die al lang bestaat, is het maken van kant. Vaak werden bruidstasjes of communietasjes van wit kant gemaakt. Ook de Ierse haakwerktechniek werd bij dit soort tasjes toegepast. Daarnaast kennen we tasjes van wit kant die hoogstwaarschijnlijk als avondtasjes gediend hebben. Gezien de kwetsbaarheid van het materiaal komen kanten tasjes niet veel voor.

Het bedrukken van stof is een techniek die in de twintigste eeuw veel werd toegepast, ook bij de productie van tassen.

Petit-point, encajes y tela

Hasta el siglo XIX, las labores de costura eran realizadas no sólo por mujeres en el ámbito de la artesanía doméstica sino también por profesionales del bordado. En parte como resultado de los avances técnicos, la variedad de técnicas de labores aumentó de forma espectacular. A pesar de que en aquella época se realizaba una menor cantidad de labores delicadas, existían muchas técnicas para confeccionar retículas, como la técnica berlinesa, los bordados negros, el encaje, el tejido, el bordado, el ganchillo y el punto de media.

Una de las técnicas que se siguen empleando hoy en día en la producción de bolsos de mano es el petit-point, el bordado de medio punto sobre cañamazo. Esta técnica se difundió en el siglo XIX debido al uso de patrones de rejilla coloreados, en los que cada cuadrado de la rejilla representaba un punto. Estos patrones también se utilizaban para aplicar otras técnicas de costura. Era una técnica tan sencilla que podían usarla tanto las bordadoras profesionales como las mujeres en sus casas. París y Viena eran los centros más importantes de producción profesional de bolsos realizados en petit-point. En ellos abundan los motivos de animales y plantas, y también se representaban personas.

Otra técnica de labores que ha perdurado durante largo tiempo son los encajes. Era frecuente confeccionar pequeños bolsos nupciales o de comunión de encajes blancos. Para este tipo de bolsos también solía utilizarse la técnica de ganchillo irlandesa. Existen asimismo algunos bolsos hechos con encajes blancos que probablemente se usaran como bolsos de noche. Debido a la delicada naturaleza del material, encontramos pocos ejemplos de estos bolsos.

La impresión sobre tela es una técnica que se difundió ampliamente en el siglo XX, también en la producción de bolsos.

Petit point, dentelle et toile

Jusqu'au cours du dix-neuvième siècle, les travaux d'aiguille délicats n'étaient pas uniquement l'apanage des femmes au foyer car des brodeurs professionnels exerçaient aussi. Grâce, entre autres, aux progrès techniques, les méthodes se sont grandement diversifiées : les travaux d'aiguille très raffinés se sont réduits à cette époque, alors que les techniques de fabrication des réticules y sont nombreuses, comme la broderie de laine, le blackwork (broderie contrastée), la dentelle, le tissage, la broderie, le crochet ou le tricot.

L'une de ces techniques sert aujourd'hui encore à la confection de sacs à main, à savoir le petit point ou broderie sur canevas. Le petit point perce au dix-neuvième siècle avec l'emploi de canevas aux motifs colorés ; chaque trou de la grille représente un point. Ces canevas étaient aussi utilisés pour d'autres travaux d'aiguille, avec une technique si simple qu'elle était employée autant dans les maisons que par les brodeurs professionnels. Paris et Vienne étaient alors les principaux centres de sacs au petit point, dont la plupart portent des représentations d'animaux, fleurs et de figures humaines.

Autre technique d'aiguille très ancienne, la dentelle (notamment blanche) a été amplement utilisée pour les petites bourses de mariage ou de communion (également confectionnées en dentelle irlandaise). On trouve aussi des sacs de soirée en dentelle blanche, même si leur fragilité fait qu'ils sont rares et difficiles à trouver.

L'impression sur tissu est une technique également employée au vingtième siècle et se retrouve dans la production de sacs.

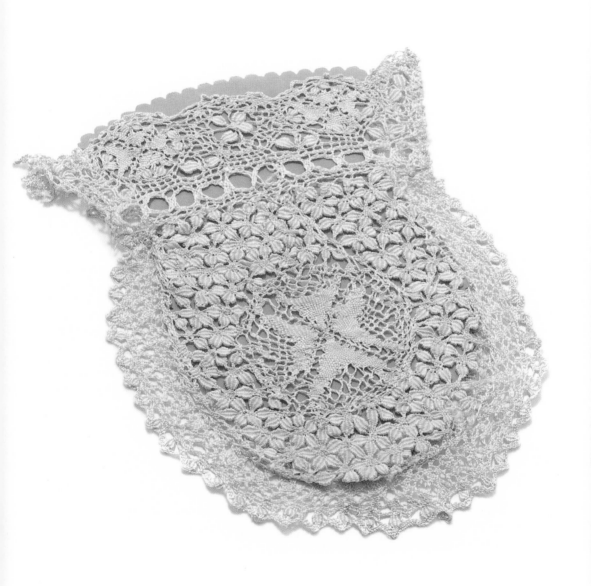

Lace reticule, Belgium, early 20th c.

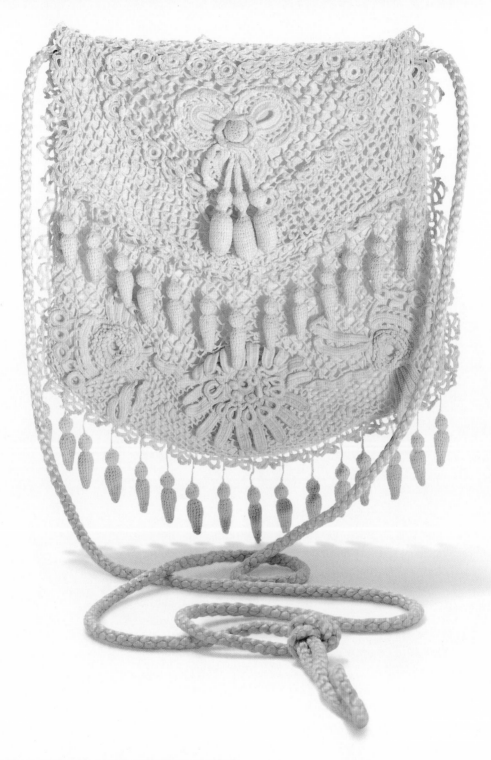

Irish crochet bag with crocheted tassels, Europe, 1910s.

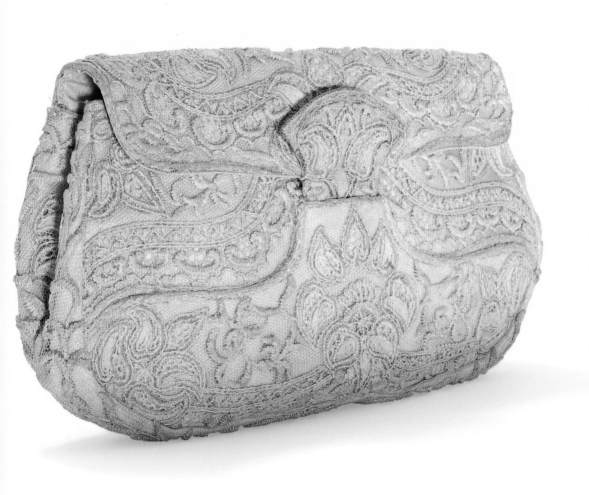

Lace clutch, **Mayer,** France, ca. 1929.

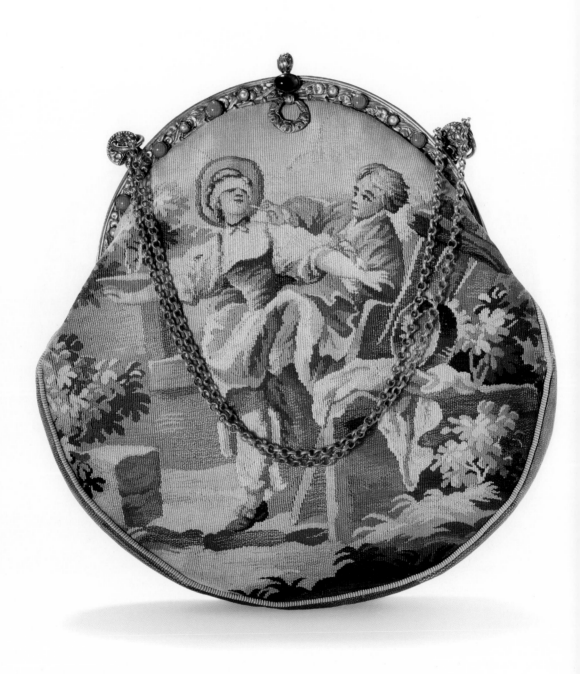

Petit-point handbag with glass stones and imitation pearls on frame, Austria, 1920s-1930s.

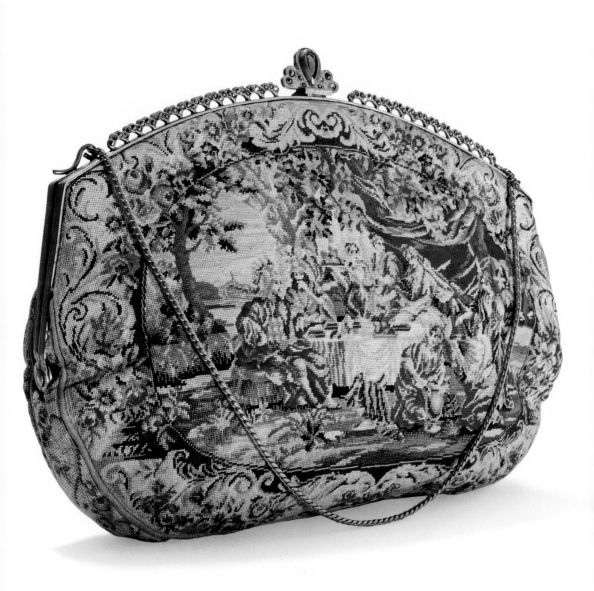

Petit-point handbag with encrusted frame, Austria, 1920s-1930s.

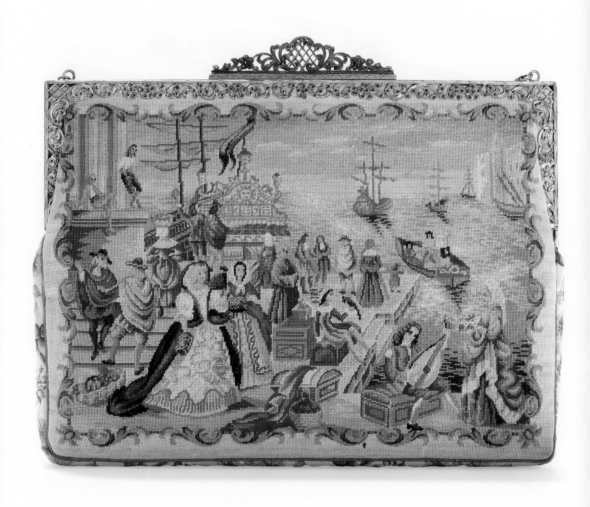

Petit-point handbag with encrusted frame, Austria, 1950s-1960s.

Fabric clutch with embroidery and chrome frame, France, 1925-1935.

Fabric evening bag and matching coinpurse embroidered with silk, gold-coloured thread and glass stones, France, 1940s.

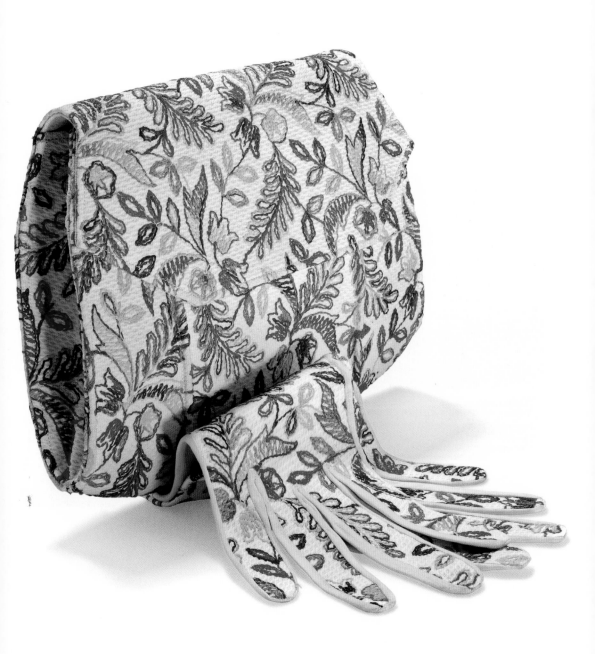

Fabric clutch embroidered with silk and matching gloves, Alexandrine, France, 1930s.

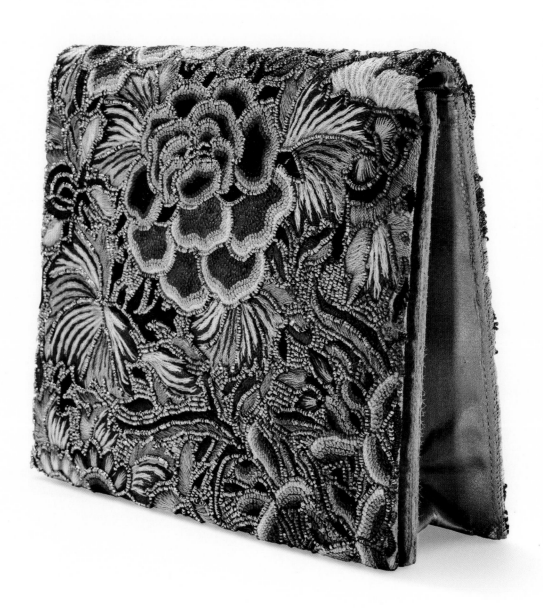

Silk clutch embroidered with silk and cut-steel beads, Duvelleroy, France, 1930s.

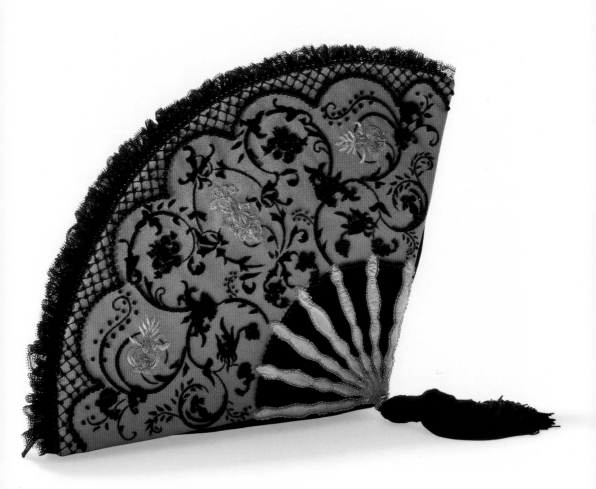

Embroidered evening bag, studio Lesage, designed by Gerard Tremolet, France, 1988.

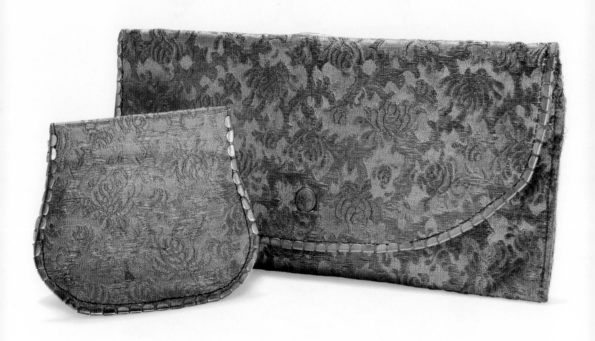

Brocade clutch with matching purse, France, 1920s-1930s.

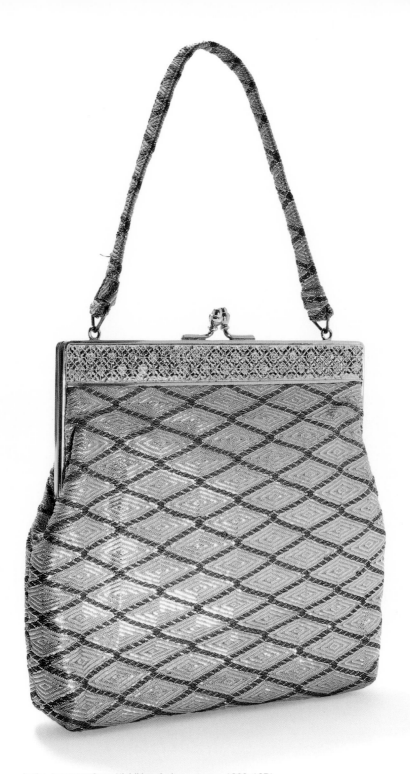

Silk handbag woven in the Japanese Saga Nishiki technique, Japan, 1968-1971.

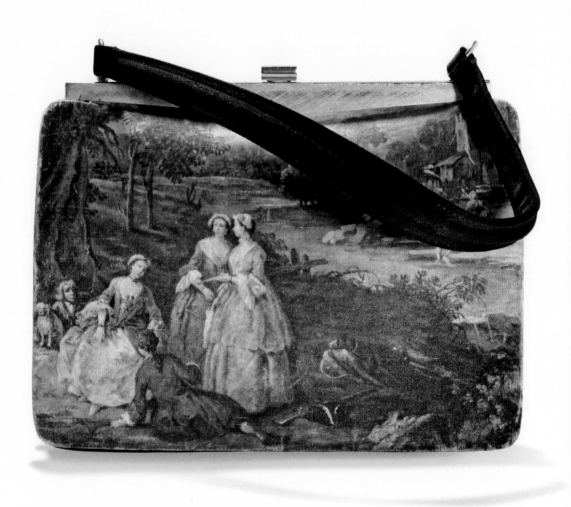

Silk handbag with printed image, Italy, 1930s.

Metal and ring mesh

Starting at the end of the nineteenth century, bags and purses made of metal were highly popular, especially silver and ring mesh. Ring mesh consists of little metal rings or plates linked to each other to form a web, like in the chain mail coats of medieval knights. Ring mesh bags were expensive because the rings had to be attached to each other one by one. They were often made of silver, but silver-plated and other metal versions also appeared. Jewellers and accessory firms specialised in the construction of the ring mesh bags and purses. Germany and the United States were major producers.

From 1909 onward, ring mesh bags became considerably cheaper due to the invention of a machine for manufacturing ring mesh (by the American, A.C. Pratt). Another American company, Whiting & Davis, acquired the patent and became the best known company in the world in this field. They manufactured bags designed by well-known fashion designers such as Paul Poiret and Elsa Schiaparelli. Starting in 1918, Whiting & Davis sold bags made of so-called Dresden ring mesh, extraordinarily fine ring mesh named after the designer of this material, who lived in Germany. By enamelling the little plates or rings in various colours, multi-coloured images were made that fitted in well with the prevailing Art Deco style of the twenties and thirties. At present, the company still sells ring mesh bags, fashion accessories and clothing.

Another American company that was famous in the interwar years for its ring mesh bags was the company Mandalian. The founder Sahatiel G. Mandalian was of Turkish descent, which perhaps explains the subtle oriental influence in his bags.

Metaal en maliën

Vanaf het einde van de negentiende eeuw waren tassen en beurzen van metaal bijzonder populair, vooral zilver en maliën. Maliën zijn metalen ringetjes of plaatjes die met elkaar verbonden zijn tot een netwerk, zoals in de maliënkolders van middeleeuwse ridders. De maliëntassen waren kostbaar, doordat de ringetjes één voor één aan elkaar werden gezet. Vaak waren ze van zilver, maar ook verzilverde en andere metalen uitvoeringen kwamen voor. Juweliers en sieradenfirma's specialiseerden zich in de vervaardiging van de maliëntassen en -beursjes. Duitsland en de Verenigde Staten waren belangrijke producenten.

Vanaf 1909 werden maliëntassen aanzienlijk goedkoper door de uitvinding (door de Amerikaan A.C. Pratt) van een machine voor de productie van maliën. De eveneens Amerikaanse firma Whiting & Davis verwierf de patenten en werd wereldwijd het bekendste bedrijf op dit gebied. Ze liet tassen ontwerpen door bekende modeontwerpers als Paul Poiret en Elsa Schiaparelli. Vanaf 1918 verkocht Whiting & Davis tassen van zogeheten Dresden-maliën: buitengewoon fijne maliën, genoemd naar de in Duitsland woonachtige ontwerper van dit materiaal. Door de kleine plaatjes of ringetjes in verschillende kleuren te emailleren, konden in de jaren twintig en dertig veelkleurige voorstellingen worden gemaakt die goed pasten in de populaire Art Deco-stijl. Tegenwoordig verkoopt het bedrijf nog steeds tassen, modeaccessoires en kleding van maliën.

Een ander Amerikaanse bedrijf dat in het interbellum beroemd was om zijn maliëntassen, was de firma Mandalian. De oprichter Sahatiel G. Mandalian was van Turkse afkomst, wat misschien de subtiele oosterse invloed in zijn tassen verklaart.

El metal y la malla de aros

Ya a finales del siglo XIX, los bolsos y monederos realizados en metal gozaban de gran aceptación, sobre todo los de plata y malla de aros. La malla de aros está formada por pequeños aros metálicos unidos los unos a los otros para formar una especie de red, como ocurre en la cota de malla de los caballeros medievales. Los bolsos confeccionados con malla de aros resultaban caros porque los aros debían unirse entre sí uno a uno. A menudo se realizaban en plata, pero también aparecieron versiones chapadas en plata y otros metales. Hubo joyeros y empresas de accesorios que se especializaron en la elaboración de bolsos y monederos de malla de aros. Entre los mayores productores se encuentran Alemania y Estados Unidos.

A partir de 1909, los bolsos de malla de aros se volvieron bastante asequibles gracias al invento (por parte del estadounidense A. C. Pratt) de una máquina que producía la malla. Otra empresa americana, Whiting & Davis, adquirió la patente y se convirtió en la empresa más célebre en este campo a nivel mundial. Producía bolsos creados por célebres diseñadores de moda de la talla de Paul Poiret y Elsa Schiaparelli. En 1918, Whiting & Davis comenzó a vender bolsos confeccionados con malla de aros de Dresde, una malla extraordinariamente fina, bautizada así porque quien la diseñó vivía en esta ciudad alemana. Esmaltando las pequeñas planchas o aros de diversos colores, en los años veinte y treinta se realizaron imágenes multicolor que encajaban bien con la corriente del momento, el art déco. En la actualidad, esta empresa sigue vendiendo bolsos de malla de aros, accesorios de moda y ropa.

Otra empresa estadounidense famosa en los años de entreguerras por sus bolsos de malla de aros era Mandalian. Su fundador, Sahatiel G. Mandalian, era de ascendencia turca, lo cual puede explicar los sutiles resabios orientales que presentan sus bolsos.

Métal et mailles

À partir de la fin du dix-neuvième siècle, les sacs et bourses de métal deviennent très populaires, notamment ceux en maille d'argent et d'or. Le maillage consiste en de petits anneaux ou morceaux de métal reliés les uns aux autres pour former un entrelacs rappelant les cottes de mailles des chevaliers du Moyen Âge. Les sacs en maille étaient onéreux car les anneaux devaient être attachés un par un. Ils étaient souvent en argent, même s'il existe des versions en plaqué argent et autres métaux. Plusieurs bijoutiers et fabricants d'accessoires étaient spécialisés dans la fabrication de sacs et porte-monnaie en maille, avec les États-Unis et l'Allemagne en tête pour la production.

À partir de 1909, le prix des sacs en maille diminue grâce à l'invention (par l'Américain A.C. Pratt) d'une machine permettant la réalisation du maillage. Une autre société américaine, Whiting & Davis, acquiert le brevet et s'impose au niveau mondial dans ce domaine. Elle fabriquera des sacs conçus par de célèbres créateurs de mode comme Paul Poiret et Elsa Schiaparelli. À partir de 1918, Whiting & Davis vend des sacs en mailles dites de Dresde, exceptionnellement fines et nommées d'après leur créateur qui vivait en Allemagne. Par la suite, dans les années vingt et trente, l'émaillage en différentes couleurs des petites plaques ou anneaux permet d'obtenir des images multicolores en accord avec le style art déco du moment. Aujourd'hui, l'entreprise vend des sacs, des accessoires de mode et des vêtements en maille.

Une autre entreprise américaine était célèbre pour ses sacs en maille pendant l'entre-deux-guerres. La subtile influence orientale des sacs de Mandalian, s'explique peut-être par l'origine turque de son fondateur, Sahatiel G. Mandalian.

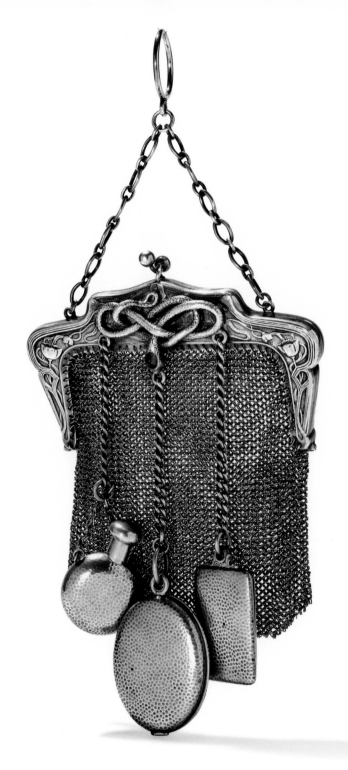

Silver ring mesh handbag with mirror, notebook and perfume bottle, Germany, 1900-1910.

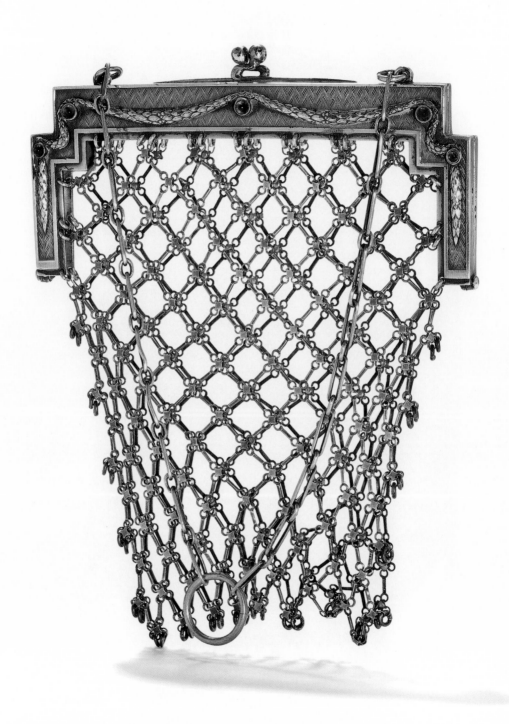

Silver mesh handbag with silver frame, Georg Adam Scheid, Austria, ca. 1900.

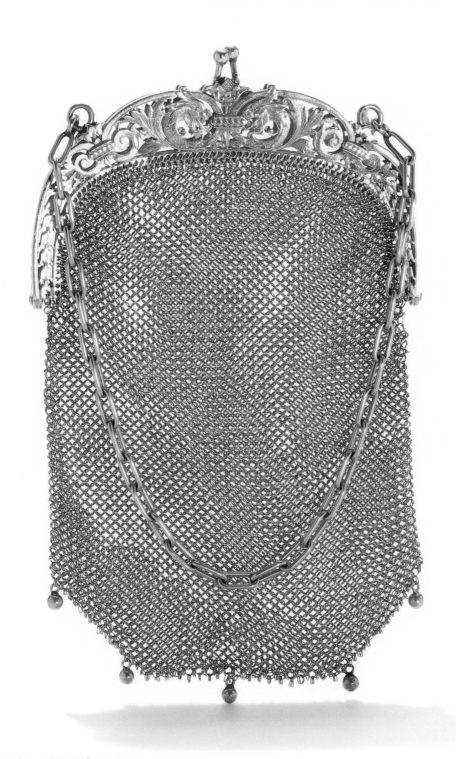

Gold mesh bag with gold frame, France, ca. 1880.

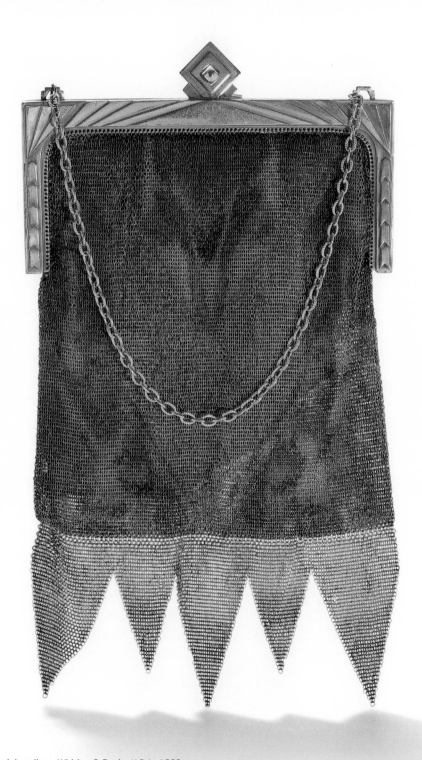

Dresden mesh handbag, **Whiting & Davis,** U.S.A., 1920s.

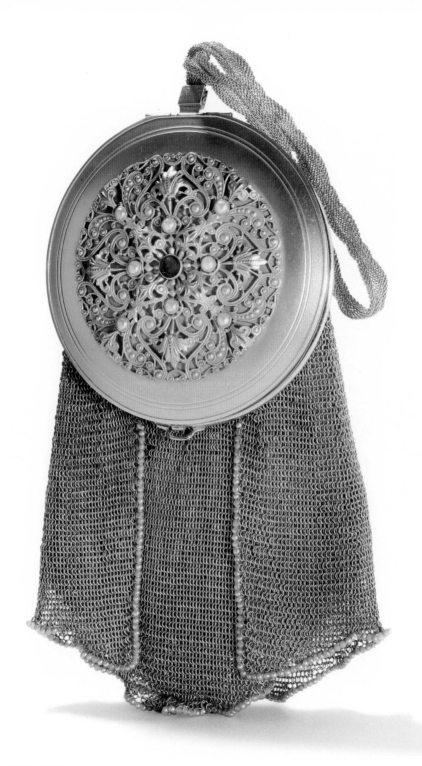

Mesh handbag, U.S.A., 1940s.

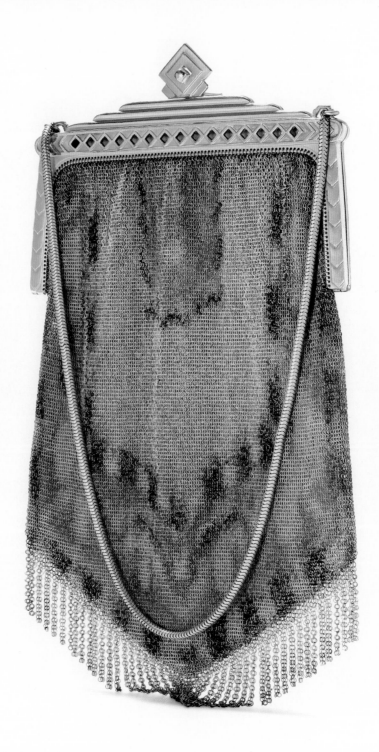

Dresden mesh handbag, El-Sah line, Whiting & Davis, U.S.A., ca. 1930.

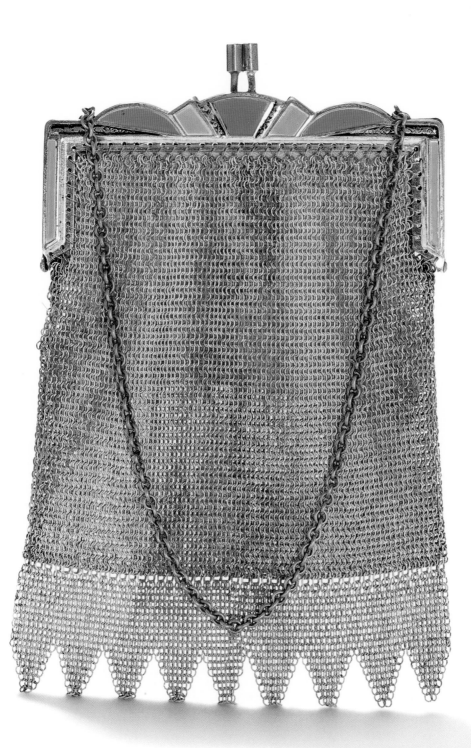

Dresden mesh handbag, Whiting & Davis, U.S.A., 1920s.

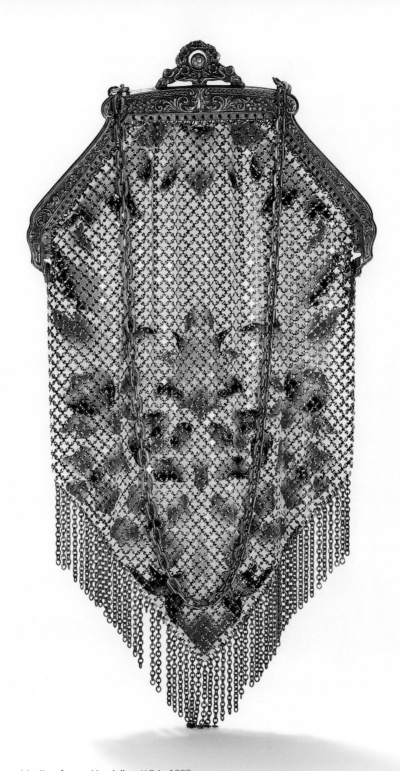

Mesh handbag with silver frame, Mandalian, U.S.A., 1920s.

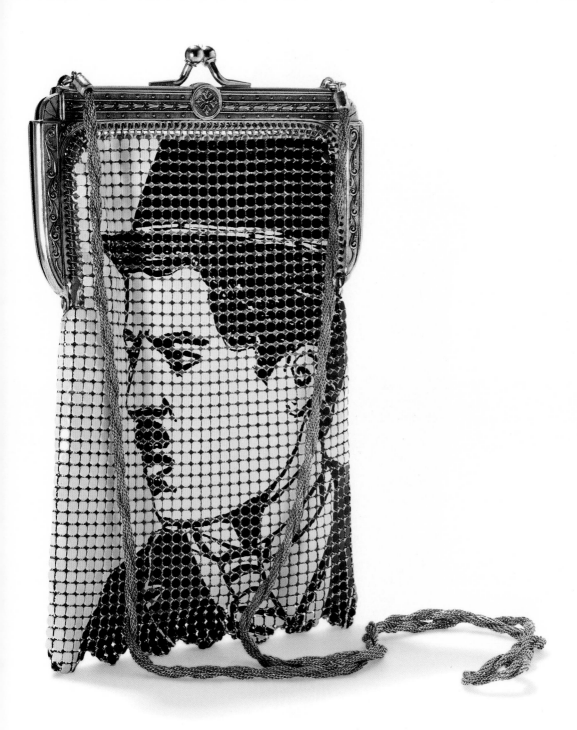

Mesh bag with picture of Charlie Chaplin, Whiting & Davis, U.S.A., 1976.

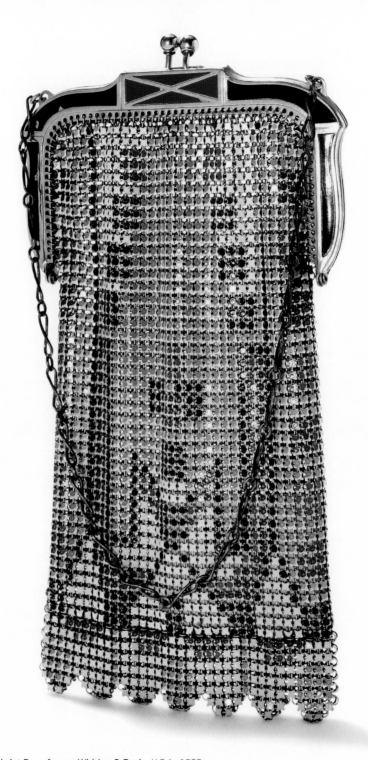

Mesh handbag with Art Deco frame, **Whiting & Davis,** U.S.A., 1920s.

Plastic

At first, plastics were used to imitate expensive tortoiseshell and ivory bag frames. They appeared in around 1919 and remained in fashion until about 1930. These semicircular plastic bag frames were flat or decorated with historical, romantic, oriental or Egyptian motifs. Initially they were only made from celluloid and casein, but from 1927 onwards they were also made from cellulose acetate.

At the beginning of the thirties, handbags and clutches appeared that were completely made of plastic. Plastic was no longer used in imitation of tortoiseshell and ivory but valued for its contemporary smooth appearance. These plastic bags stayed popular until the war. A beautiful example is the set of celluloid pochettes from 1937 in pastel shades of pink, blue and green.

In the thirties, many new plastics were invented which had many more possible applications. In the forties and fifties, they were so popular that bags were made from plastic beads, telephone wires and small tiles. In the United States in the fifties, plastic handbags dominated the fashion scene for more than a decade. These bags are box-shaped and made from hard plastic. Transparent as glass, made from Lucite (Perspex or Plexiglas) or in intense colours and decorated with strass, they were expensive bags at first. But they quickly became so popular that cheaper, lower quality versions were sold everywhere. With the arrival of softer plastics like vinyl, heavy and hard plastic handbags lost their popularity.

Kunststof

Kunststoffen werden in eerste instantie gebruikt ter imitatie van de dure tasbeugels van schildpad en ivoor. Ze verschenen rond 1919 en bleven tot circa 1930 in de mode. Deze halfronde kunststof tasbeugels waren vlak of versierd met historische, romantische, oosterse of Egyptische motieven. Aanvankelijk werden ze alleen van celluloid en caseïne gemaakt, maar vanaf 1927 ook van celluloseacetaat.

Begin jaren dertig verschenen hand- en onderarmtassen die volledig vervaardigd waren van kunststof. Kunststof werd niet langer als imitatie van schildpad en ivoor gebruikt, maar men waardeerde het om zijn eigentijdse strakke uitstraling. Deze kunststoftassen bleven tot de oorlog populair. Een mooi voorbeeld hiervan is de serie onderarmtassen van celluloid in de pasteltinten roze, blauw en groen uit 1937.

In de jaren dertig werden vele nieuwe kunststoffen uitgevonden, die veel meer toepassingsmogelijkheden hadden. In de jaren veertig en vijftig waren ze zo populair, dat men tassen vervaardigde van kunststof kralen, telefoondraden en kleine tegels. In de Verenigde Staten domineerden kunststoftassen vanaf de jaren vijftig meer dan tien jaar lang het modebeeld. Deze tassen zijn doosvormig en gemaakt van harde kunststof. Doorzichtig als glas, van lucite (perspex of plexiglas), of in felle kleuren, versierd met stras, waren het in eerste instantie dure tassen. Al snel waren ze zo populair, dat goedkopere uitvoeringen van mindere kwaliteit overal te koop waren. Met de komst van zachtere kunststoffen als vinyl verloren de tassen van zwaar, hard plastic hun populariteit.

Materiales sintéticos

Al principio, los materiales sintéticos se utilizaban para imitar las costosas boquillas de carey y marfil de que se dotaban los bolsos. Las boquillas realizadas con estos nuevos materiales aparecieron hacia 1919 y estuvieron de moda hasta aproximadamente 1930. Estas boquillas de bolso semicirculares de material sintético eran planas o estaban decoradas con motivos históricos, románticos, orientales o egipcios. Al principio sólo se realizaban en celuloide y caseína, pero a partir de 1927 también se realizaron en acetato de celulosa.

A principio de la década de 1930, aparecieron bolsos de mano realizados íntegramente en material sintético. Este material ya no se utilizaba para imitar el carey o el marfil, sino que se apreciaba por su lustre rígido y contemporáneo. Los bolsos de este tipo siguieron de moda hasta la Segunda Guerra Mundial. Constituye un bonito ejemplo el conjunto de pochettes de celuloide de 1937 en tonos rosas, azules y verdes pastel.

En la década de 1930 se inventaron numerosos materiales sintéticos con incontables posibilidades de aplicación. En las dos décadas siguientes, su uso se había difundido de tal manera que se elaboraron bolsos realizados con cuentas de material sintético, cable de teléfono y pequeños azulejos. En la década de 1950, en Estados Unidos los bolsos de material sintético dominaron el mundo de la moda durante más de una década. Estos bolsos tienen forma de caja y están realizados en material sintético duro. Transparentes como el cristal, realizados con lucite (perspex o plexiglás) o de colores intensos y decorados con strass, al principio resultaban algo caros. Sin embargo, adquirieron tanta fama que rápidamente comenzaron a venderse por doquier versiones de menor calidad. Con la aparición de materiales sintéticos más blandos como el vinilo, los pesados bolsos de material sintético duro perdieron popularidad.

Plastique

Le plastique a d'abord été utilisé pour imiter les fermoirs plus coûteux de sacs en écaille ou ivoire. Les matières plastiques sont apparues vers 1919 et sont restées à la mode jusque vers 1930. Ces fermoirs semi-circulaires en plastique étaient mats ou décorés de motifs historiques, romantiques, orientaux ou égyptiens. D'abord uniquement en celluloid et caséine, ils ont vu l'acétate de cellulose faire son entrée en 1927.

Au début des années trente, des sacs et pochettes entièrement en plastique apparaissent. Le plastique n'est plus désormais utilisé pour imiter l'écaille ou l'ivoire, mais pour son éclat moderne et sa rigidité. Ces sacs resteront à la mode jusqu'à la Guerre, comme c'est le cas de la série de pochettes en celluloïd de 1937 dans des tons pastel de rose, bleu et vert.

Dans les années trente, de nombreux autres plastiques sont inventés et offrent des possibilités multiples d'applications. Dans les années quarante et cinquante, ils sont si populaires que des sacs sont fabriqués en perles de plastique, câbles de téléphone et petits carreaux. En plastique rigide moulé en forme de boîte, les sacs à main domineront la scène de la mode américaine des années cinquante pendant plus d'une décennie. Aussi transparents que le verre, en lucite (perspex ou plexiglas) ou aux couleurs vives et décorés de strass, ils seront tout d'abord chers, pour rapidement devenir si populaires que des versions plus abordables et de qualité moindre proliféreront. Les lourds sacs à main en plastique rigide perdront les faveurs du public avec l'arrivée des plastiques plus mous comme le vinyle.

Three plastic Rodolac clutches, U.S.A., ca. 1937.

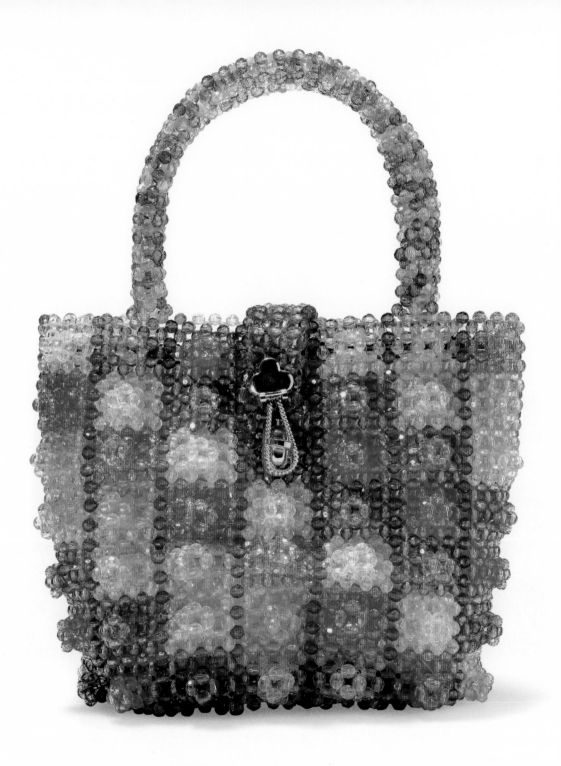

Handbag made of plastic beads, Elizabeth Arden, U.S.A., 1950s.

Plastic clutch, France, 1930s.

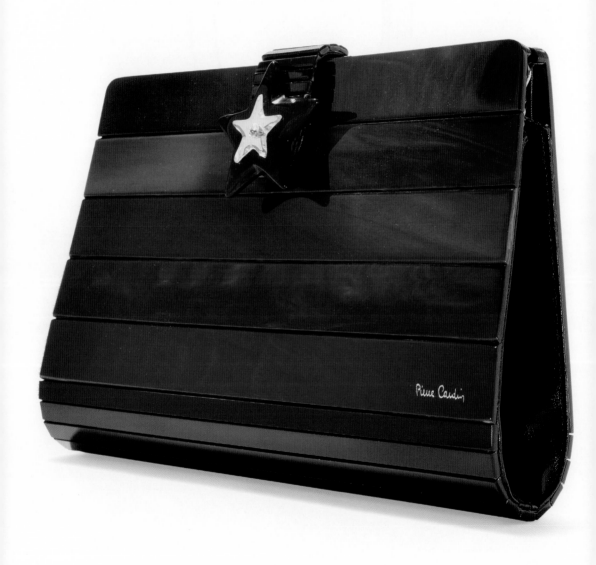

Plastic clutch in retro style of the 1950s, Pierre Cardin, France, 2006.

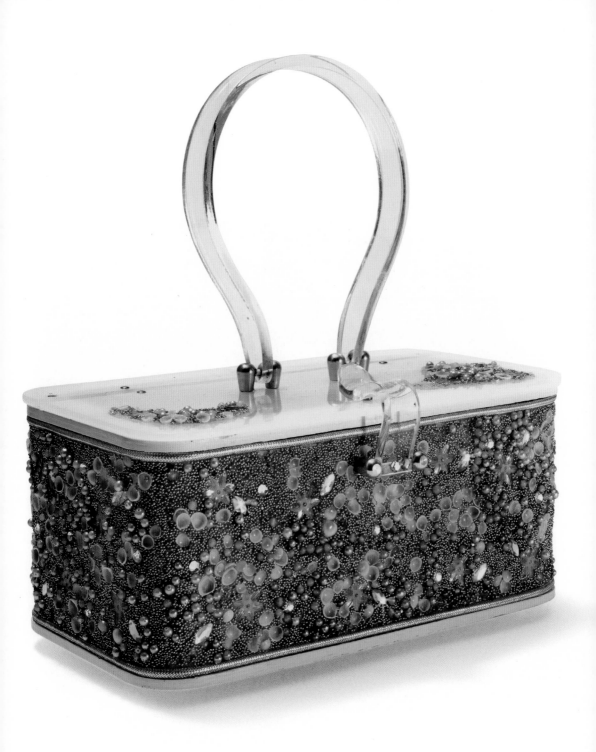

Plastic handbag with decoration of plastic shells, U.S.A., 1950s.

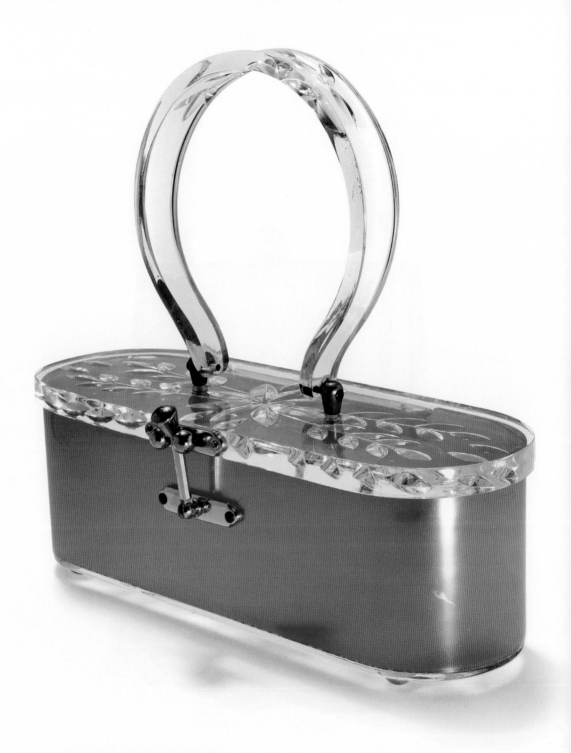

Lucite handbag, Charles S. Kahn, U.S.A., 1950s.

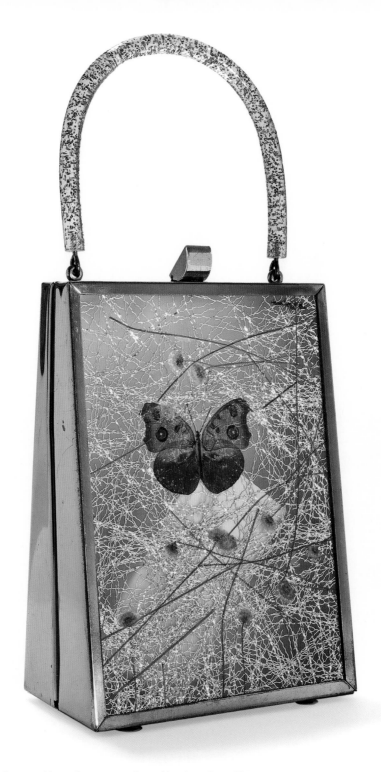

Lucite handbag with flower and butterfly pattern and metal border, U.S.A., 1950s.

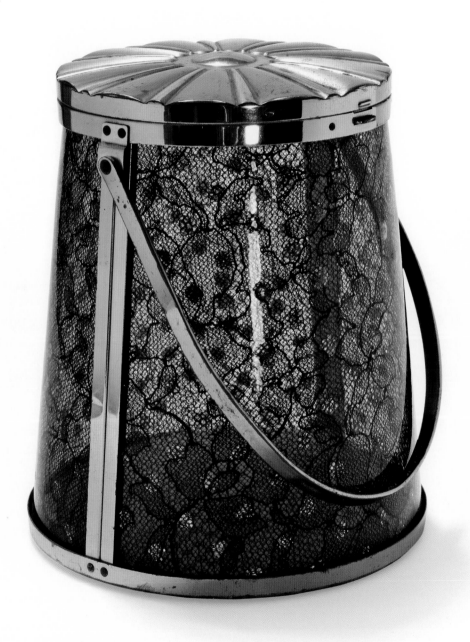

Lucite handbag decorated to resemble lace, U.S.A., 1950s.

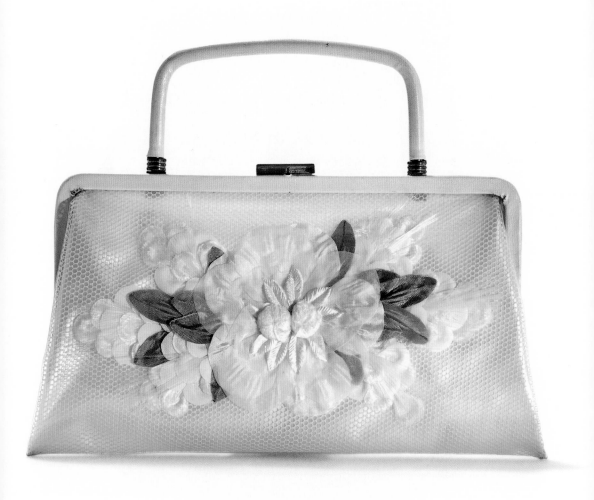

Fabric handbag encased in plastic, U.S.A., 1950s.

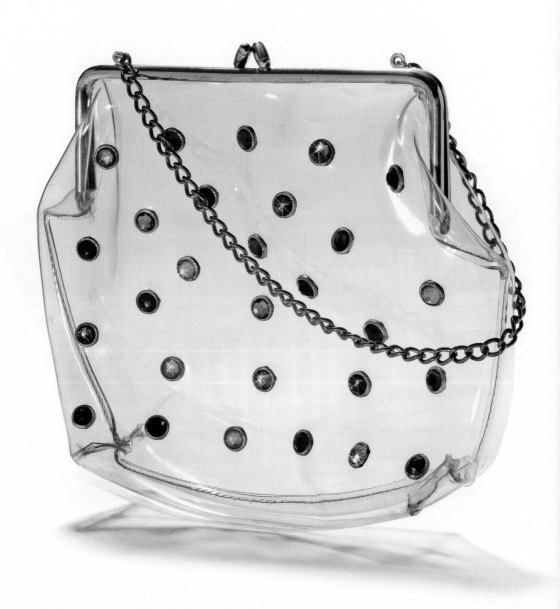

Plastic handbag decorated with glass stones, U.S.A., 1950s.

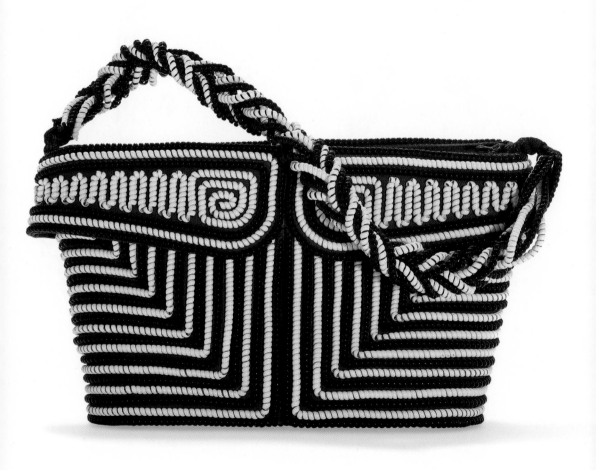

Plastic bag made of 'telephone wire', U.S.A., 1953.

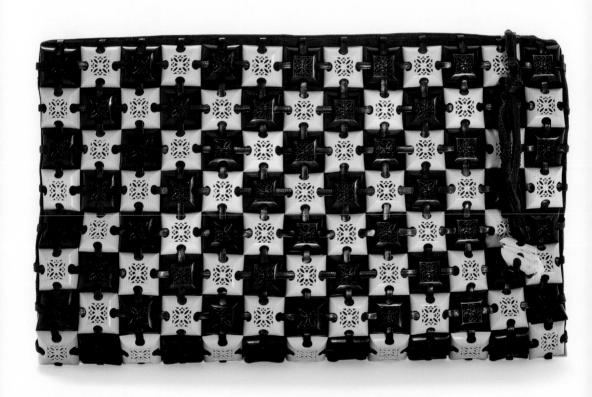

Clutch made of lightweight square plastic tiles, Plastiflex, U.S.A., 1943.

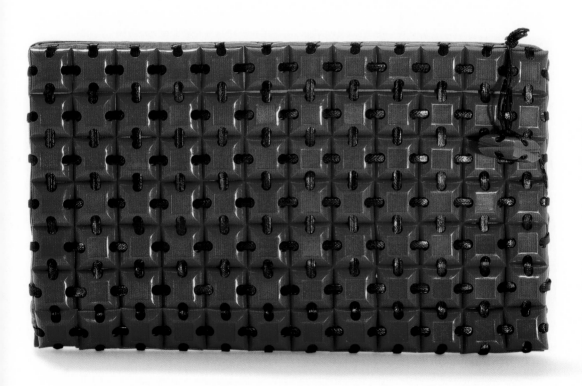

Clutch made of lightweight square plastic tiles, Gadabout, England, 1947.

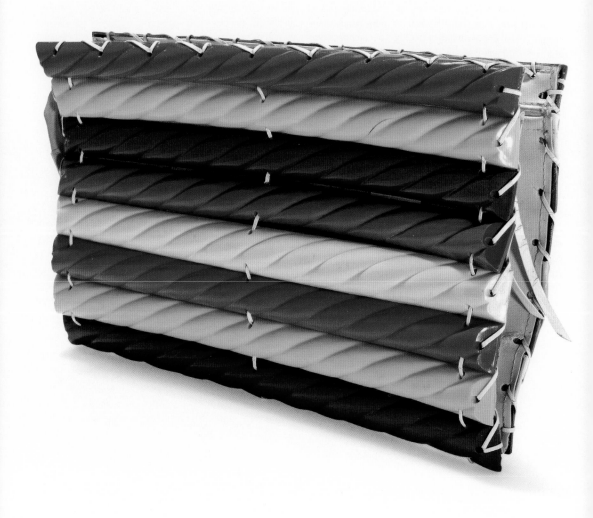

Plastic clutch, U.S.A., 1940s.

Unusual models

In the thirties, fashion designer Elsa Schiaparelli created a stir with her Surrealist fashion accessories and bags. At that time, many bags were made in entirely out-of-the-ordinary shapes, such as the clutch bag in the shape of the luxurious French cruise ship the Normandie. During its maiden voyage from France to the United States in 1935, all the first class passengers received one.

As a reaction to the sober war years, in the fifties handbags were made that were striking and novel in their use of material and shape, a development that led to some surprising bag shapes. And in certain periods, bags with unusual decorations or unconventional pictures were popular. The designers Enid Collins, Judith Leiber and Lulu Guinness created striking bags that are now sought after by collectors the world over.

One example of such an unusual object is a bag with a little light. The first idea for such a bag originated in 1922. That year, the Londoner Alfred Dunhill (1872-1959) applied for a patent for a handbag with a little light that went on automatically upon opening the bag. The invention must have sparked the imagination, because between the wars and at the beginning of the fifties various imitations followed.

One special bag with a light is the leather Lite-on made in 1953 by Amsterdam native L.F.W. Straeter. The model is often wrongly ascribed to Elsa Schiaparelli. In addition to lipstick, comb, cigarette and perfume holders, this bag has a little light so that everything can be found instantaneously. The light also shines out through an opening in the bag so that a keyhole can be found with no difficulty.

Ongewone modellen

Modeontwerpster Elsa Schiaparelli baarde al in de jaren dertig opzien met haar surrealistische modeaccessoires en tassen. In die jaren werden meer tassen gemaakt met volstrekt afwijkende modellen, zoals de onderarmtas in de vorm van het luxueuze Franse cruiseschip de Normandie. Tijdens de maiden trip van Frankrijk naar de Verenigde Staten in 1935 ontvingen alle eersteklaspassagiers een exemplaar.

Als reactie op de sobere oorlogsjaren werden in de jaren vijftig tassen vervaardigd die opvallend en vernieuwend waren door hun materiaalgebruik en vorm. Een ontwikkeling die tot verrassende tasvormen heeft geleid. Daarnaast waren in bepaalde periodes tassen met ongebruikelijke versieringen of met onconventionele afbeeldingen populair. Ontwerpsters Enid Collins, Judith Leiber en Lulu Guinness ontwierpen opvallende tassen die tegenwoordig gewild zijn bij verzamelaars over de hele wereld.

Een voorbeeld van zo'n ongewoon exemplaar is een tas met een lampje. Het eerste idee voor een dergelijke tas stamt uit 1922. De Londenaar Alfred Dunhill (1872-1959) vroeg dat jaar patent aan voor een handtas met een lampje dat bij het openen van de tas automatisch aanging. De uitvinding moet tot de verbeelding gesproken hebben, want tijdens het interbellum en begin jaren vijftig volgden diverse imitaties.

Een bijzondere tas met verlichting is de leren Lite-on, gemaakt in 1953 door de Amsterdammer L.F.W. Straeter. Het model wordt ten onrechte vaak toegeschreven aan Elsa Schiaparelli. Naast een lipstick-, kammen-, sigaretten- en parfumhouder heeft deze tas een lampje, zodat in één oogopslag alles te vinden is. Door een opening in de tas schijnt het licht ook naar buiten, zodat ook een sleutelgat zonder moeite gevonden kan worden.

Ejemplares raros

En la década de 1930, la diseñadora de moda Elsa Schiaparelli causó sensación con sus bolsos y accesorios de moda surrealistas. Era una época en la que muchos bolsos se confeccionaban con patrones completamente fuera de lo común, como es el caso de aquel que reproduce la forma del crucero de lujo francés Normandie. En su viaje inaugural de Francia a Estados Unidos en 1935 todos los pasajeros de primera clase fueron obsequiados con un ejemplar.

Como reacción a los sobrios años de guerra, en los años cincuenta los bolsos se diseñaban de modo que tanto los materiales como la forma resultaran sorprendentes y novedosos, una tendencia que produjo modelos sorprendentes. Y, en algunos momentos, se pusieron de moda los bolsos con motivos decorativos extraños o con imágenes no convencionales. Las diseñadoras Enid Collins, Judith Leiber y Lulu Guinness crearon bolsos chocantes que hoy en día buscan coleccionistas de todo el mundo.

Un ejemplo de estos modelos tan poco comunes es un bolso con una pequeña luz. La primera idea para realizar este tipo de bolso data de 1922. Ese año el londinense Alfred Dunhill (1872-1959) solicitó la patente para un bolso con una lucecita que se encendía de forma automática al abrir el bolso. El invento debió disparar la imaginación de los diseñadores posteriores, pues en el período de entreguerras y a principios de los años cincuenta aparecieron diversas imitaciones.

Un bolso especial con luz es el Lite-on, realizado en cuero en 1953 por el diseñador oriundo de Amsterdam L. F. W. Straeter. A menudo esta pieza se atribuye por error a Elsa Schiaparelli. Además de pintalabios, peine, compartimentos para cigarrillos y perfume, este bolso cuenta con una pequeña luz para que la usuaria pueda encontrarlo todo al instante. La luz también sale del bolso a través de una abertura a fin de que pueda encontrarse el ojo de la cerradura sin dificultades.

Modèles inédits

Dans les années trente, la créatrice de mode Elsa Schiaparelli fait sensation avec ses accessoires de mode et sacs surréalistes. Beaucoup de sacs sont alors des modèles qui sortent de l'ordinaire, comme la pochette présentant la forme du luxueux paquebot de croisière français Normandie, offerte à toutes les passagères de première classe à l'occasion de sa première traversée entre la France et les États-Unis en 1935.

En réaction à la sobriété des années de guerre, les sacs à main des années cinquante exploitent toutes les matières et formes les plus inédites et originales pour donner des modèles surprenants. Par exemple, des sacs aux décorations insolites ou images peu conventionnelles seront appréciés à certaines périodes. Les créateurs Enid Collins, Judith Leiber et Lulu Guinness inventent alors de drôles de sacs aujourd'hui prisés par les collectionneurs du monde entier.

Le sac avec une petite lumière est un exemple d'objet insolite. L'idée est née en 1922, lorsque le Londonien Alfred Dunhill (1872-1959) dépose un brevet pour un sac à main doté d'une petite lampe qui s'allume automatiquement à l'ouverture. L'invention excite l'imagination et sera suivie de diverses imitations pendant l'entre-deux-guerres et au début des années cinquante.

L'un de ces sacs à lumière est le modèle « Lite-on » en cuir, créé en 1953 par L.F.W. Straeter à Amsterdam mais souvent attribué à tort à Elsa Schiaparelli. Outre ses compartiments pour rouge à lèvres, peigne, cigarettes et parfum, il possède une petite ampoule pour trouver aussitôt l'objet recherché et éclairer à travers un orifice le trou de serrure.

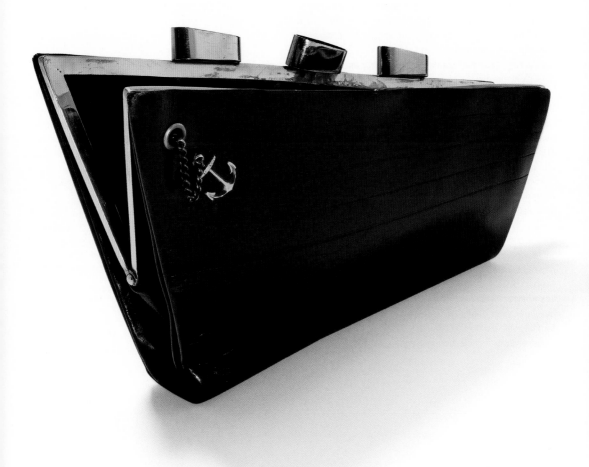

Leather clutch in shape of the cruiseship 'Normandie', France, 1935.

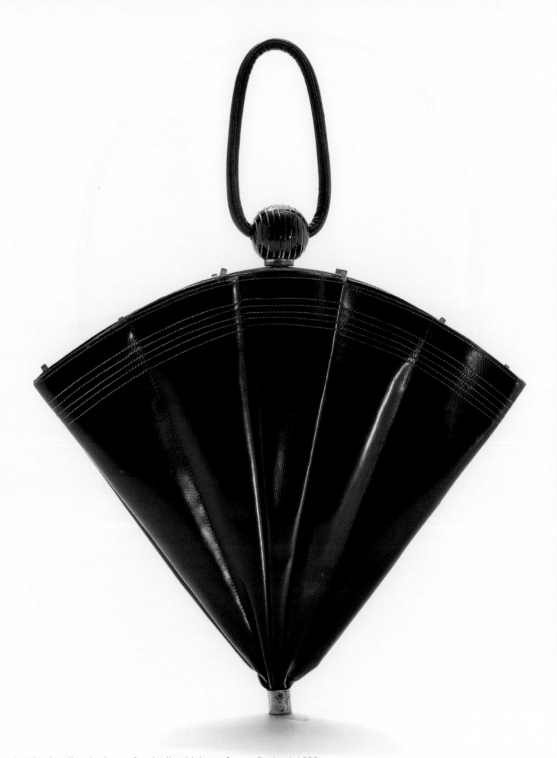

Leather handbag in shape of umbrella with brass frame, England, 1930s.

CHAMPAGNE

REIMS

~

FRANCE

SEC

Leather handbag, Anne-Marie of France, France, 1940s.

Leather handbag 'Lite On' with light, Straeter, The Netherlands, 1953.

Rattan bag in shape of a fish, U.S.A., 1960s.

Rattan bag in shape of a monkey, Marcus Brothers, Hong Kong, 1960s.

Straw handbag in shape of a dog, England, 1950s-1960s.

Beaded handbag in shape of a dog, Robin Piccone, U.S.A., early 2000s.

Linen and leather ' Sea Garden' bag, Enid Collins of Texas, U.S.A., 1965.

Rattan basket with decoration of card playing mice, Wickley, U.S.A., 1950s.

Patent leather handbag with functioning telephone, Dallas Handbags, U.S.A., 1980s.

Plastic shoulder bag with clock, Spartus, U.S.A., 1980s.

Satin handbag with embroidery and leather roof, Lulu Guinness, England, 2000.

Handbag 'Beach House' made of raffia and decorated with embroidery, Beverly Feldman, U.S.A., 2003.

Fabric and plastic children's backpack, Oilily, The Netherlands, 2003.

Leather handbag 'Sunflower', Braccialini, Italy, 2009.

Leather book bag, Paloma Picasso, France, 1980s.

Evening bag 'Diet Coke Can' decorated with rhinestones, Kathrine Baumann, U.S.A., 2007.

Magazine clutch 'Jours de France', Hong Kong, 1970s.

Retro clutch made in style of the magazine clutch from 1970s, Papa Razzi, England, 2009.

Designer bags

In addition to designing clothing, many fashion houses design things like women's handbags. Initially this occurred in order to provide accessories to match the clothes, but in recent decades brands also developed perfumes and other accessories to give their name more recognition. Some logos are widely recognised, such as D&G (Dolce & Gabbana) or the double C (Chanel). In 1896, the Louis Vuitton luggage house introduced its world-famous canvas with the LV monogram.

Well-known fashion houses and leather goods brands have always come along with new models or put classic models into production again. The best known classical shoulder bag is perhaps the Chanel bag in quilted leather with a gold-coloured chain. The official name of the bag is 2.55, based on its release in February 1955. Another classic is the Kelly bag by Hermès. It had already existed as a handbag in the 1930s, but since 1956 it has owed its name and fame to Grace Kelly, who carried it a lot. Another famous bag is the Lady Dior bag, named after Lady Diana. A new shoulder bag, already a classic, is the 1997 Baguette by Fendi. This bag with a short shoulder strap is clasped under the arm like a French loaf.
The backpack as a fashion trend is not so longstanding. Prada, in fact, launched the backpack as an accessory with its release of a black nylon model in 1985.

Unlike previous centuries, when bag fashion evolved much more slowly and the same style was in use for years, nowadays the bag is a fashion statement that changes every season, and in which fashion labels have a dominant position. Since the 1990s bags, shoes, perfume and sunglasses are the major sources of income for those labels as well as the best way of strengthening their brands. Every label hopes each season to come up with the 'IT' bag - the one worn by every film star, pop star and supermodel and thus the 'must have' for the rest of us.

Designer tassen

Naast het ontwerpen van kleding, houden veel modehuizen zich bezig met het ontwerpen van andere zaken zoals handtassen voor vrouwen. Oorspronkelijk waren deze bedoeld als accessoire om te matchen met de kleding, maar de laatste decennia ontwikkelden merken ook parfums en andere accessoires om nog meer naamsbekendheid te krijgen. Sommige logo's zijn wereldwijd bekend, zoals D&G van Dolce & Gabbana of de dubbele C van Chanel. In 1896 introduceerde het modieuze bagagemerk Louis Vuitton zijn wereldberoemde canvas met het LV monogram.

Bekende modehuizen en lederwarenmerken hebben altijd nieuwe modellen op de markt gebracht, of klassieke modellen opnieuw in productie genomen. De meest bekende schoudertas is misschien wel de Chanel tas van gevoerd leer met een goudkleurige ketting. De officiële naam van de tas is 2.55, vanwege zijn introductie in februari 1955. Een andere klassieker is de Kelly tas van Hermès. Deze bestond in de jaren '30 al als handtas, maar dankt vanaf 1956 zijn naam en faam aan Grace Kelly, die deze tas vaak droeg. Ook een beroemde tas is de Lady Dior tas, genoemd naar Lady Diana. Een nieuwe schoudertas, nu al een klassieker, is de Baguette van Fendi uit 1997. Deze tas met een korte schouderriem wordt strak onder de arm gedragen als een Franse 'baguette'.
De rugzak als fashiontrend bestaat nog niet zo lang. In 1985 lanceerde Prada de rugzak als accessoire met een zwart nylon model.

In tegenstelling tot voorgaande eeuwen, toen de tassenmode zich veel langzamer ontwikkelde en dezelfde stijl jarenlang de boventoon voerde, is de tas nu een fashion statement dat ieder seizoen verandert, en waarin modelabels de toon aangeven. Sinds de jaren '90 vormen tassen, schoenen, parfum en zonnebrillen niet alleen de belangrijkste inkomstenbronnen voor zulke labels, maar ook de beste manier om hun merk te versterken. Ieder seizoen opnieuw hoopt elk label met de 'IT bag' te komen; die ene tas die wordt gedragen door iedere filmster, popster en supermodel, en dus de 'must have' is voor de rest van ons.

Bolsos de diseño

Además de la ropa, muchos diseñadores y casas de moda dedican su tiempo a diseñar otro tipo de artículos, como son los bolsos femeninos. En un principio, se hacía para que los accesorios conjuntasen con la vestimenta, pero en las últimas décadas, las marcas se han dedicado también a crear perfumes y otros accesorios con el fin de ganar renombre. Algunos logotipos han obtenido reconocimiento a gran escala, como el D&G de Dolce & Gabbana o la doble C de Chanel. En 1896, la casa de maletas de lujo Louis Vuitton introdujo su tela con el monograma LV, famosa en todo el mundo.

Las casas de moda y marcas de artículos de piel con reconocimiento no han parado de sacar nuevos modelos al mercado o renovar sus clásicos. El bolso clásico tipo bandolera más conocido quizá sea el de Chanel, de cuero acolchado con cadena dorada. El nombre oficial del bolso es 2.55, debido a que salió a la venta en febrero de 1955. Otro clásico es el bolso Kelly, de Hermès, que ya existía como bolso de mano en la década de los 30. No obstante, desde 1956 debe su nombre y fama a Grace Kelly, que se dejaba ver con este bolso en numerosas ocasiones. Otro bolso famoso es el Lady Dior, que debe su nombre a Lady Diana. Un nuevo bolso tipo bandolera, que ya se ha convertido en un clásico, es el Baguette de Fendi de 1997, que cuenta con un asa muy corta para colgar al hombro y se lleva bajo el brazo como si de una baguette se tratase.
La mochila como accesorio de moda es algo relativamente reciente. De hecho, la primera en lanzarla como accesorio fue Prada, con su modelo de nylon negro en 1985.

A diferencia de los siglos anteriores, en los que la moda del bolso evolucionaba mucho más despacio y el estilo no presentaba demasiadas diferencias a lo largo de los años, hoy en día, el bolso es una tendencia de moda que cambia con cada temporada y en el que las marcas tienen una posición dominante. Desde la década de los 90, los bolsos, zapatos, perfumes y gafas de sol conforman las mayores fuentes de ingresos de estas firmas, así como el mejor modo de reforzar sus marcas. Cada temporada, todos los fabricantes esperan sacar EL bolso – aquel que van a lucir todas las estrellas de cine, estrellas del pop y supermodelos, marcando tendencias e imponiendo los "imprescindibles" al resto del mundo.

Sacs de créateurs

En plus de la création de vêtements, de nombreuses maisons de haute couture complètent désormais leur activité avec d'autres produits, comme des sacs à main pour femmes. À l'origine, le but était de fabriquer des accessoires qui s'accordaient aux vêtements, mais ces dernières décennies, les marques ont également mis au point des parfums et autres accessoires afin d'accroître la notoriété de leur enseigne. Ainsi, certains logos de marques ont acquis une renommée mondiale, comme D&G (Dolce & Gabbana) ou le double C (Chanel). Dès 1896, la maison de maroquinerie Louis Vuitton lançait sa fameuse toile ornée du monogramme LV, désormais connue dans le monde entier.

Les maisons de haute couture et les marques de maroquinerie ont toujours su inventer de nouveaux modèles ou relancer la production des classiques. Parmi les incontournables, le sac le plus connu reste peut-être le Chanel en cuir matelassé, avec pour anse une chaîne dorée. Le nom officiel de ce sac est 2.55, en référence au mois de février 1955, date de sa sortie. Un autre grand classique : le sac Kelly de chez Hermès. Ce sac à main, déjà en vente dans les années 1930, doit, dès 1956, son nom et sa réputation à Grace Kelly qui l'emportait souvent avec elle. Le sac Lady Dior, en hommage à Lady Diana, compte également parmi les sacs les plus célèbres. Plus récemment, on retrouve le sac Baguette de Fendi. Ce sac à main lancé en 1997 s'est déjà fait une place parmi les classiques. Ce sac est conçu pour être calé sous le bras, comme une baguette de pain, grâce à sa courte anse. L'utilisation du sac à dos comme accessoire de mode est assez récente. C'est en 1985 que Prada innove et fait du sac à dos un accessoire « fashion » avec son modèle en nylon noir.

Contrairement aux siècles précédents durant lesquels les tendances en maroquinerie évoluaient bien plus lentement et où le même style perdurait pendant des années, le sac est aujourd'hui un accessoire incontesté qui change à chaque saison et pour lequel les grandes marques de la mode prédominent. Depuis les années 1990, les sacs, chaussures, parfums et lunettes de soleil représentent la source principale des bénéfices réalisés par ces marques ; de plus, ces accessoires restent le meilleur outil de promotion de leur nom. À chaque début de saison, les marques espèrent sortir LE modèle de l'année, celui que toutes les stars du cinéma, les popstars et les top-modèles porteront et donc, le sac que l'on s'arrachera toutes.

Leather 'Kelly' bag, Hermès, France, 1990s.

Leather handbag with bamboo handle and lock, Gucci, Italy, 1970s.

Lady 'Dior' handbag with leopard print and plastic handle, Dior, France, ca. 2005.

Leather shoulder bag, 2.55, Chanel, France, 1970s.

Handbag worn by Madonna at the première of the movie Evita, Gianni Versace Couture, Italy, 1997.

Handbag made from straw and python skin, 'B bag', Fendi, Italy, 2006.

Handbag in 'New Check Lowry', with patent leather trim, Burberry, England, 2007.

Limited edition Louis Vuitton 'Conte De Fees Musette Owl', designed by Marc Jacobs and artist/illustrator Julie Verhoeven, France, 2002.

Handbag 'Bayswater' calfhair zebra, Mulberry, England, 2009.

Leather handbag with print by artist James Jean, Prada, Italy, 2008.

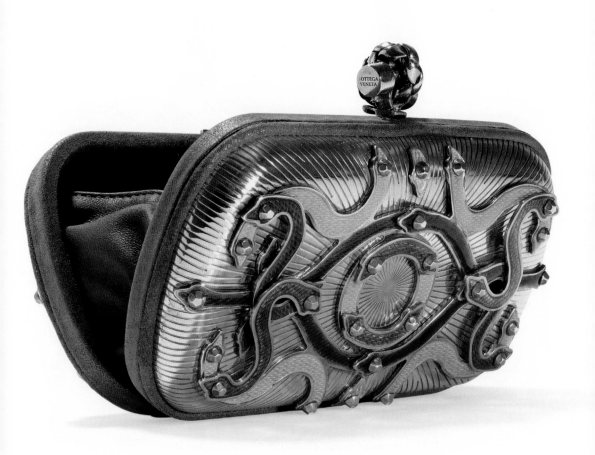

Metal clutch, 'Knot', made of silver and enamel, Bottega Veneta, Italy, 2007.

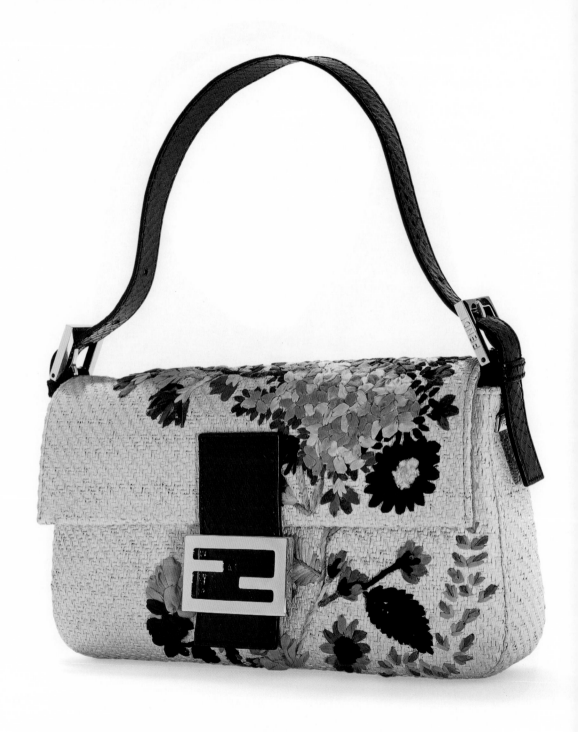

'Baguette' shoulder bag made of straw with embroidery, limited edition, Fendi , Italy, 2011.

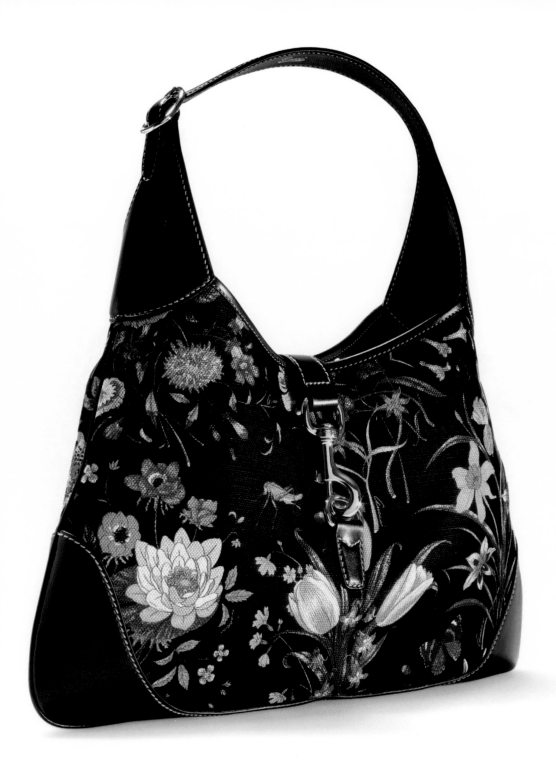

Canvas handbag 'Bouvier', named after the maiden name of Jackie Kennedy, Gucci, Italy, 2006.

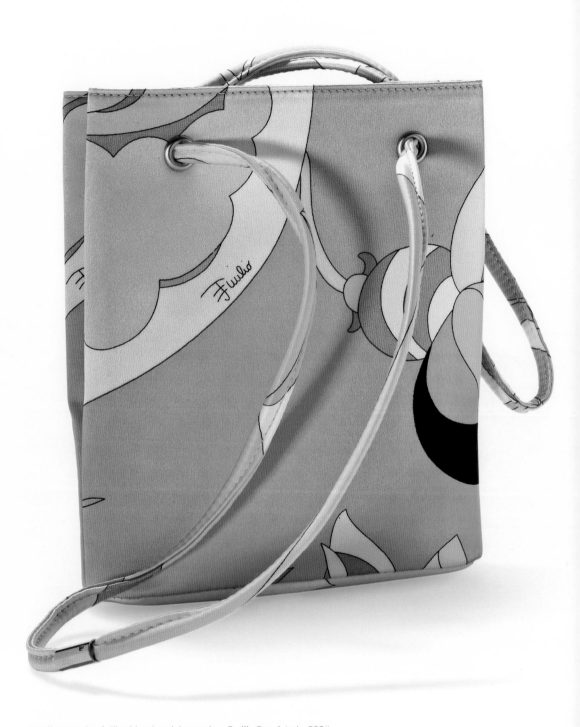

Handbag made of silk with printed decoration, Emilio Pucci, Italy, 2004.

Fur handbag, Chanel, France, 2007.

Satin evening bag 'Kabuto', Stella McCartney, England, 2004.

Patent leather handbag with matching cover, Vivienne Westwood, England, 2009.

Patent leather shoulder bag wit safety-pin as decoration, Alexander McQueen, England, 2008.

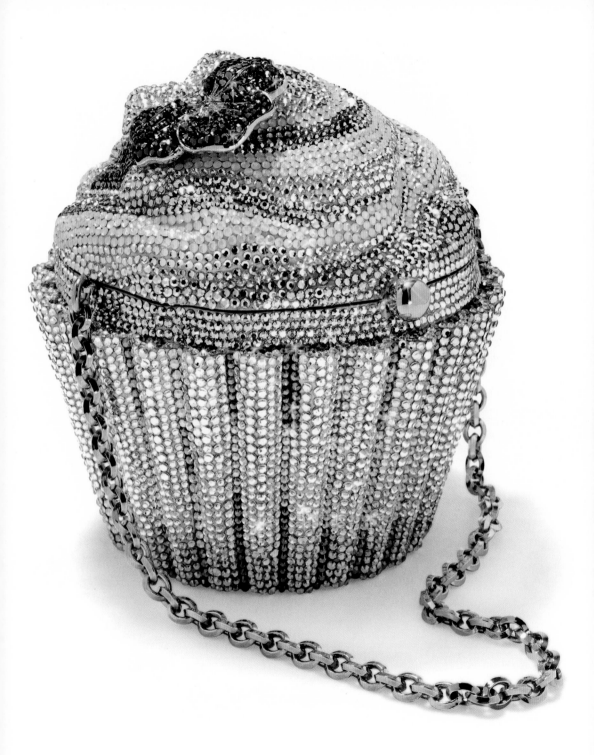

Evening bag 'Cupcake' adorned with crystals, Judith Leiber, U.S.A., 2007.

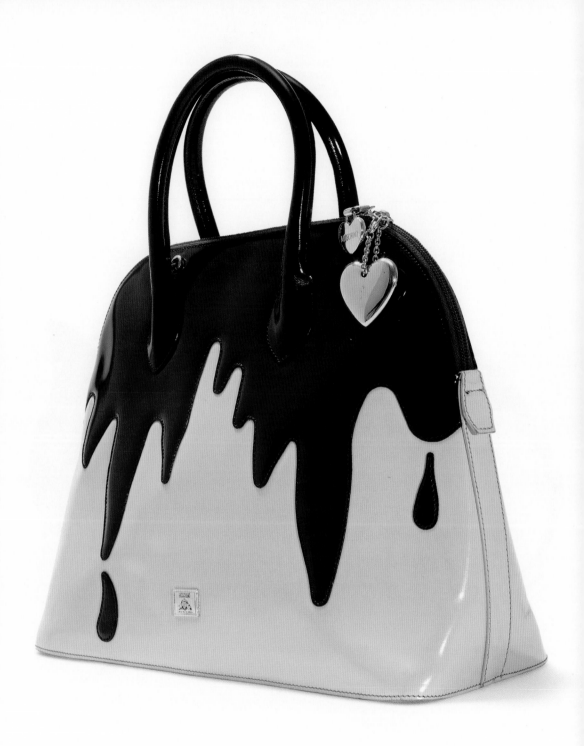

Patent leather handbag, MOSCHINO, Italy, 1996.

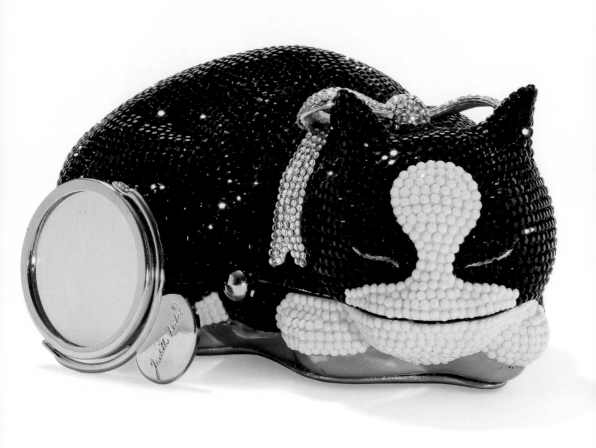

Evening bag 'Socks' named after the cat of the Clintons, Judith Leiber, U.S.A., 1996.

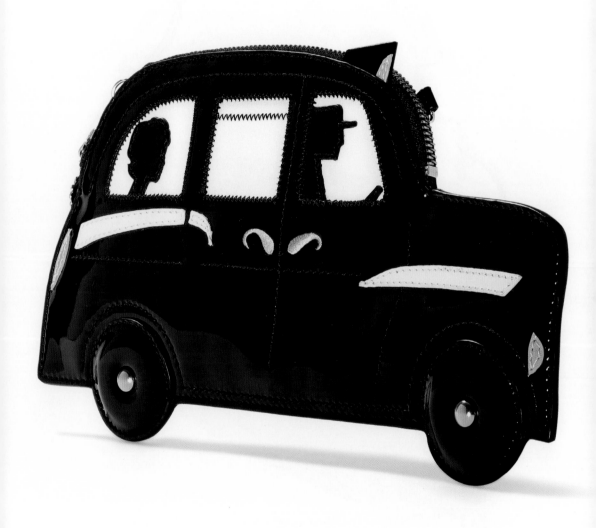

Patent leather London Taxi Clutch, Lulu Guinness, England, 2009.

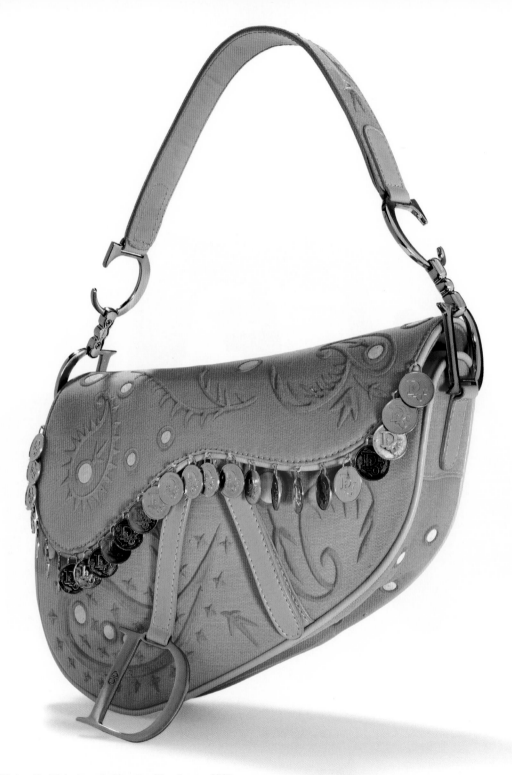

Silk bag 'Saddle' adorned with coins, Dior, France, 2004.

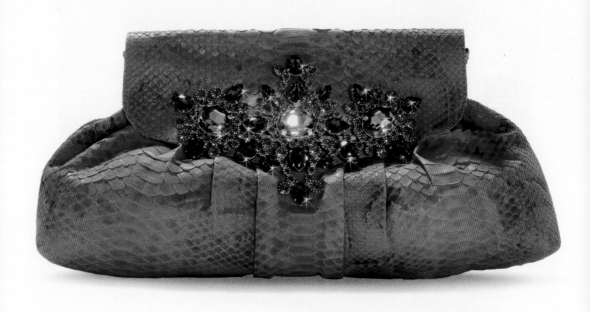

Snakeskin clutch with single stones setting, Otazu, The Netherlands, 2010.

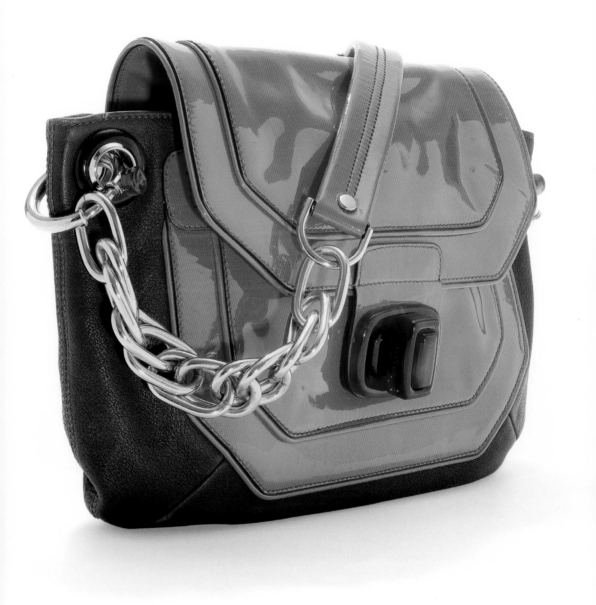

Patent leather shoulder bag, Lanvin, France, 2007.

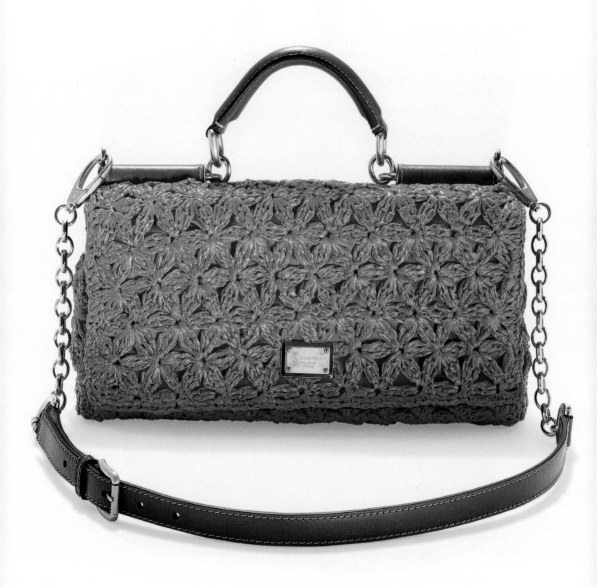

Shoulder bag of crocheted raffia, Dolce & Gabbana, Italy, 2011.

Bag with French lace, Valentino, Italy, 2011.

Bag with lasered pattern, Victor & Rolf, The Netherlands, 2010.

Fabric shopper ' I'm not a plastic bag', Anya Hindmarch, England, 2007.

Handbag 'Pleats Please', Issey Miyake, Japan, 2010.

Contemporary designs

The development of handbag design is strongly influenced by the fashion scene. The handbag is still used to accessorise clothes and continues to adapt to changing trends.

Designers of today have various starting points: functionality, shape, material, fashion and emotion. There are designers influenced by architecture, who make bags with geometrical shapes in combination with daring colour combinations. For other designers, the handbag is an implement which must be durable. They focus on the practical demands the bag must fulfil and make use of strong materials and handy compartments for a mobile phone and keys. Emotion plays a role for some designers. Portraits, Madonnas and angels turn bags into personal statements.

A new generation designers has taken up the challenge to design a bag in which the combination of old techniques and new materials lead to a new design.

Hedendaagse ontwerpen

De ontwikkeling van het tasontwerp wordt sterk beïnvloed door het modebeeld. De tas is nog steeds het attribuut dat de kleding completeert, en blijft zich aanpassen aan veranderende gewoontes.

Hedendaagse ontwerpers hebben verschillende uitgangspunten: functionaliteit, vorm, materiaal, mode en emotie. Er zijn ontwerpers die beïnvloed worden door architectuur. Zij maken tassen met geometrische vormen, in combinatie met gewaagde kleurcombinaties. Voor andere ontwerpers is de tas een gebruiksvoorwerp waarmee je intensief moet kunnen leven. Zij kijken vooral naar de praktische eisen waaraan de tas moet voldoen, zoals sterk materiaal en handige vakjes voor de telefoon en sleutels. Bij sommige ontwerpen speelt emotie een rol. Tassen met portretten, madonna's en engelen maken de tas dan tot een persoonlijk document.

Een nieuwe generatie ontwerpers gaat de uitdaging aan om een tas te ontwerpen waarbij de combinatie van oude technieken met nieuwe materialen tot een nieuw ontwerp leidt.

Diseños actuales

El desarrollo del diseño de bolsos de mano se ve fuertemente determinado por el mundo de la moda. El bolso sigue utilizándose para complementar prendas de vestir y no deja nunca de adaptarse a las tendencias que se van sucediendo.

Los diseñadores actuales parten de varios puntos: la funcionalidad, la forma, el material, la moda y la emoción. Hay diseñadores que se dejan influir por la arquitectura y que crean bolsos de formas geométricas combinados con osadas combinaciones de colores. Para otros diseñadores, el bolso es un complemento que debe durar. Ponen especial atención a las exigencias prácticas que debe satisfacer y por ello se sirven de materiales fuertes y los dotan de cómodos compartimentos para el teléfono y las llaves. También las emociones desempeñan un papel importante para algunos diseñadores: los retratos, las madonas y los ángeles convierten los bolsos en afirmaciones personales.

Una nueva generación de diseñadores acepta el desafío de diseñar un bolso en que la combinación de técnicas antiguas con nuevos materiales conduce a un diseño innovador.

Créations contemporaines

L'évolution des tendances dans le sac à main est très fortement influencée par la mode. Il continue en effet d'être choisi pour accessoiriser les vêtements et ne cesse d'évoluer.

Les créateurs contemporains prennent divers points de départ : fonctionnalité, forme, matière, mode et coup de cœur. Certains s'inspirent de l'architecture et créent des sacs aux formes géométriques et aux combinaisons de couleurs hardies. Pour d'autres, le sac à main est un accessoire fait pour durer et ils observent de près les exigences pratiques en choisissant des matières résistantes et des compartiments utiles pour le téléphone ou les clés. Enfin, pour d'autres encore, les sentiments l'emportent et des portraits, madones ou anges font du sac une déclaration de personnalité.

Une nouvelle génération de créateurs relève le défi de concevoir un sac en combinant les techniques anciennes à de nouvelles matières pour parvenir à une nouvelle esthétique.

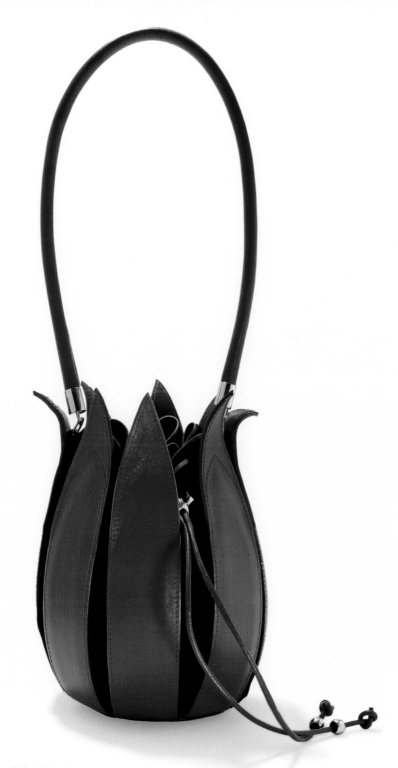

Leather and fabric handbag 'Tulip', Bylin by Linde van der Poel, The Netherlands, 2008.

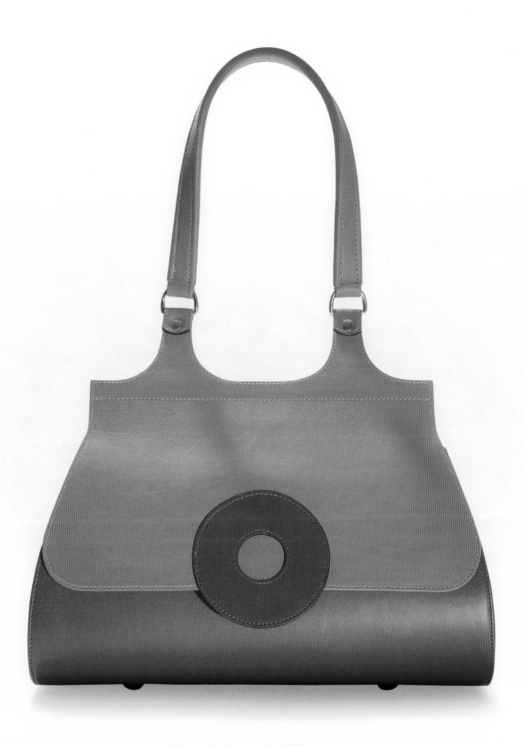

Leather handbag 'Monocle', Hester van Eeghen, The Netherlands, 2009.

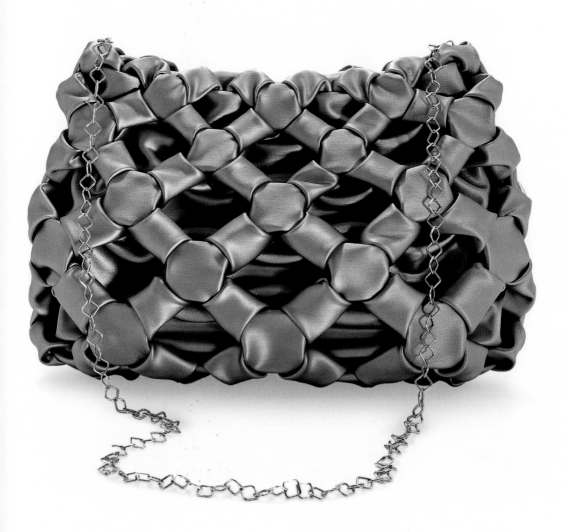

Kangaroo leather bag 'Classic small', design achieved through mathematical folding, Massuniq by Shanna Deurloo and Robert Jan Snoeks, The Netherlands, 2010.

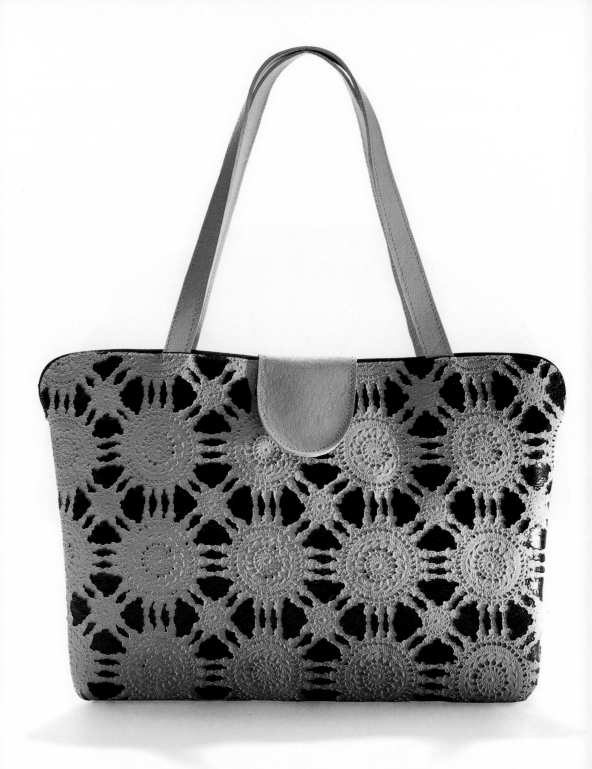

Imitation leather shoulder bag 'Kinkarakawa' with print to imitate lace, Ineke van der Struijs, The Netherlands, 2010.

Leather clutch/shoulder bag, Omar Munie, The Netherlands, 2010.

Felt and leather bag 'Guardian Angel', Vlieger & Vandam by Carolien Vlieger and Hein van Dam, The Netherlands, 2009.

Leather handbag with alpaca handle inlaid with horn, Gabriela Fiori, Argentina, 2010.

Clutch 'Le fan', stainless steel and leather, Wendy Stevens, U.S.A., 2010.

Handbag with knitted strips of horsehair, B.Thalle by Briana Smith, England, 2009.

Folding leather handbag, Ferry Meewisse, The Netherlands, 2002.

Handbag made of cardboard, felt and peacock feathers, Bouwjaar '63, Lia Kroon and Janna Middendorp,
The Netherlands, 2007.

Felt bag, Werkstück by Kerstin Schürmann, Germany, 2010.

Clutch 'Dutchess', Alison van der Lande, England, 2009.

Crocheted shoulder bag, Irá Salles, Brasil, 2009.

Further reading

Books

Allen, Carmel, The handbag to have and to hold, London 1999.

Allin, Michael, Zarafa, A Giraffe's True Story from Deep in Africa to the Heart of Paris, New York 1998.

Arnold, Janet, Queen Elizabeth's Wardrobe Unlock'd, Leeds 1988.

Arthur, Liz, Embroidery 1600-1700 at the Burrell Collection, Cat. Glasgow (Glasgow Museums), London 1995.

Brooke, Xanthe, Catalogue of Embroideries, Cat. Merseyside (The Lady Lever Art Gallery), Merseyside 1992.

Brouwer, Marcel and Joep Haffmans, Cris Agterberg, beeldhouwer en sierkunstenaar, Vianen 2001.

Carried Away, Les cas du sac, Musée de la Mode et du Textile, Paris 2004

Cummins, G.E. and N.D. Taunton, Chatelaines, Utility to Glorious Extravagance, Woodbridge 1994.

Engel, Reinhard, Luxus aus Wien, Luxury from Vienna, deel I, Wien (Vienna) 2002 (2001).

Ettinger, Roseann, Handbags, Atglen, PA (USA) 1999 (1998).

Foster, Vanda, Bags and Purses, London 1992 (1982) (The Costume Accessories Series).

Gall, Günter, Leder, Bucheinband, Lederschnitt, Handvergoldung, Lederwaren, Taschen, Heft 1, Cat. Offenbach (Deutsches Leder und Schuhmuseum) 1974.

Gulshan, Helenka, Vintage Luggage, London 1998.

Haertig, Evelyn, More beautiful purses, Carmel, CA (USA) 1990.

Ivo, S.A., "Zichtbaar of verborgen, Het tuigje, de beugeltas en de dijzakken in de mode en de streekdracht", in: Kostuum, Relaties: Mode en streekdracht, Amsterdam 2000, p. 146-162.

Ivo, S.A., Twintigste eeuwse tassen uit Tassenmuseum Hendrikje, Leiden (paper at University of Leiden) 2001.

Ivo, S.A., 17de en 18de-eeuwse tassen en portefeuilles uit de collectie van Tassenmuseum Hendrikje, Leiden (Master of Arts thesis at University of Leiden) 2002.

Katz, Sylvie, Classic Plastics, from Bakelite to High-Tech, London 1988 (1984).

Kurz, Sabine and Mary Sue Packer, Strass, Internationaler Modeschmuck von den Anfängen bis Heute, München 1997.

Mihm, Andrea, Packend....Eine Kulturgeschichte des Reisekoffers, Marburg (Ger.) 2001.

Musée de la mode et du textile, Carmed away, all about bags, Paris, 2004.

Pina, Leslie and Donald-Brian Johnson, Whiting & Davis Purses, The perfect mesh, Atglen, PA (USA) 2002.

Salmon, Larry, "Ballooning: accessories after the fact", Dress, (1976) 2., p. 1-9.

Scheuer, N. and E. Maeder, Art of Embroiderer by Charles Germain de Saint-Aubin, Designer to the King 1770, Los Angeles (Los Angeles County Museum of Art) 1983.

Schmuttermeier, Elisabeth, a. o., Cast Iron from Central Europe, 1800-1850, catalogue of exhibition. Vienna/New York (Austrian Museum of Applied Arts) 1994.

Schürenberg, Sabina, Glasperlarbeiten Taschen und Beutel, von der Vorlage zum Produkt, München 1998.

Serena, Raffaella, Embroideries and patterns from 19th century Vienna, Milan/Woodbridge 1998.

Raulet, Sylvie, Van Cleef & Arpels, Paris 1986.

Wiener Werkstätte, Lederobjekte, Cat.Wien (Österreichischen Museums für Angewandte Kunst), Wien 1992.

Ulmer, R. en J. Srasser, Plastics Design +, catalogue of exhibition. München (Die Neue Sammlung, Staatliches Museum für Angewandte Kunst), München 1997.

Ulzen, Evelyn, Glasperlen, Herstellung und textiler Verbund, Berlin 1993.

Warren, E., Treasures in needlework, comprising instructions in knitting, London 1855.

Wilcox, Claire, A century of bags, icons of style in the 20th century, Londen 1997.

Wilcox, Claire, Bags, Cat. London (Victoria and Albert Museum) 1999.

Magazines and trade catalogues

Au Bon Marché, Nouveautés d'Hiver, Paris 1927-1928.

De Bazar, 1865-1886.

Elegance, Amsterdam 1947-1956.

Femina (UK ed.) 1920-1921.

Femina, Paris 1901-1948 (incomplete).

La Femme Chic, Paris 1913 -1961 (incomplete).

Harrods News, London 1902, 1904, 1906-1914, 1916, 1919-1984.

Harpers' Bazaar, New York 1950-1955.

Journal des Dames et des Modes (new ed.) 1913, 1916.

Lederwaren, Doetinchem 1938-1968.

Liberty Gifts, London 1926, 1931-1933 (incomplete).

Liberty Christmas gifts, London 1930-1931, 1933-1934.

Liberty Yule-tide gifts, London 1908-1920, 1923-1932 (incomplete).

La Mode illustrée, Paris 1875-1919 (incomplete).

Les Modes, Paris 1901-1921 (incomplete).

Penelopé, Amsterdam 1821-1835.

Vogue (UK ed.) 1924-1926, 1930-1940 and 1951.

Vogue (French ed.) 1925-1937 and 1953.

Vogue (USA) 1932, 1950-1955.

Archives

Dunhill archives (archives from Alfred Dunhill Limited, London).

Wiener Werkstätte archives in the Austrian Museum of Applied Arts.